Painting as an Art

RICHARD WOLLHEIM

Painting as an Art

With 388 illustrations, 30 in colour

THAMES AND HUDSON

Copyright © 1987 by the Trustees of the National Gallery of Art, Washington, D.C.
The A.W. Mellon Lectures in the Fine Arts, 1984, delivered at the National Gallery of Art, Washington, D.C.

First published in Great Britain in 1987 by Thames and Hudson Ltd, London
Published in the United States of America in Bollingen Series by Princeton University Press, Princeton, NJ

Printed in Great Britain by Balding & Mansell Limited, Wisbech, Cambs.
Bound in Great Britain.

Contents

For Emilia

Preface

THIS BOOK is a greatly expanded, greatly revised, version of the Andrew W. Mellon Lectures in the Fine Arts, which I gave in the National Gallery of Art in Washington in November and December 1984. I am deeply grateful to the Director and the Trustees for an invitation which allowed me, indeed it obliged me, to put together certain long-standing interests and concerns of mine, which otherwise I would most probably never have done.

The lectures were delivered under the title 'Painting as an Art', and, though, when I originally chose the title, I did so for its accommodating character, I retained it once I saw how well it corresponded to what I wanted the lectures to be about.

Not all, but most, Mellon lecturers have been art-historians. This has somewhat eased their choice of a topic. I am not an art-historian, either by profession or by training. I am a philosopher, and, though it did occur to me that the reason why I had been invited might have been so that I should present a full-blown system of the arts today, which may well be needed, I soon put any such austerely philosophical topic out of my mind. It seemed unsuitable: and for two distinct reasons. In the first place, it would mean overlooking the fact that the lectures were to be delivered surrounded by one of the great art-collections of the world and, most probably, to an audience which was recuperating from looking at its splendours. Four o'clock on a Sunday afternoon in the National Gallery of Art seemed neither the time nor the place for a totally abstract presentation. Secondly, I had already, some fifteen years earlier, in an extended essay, *Art and its Objects*, said almost everything that I had to say on the issues of analytic or general aesthetics, and my own thoughts were moving much more in the direction of treating aesthetics in what elsewhere in philosophy – in the philosophy of mind, in ethics, in political philosophy, in the philosophy of science – has increasingly come to be thought of, and argued for, as a 'substantive' fashion. Having for some time advocated substantive aesthetics – not, I must insist, as an alternative, but as a supplement, to general aesthetics – I now had the chance to practise it. It was not a chance to be missed, and very soon I fixed on a topic within this broadly defined field. I would talk about two things: the conversion of the materials of painting into a medium, and the way in which this medium could be so manipulated as to give rise to meaning – and I would do all this through a study of a few painters who were close to my heart. It was this choice of topic that, I soon came to see, the title which I had more or less stumbled upon reflected so accurately. In sorting out these possibilities in my mind and in arriving at a decision, I had been very much helped by long discussions with my old friend, Robert S. Silvers, whose advice is always excellent.

One consequence of the decision I had reached, and one which was very congenial to me, was that, in constructing my lectures, I should start from my own experience of painting. From the age of thirteen or less, painting has been for me one of the greatest

sources of pleasure and excitement in my life. Two of the artists who figure prominently in the delivered lectures, Poussin and Picasso, also figure prominently in my earliest memories of painting. That, in the cause of delivering a series of public lectures, I should have to revive such memories, that I should be obliged to re-create some of the pleasure, some of the excitement, that painting has offered me, seemed to me, coming at the matter from philosophy, an amazing bonus.

Starting from the experience of painting does not mean stopping there. The experience of art, however heady, always craves to be understood – indeed the interlock of experience and understanding in the domain of art was one of the major themes of *Art and its Objects* – and understanding the experience of art takes the form, on my view of the matter, of coming to see the work that causes the experience as in turn the effect of an intentional activity on the part of the artist. This activity must not be envisaged in too narrow or limited a way. The intention that motivates the activity must not, for instance, be equated with the bare intention to produce a work of art – whatever that would be. At least in the context of art, intention must be taken to include desires, beliefs, emotions, commitments, wishes, that the agent has and that, additionally, have a causal influence on the way he acts. Some of these psychological factors arise from deep in the artist's psyche, some are unthinkable outside the history and traditions of painting, but it is important to realize that none of them could have an influence on the way the artist works, none of them could cause him to paint in this way rather than that, if it were not for certain further and very significant beliefs that he holds. These are beliefs about how the resultant painting will be perceived, and the artist must believe that, when a particular intention is fulfilled in his work, then an adequately sensitive, adequately informed, spectator will tend to have experiences in front of the painting that will disclose this intention. Another way of putting this point, a more dramatic way but fully justified, is to say that all art, or at any rate all great art, presupposes a universal human nature in which artist and audience share, and in Washington I expressed my gratitude, and I should like to reaffirm it, for the opportunity that the Mellon lectures gave me of asserting the common ground in which two of the deepest commitments of my life – the love of painting, and devotion to the cause of socialism – are rooted.

The highly compressed formulations that I have just attempted, in so far as they reconstruct the lines of thought along which substantive aesthetics required me to move, soon suggested the different areas into which I should have to venture. There were at least three large areas that would prove relevant. First there was, as I have already stressed, the experience of art, from which the lectures would take off, and early on I made the decision not to talk at any length about any painting that I had not seen within the previous three years. Going back to look at works I already knew, or, in a few cases, as with the great *Drunkenness of Noah*, which I talk about in the sixth lecture, seeing a work for the first time, I evolved a way of looking at paintings which was massively time-consuming and deeply rewarding. For I came to recognize that it often took the first hour or so in front of a painting for stray associations or motivated misperceptions to settle down, and it was only then, with the same amount of time or more to spend looking at it, that the picture could be relied upon to disclose itself as it was. I spent long hours in the church of San Salvatore in Venice, in the Louvre, in the Guggenheim Museum, coaxing a picture into life. I noticed that I became an object of suspicion to passers-by, and so did the picture that I was looking at. To the experience, to the hard-won experience, of painting, I then recruited the findings of psychology, and in particular the hypotheses of psychoanalysis, in order to grasp the intention of the artist as the picture revealed it. In these lectures I have not attempted to 'psychoanalyze' individual painters, but, if I am right in thinking that art presupposes a common human nature, and that pictorial meaning works through it, then it must be absurd to bring to the understanding of art a

conception of human nature less rich than what is required elsewhere. Many art-historians, in their scholarly work, make do with a psychology that, if they tried to live their lives by it, would leave them at the end of an ordinary day without lovers, friends, or any insight into how this had come about. Finally, the pursuit of experience and the reconstruction of intention would have to be undertaken under the constraints of philosophy, and it was my hope that philosophy, sensitively pursued, could often propose fresh lines of inquiry, as well as showing others to be circuitous, interrupted, or unprofitably arduous. Painting, psychoanalysis, philosophy — these are the long-standing interests and concerns to which I have already referred, but, in conjoining them for the sake of these lectures, I have had only one aim: that of advancing the understanding of painting. There has seemed to me no point in setting painting in a new light, unless I could satisfy myself that it was also a true light. I should be very pleased if this book allowed some of its readers to get closer to the works it considers.

Some twenty years or so ago, I hubristically reviewed an art-historical monograph which was a major work of scholarship. My only qualification for doing so was a total attachment to its subject. In reviewing the book, I deployed, I now see, some of the ideas about pictorial meaning, understanding, and artist's intention, that I make use of, rather more self-consciously, in these lectures, and the author, whom I knew, replied in the most charming and generous fashion, and he wondered whether I was not criticizing him for (I quote) 'having failed to write a kind of art-history which so far no-one has written'. The phrase stuck with me, and, in writing these lectures, in which I certainly do campaign for a more explanatory account of painting than is usually provided, I have had to consider carefully what I thought of the nature and status and aims of a discipline of which I am perilously ignorant. Against the mounting, clamorous demands for 'a new art-history', what do I really think of the old art-history?

Most of the criticisms I have of existing art-history are already conceded, some directly, some only indirectly, in the name it goes by: 'art-history', 'art-*history*'. Standardly we do not call the objective study of an art the history of that art. We call it criticism. We talk of literary criticism, of musical criticism, of dance criticism. What then is the special feature of the visual arts, something which must be over and above the general way in which all the arts are connected with a tradition, and which has, allegedly, the consequence that, if we are to understand painting, or sculpture, or graphic art, we must reach an historical understanding of them? I do not know, and, given the small progress that art-history has made in explaining the visual arts, I am inclined to think that the belief that there is such a feature is itself something that needs historical explanation: it is an historical accident.

But the most serious criticisms that I have of the way in which the visual arts are currently studied arise, not just from the fact that they are studied historically, but from a number of methodological errors that surround historical inquiry itself. An umbrella term for these errors is positivism. Art-history is deeply infected with positivism, and central to positivism are the overestimation of fact, the rejection of cause, and the failure to grasp the centrality of explanation. Positivism is a pernicious disease, and in particular it ravages those who did not gain immunity through close contact with it at some early moment in their lives.

The most casual reader of this book will soon appreciate that, unlike most thinkers who wish to extend the scope of art-history, I am not drawn to two bodies of thought which are widely regarded as sources of revitalization for the subject. One is the tradition of social or sociological explanation of the arts. I admire a great deal the learning and the originality of the two great proponents of this method in the English-speaking world: T.J. Clark on the theoretical, Francis Haskell on the anecdotal, wing. But neither wing seems to me to promise much as far as my interests, or the central problems of the study of art,

are concerned. For, whereas one encourages an insufficiency of theory, and so leaves explanation as far out of reach as it ever was, the other theorizes into existence something which, as far as I can see, is unsupported either by evidence or by general plausibility: that is, a social function that all works of visual art universally and of necessity discharge. I have, incidentally, never regarded a commitment to social explanation as a required concomitant of socialism. The other body of thought that I pass over, and I do so with less disquiet, is the structuralist and post-structuralist tradition, the distinctive vocabulary of which permeates much art criticism that promises new ideas, new methods. Friends whose intelligence I esteem very highly tell me of the merits and insights that this body of thought has to offer, but, if *they* have been unable to convince me on this score, I can only conclude that this whole tradition is, subjectively at least, unavailable. When I turn to its leading exponents, and try to read what they have written, I find daunting their seeming indifference to the particularity of the works they engage with and the readiness with which they allow their perceptions to be blurred by what is called by their adherents, quite inappropriately, 'theory'. Quite inappropriately, because the term 'theory' is in place only when some distinction is respected between description and explanation.

The truth is that the art-history in which I have found most to admire is art-history in its most traditional mode. Connoisseurship, or the science of attribution, still seems to me the best hope for the objective study of painting: though it must remain no more than a hope so long as it fails to find — or, more accurately, so long as it fends off — a suitable theory which would at once constrain and vindicate its practice. In composing these lectures, I have derived most benefit from two art-historians who would be thought of as traditionalist, but who have opened my eyes. They are Denis Mahon and Johannes Wilde, and their influence is manifest all over Lectures IV and VI, respectively.

In preparing, delivering, and then rewriting, these lectures I have incurred innumerable debts, and I shall try to acknowledge them in the order in which they were contracted. But I shall start with two general debts, which go back a long way. The first is to a few friends with whom I have, over the years, looked at many pictures: I have learnt from each something about how to do so. They are John Golding, Benedict Nicolson, John Richardson, Meyer Schapiro, and Adrian Stokes. The second debt is to the writings of Ernst Gombrich. What has always been far more important for me than the points on which we may happen to agree or disagree is the marvellous example that he has set of how to think about the visual arts in a systematic fashion, and, as I see his work, how to set them inside a general theory of human nature.

In the course of preparing these lectures I received a great deal of help and was shown much kindness at a number of museums and galleries. I should like to thank in particular: Dominique Vila, at the Louvre; Pierre Barousse, at the Musée Ingres, Montauban, who was always welcoming; Joyce Egerton, at the Tate Gallery; Hugh MacAndrew, at the National Gallery of Scotland; Timothy Stevens and Edward Morris, at the Walker Art Gallery, Liverpool; Edward Pilsbury and Michael Mezzatesta, at the Kimbell Art Museum, Fort Worth; Maurice Tuchman, at the Los Angeles County Museum, Los Angeles; Jill Weisberg, at Xavier Fourcade, Inc.; and Robin Vousden, at the Anthony d'Offay Gallery. I should also like to convey my deep gratitude to Matilde Dolcetti, whose kindness and generous hospitality in Venice made my trip there even more agreeable than it would otherwise have been.

A task for which I was totally unprepared when I began work on these lectures was the accumulation of slides. I started off with what I was told were totally unrealistic standards, but thanks to the advice and assistance that I received, I barely had to depart from.them. For this advice and for assistance far in excess of what I could have expected, I should like to thank, in addition to the museum and gallery staff I have already mentioned: Sylvia Bay, of the Guggenheim Museum; Allan Braham, of the National

Gallery; Helmut Börsch-Supan; Jerome Bruner; Françoise Camuset, of the Réunion des Musées Nationaux; Derek Carver, of the Miniature Gallery; Patricia Condon; Pietro Corsi; Pieter Diemer; John Fleming; FMR; Sydney Freedberg; Peter Galassi, of the Museum of Modern Art, who helped me to choose photographs in illustration of a number of points; Lawrence Gowing; Egbert Haverkamp-Begemann; Charles Henneghien; Rosemary Lauer and Anna Whitworth, of the Courtauld Institute of Art; Marilyn Aronsberg Lavin; Evan Maurer, of the University of Michigan Art Gallery; Margaret Noland, of the Metropolitan Museum of Art, who was endlessly kind; Francesco Papafava dei Carraresi, of Scala; John Pope-Hennessy; Annalise Rablen, of the Nasjonalgalleriet, Oslo; John Sheeran, of the Dulwich Picture Gallery; Robert S. Silvers; John Steer; Renate Wiedenhoeft, of Saskia; and the slide libraries and photographic units of Birkbeck College London, University College London, and Columbia University. However, even with such excellent slides as I came by, I was constantly reminded that many of the pictorial effects that I talked about in Washington are not, for a variety of reasons, conveyed by reproductions, and I hope that readers of this book will remember this fact. Since the days of the great Heinrich Wölfflin, art-historians have tended to identify the object of their inquiry with those properties of a painting which a good slide preserves.

During the period when I delivered the lectures I was a guest of the Center for Advanced Studies in the Visual Arts, housed in the National Gallery of Art. I could not believe my good fortune. CASVA was a wonderful oasis in one of the most unwelcoming of cities. The Dean, Henry Millon, has contrived to endow it with what are to my mind the two virtues that are the prerequisites of any institution that holds out promise of serious intellectual work: elegance of style, and egalitarianism. Only indolence stopped me from being in the Center every morning as the doors opened, and it was always with the greatest reluctance that I dragged myself away at night, and walked in the dark across the large expanses of worn grass, past the great dream-palaces of empire, to where I lived. While I was in CASVA I derived pleasure and profit from everyone I met. I should particularly like to recall conversations with Jonathan Alexander, Susan Barnes, Beverley Brown, Elizabeth Cropper, Charles Dempsey, Linda Docherty, Charles Mitchell, John Onians, and Martin Powers, as well as with Hank Millon. I have a special debt of gratitude to Anne von Rebhan and Danielle Rice for the good reason that, as they well know, if it had not been for their help and kindness with the practical details of the lectures, the lectures would never have been delivered.

Another great stroke of fortune was that, at a crucial point in the rewriting of these lectures, I was invited for three weeks to the J. Paul Getty Center for the History of Art and the Humanities. I should like to thank the Director, Kurt Forster, for his very kind invitation and for the events that he planned around my stay. Without such a period of uncommitted time, and without the scholarly resources that were open to me, the text of these lectures would have been a much thinner affair. Both the scholars and the administrative and research staff of the Center provided congenial and stimulating company. Every query of mine found someone to answer it.

Various friends and colleagues have read parts of these lectures in manuscript, and I have learned a great deal from their comments. I should like to thank them very much for the time and trouble that they have taken with my ideas, which they may not always have found congenial. I am deeply indebted to Svetlana Alpers, Malcolm Budd, Patricia Condon, Charles Dempsey, Hanna Segal, and Leslie Sohn. I have also benefited a great deal from conversation on the topics of these lectures with various friends. Let me thank Arthur Danto, Sandra Fisher, Andrew Forge, David Freedberg, Raymond Geuss, Lawrence Gowing, Richard Hennessy, R.B. Kitaj, Michael Kitson, Thomas Nagel, Antonia Phillips, Michael Podro, John Richardson, and Barry Stroud. I owe individual

observations or points of scholarship, some of which turned out to be crucial to the development of my argument, to Michael Baxandall, Jerome Bruner, Myles Burnyeat, David Charlton, Marjorie Cohn, David Davies, Kurt Forster, Jacques Foucart, Michael Fried, Marie Gallup, Patrick Gardiner, Alexander Goehr, John Golding, Stephen Grosz, Sylvia Guirey, Michael Hirst, David Hockney, Peter Holliday, Jim Holt, William Jordan, Richard Kuhns, Marilyn McCully, Graham McFee, Deborah Marrow, Jean Mongrédien, Edward Morris, Martha Nussbaum, Nicholas Olsberg, Christopher Peacocke, David Rosand, Paul Taylor, Will Vaughan, Kayley Vernallis, Ralf Weber, and Bruno Wollheim.

I have had the enormous advantage of delivering some of the material that I use in this volume in classes given at Columbia University, University College London, the University of California Berkeley, and the Architectural Association, London. I have been greatly helped and encouraged by those who attended these classes, and I should like to thank them. I have also been invited to give lectures on these topics to universities in Great Britain, the United States, and South Africa. I should like to thank John Dolan, Andrew Forge, Laurie Gane, Raymond Geuss, Dale Jamieson, Gene Mason, Paul Taylor, and Bob Zimmerman for bringing about these occasions. I was particularly impressed by the close attention accorded to these lectures in South Africa, where staff and students had daily to face the facts of oppression and inhumanity.

In the final stages of this book I received a great deal of assistance and support from Frances Smyth of the National Gallery of Art, and my publisher Nikos Stangos. I should like to thank them both warmly, and also Elizabeth Clarke and Pauline Baines to whom the book owes its appearance. Malcolm Budd generously allowed me to use the resources of the Department of Philosophy, University College London. My final and deepest debt of gratitude is once again to Katherine Backhouse, who, over two years, prepared innumerable drafts of each lecture. Despite the massive toil and tribulation that the final stages involved, she always gave me help and encouragement, without which I would have been lost.

Note: In the captions to the black and white illustrations, all works are oil on canvas unless otherwise stated.

I

What the artist does

1. The title that I have chosen for these lectures, 'Painting as an Art', draws its sense from the other contrasting ways in which people can, and do, paint. Let us take stock of them. So, there are house-painters: there are Sunday painters: there are world-politicians who paint for distraction, and distraught business-men who paint to relax. There are forgers — an interesting group. There are chimpanzees who have brush and colour put invitingly within their reach: there are psychotic patients who enter art therapy, and madmen who set down their visions: there are little children of three, four, five, six, in art class, who produce work of explosive beauty: and then there are the innumerable painters of street-scenes, painters of Mediterranean ports, still-life painters, painters of mammoth abstractions, whose works hang in old-fashioned restaurants or modern banks, in the foyers of international hotels and the offices of exorbitant lawyers, and who once, probably, were artists, but who now paint exclusively for money and the pleasure of others. None of them are artists, though they fall short of being so to varying degrees, but they are all painters. And then there are the painters who are artists. Where does the difference lie, and why? What does one lot do which the other lot doesn't? When is painting an art, and why?

2. But to pose the question in these terms shows that we are already some distance into the subject, into pictorial aesthetics or the philosophy of painting: and it would be useful to see how this could be so, and just where we are.

 The question that is the usual starting-point for an inquiry into the nature of pictorial art is not, What makes painting an art? It is, What makes a painting a work of art? What ordinarily initiates the inquiry, is, in other words, a question not about an activity, but about a thing, and to this question many many different answers have been proposed. Into this variety order may be introduced by thinking of these answers as either *externalist* answers or *internalist* answers.

 I start with one particular answer, which is an externalist answer, and, through understanding it, we can come to see how externalist and internalist answers differ. But the answer enjoys a popularity in its own right, and that is another reason for starting with it. Its popularity is not exclusively with philosophers of art: it may not even be largely so. It is popular with art-critics, with administrators and impresarios of art, with successful dealers, and (it must be said) with artists too. Small wonder, as we shall see: small wonder despite its fundamental implausibility.

3. I start with the answer given by the *Institutional theory of art*, as it calls itself.[1] The Institutional theory comes in various grades of refinement or sophistication, but I shall consider it in its simplest form. I believe that the theory is at its best at its simplest, and that refinement only obscures what it has to offer us without reducing any of the very serious difficulties that attach to it.

The core of the theory is this: A painting is a work of art just in case certain people occupying certain socially identified positions – the theory calls them 'the representatives of the art-world' – confer this status upon it. Another way of putting the theory is to say that for a painting to be a work of art the representatives of the art-world must recognize it to be one: and, with the theory put this way, the trick is to grasp how we are supposed to understand 'recognition'. What 'recognition' does not mean in this context is that, before the representatives of the art-world appear on the scene, the painting already is a work of art and this fact about it leads them, being so knowledgeable or so discriminating or both, to see it, and think of it, as one. On the contrary: what the theory tells us is that, first, the representatives of the art-world must think of and see the painting as a work of art, and, then, in consequence of this fact – this fact about them – the painting becomes a work of art. Recognition, in so far as this notion occurs in the expression of the theory, isn't like the botanist's recognition of a plant, or an aircraft-spotter's recognition of an enemy plane: it is closest to the recognition that a nation state gives to, or withholds from, a foreign government after the violent overthrow of its predecessor.

And here we have what explains the popularity that the Institutional theory enjoys in certain circles. For what the theory manifestly does is that, by laying upon them legendary powers, it grossly enlarges the self-esteem of those tempted to think of themselves as representatives of the art-world. Painters make paintings, but it takes a representative of the art-world to make a work of art.

Can this really be so?, we might wonder. To particularize: In the 1950s and the 1960s, when Clement Greenberg was able, before our eyes, to make and unmake the reputations and prices of works of art, could he also make and unmake that they were works of art? If he could, how did he do it? And, if he couldn't, who in the history of painting was likelier to have been able to do so?

A question to put to the theory, which nicely divides its supporters into the faint-hearted and the bold, is this: Do the representatives of the art-world have to have, or do they not have to have, reasons for what they do if what they do is to stick? Is their status enough for them to be able to confer status upon what they pick out, or must they additionally exercise judgment, or taste, or critical acumen, so that it is only if the paintings they pick out satisfy certain criteria or meet certain conditions that status is transferred?

Suppose that an Institutionalist says, Yes, a representative of the art-world must have reasons if he is to be effective, then one immediate response to him would be that the theory – at any rate, as he conceives it – is incompletely before us. We need to know what those reasons are. Until we are told what they are, we have only part of the theory.

That we should not put up with part of a theory when the theory is supposed to answer a question that troubles us is a standard response. But, in the present case, there is more to the response than that. For it is possible that, once we are told what reasons the representatives of the art-world have to have for declaring a painting to be a work of art, these reasons will turn out to be all that we need to know. They will provide us with a total account of what it is for a painting to be a work of art. For, if it is necessary that paintings, to be works of art, should satisfy certain criteria, why isn't the satisfaction of these criteria sufficient in itself, and what is the further need for there to be representatives of the art-world who first apply these criteria to paintings and then announce to the world which paintings satisfy them? Such socially identified persons seem to have no contribution to make to the account of art, they belong only to the presentation of the account: rather as though an account of disease were to try to characterize disease in terms of what doctors do and say about it. In its faint-hearted form, in which it insists upon reasons, the theory we have been offered seems certainly not to be wholly, and only dubiously to be in part, an Institutional theory. For what appeared to earn the theory that

description – the reference to the art-world and its representatives – looks to be no more than a decorative flourish in its formulation.

So I turn now to the bold form of the theory, in which the representatives of the art-world are absolved from having to produce reasons for the pronouncements they make. In this pared-down form the theory really is an Institutional theory, and the objections to which it is exposed, which are of two broad kinds, are out in the open.

Let us look at them in turn.

The intellectual appeal of the theory, as opposed to its self-serving attractions, is its hard-headedness. It offers to demystify art by reducing it to certain ascertainable social facts. However, once we appreciate this aspect of the theory, we must then start wondering whether there really are such facts as those in terms of which it professes to explain art and which it wants us to take for granted. If we are not prepared to take these facts on trust, we shall have to ask ourselves such questions as, Does the art-world really nominate representatives? If it does, when, where, and how, do these nominations take place? Do the representatives, if they exist, pass in review all candidates for the status of art, and do they then, while conferring this status on some, deny it to others? What record is kept of these conferrals, and is the status itself subject to revision? If so, at what intervals, how, and by whom? And, last but not least, Is there really such a thing as the art-world, with the coherence of a social group, capable of having representatives, who are in turn capable of carrying out acts that society is bound to endorse? In another context these questions might strike us as niggling, and we might be ready to take the existence of the art-world as, if not a fact, then a reasonable *façon de parler*. But in the present context, where whatever the theory has to offer us in the way of explanation it offers us in terms of this art-world, we cannot do this, and there must be precise, specific answers to each of the questions I have raised. It would be, for instance, totally inadequate for upholders of the theory to pick out some social act whose existence no one would deny – say, the purchase of a painting by a museum – and then tell us that we could regard that act as the art-world in action, or that we could interpret it as the conferral of the status of art. Of course we *could*. But, if we did, that would not show anything about how, up to that moment, the status of art had been grounded. Unless there is a convention accepted in our society whereby the purchase of a painting counts as the conferral of status, and unless, when paintings are bought by museums, this convention is knowingly and appropriately invoked, the theory has failed to come up with what it promised. In the absence of hard social facts of this tenor, the theory has not shown that the status of art is an appearance, which social reality explains.

So much for the first kind of objection. The second kind of objection latches onto the very feature of the theory that has introduced it into the present discussion. It also helps us to understand that feature. The objection is then that the theory gives an externalist answer to the question, What makes a painting a work of art? In other words, it answers the question by picking out a property of the painting that has nothing to do with its being a painting, with its paintingness. The mere say-so of certain socially identified persons is clearly such a property. And this is so even when we include amongst representatives of the art-world the artist himself and make his say-so a major determinant of the status of what he produces. For what makes a painting a painting is what the artist does, not what he says. It is what he does that matters. What the artist says is, in this context as in many others, merely evidence, and tainted evidence at that, for what he has done or will do. At best it is one remove away from what matters.

So we must ask, What is wrong with an externalist answer? The characterization I have offered of externalism gives us all the materials we need for answering this question. What is wrong with any externalist answer is, basically, its intuitive unacceptability. Any such answer goes against what is surely one of the few intuitions that we have on this

topic: that is, that we cannot, having judged that a painting has as a painting a certain character, then, when we come to determine whether the painting is or isn't a work of art, treat this character as totally irrelevant. If a painting is a work of art, this must be because of being the kind of painting that it is, of having the kind of pictorial character that it has. A pictorial work of art cannot be only coincidentally a painting.

A characteristic defence of the Institutional theory against this second objection is revealing just because it shows how far the theory is willing to distance itself from natural considerations.[2] The defence is this: If the Institutional theory appears to trivialize the question, What makes a painting a work of art?, this cannot be pressed as an objection to the theory. For the question is indeed trivial, and the only reason why anyone might think otherwise is through confusing it with the altogether different and certainly non-trivial question which is, What makes a painting a good work of art? Now this defence, so far from reconciling the Institutional theory to our natural assumptions, only brings it into conflict with another intuition that we have in this area: for now, in addition to severing the question, What is a work of art?, from, What is a painting?, the theory also severs the question, What is a good work of art?, from, What is a work of art? Surely it is counter-intuitive to think that a totally different body of material has to be introduced in order to establish the value of a work of art from what has proved pertinent to fixing its status as a work of art. Admittedly the two questions are not the same. Admittedly there are foolish ways of relating them: for instance, to hold that a good work of art is something that is a work of art to a high degree. But, just as obviously, to divorce the two questions, or, having conceded that the value of a work of art introduces internalist issues, still to insist that the status of art can be settled on purely externalist grounds, makes nonsense of our intuitive thinking.

At this stage we naturally turn from an externalist answer to the question, What makes a painting a work of art?, to an internalist answer, knowing by now that this will be an answer that picks upon a property that is essentially connected with the painting being a painting. It cannot, of course, be the property of being a painting, nor one that follows from it, for that would make all paintings works of art: but it must be a property that presupposes, and in some substantial fashion, that the work to be considered is a painting.

Externalist answers to our question vary greatly, but internalist answers, or internalist answers that have stood the test of time, seem to be only two in number, though each answer consists in a fairly tight-knit cluster of variants.

The first of the two answers insists that the criterion of art lies in some directly perceptible property that the painting has, and then different variants of this answer record the different properties that different theorists favour. The favoured property is invariably an overall property: like goodness of form as Gestalt theory defines it, or spirituality, or Significant Form. As these examples show, the particular theories can be more, or less, formalist.[3]

But so long as the theory insists that the criterial property is perceptible, or that a pictorial work of art must not merely have this property but must be perceived to have it, it runs into a difficulty. The difficulty arises from the fact that — perhaps the very simplest cases apart — whether a painting can be perceived to have a certain property always depends on what else the spectator knows or believes either about that painting or generally. This indeed is a general truth about perception, which one of my most distinguished predecessors in this series, for many years a colleague and whom I count as a friend, Ernst Gombrich, likes to put by saying that there is no such thing as 'the innocent eye'.[4] One immediate implication of this truth is that it appears to put the theory we are now considering in exactly the same position as the Institutional theory proved to be in at a certain point in its exposition: the theory is incompletely before us. The theory is incomplete until we attach to it some specification of the background knowledge and

What the artist does

belief, the *cognitive stock* as I shall call it, upon which the spectator can and must draw in determining whether the painting satisfies the criterion of art.

For, once we start to reflect upon what should go into the spectator's cognitive stock, an obvious contender – obvious if only because its presence or absence is bound to make a vast difference to the overall properties that the picture can be perceived to have – is how the painting came to be made, or the nature of the process that terminated on the picture. However, once we admit how the work came to be made as required background information for determining the properties that the painting has, we have on our hands the makings of an alternative internalist account: an answer that holds in effect that a painting is a work of art in virtue of the activity from which it issues – more precisely, in virtue of the way in which this activity is practised. Admit the activity and how it is practised as relevant background information for determining the criterial property of art, and it edges its way forward into the position of the criterial. And that is because any motive that we might have for subscribing to an account that makes properties of the work criterial has justice done to it and more within an account that makes the activity from which paintings issue and how it is practised criterial, whereas the converse is not true. The reason for this is simple. It is that two paintings could have the same property, indeed they could have the same overall property, or general look, and this might have been brought about in the two cases in significantly different ways or with radically different intentions.[5]

And now it is time to pause and take stock. For since the activity from which paintings issue is *painting*, and since the way in which painting has to be practised if it is to give rise to works of art can only be *as an art* – however uninformative it may be to say this at this stage – here we are back to the title of these lectures and with some understanding of why this is, as I put it, some distance into the subject. To make this the starting-point assumes that certain ideas which are initially plausible have been superseded.

So, How is painting to be practised if it is to be an art?

4. Let us, in trying to get an answer to this question, focus not on the activity of painting as such but on particular acts of painting: on acts, that is to say, out of which individual paintings come into being.

Now any particular act of painting can be described truly in a very large number of different ways, and, in the ordinary course of events, which description or descriptions we offer will depend upon our interests. However out of all these true descriptions of just one act there is a sub-set of descriptions that are privileged. (I say, 'sub-set', but these privileged descriptions can with ingenuity can be compressed into one description, most likely of great complexity.) Now what makes these descriptions privileged is that they are those under which the act is intentional, and, though I shall spend the rest of this section trying to explain this very special feature, I can here and now say that, in trying to isolate the special way in which acts of painting have to be undertaken in order to be art, we can, for a start, disregard all but the privileged descriptions true of them.

That an intentional action is so always relative to a description true of it is a very general point about human behaviour,[6] and that this not only holds for painting but has significance for it places painting firmly within the domain of the theory of action. But to clarify the point itself I take an example well outside painting, well outside art.

So we look out of the window, and we see a man across the street. We watch him. We follow what he does with great care, and we find that we can truly describe his action in the following ways: (one) that he walks up and down, (two) that he attracts the attention of the police, (three) that he is wearing out the soles of his shoes, (four) that he is preventing the children of the neighbourhood from playing their midday game of hopscotch, (five) that he casts a sharp shadow on the pavement, and (six) that he has

disturbed the old lady who lives in the front room across the street and usually sleeps late, and made her rise from her bed and pull down the blind.

But, though the man certainly does all these things, he does not do them all intentionally. All he does intentionally, let us say (for, after all, the case is made up, and we can say what we choose), is to walk up and down. The only description under which his action is intentional is the first on my list. Or, vary the case a little, and what he does intentionally is now something more complex: he walks up and down so as to arouse the suspicions of the police – while his friend robs the pawnshop round the corner. Now his action is intentional under a description built up out of the first and second on my list. And in different cases, with different narratives, it would be different things he does intentionally – a real Scrooge, he has set his heart on spoiling the game to which the children look forward every morning – and consequently there would be different descriptions under which his action is intentional. Of the descriptions I listed it is highly improbable that his action would be intentional under all of them. It is highly improbable, though possible, that his action would be intentional under the description 'wearing out the soles of his shoes'. However the crucial point to note is that correlated with each change in the narrative, with each shift in the privileged description, there is a real difference, a difference in what actually goes on.

But how are we to characterize these differences? To put it another way: Why is one description of the man's action privileged, or how do we select out of the many many descriptions true of it that under which it is intentional?

The answer I propose is this: Corresponding to each description of an action is a thought, and an action is intentional under a certain description if what guides the person's action is the corresponding thought. A thought guides an action when it both causes it and forms its character. So, in our example, the man acts intentionally under the description 'walking up and down' if a thought expressible as 'Keep on walking, keep on walking up and down' is what guides his action. Other thoughts – thoughts of the police, of the soles of his shoes, of the children and their midday game, of the insomniac old lady – may, may not, enter his head. But so long as it is true that his action is not intentional under the corresponding description, any such thought exists in his head idly. It doesn't cause him to act. It floats there. Once it ceases to float there, then there is, of course, a different description under which his action is intentional, and a different narrative to tell about what he does intentionally.

To the question, How do we select the description under which he acts intentionally, a short answer would be, We don't. He does. It isn't we who select the description, it is he who does. Everything depends on what goes on in his head.

5. If we are to give an account of the special way in which painting must be practised so as to be an art, we need to concentrate on the descriptions under which specific acts of painting are intentional. We may ignore the descriptions that are merely true of such acts. This is so because, painting being an intentional activity, particular ways in which it is practised must equate with particular descriptions under which it is intentional. Ways of painting pair with kinds of intention.

However, in recognizing this, we must be on our guard. Few words have caused such barren discussion in aesthetics as the word 'intention'.[7] One reason is that the word has been used by philosophers of art either far more narrowly or far more broadly than seems reasonable elsewhere. On the excessively narrow understanding, intention is equated with a mere volition or optative thought on the part of the artist that the work should look a certain way or that the spectator should have a certain response to it. More specifically, it is envisaged as a kind of internal command addressed to himself, telling him to paint in such a way that the spectator will identify what he has done in some required

What the artist does

fashion. On the excessively broad understanding, intention is equated with just about everything that goes on in the artist's head as he paints. A way through is needed. 'Intention' best picks out just those desires, thoughts, beliefs, experiences, emotions, commitments, which cause the artist to paint as he does. A further cause of error has been to think that these mental phenomena, in order to exercise causal power, have to be assembled into some inner picture which is a complete facsimile of the picture to be.[8] No total preconception of the picture that is independent of all engagement with the medium is a serious possibility. In Lecture V I shall consider the pathological as opposed to the purely philosophical attractions of this idea. And I shall also at some point need to make a distinction within intentions between those which are realized or fulfilled in the work and those which, though they contributed to the making of the work, are not realized in it.

And there is a further respect in which we need to be on our guard. I may seem to have encouraged the view that whether painting is practised as an art depends upon the specific intentions that motivate it, so that, if it is intentional under this or that description, it is an art, if it is intentional under any other descriptions, it isn't. But things are not as simple as that. What is relevant turns out to be something a bit different and quite a bit more complex. It is more a matter of the way the intentions are formed, or the way one intention gives rise to another. It is a matter of how the descriptions under which the activity is intentional are arrived at, and how they interrelate. I shall try to familiarize this idea by tracing the development, the imaginary development, of an activity that isn't painting but is like it, though more primitive.

6. I call this activity *Ur-painting*.

My account of Ur-painting is, in spirit, rather like those seventeenth- and eighteenth-century accounts of how civil society emerged out of the State of Nature. I don't even entertain the thought that I am reconstructing an actual historical process. I tell a myth to illuminate some part of reality.[9]

The story of Ur-painting begins like this: An agent — he is as yet no artist — holding a charged instrument places himself next to a support and deposits marks. That is all there is to it: he deposits marks. And by saying that that is all there is to it, I mean that that is the total privileged description: that is *the* description under which the action is intentional. The thought of the mark enjoys a monopoly in the agent's head when it comes to the guidance of his action. Though there may well be other thoughts floating around there.

But, although depositing a mark is the only description under which the action is intentional, there are lots of other descriptions true of it. For instance this: that, as the marks are deposited on the support, there will be one part of its surface that is obscured by the marks and another part — an ever-decreasing part — that is unmarked and contrasts with the marks. But our agent is indifferent to this fact: except to the extent that it tells him where he can put the next mark if he wants it to show up.

Then, I ask you to imagine, the agent ceases to be indifferent to this fact. He takes stock of it, and in such a way that now not merely does the thought of the surface occupy a place in his head but it joins the thought of the mark in guiding his action. What this comes to in practice is that, in placing marks on the surface, he will now be influenced by the contrast between mark and what lies around the mark.

But, once again, over and above the description under which the agent's action is intentional — that of 'depositing marks on a surface', or (a more explicit formulation) 'covering some parts of the surface with marks while leaving other parts uncovered' — there will be other, many other, descriptions true of what he does. For instance, it will be true that, the surface on which the marks are deposited being bounded, each time a mark is deposited, it will lie at a certain distance from each of the various edges. But, once again, this is a fact to which our agent is indifferent.

But now we are to imagine that the agent takes stock of this fact and in such a way that the thought of the edge not merely enters his head – and, of course, it may have been there already – but it joins thoughts of the mark and of the surface in guiding his action. And what this comes to in practice is that those aspects of the mark which gain visual prominence when the edge of the surface registers itself with the eye receive attention.

For this process by which the agent abstracts some hitherto unconsidered, hence unintentional, aspect of what he is doing or what he is working on, and makes the thought of this feature contribute to guiding his future activity, I use the term 'thematization'.[10] So far our agent has successively thematized the *mark*, the *surface*, and the *edge*.

Thematization is, I believe, crucial to the way in which painting must be carried out if it is to be an art. However just how the two are related must be left until thematization itself is further clarified. There are two ways in which the phenomenon needs to be filled out.

From the examples of thematization that I have chosen, it would be easy to go away with a one-sided idea of what can be thematized. And from what I have found to say about the chosen examples, it would be easy to go away with an over-simplified idea of what thematization itself amounts to. My account is exposed to the twin hazards of one-sidedness and over-simplification: one a misunderstanding of the thematized feature, the other a misunderstanding of the thematizing process.

What I propose to do is to imagine the activity of our agent taken a few stages further forward: three, to be precise. By doing so, we shall be able to avoid these two dangers, and also to have thematization more clearly, more fully, more accurately, before us. Then, and only then, will it be possible to examine the significance of thematization for the art of painting.

7. So, first, against one-sidedness.

One-sidedness might arise because in all three cases so far considered – mark, surface, edge – what is thematized pre-exists its thematization. Mark, surface, and edge, are all, we might say, facts of the matter. But it doesn't have to be like this. In certain cases thematization, along with (of course) the facts of the matter, brings about what is thematized. An example: As the agent places his marks on a surface with an edge – doing all this intentionally – he notices something. He notices that the marked surface looks better one way up than another. Then the thought that one way up is the right way up and the other ways up are wrong helps to guide what he does: and, when this happens, he thematizes what I shall call *orientation*, and, as he does so, orientation comes into existence. Just what this comes to in practice, or how the thought of a right and a wrong way up can influence an agent's action, I leave to be filled in, but I have introduced orientation to make the point that orientation doesn't pre-exist thematization of orientation. All that does, the only fact of the matter, is that any marked surface, any surface humanly marked, will look different different ways up, so that between those different ways up preferences can form.

Secondly, against incompleteness, and the two further steps forward which should help remove incompleteness from the account.

As the agent continues to mark the canvas – now the thoughts of mark, surface, edge, orientation, all active in his mind – he notices that some of these marks, because of how they have landed on the surface, coalesce. Perceptually they form wholes or units. Groups of them are seen as one. And, if we now imagine that the agent, having noticed this fact, lets the thoughts of these units not merely colour the perception of what he has already done but guide what he goes on to do, he has made another step forward in thematization. He has thematized the *motif*. Once again, what this amounts to in practice I shall leave to you.

But now, having done this, as the agent proceeds to construct motifs intentionally, he

What the artist does

notices a new fact. He notices that quite often, as he steps back and looks at one of these motifs, he will have a special kind of perceptual experience. As well as continuing to see the marks as they have fallen on the surface, he will also, at the same time, within the same experience though as another aspect of it, see something in front of, standing out ahead of, something else. This special kind of experience, which I call *seeing-in*, marked by this strange duality — of seeing the marked surface, and of seeing something in the surface — which I call *twofoldness*, is not something altogether new to our agent.[11] He has had such experiences before. He has had them looking at differentiated surfaces which owe nothing to the action of an agent. He has had them on looking at stained walls or at clouds and seeing in them fighting horsemen, or whales, or camels. But now we are to imagine that the thought of things that can, through such experiences, be seen in front of other things comes to guide the way he marks the surface. He now marks the surface, he forms motifs, so as to produce such experiences, so that, when the surface is looked at, something will be seen in front of something else. In doing so, he thematizes the *image*.

It is important to recognize that thematizing the image is a step beyond thematizing the motif.[12] For, though the front edge of the deposited motif, or the edge closest to the agent, will indeed be raised above the surface on which it lies, this is far too fine a point for the agent to notice, at any rate standardly. No, what he sees in front of something else is something that he sees through, as a result of, looking at the motif. And it is this which I call the image.

If the story I have been telling of the evolution of Ur-painting had been an historical account, which it isn't, the step we have reached would correspond to a momentous event in its development. It would correspond to the discovery of *representation*. Thematization of the image ushers in representation: representation, not *figuration*, which is a specific form of representation, in which we identify the thing we see in front of something else as, say, a man, a horse, a bowl of fruit, the sky, the death of an animal.[13] All that representation requires is that we see in the marked surface things three-dimensionally related.

In my next lecture I shall have something further to say about representation and the special kind of visual experience in which it is grounded: seeing-in. But I have taken the argument up to the image in order, you may recall, to remove an incompleteness, a radical incompleteness, in my account of what thematization is. The point which has not so far been made but which can best be made in the context of the image is this: Thematization is always for an end. The agent thematizes in pursuit of a purpose. Thematization belongs to an instrumental, or means-end, way of using the materials of painting, and it is this imposition of an end upon the materials that converts them into a medium.

To some of you this fact about thematization will come as no revelation, and others will have already given it implicit recognition. You will have smuggled some end into your understanding of my account of Ur-painting and its development. You may, for instance, have assumed that the Ur-painter sought pleasure: giving pleasure, or getting pleasure. I say this because, in the absence of attributing some end — some one end or some multiplicity of ends — to the agent, it seems that you could not have followed me when I suggested, or when I asked you to fill in, what thematization of this or that aspect of the painting would (as I put it) come to, or would come to in practice. It is only in conjunction with some end that it becomes intelligible how the agent's thought that he has the surface, or the edge, or orientation, or the motif, to work with could guide him in how he marks the surface, or could lead him to place the mark here rather than there, or to give it this size or shape or texture, or to bring it into concatenation with these rather than those other marks.

But now, with thematization of the image, all this is out into the open. The presence of a purpose or an end is now manifest, and that is because an end is built into the very

concept of an image. An image necessarily represents: though — to repeat a point, which bears repetition — it isn't necessarily figurative.

At this point, a small revision is needed.[14] What I suggested as the starting-point for the process of thematization — that is, when the thought of the mark alone guides the agent's action — is an impossibility. An agent cannot be guided solely by the thought of the mark. He cannot be guided solely by the thought of any one thematized feature: or, for that matter, by a set of such thoughts. Additionally there must be operative in his mind the thought of an end, which the thematized feature or features then advance. In the absence of such a thought thematization is inert. This is true of Ur-painting, and it must be truer of painting practised as an art.

8. But, if thematization is always for an end, is there anything that can be said very generally about the end or ends for which it is pursued? Is there a broad formula under which the ends of Ur-painting, and so in time and with luck the ends of painting, and then of painting as an art, can be subsumed? I suggest that the broadest obtainable formula is this: the acquisition of *content* or *meaning*. Thematization is by and large pursued so as to endow the resultant surface with meaning. And meaning may in turn be glossed as that which we grasp when we understand a painting: when we understand, not some fact about the painting, but the painting itself. But for all its breadth, this formula about the ends of painting cannot be regarded as all-inclusive. It omits at least one end to which Ur-painting, as also the art of painting, has a powerful commitment. This is the end already referred to as the giving and getting of pleasure.

Pictorial meaning is diverse, and it is a separate task, to which subsequent lectures will be given over, to codify the varieties of pictorial meaning. But without anticipating what I shall say then, I want to indicate the type of account that I believe is appropriate to pictorial meaning. It is an account that runs counter to a number of views widely held today of what it is for a picture to have meaning. These views include structuralism, iconography, semiotics, and various breeds of cultural relativism, which, while widely diverging amongst themselves, have in common the belief, explicit or implicit, that pictorial meaning is primarily determined by rules, or by codes, or by conventions, or by the symbol system to which the meaningful picture belongs. I reject this belief. I do not deny that such factors can have *a* role to play in shaping, modifying, extending, meaning in certain cases, but I do deny that they are primary determinants of meaning.

Another way of putting the account that I am against is to say that it is one that assimilates the kind of meaning that pictures have to the kind of meaning that language has. For it is right to think that, very broadly speaking, linguistic meaning can be explained within some such set of terms as rules, codes, conventions, symbol systems. But pictures and their meaning cannot be.

What kind of account of pictorial meaning do I substitute for that furnished by the linguistic model? The proper account of pictorial meaning is, I believe, a psychological account. The kind of account that has quite rightly been chased out of the field of language, most notably through the influence of Wittgenstein,[15] is at home in painting. On such an account what a painting means rests upon the experience induced in an adequately sensitive, adequately informed, spectator by looking at the surface of the painting as the intentions of the artist led him to mark it. The marked surface must be the conduit along which the mental state of the artist makes itself felt within the mind of the spectator if the result is to be that the spectator grasps the meaning of the picture.

This triad of factors upon which pictorial meaning is dependent — the mental state of the artist, the way this causes him to mark the surface, and the mental state that the marked surface sets up in the sensitive and informed spectator — will never be far away from these lectures, but a more general point that has clearly emerged from the preceding

What the artist does

discussion, and which we must now take stock of, is that any adequate account even of Ur-painting – let alone of painting as an art – must have two parts to it. And these two parts are interlocking and ultimately inextricable one from another. One part is dedicated to the medium of painting, the other part to meaning in painting. There must be an account of how the brute materials of painting are converted into a medium, and there must be an account of how the medium is used to generate meaning and of the different varieties of meaning in which this can issue. And now I return to the account of the medium, which is what thematization introduces us to.

9. There is yet another possible misunderstanding about thematization to remove. This time it is not a misunderstanding about what can be thematized (like that removed by considering orientation), nor is it a misunderstanding about what thematization is (like that removed by considering the image). It is a misunderstanding about the implications of thematization for painting. The misunderstanding would be about how thematization affects the look of the marked surface. For so far, in sketching the development of Ur-painting, I have countenanced the view that, as the thought of a certain pictorial feature comes to guide what the agent does, so that feature will gain in prominence on the surface. Indeed I have drawn on such a view – that is, I have drawn on your entertaining such a view – each time I suggested what thematization of this or that feature is likely to come to, to come to in practice.

Now in the vast majority of cases it works just like that. Prominence on the surface ensues upon thematization in the head. But it need not. Sometimes it doesn't, and, when it doesn't, this is because a process of *deletion* has been at work.[16] When deletion operates, what happens is that an agent thematizes some feature of the work and then goes on to ensure that this feature of the work does not show up on the surface or shows up only in an attenuated fashion. An agent thematizes, say, the edge, and the way the thought of the edge guides the way he works is that the marks are now placed in studied indifference to their relationship to the edge. The constraints that the thematized edge would normally impose upon the artist's activity are deliberately flouted. But flouting such constraints presupposes, no less than respecting them, that the edge has been thematized.

If we now ask, Why is deletion ever practised?, What motivates its employment?, the answer is interesting for where it takes us. For the likeliest reason why an agent will want to attenuate a certain feature which he has thematized is his sense that this feature has become a distracting, or an insipid, or an anodyne, or – to put it at its most general – a meaningless, presence in the work of his contemporaries and his predecessors.

Two things about this explanation are interesting. First, there is the way in which it further rivets together thematization and the generation of meaning. Indeed it connects thematization and meaning conceived as I maintain it should be: that is, psychologically. It is just because there are no rules or conventions of pictorial meaning, it is just because pictorial meaning has constantly to be re-created, that deletion comes into its own as a method for ensuring meaningfulness. Deletion gets rid of what once had, but no longer has, meaning. Secondly, for the agent to think in these terms, or to take account of other people's work while working on his own, it looks as though the enterprise in which he is engaged must already be an historical phenomenon. That is to say, it must now be an enterprise in which tradition, or a sense of the past as providing a starting-point for the present, constrains – constrains and encourages – what those who undertake it do.

10. Thematization has not gone totally unrecognized by theorists of painting, though it has not been much discussed as such. However in one well-known, much publicized, account of how contemporary painting came to be as it is, the concept of thematization

has been heavily used.[17] I do not intend to confront directly the issue of the historical truth of this account, I want to consider only the way in which it understands thematization. I single out this account because I believe that it completely traduces thematization.

The premiss of the account is that, over the last hundred years or so, advanced artists have tended to thematize not just the surface but the flatness of the surface and to do so emphatically. ('Emphatically', as used here, conveniently reminds us that, when several features are simultaneously thematized, there must be a pull between them, and so there will be a difference in weighting.) From this premiss the account concludes that thematization of flatness can be used to identify mainstream modernism. Whether this is a correct identification of mainstream modernism, and whether there is such a thing as mainstream modernism, is the issue of historical truth, which I do not want to confront, but in establishing this developmental thesis the account has built into it a view of what thematization is. For in this account what happens, progressively, in the work of, say, Cézanne, Matisse, Barnett Newman, is that — and these are supposed to be interchangeable ways of saying the same thing — the flatness of the surface is asserted by the picture, alternatively the picture makes reference to its flatness, alternatively the flat surface is about itself. Now all these ways of putting the matter, taken, that is, as descriptions of thematization of flatness, are, I believe, wrong. They are wrong because of what they assume thematization to be. Let us look at what is wrong about them.

In the first place, the view of thematization that emerges does nothing, as far as I can see, to establish the interest of the resultant paintings. What does a painting that has a flat surface have further to offer us by telling us that its surface is flat — and so on for any thematized feature? I am aware of no serious attempt to confront this issue.

Secondly, the view presents thematization as fundamentally a hermetic process. For, on this view, as a feature is thematized, so it is turned round upon itself and it becomes the mouthpiece of its own existence. Such a view obviously goes against what I have been insisting upon: that is, that as a feature becomes thematized, so it becomes available to the agent as a means to some end. Of course, it is not inconsistent with my view that sometimes this end might turn out to be the assertion of that feature's existence. But surely this must be a rare case, and, above all, it cannot be taken as definitive of thematization as such.

Thirdly, the view connects thematization and reflexiveness: it is inviting to do so: the two phenomena seem to go together. But where the view goes wrong lies in the particular way in which it connects the two terms. Specifically it picks on, and associates thematization with, the wrong kind of reflexiveness. There are two stages to this process. First, the view holds that what is reflexive is the thematized feature itself, and, secondly, it holds that the way in which the thematized feature is reflexive is the way in which a sentence is reflexive when it refers to itself — as, for instance, does the sentence, 'This sentence has five words'. This kind of reflexiveness has much attracted the attention of logicians because in certain circumstances, which therefore reward investigation, it can generate paradoxes: that is, sentences such that, if we assume them to be true, it follows that they are false, and, if we assume them to be false, it follows that they are true. An example of such a paradoxical sentence is 'This sentence is false'. But this kind of reflexiveness, which we may call 'self-referentiality', has, I believe, nothing to do with thematization. The correct way of connecting thematization and reflexiveness is surely this: First, it is the agent (not some part of the surface that he marks) that is reflexive, and, secondly, the agent is reflexive in that he thinks over what he has done, brings to light inadvertent features of his action, decides on how these features could be made to count for something, and resolves next time and onwards to put this into practice. The relevant reflexiveness is of a psychological not a semantic order.

What the artist does

What is the importance of this issue? Why does it matter whether we get right the kind of reflexiveness that is integral to thematization?

The answer is simple.

If thematization has built into it the kind of reflexiveness that I suggest, then we can see how thematization invariably ties in with that process which I have introduced in connection with deletion: the dissatisfaction with the over-familiar, the desire for new resources, and the need to renew, to refresh, the roots of pictorial meaning. By contrast, if thematization involved reflexiveness in the sense of self-referentiality, this would deny any role to thematization in the generation of meaning. Indeed, since self-referentiality, or being about oneself, is a form of meaning, thematization on this view would presuppose meaning.

11. It is now time to return to painting, and to the way it has to be practised if it is to be an art. This, I said, could be regarded as a matter of the descriptions under which it is intentional. But, if it is, this, I also said, must not be understood simplistically. For I am not saying that painting is an art if it is intentional under this description, but that it is not an art if it is intentional under some other description. Painting does not acquire the status of art as a direct reward for the intentions that cause it. The position is rather this: For painting to become an art, it is a matter not of the specific descriptions under which it is intentional, but of how the descriptions under which it is intentional come to be adopted, and how one such description gives rise to, or gives way to, another. I have introduced thematization into the discussion to suggest how this can happen: and also to suggest why it should happen. Thematization arises out of the agent's attempt to organize an inherently inert material so that it will become serviceable for the carriage of meaning.

However there are still some further ways in which the account that I have produced, or that thematization has suggested, needs to be enriched if it is to be in any way adequate to what is distinctive of painting as an art.

In the first place, I have considered thematization only of the grosser aspects of painting. From mark all the way to image the thematized aspects I have isolated have been aspects of the painting that readily get captured in words. But thematization by an artist must reach to aspects of painting too fine-grained for language to follow it. These will include minute aspects, and overall aspects, and relational aspects.

Secondly, I have talked so far about thematization as one might about, say, addition or inference, as though it were a purely abstract or intellectual process. But this is not right. For in real life, or when painting is conducted as an art, thematization occurs within that fragment of our psychology which is essentially embodied. And this turns out to be crucial. Thematization requires an eye. It requires an eye that can make fine distinctions within the thematized feature. And it requires a hand. It requires a hand that can generate fine differences within the thematized feature. If the demands that thematization makes either upon the eye or upon the hand turn out to be more strenuous than the organs or muscles of our body can meet, even after arduous apprenticeship, thematization stops in its tracks.

And, thirdly, it is not the case, as, once again, my account of Ur-painting may suggest, that the conversion of unintentional aspects of the painting into intentional aspects is a continuing, let alone a continuous, process, or that it proceeds at a uniform pace throughout the career of the artist. At a certain stage in the artist's career, important advances, once made, are banked. In saying this I have in mind a phenomenon which the more traditional modes of art-history have always rightly recognized to be at the very centre of their subject: *style*. They have recognized it to be at the core of painting practised as an art, even if they have not recognized what it is. Failure to recognize what style is persists, I believe, into current theory.

12. When we talk of style in painting, there are two different ways in which we may talk about it.[18] There are two different conceptions of style. There is the conception that we use when we talk of *general style*, and there is the conception that we use when we talk of *individual style*, and the difference between the two conceptions is greater, much greater, than meets the eye.

General style comes in different forms. There are the *universal styles*: like classicism, or the painterly style, or the geometrical style. There are the *period* or *historical styles*: like neo-classicism, or International Gothic, or art nouveau, or (on one understanding of the term) the baroque. And there are the *school styles*, like the Giottesque, or the Norwich School, or the style of the Nazarenes. Universal style, period style, school style – all this is general style, and general style contrasts with individual style, which comes in only one form. Individual style is the style of an individual painter. But not just of any individual painter: only of an individual painter who has one. It is, in other words, a real question, or a question about the world, whether a given painter has a style of his own – though I believe it is a condition that must be met by any painter who is also an artist.

The claim that not every painter has a style of his own is a claim that it is possible to appreciate only when we have fully mastered what individual style is. To do this we must return to the contrast between individual and general style.

When we talk about a general style and apply it to a body of work – and it is all the same for these purposes whether it is a universal, a period, or a school, style – what we are in effect doing is employing some kind of shorthand for a set of characteristics which we and those who share our outlook find particularly interesting, arresting, innovatory, in that stretch of painting. It picks out what we find distinctive of that painting. So, for instance, when we, we nowadays, use the term 'baroque' in the sense of a period style, we are likely to be referring in that body of work to which we apply it to some number of the following characteristics: strong chiaroscuro, forceful movement, liveliness of touch, recession, diagonal composition, deletion of defined volume, heady emotionalism, sensitivity to represented texture. Significantly they are a mixed bag of characteristics. However at different moments, there will be different historical interests, different contemporary concerns, that will make different characteristics, though still a mixed lot, seem distinctive of a particular stretch of art and, as this happens, the characteristics associated with a given general style will alter. The new characteristics will replace the old characteristics in fixing for us and our contemporaries the nature of the baroque. General styles form and reform according to the shifting perspectives of art-history, and some methodologists, not unreasonably, have seen in these shifts the perennial vitality of the subject.

In the case of individual style too, there is a set of characteristics associated with each style. And at this point the resemblance between the two conceptions of style stops, and the differences begin. Let us look at them.

In the first place, the characteristics associated with individual styles do not alter. They are fixed immutably, though inevitably, art-historians, struggling towards the correct formulation of these characteristics, will come up with formulations that fall short of this ideal and thus differ amongst themselves. Secondly, to talk of an individual style is not to employ a shorthand for those characteristics. The style itself is distinct from the characteristics associated with it, and it is it that causes them to be as they are. Individual style is in the artist who has it, and though, in the present state of knowledge, it must be a matter of speculation precisely how it is stored in the mind, style has psychological reality. These two distinctive marks of individual style are linked. It is just because the characteristics associated with individual style are characteristics caused by something that is different from them and is in the artist that it is not up to us to decide what they are, settling now for this set, now for that set.

What the artist does

And now an analogy may bring out the kind of thing individual style is. Style, pictorial style, is not at all like language, though some have claimed that it is. The two have, for a start, totally different structures. So my analogy is not one between style and language (the two things), it is between having a style and knowing a language (the two competences).

(Of course there are differences too between the two competences, reflecting, in part, the differences between the things. A person knows a language because he has learnt it, an artist has a style because he has formed it. Another difference is that, though both knowledge of a language and possession of a style are inconceivable except in an embodied creature, style reaches deeper into the body to find its moorings. It modifies — something we have already seen with thematization — innervations to the limbs and muscles, and it imposes discriminations upon the eye. Individual style has not only psychological reality, it has psycho-motor reality. Though this is true to some degree, it is true to a lesser degree, of knowledge of a language.)

The burden of the analogy is that both knowing a language and having a style, being competences, are deep-seated in the person, and they manifest themselves in output: in uttering words, in marking a surface. In response to different stimuli or different problems, the same competence will manifest itself in bewilderingly different solutions, though in each case the manifestation will fall within precisely defined boundaries. Diversity of output is, given variety in circumstance, not merely perfectly compatible with, it is to be predicted from, identity of competence. And a further fact to be noted about both these competences is that they, like the creatures in whom they are embodied, have a natural history. They arise, they persist, they develop, they are responsive to internal and external influences, and, in unfavourable circumstances, they may decline or decay. But the basic idea that this analogy fosters is that individual style has great explanatory power. Subsumption of an artist's work under a general style has no explanatory power, though it may sharpen our eyes to characteristics, even individual stylistic characteristics, which we should otherwise have overlooked. If general style dropped out of our thinking, we should lose a tool of classification. If individual style dropped out of our thinking, we should lose a form of explanation – as well as losing sight of a piece of reality.

Let us look briefly at the variety of ways in which we may invoke individual style explanatorily.

In the first place, and this is the simplest case, we may invoke style to explain how a given painting by a painter who has a style of his own looks the way it does, or, for that matter, how two paintings by him, painted sufficiently close together, look alike. It is barely an extension of this point that we can also invoke style to explain how two paintings by different painters, each with a style of his own, look unlike.

Of course, since not all the characteristics that an artist gives his paintings are stylistic characteristics, we shall not be able through invoking style to explain all the peculiarities of the single picture, or all the similarities between the first pair of pictures, or all the dissimilarities between the second pair of pictures. We shall be able to explain only the peculiarities, the similarities, the dissimilarities, that have style as their origin. And, if we want to know how such characteristics can be demarcated, or what stylistic characteristics have in common, I suspect that, until we have knowledge on a topic about which I have suggested we are almost totally ignorant – namely, how style is stored in the mind – we ought not to hazard a guess. To say, for instance, that stylistic characteristics are always formal characteristics is – unless 'formal' is simply being used to mean stylistic – in excess of what we know or have any good reason to believe.

All the preceding cases in which style is invoked to explain how paintings look do not involve what I have said is an essential fact about individual style: that it has a history.

1 Paul Cézanne
View of Auvers c. 1874

From the point of view of style these explanations are synchronic explanations.

Next in line then are explanations that do make use of the fact that style has a history. The simplest case of such diachronic explanation is one in which we take two paintings by the same artist painted at different periods, and we then explain how they look unalike by invoking developments or modifications in the style. It is the same style, but the style has changed.

However there are more complex ways in which diachronic explanation that invokes style can be structured. These ways are often overlooked by art-history, and sometimes they are, implicitly at any rate, denied. The ways I have in mind explain the difference between two paintings by the same artist by invoking, not changes within the style, but changes between style and non-style. They appeal to the fact that one painting is stylistic and the other painting is non-stylistic. Or, as a variant upon this, the peculiarities of a single painting can be explained by the fact that it is non-stylistic.

Once we recognize that style can be employed in explanation in this way — and that it can be employed in this way is made possible only by taking a substantial or realist view

What the artist does

of what style is – it should also be apparent that this explanation comes in different forms. It comes in as many forms as there are ways for a painting to be non-stylistic: ways intrinsic to the natural history of style.

2 Paul Cézanne
View of Médan c.1880

The first and most obvious way in which a painting can be non-stylistic is that it can be *pre-stylistic*. It happens to all except those whose lives have become enfolded in myth – myth of their own or of others' making, Picasso or Giotto – that their work passes through a phase before their style is formed. However, as a corollary of this, it is only with an artist whose style is formed late that it is illuminating to recognize that some of his work is pre-stylistic. And then it is. A striking case is Cézanne, whose work may be regarded as pre-stylistic right up until the mid 1870s. Recognizing this fact allows us to see what a triumph it was for Cézanne when he could allow his work to be tentative. A lack of confidence, which a lack of style induced in him, had forced him, up until that moment, to be emphatic. The point becomes clear when we compare, say, the pre-

1 stylistic *View of Auvers* (Art Institute, Chicago), of *c.*1874 with the fully stylistic *View of*
2 *Médan* (Burrell Collection, Glasgow Museums and Art Galleries, Glasgow), of *c.*1880.

3 Guercino
Elijah fed by Ravens
1620

Another variety of the non-stylistic, which is to be found only amongst the less than fortunate artists, is the *post-stylistic*, or work done in the years after their style had collapsed. It has been plausibly argued, though not in these very terms, that the seventeenth-century Emilian artist Guercino lost his style after he came under what was for him the baneful influence of Domenichino and Roman classicism.[19] After his conversion he worked in a style, in a school style, but he ceased to have a style of his own, and the inflexibility of his work, beautiful though much of it is, and the inertness of so many aspects of his painting, may then be understood in terms of this fact. A relevant comparison would be between the stylistic *Elijah fed by Ravens* (collection Sir Denis 3

What the artist does

4 Mahon, London), of 1620, and the post-stylistic *The Return of the Prodigal Son* (Timken Art Gallery, San Diego, California), of the mid-1650s.

A third variety of the non-stylistic is the *extra-stylistic*, or work done by an artist who has formed a style, not lost it, but is confronted by a challenge that he cannot meet. He does not decline the challenge, he takes it on, but his style will not reach to the new assignment: the work he does bypasses his style. A false or idealized view of the psychology of the artist has led traditional connoisseurship, or the science of attribution, to deny the extra-stylistic. It has done so as though to concede the point that an artist might ever work outside the boundaries of his style would put all the findings of connoisseurship in jeopardy. But such cases clearly exist, and they do nothing to dispute the validity of connoisseurship provided that only we can in turn explain how these anomalous cases occur, or how style can be inoperative. One example of the extra-

5 stylistic is provided by Hogarth, *Moses brought to Pharaoh's Daughter* (Thomas Coram Foundation, London): in this painting Hogarth reaches outside his normal subject-matter, attempts allegory, but cannot get his style to negotiate the new demands. This emerges

4 Guercino
*The Return of the Prodigal
Son* 1654–5

What the artist does

5 William Hogarth
Moses brought to
Pharaoh's Daughter 1746

6 William Hogarth
Scene from 'The Beggar's
Opera' 1728

7 Auguste Renoir
Bathers 1887

8 Auguste Renoir
*The Luncheon of the
Boating Party* 1881

clearly when we compare *Moses brought to Pharaoh's Daughter* with the highly stylistic
6 *Scene from 'The Beggar's Opera'* (Tate Gallery, London). A yet more striking example of the
extra-stylistic is provided by certain works of Renoir executed in the 1880s, when out of
deference to the High Renaissance and in pursuit of Ingres, he hardened his contours and
7 simplified the paint surface. We see the consequences in a work like the extended *Bathers*
(Museum of Art, Philadelphia), when we set it beside a fully stylistic masterpiece like *The*
8 *Luncheon of the Boating Party* (Phillips Collection, Washington, D.C.).

What the artist does 33

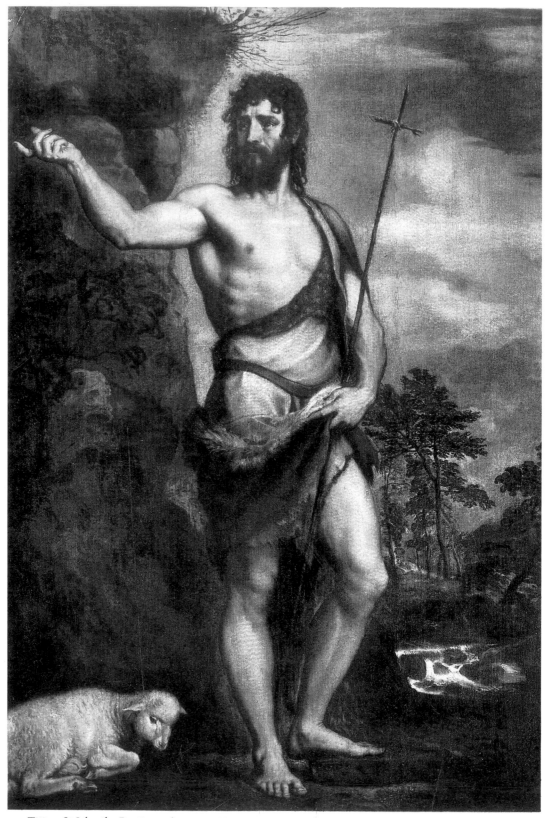

9 Titian *St John the Baptist* early 1540s(?)

But the most intriguing, most disturbing, case of the extra-stylistic, which tells us something new about style, occurs in the work of an artist unexcelled in genius, about whom I shall be talking later on in these lectures: Titian. For with Titian style has some of the structure of a personality. Confronted by a rival, whose name may be Pordenone or Michelangelo, Titian responds by engorging him. He appropriates his opponent's style, or some part of it, which remains, for a brief moment, undigested within his own. We can see this in the *St John the Baptist* (Accademia, Venice), or the *St John the Evangelist on Patmos* (National Gallery of Art, Washington, D.C.). The result is not, as with Hogarth or Renoir, disappointing: it is harrowing, and short-lived. Titian works through the challenge, and his style reasserts itself.

It will be noted that, in talking of these more complex ways in which style-explanation can be diachronic, I said that in such cases we invoke, not changes within a style, as we do in the simpler cases, but changes between style and non-style. I did not speak of explanation that invokes change from one style to another style. I did not do so because I believe that, only in exceptional circumstances, should we concede that such a thing can happen. It isn't a strict consequence of, but it goes along very well with, the view of individual style as something real, hence explanatory, that we should be extremely reluctant, without evidence of massive psychological disturbance, to multiply styles by departing from the maxim, One artist, one style. The cottage industry which has subdivided Picasso's work into a proliferating plurality of styles should serve as a

10 Titian
St John the Evangelist on Patmos probably 1544

9, 10

cautionary example. If we cannot discern the common processes that underlie paintings only a limited number of years apart, then we should ask ourselves, first, whether we have not confused what is not style with style, and, secondly, whether we have not identified stylistic characteristics in ways that are too superficial or too narrow to reveal their roots in underlying processes. Surely an artist's style should be no more thought of as susceptible to fragmentation or fission than his personality.

13. To bring the issue of style into sharper focus it is necessary to make the distinction, missing from many discussions of the issue, between *style* and *signature*.[20] By signature what is meant are those features of a particular artist's work which are singled out because, like the artist's signature itself, they are found to be the surest guides to establishing the authorship of individual pictures.

Obviously signature is a relativized notion: relativized, that is, to the connoisseur who is attempting to establish the corpus of a given artist's work. It depends on the methods and instruments that the connoisseur has at his disposal, as well as on the nature of the cognitive stock upon which he can draw, which features of the artist's work will be evidentially valuable for him. For that matter the condition of the pictures he is considering will affect what it is appropriate or efficient for him to take as signature. It will be of little use for him to know that the artist in question used certain pigments and not others if he lacks the means of chemically analyzing the paint surface. It will be of even less use to him to be told that the artist characteristically made frequent microscopic changes of direction in his line if he has no access to the magnification necessary to discern this. It will be worthless to him to know that his artist used certain glazes if a zealous restorer removed them twenty years earlier.

But the most important fact to recognize about the style versus signature distinction is that it is a conceptual distinction. There is no a priori reason why the style-characteristics of a given artist and those features of his work which best reveal his hand to someone with a specific body of expertise should not be identical: it might be that the most practical way of reconstructing the corpus of an artist's work is on what are purely stylistic grounds. But the crucial point is that, even if there is a complete overlap of style-characteristics and features of signature, the grounds on which aspects of an artist's work will be classified as style and those on which they will be classified as signature will differ. Aspects belong to signature if they play a significant role in a certain kind of scholarly inquiry. Aspects belong to style if they derive from an underlying competence deep in the artist's psychology.

Once this distinction is grasped it will come as no surprise to learn that often style and signature do not coincide. For very few artists indeed will they completely coincide. Signature will often be compiled out of superficial mannerisms which repeat themselves across a wide variety of works: rather in the way in which a graphologist – the poor man's connoisseur – may recognize a piece of handwriting on the basis of certain twists and curlicues rather than on the fundamental way in which the letters are formed, or what has been called the *Formniveau*.[21] It is a defect in traditional connoisseurship that the distinction between style and signature has not always been recognized: either explicitly, or in practice.

14. Throughout this lecture I have been claiming that, if we are to understand when and why painting is an art, we must consider it in the perspective of the artist. But I should make the same claim about how we should proceed if we were not interested in the question of painting as an art, but were simply interested in painting and were prepared to take its status as art for granted. If we are interested in understanding either painting as such or individual paintings, we must start from the artist.

What the artist does

The considerations that would be needed to establish this point are more inclusive than any I have so far introduced, just as the point itself is more general, but the prime consideration in such an argument would be the by now familiar claim that painting is an intentional activity. Indeed, given that this is the case, the burden of proof would seem to fall upon those who think that the perspective of the artist, which means in effect seeing the art and the artist's activity in the light of his intentions, is not the proper starting point for any attempt to understand painting. For it is they who break with the standard patterns of explanation in which understanding is preserved.[22]

To gain an overview of the issue, let us try to imagine how someone could maintain that, for the purposes of understanding painting, painting either in general or in particular, we do not have to retrieve the intentions that motivate the artist. Roughly there are two strategies that might be adopted so as to secure this position. The first strategy is to insist that, if we are interested in understanding painting, at any rate painting in particular, then all we have to concern ourselves with is the things themselves: the activity from which the things result, hence the intentions that motivate this activity, are of no concern to us. The second strategy compromises on this last point. It allows that understanding painting does require us to concern ourselves with the activity from which the things result as well as with the things themselves, but it goes on to insist that this concern does not stretch to the intentions that motivate the activity. So the first strategy says that we do not have to bother ourselves with what the artist does, whereas the second strategy says that we do not have to do so in the artist's perspective.

The first strategy as we have it before us is far too limited for the argument to reach its objective. For it should be a matter of common agreement that, when we try to understand at any rate particular paintings, it is things on which we must concentrate. That is because particular paintings are things. But the question remains whether, in concentrating on these things, we have to appeal to the activity from which they result if we are to understand them. There is obviously no inconsistency, and quite a lot of plausibility, in claiming that, when paintings, the things, are the *explicanda*, painting, the activity, has to come in as the *explicans*. Explanation requires – the claim would go – that we appeal from paintings to painting.

The success of the first strategy depends, then, upon its ability to block this appeal, and to show that consideration of the activity is unnecessary. To do this, it must generate a subsidiary tactic, and the tactic will be to pick out some other property that paintings have, a property which has nothing to do with how they are made, and which yet suffices to explain them. Their meaning can be understood – the tactic claims – through a grasp of this property. There are two, perhaps three, candidate properties. One candidate is the place that the painting occupies within a general symbol system. The other candidate is a function that the painting fulfils within a social system. A third variant of the tactic is to identify the property with what has been said in interpretation of the painting by some favoured institution. The institution may be the academy, it may be the professoriate, it may be the body of *avant-garde* artists. On this variant, we do not have to appeal to what the artist did in order to understand the painting, because what these people say goes. Once again we have an Institutional theory, though this time it is a theory not of what art is but of what art means. This variant of the tactic is however a variant of despair because it does not deliver what it promises. It allows us to say what a painting means, but it does not allow the painting itself to have meaning. For it makes meaning something inherently unstable. Hence it offers us not understanding, but the illusion of understanding.

The first two variants of the tactic would clearly do better than the third if there were such a property as that on behalf of which it is claimed that it can give us the meaning of the painting without appeal to how the painting was made. But is there really such a property as either variant picks out? Does every pictorial work of art occupy a place in a

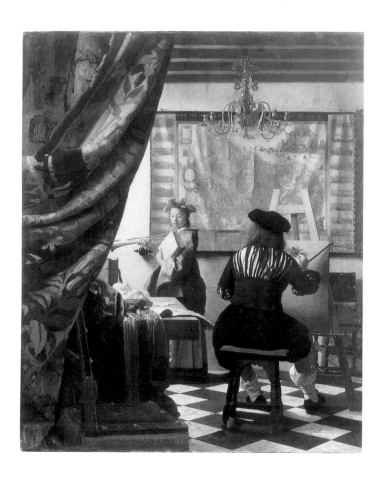

symbol system? Does every work of art fulfil a social function? In the next lecture I shall consider the first of these issues. As to the second I think it is manifest that the answer is, No, there is no one social function, there is not even a limited set of social functions, that all pictorial works of art necessarily discharge. What is certainly true is that *some* pictorial works of art, like altarpieces or dynastic cycles, do have a social function – though I would insist that it is extraneous to their being pictorial works of art. However in each case the work of art's function clearly underdetermines its meaning. Once we know the programme or the commission, our curiosity remains massively unsatisfied about what the work of art means. So, even if every pictorial work of art had a social function, it is unlikely that appeal to this function would suffice for interpretation.[23]

Accordingly I now turn to the second strategy, which comes into operation when the first has failed. It tells us that, though, in understanding paintings, we may have to concern ourselves with the activity from which they result, this concern does not extend to the intentions that motivate the activity. We must now ask, How could this be? What reason could we have for taking account of the activity but ignoring the intentions that motivate it? For, as we have already seen, in the ordinary course of events we appeal to intention even to *describe* an action or activity that we are talking about. How then can it be claimed that the reference to intention is gratuitous? As far as I can see, there is only one set of circumstances in which such a claim could be justified, and that would be when the activity has been so fully choreographed that it unfolds according to a pattern in which the agent has no hand: for then the progress of the activity would be exactly the same no matter what the agent thought or felt. And this means, it must be stressed, not only that the agent would be unable to alter the drill, but that he would have no say in initiating it. He would have to act rather in the way in which an operative in a fully automated factory (but without robots) makes a machine part: for, in such a case, though

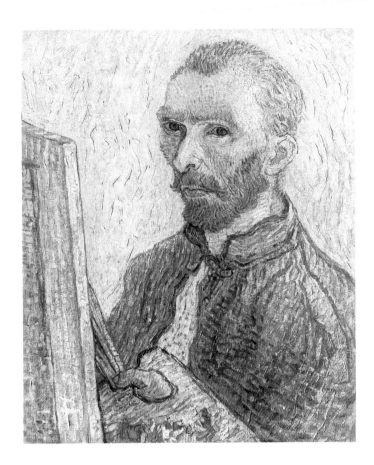

12 Vincent van Gogh
Self-Portrait 1889

the operative's activity will be cited to explain the product, his intentions will not be. It seems to me clear that this is not how the painter, the painter as an artist, acts.

But it is crucial to recognize that, though adopting the perspective of the artist requires us to give pride of place to what the agent does, it does not require us to stop there. Above all, it does not require us to ignore or reject the point of view of the spectator. It requires us only to rethink it. And, if we start to rethink it, the first thing to strike us will be that the distinction between agent and spectator is primarily a distinction not between persons but between roles. And the second thing to strike us is that not merely can these different roles be adopted by the same person, but there is one person, one kind of agent, who must do so. That is the artist. The artist is essentially a spectator of his work. To understand why this should be so, I propose to raise, and leave you with, a question which, as far as I know, has not had much attention paid to it within aesthetics. It has not been found worth it. This question, long ignored, long despised, is, I believe, going to take us a good deal further into the philosophy of painting.

15. Over the centuries, there have been many many changes in the conditions of painting. There have been changes in the materials, in the physical scale of the work, in painting's social evaluation, in the presiding conventions, in the mutual expectations of painter and public, in myriad things. But, as painting's representation of painting makes clear to us, there has, amidst all this flux, been one noteworthy constancy, and that has been the posture, the bodily stance, that the painter adopts in the act of painting. It has been the practice for the painter to position himself in front of the support, on that side of it which he marks, facing it, with his eyes open and fixed upon it. Whether the representation aims at naturalism or at allegory, no matter what relocation of the painter it presupposes, to some fictional or distant scene, it conserves this posture. The

11–16

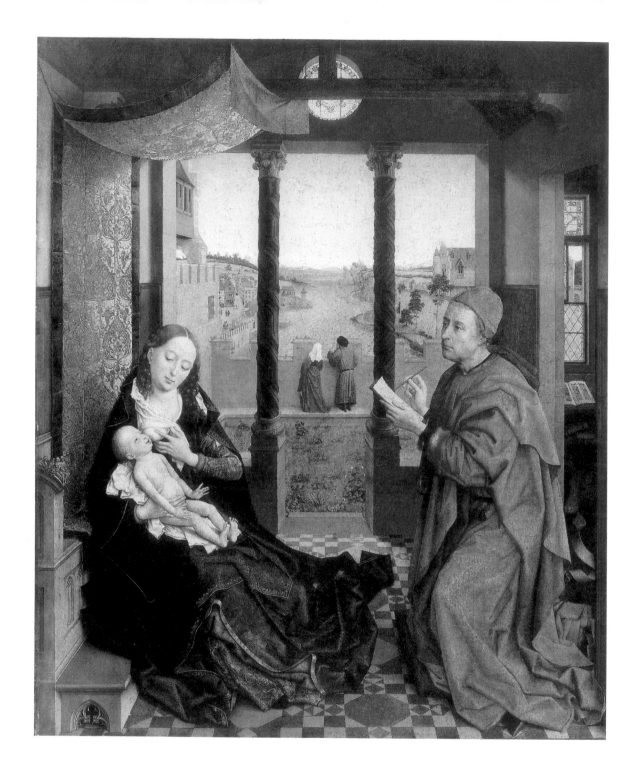

13 Rogier van der
Weyden
*St Luke Painting the
Virgin c.* 1435, panel

testimonies of Vermeer and van Gogh, of Rogier van der Weyden and Corot, of a ninth-century artist and Jackson Pollock, concur in what they have to tell us about the deportment of the painter.

Why does the painter adopt this stance? What does he gain by it? What does its persistence show us about the nature of what he is doing? This seemingly dry and unpromising question takes us, I believe, to the heart of the question, Why must the artist be a spectator of his own work? It will be the starting-point of the next lecture.

40

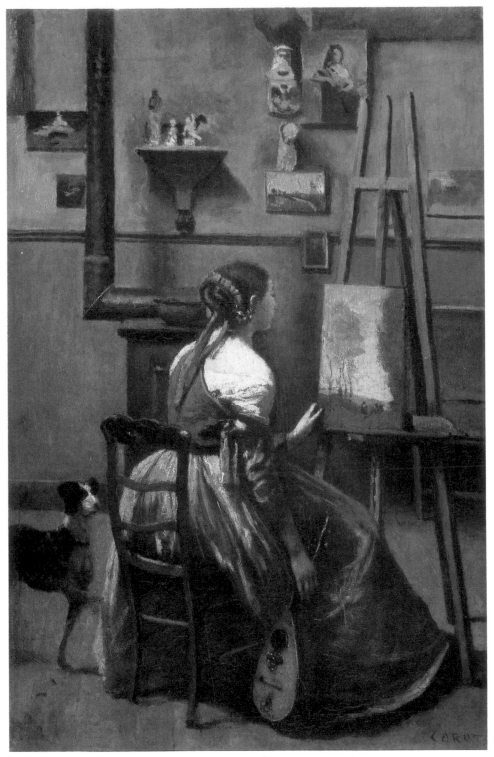

14 Jean-Baptiste-Camille Corot *The Artist's Studio* 1855–60, panel

15 Greek, 9th century
*A Panel Painter copying a
Picture* (*Sacra parallela* of
John of Damascus)

16 Jackson Pollock
working, photograph

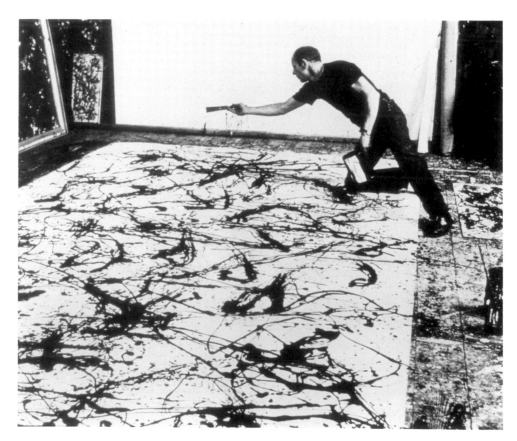

II

What the spectator sees

A. 1. The principal claim of Lecture I was that, if we are to understand painting when it is practised as an art – that is, either painting as such or individual paintings – we have to start from the perspective of the artist. However it is crucial to recognize that this does not involve ignoring the point of view of the spectator. It requires only rethinking it. And rethinking it leads us to two conclusions. The first is that to be a spectator is not to be a certain kind of person: it is to fill a certain role. Different roles can be filled by one and the same person. And the second is that, in the case of an artist, multiplicity of roles is a requirement. An artist must fill the role of agent, as we saw in the last lecture, but he must also fill the role of spectator. Inside each artist is a spectator upon whom the artist, the artist as agent, is dependent. And this dependence is enshrined in what is one of the few constancies in the history of pictorial art: that is, the artist's posture, or that, in the act of painting, he positions himself in front of the support, on the side of it that he is about to mark, facing it, with his eyes open and fixed upon it. I ended Lecture I by asking, Why does the artist adopt this posture?

2. Confronted by this question, the self-respecting amateur of art, who is unlikely until that moment to have regarded the question as worthy of his attention, will probably give it the wrong answer. He will probably say, In order to see what he has done. According to this answer the artist is like a man dressing in the morning who looks in the mirror to see how he has tied his tie, or like a young ballet dancer at the barre who glances down her body to see where she has placed her feet. As an answer this must be wrong, if only because it implies that the artist might eventually reach a level of accomplishment at which he can dispense with the help of the eyes. But, as I see it, the only circumstance in which this could happen is the very special case, which repels generalization, when a great artist, after years of experience, goes blind and has no eyes to help him. All he has to help him are the years of experience.

A better answer is that the painter places himself as he does because he paints with – that is, partly with – his eyes.[1] It isn't that he paints first, and looks afterwards. The eyes are essential to the activity. But the problem is that, if this answer is right, which I believe it is, the same goes for, say, driving a car, and the answer, as we have it, doesn't discriminate.

The truth seems to be this: In driving a car, the driver uses his eyes to keep him on track. (He doesn't drive first and then see whether he is on track.) But if the artist's eyes keep him on track, they also do more. For the track that the driver's eyes are expected to keep him to, which is the road, has been independently laid down, independently, that is, of him: but the track to which the artist's eyes keep him is a track of his eyes' making. Indeed 'keeping the painting on track' is just a phrase, a metaphor, for making the painting acceptable to the eyes: the eyes, it must be appreciated, determining acceptability by very

varied criteria. To sum up: Like the driver, the artist does what he does *with* the eyes. Unlike the driver, he also does it *for* the eyes.

3. Another way of putting what I have just been saying is to say that the artist paints in order to produce a certain experience in the mind of the spectator, and that this is so is not a fact that has been missed by theorists of painting, but they have tended to do justice to it only in one connection: pleasure. Not a negligible connection, but a limited one.

For it goes without saying that, if an artist aims to give pleasure, he paints so as to produce a certain experience. He paints so as to produce a pleasurable experience. But my claim is that, equally, when he aims to produce content or meaning, which is his major aim, he also paints so as to produce a certain experience. He does so because this is how pictorial meaning is conveyed, and this is so because of what pictorial meaning is.

Of course, if an artist is going to make his painting mean something, it is not enough that it should arouse *an* experience in the mind of the spectator. Equally it is not enough, if the spectator is to understand what the painting means, that he should have *some* experience or other in front of it. Something more specific is required. So what further can be said about the experience?

In the first place, the experience must be attuned to the intention of the artist where this includes, I have stressed, the desires, thoughts, beliefs, experiences, emotions, commitments that motivate the artist to paint as he does. Intention excludes such mental phenomena is so far as they merely float in the artist's head while he paints, and in no case is it reasonable to think that intention calls for a total preconception in the artist's head of the painting that he intends to make – a kind of inner image of an outer picture which does not as yet exist.

Secondly, the required experience must come about through looking at the picture: it must come about through the way the artist worked. The spectator's experience is irrelevant to the understanding of the picture if it comes about solely through hearsay, or through having independent knowledge of what the artist intended. Of course, such knowledge can, it very often will, serve as background information in shaping or forming how the spectator sees the painting. But – a point to which I shall return – it oversteps its legitimate role when it leads the spectator to say or think things about the painting that he does not see when he looks at it.

More than this cannot, I believe, be attempted in the abstract. What more there is to be said about the spectator's experience depends on the kind of pictorial meaning sought: as I hope to show in going through the varieties of meaning a picture can have. However let me disavow in advance one general view of how the spectator's experience should relate to what went on in the artist's head. It might be called the Contagion theory, and it holds that, in each and every case, for the spectator to grasp what the artist meant, there must be re-created in his mind when he looks at the painting precisely the mental condition out of which the artist painted it. This view was embraced by Tolstoy in old age,[2] but it has little else to recommend it.

But something general and informative is presupposed by what I have been saying. I anticipated it in my last lecture. It is that general account of pictorial meaning which locates pictorial meaning in a triad of factors: the mental state of the artist, the way this causes him to paint, and the experience that a suitably informed and sensitive spectator can be expected to have on looking at the artist's picture. I call this a psychological account, and one consequence of holding to such an account is that it sets me against all those schools of contemporary thinking which propose to explain pictorial meaning in terms like rule, convention, symbol system, or which in effect assimilate pictorial meaning to something very different, which is linguistic meaning. These schools of thought include structuralism, iconography, hermeneutics, and semiotics.

What the spectator sees

4. I return to the artist's posture in the act of painting, the better to get at the way in which the artist encapsulates a spectator upon whom he depends.

In the simpler of the two cases in which the artist paints so as to produce a certain experience – that is to say, when he is concerned solely with the production of pleasure – his reliance upon the experience that he himself has in front of the picture is straightforward. He is interested in the experience solely in order to discover whether it is or isn't pleasurable. He has a firm grasp, we must assume, of what a pleasurable experience is like, and he tests the experience he has before the picture to see whether it meets the standard. If it does, then he concludes by analogy that it will produce a pleasurable experience in others, provided only that his pleasure is not conditional upon unique or idiosyncratic factors.

But, when we turn from the simpler to the more complex of the two cases in which the artist paints so as to produce an experience – that is to say, when the experience is designed to carry meaning or to offer understanding – then his reliance upon the experience that he has as he paints, his dependence upon himself as spectator, is heavier. Fundamentally his interest in the experience is so as, as I have put it, to keep the picture on track: that is, to ensure that the experience that the picture is calculated to produce in others is attuned to the mental condition, or the intention, out of which he is painting it. It is indeed because the experience has, in this role, such an important share in the formation of the picture that it must be wrong to think that the intention is formulated in an inner facsimile of the painting to be. For, if there were this inner facsimile, which the artist has then only to copy, the experience that the artist has of his painting while he is painting it would be left with too small an influence upon the painting itself. Feedback,[3] which is the primary role of the experience, would be in effect denied.

But feedback is not all there is for the experience to do. There are at least two other roles for it to fill. It can inform the artist on two other issues on which he will always feel that he has a weaker grip than he would wish. For, in the first place, the experience can refine his knowledge of what it is for an experience had in front of a painting to be attuned to the mental condition that motivated it. And, secondly, the experience can enlarge his knowledge of just what mental condition it is that has been motivating him to paint the painting in front of him in the way that he has. And it can do all this without having to do any of it explicitly, or even consciously.

5. And there is another thing that the artist's posture can do for him.

None of this reflexiveness, none of this pondering what he has done, and to what effect, and how he might go on to do better, is feasible unless the artist in the course of painting can assume certain broad perceptual capacities that the spectator has and will bring to bear upon the completed painting. There are various sources from which the artist can be expected to derive this knowledge. But there is, I believe, no source of information that has for him the same weight, the same authority, the same immediacy, as the posture that history requires of him. The posture draws the knowledge out of him.[4]

There are three fundamental perceptual capacities that the artist relies upon the spectator to have and to use. They are – and this lecture will be devoted to explicating them – (one) *seeing-in*: (two) *expressive perception*: and (three) the capacity to experience *visual delight*. Upon these perceptual capacities rest the three basic powers that belong to painting, from which other powers derive. The basic powers are (one) the power to *represent* external objects: (two) the power to *express* mental or internal phenomena: and (three) the power to induce a special form of *pleasure*, or the much maligned property of the decorative. I shall have something to say about the first two, and only a suggestion towards the third. Later lectures will be devoted to the powers that follow from these three.

B. 1. I begin with 'seeing-in'.[5]

Seeing-in is a distinct kind of perception, and it is triggered off by the presence within the field of vision of a differentiated surface. Not all differentiated surfaces will have this effect, but I doubt that anything significant can be said about exactly what a surface must be like for it to have this effect. When the surface is right, then an experience with a certain phenomenology will occur, and it is this phenomenology that is distinctive about seeing-in. Theorists of representation consistently overlook or reduce this phenomenology with the result that they garble representation. The distinctive phenomenological feature I call 'twofoldness',[6] because, when seeing-in occurs, two things happen: I am visually aware of the surface I look at, and I discern something standing out in front of, or (in certain cases) receding behind, something else. So, for instance, I follow the famous advice of Leonardo da Vinci to an aspirant painter and I look at a stained wall,[7] or I let my eyes wander over a frosty pane of glass, and at one and the same time I am visually aware of the wall, or of the glass, and I recognize a naked boy, or dancers in mysterious gauze dresses, in front of (in each case) a darker ground. In virtue of this experience I can be said to see the boy in the wall, the dancers in the frosty glass.

The two things that happen when I look at, for instance, the stained wall are, it must be stressed, two aspects of a single experience that I have, and the two aspects are distinguishable but also inseparable. They are two aspects of a single experience, they are not two experiences. They are neither two separate simultaneous experiences, which I somehow hold in the mind at once, nor two separate alternating experiences, between which I oscillate – though it is true that each aspect of the single experience is capable of being described as analogous to a separate experience. It can be described as though it were a case of simply looking at a wall or a case of seeing a boy face-to-face. But it is error to think that this is what it is. And we get not so much into error as into confusion if, without equating either aspect of the complex experience with the simple experience after which it can be described, we ask how experientially like or unlike each aspect is to the analogous experience. We get lost once we start comparing the phenomenology of our perception of the boy when we see him in the wall, or the phenomenology of our

What the spectator sees

17 Aaron Siskind
Chicago 1948,
photograph

(Above right)
18 Minor White
*Empty Head, Frost on
Window, Rochester, New
York 1962,* photograph

perception of the wall when we see the boy in it, with that of our perception of boy or wall seen face-to-face. Such a comparison seems easy enough to take on, but it proves impossible to carry out. The particular complexity that one kind of experience has and the other lacks makes their phenomenology incommensurate. None of this is to deny that there is an important causal traffic between seeing-in and seeing face-to-face. Children learn to recognize many familiar and unfamiliar objects through first seeing them in the pages of books.[8]

The twofoldness of seeing-in does not, of course, preclude one aspect of the complex experience being emphasized at the expense of the other. In seeing a boy in a stained wall I may very well concentrate on the stains, and how they are formed, and the materials and colours they consist of, and how they encrust or obscure the original texture of the wall, and I might in consequence lose all but a shadowy awareness of the boy. Alternatively, I might concentrate on the boy, and on the long ears he seems to be sprouting and the box he is carrying – is it a bomb, or a present for someone? – and thus have only the vaguest sense of how the wall is marked. One aspect of the experience comes to the fore, the other recedes. And sometimes this preference for one aspect of the experience gets carried to the point where the other aspect evaporates. Twofoldness is lost, and then seeing-in succumbs to an altogether different kind of experience. This shift can take place in either direction, so that seeing-in may be succeeded by seeing the wall and its stains face-to-face, or it may give way to visualizing the boy in the mind's eye. But, given that the wall was adequately differentiated so as to permit seeing-in in the first place, it is unlikely that either of these successor experiences will prove stable. Seeing-in will probably reassert itself: such is its pull.

2. Seeing-in, as I have described it, precedes representation: it is prior to it, logically and historically. Seeing-in is prior to representation logically in that I can see something in surfaces that neither are nor are believed by me to be representations. To the examples we
19 have just looked at, others can readily be added. Clouds: I can, for instance, see headless

Ansel Adams
Ellery Lake, Sierra Nevada
1934, photograph

torsos or great Wagnerian conductors in clouds ranged against the vault of the sky. And 20
seeing-in is prior to representation historically in that surely our remotest ancestors
engaged in these exercises long before they thought to decorate their caves with images
of the animals they hunted.

But it is not just that seeing-in precedes representation. Representation can be
explained in terms of seeing-in, as the following situation reveals: In a community where
seeing-in is firmly established, some member of the community — let us call him
(prematurely) an artist — sets about marking a surface with the intention of getting others
around him to see some definite thing in it: say, a bison. If the artist's intention is 21, 2
successful to the extent that a bison can be seen in the surface as he has marked it, then the
community closes ranks in that someone who does indeed see a bison in it is now held to
see the surface correctly, and anyone is held to see it incorrectly if he sees, as he might,
something else in it, or nothing at all. Now the marked surface represents a bison.

Representation arrives, then, when there is imposed upon the natural capacity of
seeing-in something that so far it had been without: ⌐ standard of correctness and
incorrectness. This standard is set — set for each painting — by the intentions of the artist in
so far as they are fulfilled. Holbein's famous portrait, which has come down to us in 23
various versions, is not a portrait of Charles Laughton, though old film buffs can, and I 24

What the spectator sees

21 Palaeolithic art
Bison Niaux, Ariège,
France

22 *Bison,* photograph

(Top left)
23 After Hans Holbein the Younger
Henry VIII c. 1536, copper

(Top right)
24 *Charles Laughton as Henry VIII.*
Film still from *Private Life of Henry VIII*

25, 26 Hermann H. Rorschach
Test Card, nos. VIII, II

dare say will, see Charles Laughton in it. It is a portrait of Henry VIII, because Henry VIII too can be seen in it and this is the visual experience that Holbein intended. With damp-stains, with frosted panes of glass, with clouds, there is – as the famous interchange between Hamlet and Polonius makes clear – nothing that it is correct to see in them. It is not even correct to see something in them rather than nothing.

What prompts this very last point is that there is a kind of picture that is a half-way house to representation. There are pictures in which it is correct to see something – to see something rather than nothing – but there is nothing – there is no one thing – of which it is true to say that it is correct to see it in the picture. A good example is the Rorschach card. The efficacy of these simulated ink-blots as diagnostic tests depends upon the satisfaction of two conditions: that it is possible to see something in them, but that nothing, no one thing, has a stronger claim to be seen there than anything else.

However, even with full-blown representation, where the standard of correctness stipulates specifically what is to be seen in the picture, it is still possible, enjoyable, and

25, 2

50

maybe profitable, to take holidays from this standard and select out of the various things we can see in a painting what we choose to. Proust, for instance, used to do this: he would go to the Louvre and find in the paintings of the Old Masters likenesses of his friends or his acquaintances from the Faubourg. Lucien Daudet tells us that, standing in front of the

27 Ghirlandaio double portrait, he pretended that the figure with a polyp at the end of his nose was the old friend of the Comtesse de Greffuhle, the clubman *pur sang*, the Marquis

28 du Lau, whose features are preserved in a faded photograph.[9] And readers of *Swann's Way* will recall how Swann himself had the same fondness for these tricks of perception, feeling that they somehow enhanced his friends for him. His infatuation with Odette was sealed when he found her features in Botticelli's representation of Zipporah, daughter of Jethro.[10] But neither in the person of Swann nor in his own person did Proust claim that these games transformed the representational content of the paintings he played them on. He simply, for the pleasure of the moment, or for some enduring consideration, overruled the intention of the artist.

27 Domenico Ghirlandaio *Old Man and Boy* 1480s(?), panel

28 Marquis du Lau, photograph, detail, from *Marcel Proust, Documents Iconographiques*

What the spectator sees

3. 'The intention of the artist'. In the last lecture explicitly, in this lecture implicitly, I have held out against both an excessively narrow and an excessively broad understanding of artist's intention. But now it might seem as if I have shifted ground, and that, in looking to intention as providing the criterion of correctness for representation, I have, if without saying so, moved towards the narrow understanding. For, if the artist's intention is something that is in the artist's head and that determines that a bison, say, and not an ox, or Henry VIII and not Charles Laughton, is to be seen in a given surface, then it looks as though the candidate that is best qualified for this role is a mere volition on the artist's part that the spectator should identify what he, the artist, sets out to represent. What need is there for the thoughts, beliefs, experiences, emotions, commitments that the broader understanding of artist's intention brings in train? It might seem that there is no call for them.

However this would follow only if what I have just been saying was that, in setting himself to represent something, the artist may mark the canvas in any way whatsoever just so long as a certain effect is achieved: that is, that the spectator identifies what the artist wants the picture to represent. But this is not at all what I have been saying. Clearly there is more than one way in which a spectator can identify an object or an event in a picture. There is a diversity of clues that he can use. For instance, he might anticipate the artist's intention. However it is only if the spectator identifies an object or an event through seeing it in the picture's surface that his response bears on the picture's representational content. In consequence the representational artist must at least set himself to do this: to mark the canvas in such a way as to ensure that the spectator will not merely identify, he will be able to see, to see in the picture, what the picture is intended to represent. And this requirement has the effect that the artist must at any rate draw on his perceptual beliefs. Perceptual beliefs about the thing to be represented must contribute causally to the making of the representation, and this means that they will be included in the artist's intention.

But, though this has the consequence that the very narrowest interpretation of the artist's intention proves inadequate to account for representation, might it not still be the case – the objection would run – that a fairly narrow interpretation is in order, and that the broad understanding that I have been proposing is inappropriate? Can we not eliminate from the intention of the representational artist further mental phenomena like thoughts, emotions, and commitments?

At this point it is necessary to go back to the title of these lectures and remind ourselves of the distinction that it assumes: painting as an art versus painting practised some other way. For, once painting is practised as an art, then it is certain that the agent will mobilize not only his perceptual beliefs about what he represents but also a range of attitudes towards that thing. Indeed some of the perceptual beliefs that he mobilizes will themselves rest upon such attitudes. The way he represents a face will be bound up with what he feels about its owner: the way he represents a building is now inextricable from how he responds to its dignity or charm.

This last point is sometimes put by saying that the artist – in contrast, say, to the Ur-painter – is concerned to do justice not only to the *what*, but also to the *how*, of representation: he will try to set down how what he represents is likely to strike its viewer. But this is not a good way of putting the point. For, in producing an ever more refined image of how the represented thing looks, the artist is in effect representing an ever more specific kind of thing. There is within the representational task no line worth drawing between the what and the how: each fresh how that is captured generates a new what.

29 *Horizontal Pictorial Space,*
from W. Hudson, Test Card, Fig. 1

30 *Horizontal Pictorial Space,*
from W. Hudson, Test Card, Fig. 4

4. At one time it used to be believed that seeing-in, hence representation, was culturally relative: occurring, that is to say, in some societies but not in others. But the evidence that some anthropologists assembled to make this point actually shows something far more limited and of no general significance.[11] So, for instance, they presented tribesmen of south-west Africa with drawings of the sort I illustrate, and then they asked them, Could the huntsman, standing where he is, hit the stag? Now in so far as the subjects answered, No, he couldn't, for the hill, or the road, is in between, what these answers reveal is that it takes experience to grasp paintings that depict comparatively complex spatial relations, and, in doing so, depend upon comparatively subtle visual cues. But the fact that the subjects answered the questions at all, or could apply such terms as 'huntsman', 'stag', 'hill', 'road', to the picture, showed, surely beyond a doubt, that they had the capacity for seeing-in, even if to a less developed degree than well-primed Europeans.

What the spectator sees

But a more sweeping, a more momentous, point is that seeing-in appears to be biologically grounded. It is an innate capacity, though, as with all innate capacities, it requires an environment sufficiently congenial and sufficiently stimulating, in which to mature. A baby a few days old will respond to the drawing of a face: fleetingly, of course, but the same goes for all its responses to the external world.[12] I show you a photograph of 31 my daughter, taken four years ago when she was twelve months old, hailing a represented companion in the Kunsthistorisches Museum in Vienna. This photograph was taken by a total stranger, who only let us know what he was doing after he had done it. It exemplifies one of the least tainted experiments in psychology.

5. The connection between representation and seeing-in was noted by theorists of representation both in antiquity and in the Renaissance.[13] Yet almost to a person these thinkers got the connection the wrong way round: they treated seeing-in as – logically and historically – posterior to representation. For they held that, whenever we see, say, a horse in a cloud, or in a stained wall, or in a shadow, this is because there is a representation of a horse already there – a representation made, of course, by no human hand. These representations, which would be the work of the gods or the result of chance, wait for persons of exceptional sensitivity to discern them, and then they deliver themselves up.

This reversal of explanatory direction got into, and created an interesting problem for, representation when Quattrocento artists wished to represent the activity of seeing-in: seeing-in, that is, directed on to natural phenomena. For in order to represent this activity, they had to represent that which, on their account of the matter, this activity presupposes: they had to display nature as an album of well-contrived but also well-concealed representations. A famous example is provided by Andrea Mantegna, *Martyrdom of St Sebastian* (Kunsthistorisches Museum, Vienna), where the artist, in 32 attempting to represent the kind of cloud in which a horseman can be seen, represents the

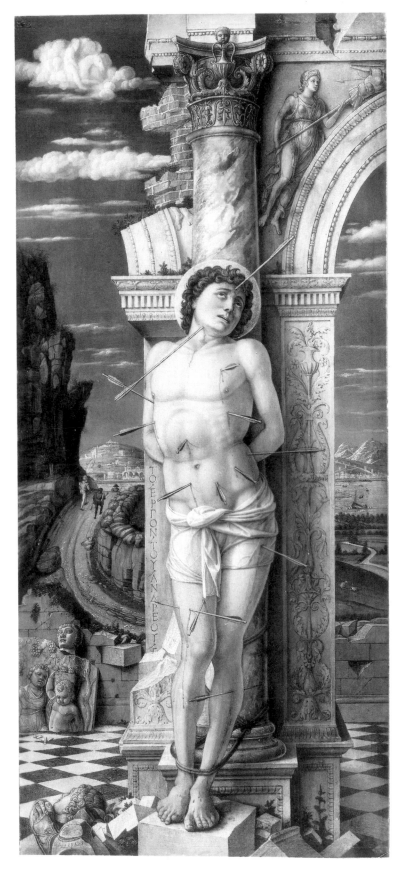

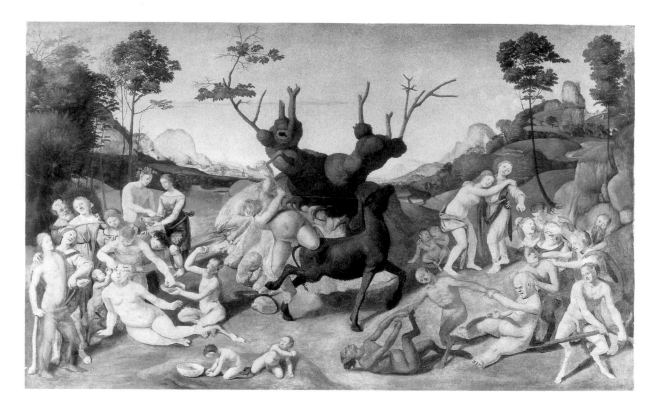

33, 34 Piero di
Cosimo
*The Misfortunes of
Silenus c.* 1500–7, panel.
Detail, right

cloud as though it were an antique cameo of a horseman. Weirder examples are two
mythological paintings by Piero di Cosimo: *The Misfortunes of Silenus* (Fogg Art 33, 34
Museum, Harvard University, Cambridge, Mass.) and *The Discovery of Honey* (Worcester 35
Art Museum, Worcester, Mass.). In these paintings wild figures have their images
cunningly stamped into the branches and pollarded trunks of the trees.

 Of course, even once the traditional account of representation, which reverses the
proper explanatory direction, is discarded, it still remains a problem, and it might be
thought an insuperable problem, for representational artists to refer in their work to the
kind of perception on which, according to my account of the matter, their work depends.
It asks for something that is probably inherently beyond their means. Examples of an
attempt to solve the problem are provided by two drawings (Clark Institute, 36
Williamstown, Mass.) by Charles Meryon, the great architectural draughtsman and
etcher of nineteenth-century Paris, which set out to represent clouds in which women can
be seen. The task, as Meryon saw it, was to represent the clouds but not to represent the
women: the women, in other words, are to be seen in the clouds but not in the drawings.

What the spectator sees

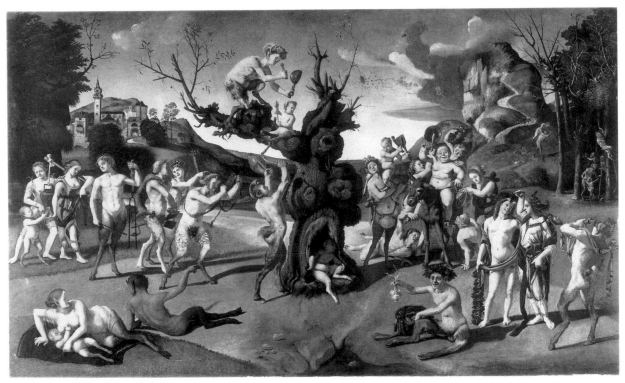

35 Piero di Cosimo
The Discovery of Honey c. 1500–7, panel

36 Charles Meryon
Anthropomorphic Cloud Studies (second version) probably 1855–6, drawing

Buyten Haerlem (wonder saken:)
In het hout dees beelden staeken;
Sonder hand daer in gestdt.
wat maght wesen? my vertelt.

Burger, wilt gij wel gelooven,
Dat het werken syn van boven!
'k bid u, hier doch niet en spot:
In het hout soo leeft oock God.

37 Anonymous *Miraculous Images found in an Apple Tree 1628*, print

In her book *The Art of Describing*, Svetlana Alpers provides us with an amusing example of the attempt to come to grips with seeing-in.[14] In the year 1628, in a village just outside the city of Haarlem, an old apple tree was cut down. Inside its bark there were said by the pious to be miraculous images of Catholic priests. A devout print was soon published to celebrate this discovery. Then, within the year, in order to rebut these superstitious beliefs, to 'belie rumours', and to furnish the materials for a naturalistic explanation of how these beliefs arose, Pieter Saenredam executed a drawing, after which another print was made, exhibiting the tree in cross-section. To make his point Saenredam was committed to showing that the bark was so formed that priests could be seen in it. But, though they could be seen in it, they could not be seen in it with such force, or such clarity, as to make us conclude that this is what some divine artificer expected us to see: unless, the print hints, we were superstitiously motivated to think so.

37

38

What the spectator sees

6. That representation is grounded in seeing-in is confirmed by the way seeing-in serves to explain the broad features of representation. For the most general questions about representation become amenable once we start to recognize that representation at once respects and reflects the nature and limits of seeing-in — so long as we also recognize that seeing-in is itself stretched by the experience of looking at representations. I have in mind three general questions. They are, (one) How do we *demarcate representation*?, or, What is, and what is not, a representation?: (two) What can be represented?, or, more particularly, What are the different kinds of thing that can get represented, and what are the *varieties of representation* to which they give rise?: and, (three) What is it for a representational painting to be — and now I use these terms interchangeably to refer to the same elusive property — *realistic, naturalistic, lifelike, true*? This last question is one that we can pursue without attaching any particular value to the property itself.

38 Cornelis Korning after Saenredam
Print to Belie Rumours about the Images found in an Apple Tree 1628, etching

What the spectator sees

39 'Women' Sign on
Public Lavatories

40 Pure Wool Logo

41 Map of Netherlands

I shall consider these three general questions in turn.

7. First, then, how do we demarcate representations?

Pretheoretically, or before a discussion like this starts, we do not have many strong convictions on this issue, and connecting representation and seeing-in has the advantage of allowing us to organize our thinking about representation in such a way as to preserve and foster those intuitions we do have.

In the first place, then, the connection tells us that representation does not have a very sharp boundary. International road signs, logos, stickmen, the signs on public lavatories — are they representations or not? Availing ourselves of the connection I propose, we may now recast the question as, Do we, when we look at such things, see whatever they are of in their surface, or do we just see the things as marks, which we then, in virtue of our knowledge of the system to which they belong, recognize to be signs of what they are of? Another way of putting the question is, Do we, in so far as we treat these things as meaningful, have to be aware of depth as well as to pay attention to the marked surface? And I think that in answer to such questions we are likely to say in some of these cases that we probably do, and in other cases that we probably don't: but neither way round are we likely to say this with much conviction. And this suggests that all such cases are on the borderline of representation. That they are, and furthermore that representation exhibits a broad swathe of borderline cases, coincides, I believe, with our pre-existent intuitions such as they are.

Secondly, the connection allows us to exclude from representationality signs like maps that are not of whatever it is that they are of because we can see this in them. We may or we may not be able to see in them what they are of but, if we can, it is not this fact that secures their meaning. A map of Holland is not of Holland for the reason that the land

40, 39

41

What the spectator sees

mass of Holland can be seen in it — even if to a modern traveller a map reminds him of what he can see, looking down upon the earth, at the flying altitude of a plane. No: what makes the map be of Holland is what we might summarily call a convention.

This fact about maps and what they map is confirmed by the way we extract from them such information as they contain. To do so we do not rely on a natural perceptual capacity, such as I hold seeing-in to be. We rely on a skill we learn. It is called, significantly, 'map-reading': 'map-*reading*'.

The difference between representations and maps — the difference between the two things and between the ways in which we relate to the two things — is well brought out if we juxtapose representation and map: better still, if we consider a representation that embeds a representation of a map. Consider, for instance, Jan Vermeer, *Officer and Laughing Girl* (Frick Collection, New York City), which represents a man and a woman and a map of Holland. For that which makes some area of Vermeer's painting be of a woman, and, for that matter, that which makes some other area of the painting be of a map, is something quite different from that which makes that map be of Holland. As a consequence, quite different capacities on the part of the spectator, with quite different histories within his life-history, have to be mobilized if he is to learn, on the one hand, what the picture can inform him about the map, and, on the other hand, what the map could inform him about Holland. If he made the grossly inefficient decision to look at the Vermeer in order to find out the facts of Dutch geography, then he would have to mobilize the two capacities serially: first, seeing-in, to tell him that there is a map on the wall and what it looks like, then, map-reading, to tell him what the map, given how it looks, has to say about the land surface of Holland.

Once again, the distinction between representations and maps fits in with our prior intuitions, even if they do not clamour for it.

42 Jan Vermeer
Officer and Laughing Girl
c. 1655–60

Thirdly, the connection between representation and seeing-in allows us to reject the contrast, often drawn but quite unwarranted, between representational and abstract painting. To appreciate this point we need to get clear, first, the full scope of seeing-in and, secondly, the nature of abstract painting as we have it or the demands that it characteristically makes upon the spectator. I shall take them in turn.

In one respect the examples I have given of seeing things in natural phenomena could be misleading. I have quoted seeing a boy in a stained wall; seeing dancers in a frosted pane of glass; or seeing a torso or a great Wagnerian conductor in towering clouds. But continuous with this kind of case are cases in which we see an irregular solid in a sheet of oxidized metal, or a sphere in the bare branches of a tree, or just space in some roughly prepared wall. The two kinds of case differ primarily in the kind of concept under which we bring that which we see in the differentiated surface. In the kind of case I have so far been considering, we use 'boy', 'dancer', 'torso': we use figurative concepts. In the new kind of case, we use 'irregular solid', 'sphere', 'space': we use non-figurative or abstract concepts. This being so, a natural thing to think is that, while both kinds of case are genuine cases of seeing-in, and as such both pave the way for an art of representation, they differ in that they pave the way for different kinds of representational art. One paves the way for a representational art that is figurative, the other for a representational art that is abstract.

When we now turn to abstract painting as it has in fact emerged in this century, we can see there that this way of thinking is fully borne out. Abstract art, as we have it, tends to be an art that is at once representational and abstract. Most abstract paintings display images: or, to put it another way, the experience that we are required to have in front of them is certainly one that involves attention to the marked surface but it is also one that involves an awareness of depth. In imposing the second demand as well as the first, abstract paintings reveal themselves to be representational, and it is at this point irrelevant that we can seldom put into adequate words just what they represent.

Consideration of a painting like the magnificent Hans Hofmann, *Pompeii* (Tate Gallery, London) should clarify the point. For manifestly this painting requires that we see some planes of colour in front of other planes, or that we see something in its surface. And this is true despite the fact that we shall be able to say only in the most general terms what it is that we see in the surface. 43

I have talked of what most abstract paintings are like. This provokes the question whether there are indeed any abstract paintings that are non-representational or that do not ask for seeing-in. (I have noticed as a strange fact that, once people have had their resistance broken down to the idea that some abstract paintings are representational, they become dogmatic that all abstract paintings are representational: they repudiate the very idea of a non-representational abstract painting.) On this point there is cause for circumspection. It is plausible to think that, for instance, some of the vast machines of Barnett Newmann, such as *Vir Heroicus Sublimis* (Museum of Modern Art, New York City), are non-representational. Arguably correct perception of such a picture, or perception that coheres with the fulfilled intention of the artist, is not characterized by twofoldness. 45

It is however worth noting that, if there are certain abstract paintings that are non-representational for the reason that they do not call for awareness of depth, there are also paintings that are non-representational for the complementary reason, or because they do not invoke, indeed they repel, attention to the marked surface. *Trompe l'oeil* paintings, like the exquisite series of cabinets executed in gouache by Leroy de Barde (Cabinet des Dessins, Louvre, Paris), are surely in this category. They incite our awareness of depth, but do so in a way designed to baffle our attention to the marks upon the surface. 44

What the spectator sees

43　Hans Hofmann *Pompeii* 1959

44　N. Leroy de Barde
Réunion d'Oiseaux étrangers placés dans differentes caisses 1817,
watercolour and gouache

45　Barnett Newmann *Vir Heroicus Sublimis* 1950–1

8. The second broad question is, What can be represented?, or, on the plausible assumption that what can be represented is sub-divisible in some principled way, What kinds of thing can be represented? What, in other words, are the varieties of representation?

It might seem plausible to think that an answer to the question, What can be represented? is to be found, not in the connection that I have been canvassing between representation and seeing-in, but in the connection, seemingly more fundamental, between representation and seeing. More fundamental: for how can something be seen in a marked surface unless it can be seen – seen, as I have been putting it, face-to-face? So the answer that proposes itself is that what can be represented is whatever can be seen face-to-face. Representation is essentially of the visible.

Later, by the end of the next section, I shall suggest that, for comparatively subtle reasons, this answer is less adequate than it might initially seem, and that, in the matter of scope too, seeing-in, rather than seeing, remains the more reliable guide to representation. However, since the reason why seeing is the less reliable guide is because it is too restrictive in scope, or unduly limits the varieties of representation, it follows that any account of representation that not only bases itself on seeing but then takes an excessively restrictive view of what can be seen compounds its inadequacy. It is in double trouble. Just such an account is to be found in what is perhaps the most remarkable treatise dedicated to – some would say, against – the visual arts: Gotthold Ephraim Lessing's *Laocoon*. In discussing the scope of representation I shall start from the *Laocoon*.[15]

Lessing puts at the centre of his argument the claim that the pictorial arts, being directed to the eye, can be only of what can be entrapped by the eye. However from this acceptable premiss Lessing proceeds to derive unacceptably strong conclusions about what cannot be represented, and it is here that his restrictive view of what can be seen makes itself felt. Lessing concludes, for instance, that a visual work of art cannot represent an action, and that any representation of a cloak must be neutral between representing a cloak that cloaks a figure and representing a cloak with nothing immediately underneath it. These, and other restrictions upon representation, follow directly, Lessing would have

46 Frans Hals
The Company of St George 1616 (The St Jorisdoelen)

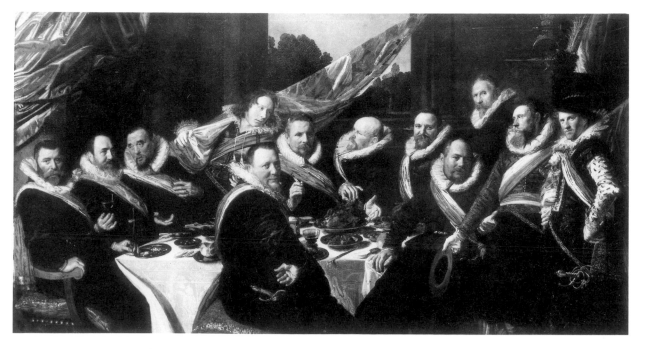

64

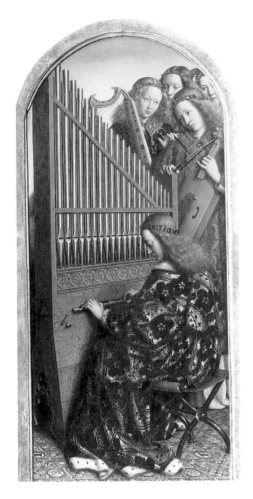

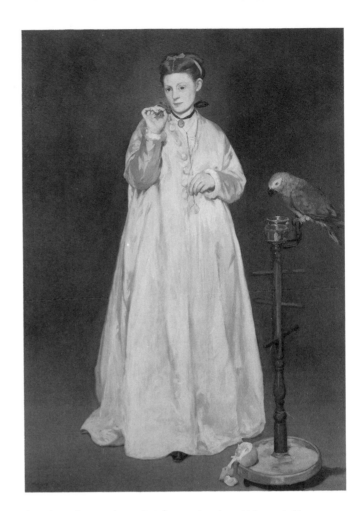

us believe, from the self-evident limits of vision: and to drive home the point, he contrasts the limited nature of vision, and the narrow scope of the visual arts, with the free nature of language, and the wider scope of literature.

At this stage, I suggest that we remind ourselves of certain broad truths about what it is possible to see: that is, to see face-to-face. We are recalled to a better sense of the scope of vision when we remember such things as that we can see something or other even if we cannot see every part of it; that we can see one thing rather than another, even if the two look so alike that, in other circumstances, or knowing nothing about either, we might not be able to tell them apart or might mistake one for the other; or that we can see something doing or undergoing something, even if what it does or undergoes cannot be identified except by referring to something we cannot see.

So long as we keep these truths in mind, then, even if we continue to think that what can be represented is co-extensive with what can be seen, we shall be freed from thinking that representation is circumscribed in the way that Lessing thought. We shall be able, for instance, to acknowledge the existence of the following representations: In the first place, Frans Hals, in his group-portrait of *The Company of St George 1616* (Frans Halsmuseum, Haarlem), represented their colonel, even though, since the colonel is seated at table, his lower half is not visible. Indeed in depicting the music-playing angels in *The Adoration of the Mystic Lamb* (Church of St Bavon, Ghent), van Eyck went further and represented an angel blowing the bellows of an organ, even though, since the angel is behind the organ, everything except a tress of the angel's hair and a sliver of drapery is not visible. Secondly, Edouard Manet, *Woman with a Parrot* (Metropolitan Museum of Art, New York City) represents a woman with a live parrot, and Nicolas Poussin, *The Death of*

46

47

48

49

(Above left)
47 Jan van Eyck
The Adoration of the Mystic Lamb, detail, *c.*1432, panel

(Above)
48 Edouard Manet
Woman with a Parrot 1866

What the spectator sees

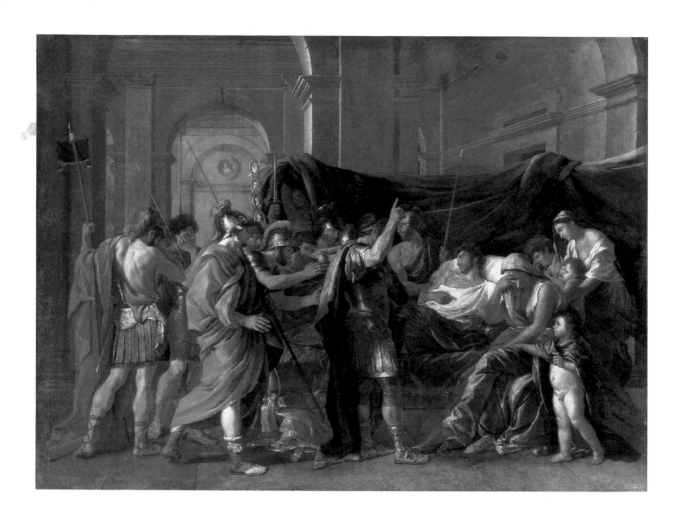

49 Nicolas Poussin
The Death of Germanicus
1627

50 El Greco
Laocoon c. 1610

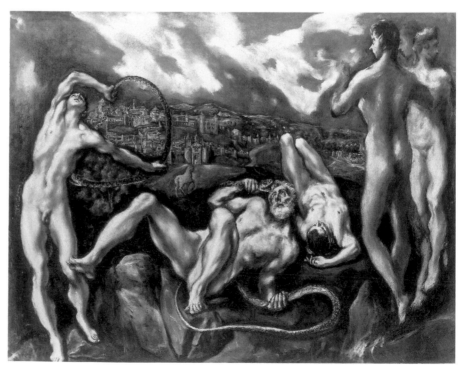

51 J.-A.-D. Ingres
Madame Moitessier 1851

Germanicus (Minneapolis Institute of Arts, Minneapolis) represents a man on his deathbed, even though a live parrot is not necessarily distinguishable from a cunningly stuffed parrot, and a man on his deathbed cannot invariably be discriminated from a man shamming illness. Thirdly, and this takes direct issue with Lessing's own example, a painting of Laocoon can represent Laocoon as about to cry out in agony or as caught in the coils of serpents sent by Pallas Athene to afflict him, even though his crying out lies in the future and Pallas Athene is in a distant land, so that neither is visible.

However, even if, on a juster understanding of visibility, the limits that Lessing set to the visual arts would have to be massively expanded, it remains the case that what can be seen gives us an inadequate criterion of what can be represented. This will emerge more clearly once we move beyond the general requirement upon representation, and start to classify the varieties of representation. It is to this that I now turn.

9. There are, of course, many many ways of classifying representations by what they represent, as many ways indeed as there are of being interested in the things represented, but the most basic way – basic, because it takes us to the core of how representations relate to reality – gives us a cross-classification. Read one way, the classification divides representations into representations of *objects* and representations of *events*. Read the other way, it divides them into representations of *particular* objects-or-events and representations of objects-or-events *that are merely of some particular kind.*[16] Examples will elucidate this classification.

A painting can represent a young woman: then it would represent an object. Or it can represent a battle: then it would represent an event. If it represents a young woman, then it might, like Ingres's portrait, represent Madame Moitessier (National Gallery of Art, Washington, D.C.): then it would represent a particular object. Similarly, it might, if it

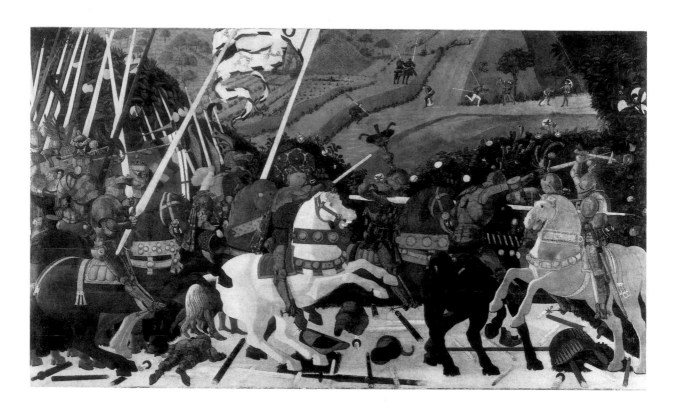

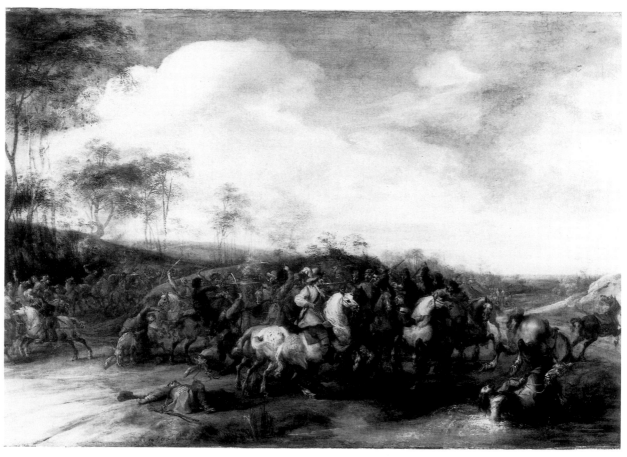

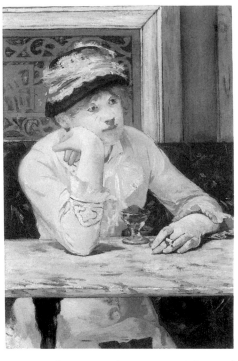

(Left)
52 Paolo Uccello
Rout of San Romano
1450s, panel

(Below left)
53 Peter Snayers
A Skirmish of Cavalry
before 1648

54 Edouard Manet
La Prune c. 1877

52 represents a battle, represent, like Uccello's painting, the *Rout of San Romano* (National Gallery, London): then it would represent a particular event. However, in representing a young woman, a picture might, like Manet, *La Prune* (National Gallery of Art, Washington, D.C.), represent just *a* young woman, or *a* young Frenchwoman, or *a* young 54 Frenchwoman of a particular epoch and class and age and character and occupation and prospects, but still not any young woman in particular: then it would represent something that was merely an object of a particular kind. Similarly, in representing a battle, a picture might represent just a battle, or maybe a cavalry battle, or even a cavalry battle fought between horsemen unevenly matched, some armed with muskets, some with sabres, some with pistols, some with, some without, breastplates, in a terrain that made ambush easy, but still no battle in particular: then it would represent something that 53 was merely an event of a particular kind.

A way of bringing out this second distinction between pictures that represent particular objects-or-events versus pictures that represent objects-or-events that are merely of a particular kind would be this: Told of a painting that it represents, say, a young woman, we might ask, Which young woman? Now for some pictures like the Ingres portrait, there *is* an answer to this question even if the actual person we ask turns out not to know it. In such cases the picture represents a particular object. However for other pictures such as the genre picture by Manet, there is no answer to the question, and asking the question shows only that we have misunderstood what we have been told. In such cases, the painting represents merely an object or an event of a particular kind.

But the situation has a twist to it.

The exclusive categories are not paintings that represent particular objects-or-events versus paintings that represent objects-or-events of a particular kind. No: the exclusive categories are paintings that represent particular objects-or-events versus paintings that represent objects-or-events that are *merely* of a particular kind. For every representational painting represents something of a particular kind. And this is not an idle fact about it. For if, additionally, the picture represents something particular, then it represents whatever that something is as belonging to that very kind.[17] So Ingres's portrait of Madame Moitessier representing (as it does) a woman, young, French, born in the early nineteenth century, self-assured, expensive, represents its sitter as just such a person.

A principle to which paintings by and large will seek to conform is that they represent things as belonging only to those kinds to which in fact they belong – though, of course, no picture can represent something as belonging to every kind of which it is actually a member. We might call the principle to which no painting can be expected to subscribe, *The whole truth*, and that to which most paintings aim to subscribe, *Nothing but the truth*, and there are various motives over and above sheer ignorance or incompetence that could from time to time lead a painter to diverge from it too: for instance, flattery. However a more or less systematic departure from *Nothing but the truth* is to be found in a category of painting which makes a virtue of representing things as they aren't: caricatures. We can see this in Philippon's excessively well-known caricature of Louis 55 Philippe, representing him as a pear, which he wasn't, and in an ingenious Victorian portrait of *Sir Edwin Landseer* (National Portrait Gallery, London) representing him twice 56 over – once as himself, and once as one of the lions which he executed for Trafalgar Square.

(Below)
55 Philippon
Louis Philippe 1834,
caricature

56 John Ballantyne
Sir Edwin Landseer
c. 1865

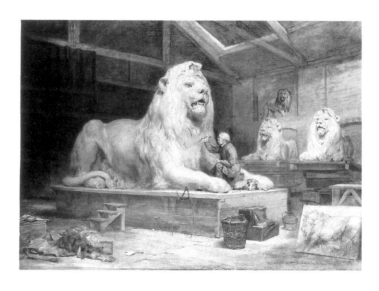

LES POIRES,

Faites à la cour d'assises de Paris par le directeur de la CARICATURE.

Vendues pour payer les 6,000 fr. d'amende du journal le *Charivari*.

(CHEZ ALBERT, GALERIE VERO-DODAT)

Si, pour reconnaître le monarque dans une caricature, vous n'attendez pas qu'il soit designé autrement que par la ressemblance, vous tomberez dans l'absurde. Voyez ces croquis informes, auxquels j'aurais peut-être du borner ma défense :

Ce croquis ressemble à Louis-Philippe, vous condamnerez donc ? Alors il faudra condamner celui-ci, qui ressemble au premier.

Puis condamnez cet autre, qui ressemble au second. Et enfin, si vous êtes conséquents, vous ne sauriez absoudre cette poire, qui ressemble aux croquis précédens.

Ainsi, pour une poire, pour une brioche, et pour toutes les têtes grotesques dans lesquelles le hasard ou la malice aura placé cette triste ressemblance, vous pourrez infliger à l'auteur cinq ans de prison et cinq mille francs d'amende !! Avouez, Messieurs, que c'est là une singulière liberté de la presse !!

What the spectator sees

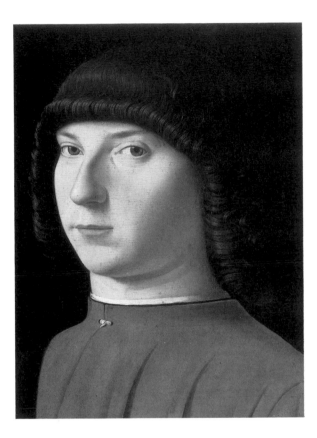 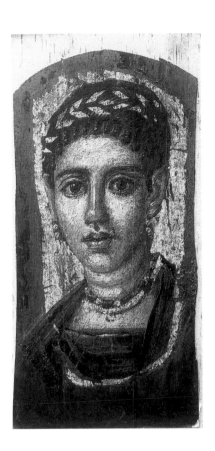

And now I must emphasize that the distinction between pictures of particular things and pictures of things merely of a particular kind is a distinction that applies in virtue of the intentions, the fulfilled intentions, of the artist. It has to do with how the artist desired the picture to be taken, and how well he succeeded in making the picture adequate to this desire. The distinction in no way depends upon what we happen to know about who or what the picture is of. So, for instance, a Renaissance portrait of some man, or a Fayum portrait of some princess, whose identity has long been lost and will never be recovered, is now and ever will be what it originally was: it is, like Ingres's portrait of Madame Moitessier, a picture of a particular person, and the fact that probably no one will ever know who does not alter this fact.

In a lecture that set itself a more narrowly theoretical or philosophical aim, much more would be heard of this cross-classification: just because it takes us to the core of how representation relates to the world. In this lecture, it is intended to serve only one purpose, which is to confirm and to expand the dependence of representation upon seeing-in — upon seeing-in rather than seeing face-to-face. For what I see in a surface is subject to precisely the same cross-classification as what a painting represents: objects versus events, and particular objects-or-events versus objects-or-events that are merely of a particular kind. And, even if the first part of this classification also applies to what I see face-to-face, it is significant that the second part doesn't. If I claim to see a young woman face-to-face, I cannot, when asked, Which young woman?, beg off and say that the question doesn't apply and that to ask it only betrays a misunderstanding of what I have said. Of course I can say that I don't know the answer: but not that there isn't one. It is this fact that argues most conclusively for the view that what can be represented is just what can be seen in a marked surface rather than what can be seen face-to-face.

57 Antonello da Messina
Portrait of a Young Man
c. 1475, panel

(Above)
58 Fayum
Portrait of a Woman 2nd century AD, encaustic on wood

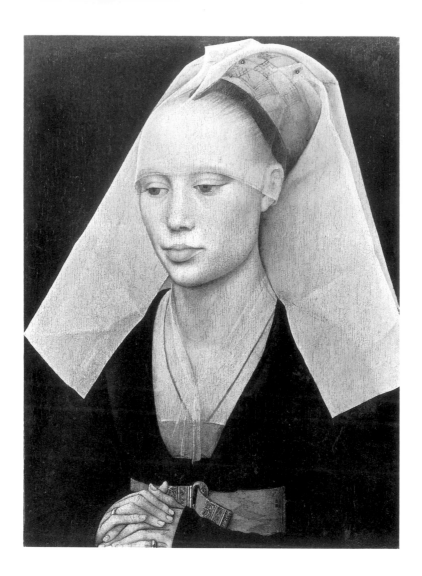

59 Rogier van der Weyden
Portrait of a Lady
c. 1460, panel

10. Thirdly, there is that elusive but noteworthy property in terms of which we can sort representations and which we may call, interchangeably I have suggested, naturalism, realism, lifelikeness, truth to nature. I say 'interchangeably' rather than 'synonymously', because I doubt if they are synonyms. It seems to me that we use a variety of words, which do not mean exactly the same, to pick out a property with which we are familiar, and of which each word catches some aspect. It is the property itself that interests us, and the property is identified partly by reference to a certain effect that is brought about in the spectator, and partly by reference to the way in which the picture brings about this effect. The effect is one that we have all experienced in front of works like Rogier van der Weyden, *Portrait of a Lady* and George Romney, *Sir Archibald Campbell* (both National 59, 6 Gallery of Art, Washington, D.C.). The effect is however not capturable in words, and therefore the property is best approached, I suggest, through the way in which the effect is brought about. It is on this subject that I shall say something. For the property itself I shall use throughout the term 'naturalism'.

Once again my claim is that, in order to appreciate a crucial aspect of representation – this time, how the naturalistic effect is achieved – the connection between representation and seeing-in provides the essential materials. Specifically we need to invoke the phenomenology of seeing-in: twofoldness.

What in effect most accounts of naturalism do, and how they go wrong, is that they

72 *What the spectator sees*

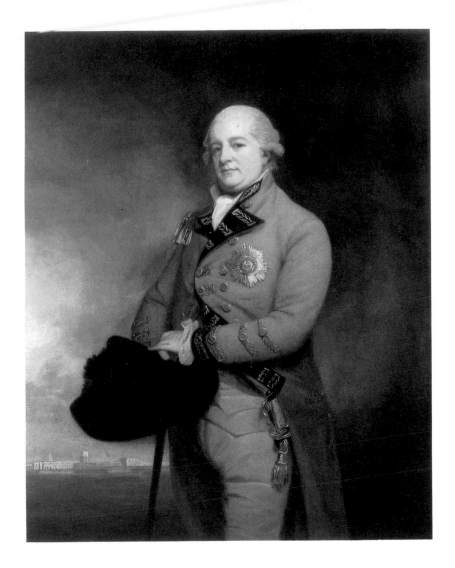

concentrate on just one of the two aspects of seeing-in, and then try to explain the naturalistic effect solely by reference to it. More specifically, they concentrate on our discerning something in the marked surface, or what I shall call the *recognitional aspect*, and they then proceed to identify the naturalistic effect with the facility, or with the speed, or with the irresistibility, with which what the picture represents breaks in upon us. The other aspect of seeing-in, which is our awareness of the marked surface itself, or the *configurational aspect*, is ignored as though it were irrelevant to the issue.

I believe that all accounts reached in this way are fundamentally misguided.[18] Any such account covers only a limited number of cases, and it covers them only coincidentally. To get an adequate account of naturalism, or one which covers all cases and explains them, we have to reintroduce the configurational aspect, for the naturalistic effect comes about through a reciprocity, a particular kind of reciprocity, between the two aspects of the visual experience that we have in front of those pictures which we therefore think of as naturalistic. It is not any kind of reciprocity: it is, I emphasize, a particular kind of reciprocity. There is no formula for this reciprocity, which is what we should expect, and this is why the naturalistic effect has to be rediscovered for each age: more specifically, for each change in subject-matter, and for each change in technique. The very imprecision of the word 'reciprocity' is a good thing if it allows us to keep the improvisatory character of naturalism to the fore.

61　Pieter de Hooch *A Dutch Courtyard c. 1660*

It is only an account like this, concocted out of richer materials than are generally used for this purpose, that can accommodate, indeed that can predict, the wide variety in appearance exhibited by paintings all of which are equally naturalistic. This wide variety of look is well exemplified in the paintings by van der Weyden and Romney, which is why I have chosen them: and the same contrast of appearance within naturalism could be illustrated from painters as far apart as, say, Pieter de Hooch and Grünewald; or Monet and Fantin-Latour; or Bronzino and Picasso. All these painters, different though they otherwise are, are capable of the naturalistic effect.

59, 60

1, 62,

3, 64,

5, 66

62 Mathis Grünewald *Crucifixion* (central panel from *The Isenheim Altarpiece*) 1515, panel

The point that I must now clarify is that, in thinking of naturalism as lying in some kind of reciprocity or match between the two aspects of seeing-in, we must be careful not to equate awareness of the marked surface with attention to the brushwork. Attention to the brushwork is just one form that awareness of the marked surface can take, and it is not a form that, for historical reasons, it could have taken before 1500 or so, when the unit mark or stroke came to be thematized. But, long before the stroke became a required object of aesthetic scrutiny, there were plenty of other features of the marked surface that claimed attention: contour, modulation, punch mark, aerial perspective, fineness of detail, as well as, for that matter, smoothness of surface or invisibility of the brushwork.

What the spectator sees

63 Claude Monet
Banks of the Seine,
Vétheuil 1880

11. So much for the broad questions that can be raised about representation, and for the contribution that the view of representation that I have been urging, or the connection with seeing-in, can make to their resolution. And now I want to bring my view into sharper focus by contrasting it with its principal competitors. They are:

(one) the *Illusion view*, which holds that a picture represents whatever it does in virtue of giving the spectator the false perceptual belief that he is in the presence of what it represents;[19]

(two) the *Resemblance view*, which holds that a picture represents whatever it does in virtue of being like what it represents – or, a variant, in virtue of producing an experience which is like the experience of looking at what it represents;[20]

(three) the *Make-believe view*, which holds that a picture represents whatever it does in virtue of our correctly making-believe that we see face-to-face what it represents;[21]

(four) the *Information view*, which holds that a picture represents whatever it does in virtue of giving us the same information as we should receive if we saw face-to-face what it represents;[22]

(five) the *Semiotic view*, which holds that a picture represents whatever it does in virtue of belonging to a symbol system which, in the course of laying down rules or conventions linking marked surfaces or parts of marked surfaces with external things and relations, specifically links it or some part of it with what it represents.[23]

What the spectator sees

Each one of these views can be faulted on points peculiar to it. So it is a grave objection to the Semiotic theory that it cannot account for the evident fact of transfer. By the term 'transfer' I mean, for instance, that, if I can recognize a picture of a cat, and I know what a dog looks like, then I can be expected to recognize a picture of a dog. But on the Semiotic view this ought to be baffling. It should be as baffling as if, knowing that the French word '*chat*' means a cat, and knowing what dogs look like, I should, on hearing it, be able to understand what the word '*chien*' means.

But the basic divide within views of representation is between those views which ground what a painting represents in the kind of visual experience that the representation will cause in a suitably informed and sensitive spectator and those views which do not. Those views which do not ground representation in visual experience disqualify themselves on the spot. Those which do are, my view apart, the Resemblance view and the Illusion view, but both these views misconceive the crucial experience. The Illusion view identifies it with the sort of experience that a spectator is likely to mistake for seeing the represented thing face-to-face, and the Resemblance view identifies it with the sort of experience in which the spectator compares, in some unspecified respect, what is in front of him with something that is absent. The Resemblance view gives the visual experience a gratuitous complexity, whereas the Illusion view denies it the special complexity that it has: that is, twofoldness.

64 Henri Fantin-Latour
Still Life 1866

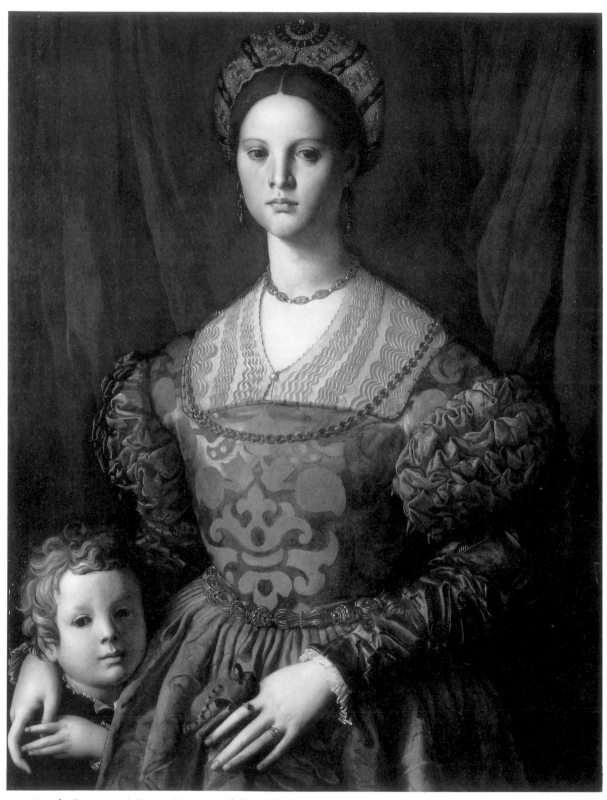

65 Agnolo Bronzino *A Young Woman with her Little Boy c.* 1540, panel

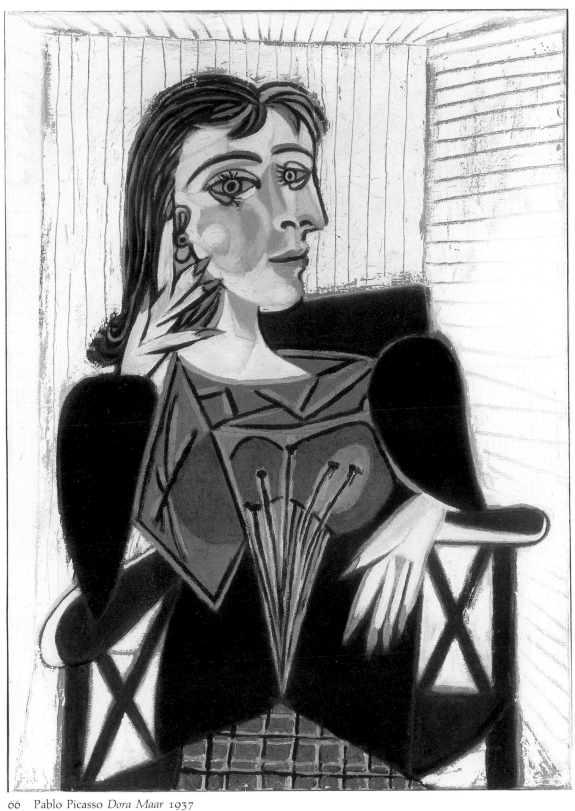

66 Pablo Picasso *Dora Maar* 1937

C. 1. After seeing-in I turn to expressive perception.

By expressive perception I mean – for I shall restrict myself to vision – that capacity we have which enables us, on looking at a painting, to see it as expressing, for instance, melancholy, or turbulence, or serenity. But note that melancholy, turbulence, serenity, are textbook objects of expression, and they are deeply misleading if they suggest that, whenever a picture is expressively perceived, it is perceived as expressing something as simple as these examples. If I continue to use these examples for the sake of convenience, it is only for the sake of convenience, and it is to be remembered that they stand in for far finer-grained examples and perhaps for something that eludes the grasp of language. It is unwarranted to think that, as has often been thought, a painting cannot express an emotion or feeling unless that emotion or feeling can also be caught in language. Why should something, if it can be expressed once, have to be expressible twice – and, if it has to be, why stop there? However, contrary to some recent views,[24] I concur with the traditional requirement that what is expressed is invariably a mental or psychological phenomenon.

What is it then to see a painting as expressing melancholy, or turbulence, or serenity? Is it, for instance, a genuine species of seeing, or is the notion of seeing used here in a loose or extended sense as when I say that I see the force of an argument, or the need for disagreeable action?

I believe that expressive perception is a genuine species of seeing, and it is for this reason that it is capable of grounding a distinctive variety of pictorial meaning. However expressive perception is not a narrowly visual capacity, for not only does it, like all species of seeing, presuppose beliefs, which in turn derive from a certain experience of the world, but it also presupposes a deep part of our psychology, which consists in a mechanism for coping with feelings, moods, and emotions. Expressive perception, like seeing-in, pre-exists the experience of painting, but the experience of painting – indeed the experience of art generally – contributes, massively contributes, to its elaboration and refinement.

What the spectator sees

In order to grasp what expressive perception is, we should first turn to two reasonably familiar kinds of experience, with which expressive perception may be compared.

 The first kind of experience occurs when we are in the grip of some strong or poignant emotion, and this emotion then comes to colour everything we set eyes on. We have enjoyed a sudden success, or we have been frustrated or rejected in love, and the whole world, the world as such and every detailed part of it, presents itself to us in a light to which this emotion disposes us. It seems to us sparkling and resplendent, or it strikes us as a chill and unwelcoming place. And it does so, not because of how the world is, but because of how we are. The second kind of experience occurs in somewhat different circumstances. We are driving along, say, a country road, not far, we know, from the coast, and, turning a corner, we suddenly see stretched ahead of us hard rocky land, broken up by fingers of water, there are low-flying birds, and a solitary tower or cottage is the only sign of habitation. Or we have fallen upon a river scene in the heart of a countryside of fields and small villages and woods: there are tall poplars, and water-meadows, and broken fences subside into the sedge. In each case a mood of loneliness and despair, finely shaded to match the differences between the two landscapes, creeps over us.

<p style="margin-left:-2em">67</p>
<p style="margin-left:-2em">68</p>

68 Edwin Smith
*River Trent at Kelham,
Nottinghamshire* 1956,
photograph

The two kinds of experience are in two important respects mirror-images of one another. With the first kind of experience, the emotion flows from us to what we perceive, and it is correspondingly indifferent to the look of the scene. With the second kind of experience, the emotion flows from what we perceive to us, and it is in consequence responsive to how the external world looks. For the relation that holds between some part of the external world – a scene – and an emotion of ours which the scene is capable of invoking in virtue of how it looks, I use a term which, originating with the mystical philosopher Swedenborg, was adopted by Baudelaire: 'correspondance', 'correspondence'.

On the face of it, it must be the second kind of experience, where something perceived gives rise to an emotion in us, and does so because of how it looks, that prefigures expressive perception. This is true, but it is subject to certain qualifications, and these qualifications are important. There are two, and they are crucial to an understanding of expressive perception.

The first qualification concerns the way in which correspondence engages with experience, and it involves borrowing a condition from the first kind of experience. The condition is that the corresponding emotion, once invoked, should not stand apart from the perception through which it is invoked. It should not be a mere association to what is perceived. The emotion should flood in on the perception. In expressive perception it is not enough that what is perceived invokes the corresponding emotion: the emotion must effect how we perceive what we perceive. Expressed emotion and perception fuse.

The second qualification concerns the way in which correspondences are formed. Correspondences are formed in projection, and *projection* is a process in which emotions or feelings flow from us to what we perceive. In consequence, though expressive perception is indeed prefigured by the second kind of experience, it rests upon an experience that is quite a bit like, though it is much more primitive than, an experience of the first kind. This is important, for expressive perception is one of those capacities of ours of which we cannot have an adequate understanding until we take account of how they originate.

I turn then to projection.

2. In point of fact – and for our purposes this is an important fact – projection comes in two forms.[25] It comes in a simple and in a complex form.

In its simple form the course of projection runs as follows: A person is, say, sad; his sadness causes him anxiety; as a result of this anxiety, he projects his sadness on to some other figure in the environment; now he no longer believes that he is sad, but he believes that this other figure is sad. His new belief about himself may be true, and, if it is, it will be true because of the projection. Projection may lift the sadness as well as the anxiety about the sadness. The course of projection in its complex form runs as follows: A person is (to re-use the example) sad; his sadness causes him anxiety; as a result of this anxiety he projects his sadness on to, more generally, the external world; and now, along with no longer believing that he is sad, perhaps no longer being sad, he begins to experience the external world as of a piece with his sadness. Once again, any changes that occur not just in the person's beliefs about himself but in himself are also to be credited to the projection. The two examples I have given of projection must not suggest that only a negative or unhappy emotion or feeling is projected. A happy or positive emotion or feeling, like love, may also be projected, and, when this happens, it will be projected in response to anxiety not about, but on behalf of, the feeling: the person will desire to protect or perpetuate the love, and it follows that in such cases projection will not have the effect of purging the person of what he feels.

Even this highly schematic account allows us to see that there are two major differences between the simple and the complex form of projection.

What the spectator sees

The first difference is this: With simple projection the person ends up with a belief about the figure on to whom he has projected his sadness, whereas, with complex projection, he ends up with a way of experiencing the external world. The difference is between belief, in the one case, and experience, in the other, as the residual condition of projection. The second difference, which is the core difference, is this: In the case of simple projection the property that the person ends up believing some figure to have is the same as the property that he started off by having himself and then projected; in my example, it is sadness. However in the case of complex projection the property that the person ends up experiencing the world as having is not the same as the property that he started off by having himself. It is not the property that he projected. In my example it is not sadness. Inattention apart, who could believe that the person who projects sadness ends up by experiencing the external world, or some fragment of it, as about to sigh or as on the edge of tears? It is in order to convey this point that I have employed the makeshift phrase 'of a piece with his sadness': the person experiences the world as of a piece with his sadness. In fact I have employed this phrase to make two points. The first is that in the aftermath of complex projection, the person does not experience the world as, say, being sad, or having the property of sadness. The second is that the property that he does experience the world as having is not fully comprehensible without going back to projection itself. I call this property and other such properties 'projective properties', and their long-term significance for the present discussion is that expressive perception too is perception of projective properties. It should now be emerging how it is that expressive perception rests upon projection, and that, in so far as it does so, it more particularly rests upon complex projection.

But there might seem to be a real difficulty in the way of accepting this dependence, or of seeing how correspondences could be forged in projection. The difficulty arises out of something that I have made no effort to conceal. And that is that, whereas expressive perception, as a form of seeing, is responsive to features of the perceived scene, projection, on the account so far offered, is not. I have given no reason to believe that, when an emotion or feeling is projected on to some part of the world, what this part of the world actually is or what it looks like has any responsibility for the projection. Consequently its features have no responsibility for how it is residually experienced, once projection has occurred. Projection is haphazard and responsive solely to inner needs and demands. Or so I have suggested.

It is now time to start revising this picture, which is exaggerated if it is taken to hold good for all projection. Certainly at the earliest moments of life, or in its most primitive manifestation, projection is haphazard: emotions, particularly negative emotions, are projected in a way that shows no respect for how things are. But in so far as it is haphazard, projection is also transient. There is nothing out there to sustain the experience of the world that projection induces, and the experience fades as abruptly as it was formed. But gradually this changes. Projection matures, and projective properties start to owe something to the features upon which they are overlaid.

But, it might be asked, How can this be? What could there be about the world, or what properties could it have, which would make it more plausible for us to project one emotion on to it rather than another, or which would contribute to our experiencing it as of a piece with the emotion projected?

There is no simple way of answering this question, which is what we should expect. What we can say is that the suitability of some part of the world to support projection, its fitness to be the bearer of projective properties, its power to forge correspondences, is not something that discloses itself in a flash: it becomes apparent only through trial and error, and all kinds of influence, cultural as well as private, may be assumed to stabilize projection, and thus to mould correspondence. In this way we can posit a slow and

gradual transition, rather than a sharp contrast, between projection and expressive perception.

I conclude this section by saying something about the mechanism of projection, or how projection achieves what it does.

Projection is fundamentally an unconscious process, and it operates, at any rate in its complex form, through phantasy. Of these two facts it is the second rather than the first that ensures that projection always remains less than fully comprehensible. For that projection operates through phantasy, or that it has phantasy, unconscious phantasy, as its vehicle, means that projection belongs, not just to unconscious mental functioning, but to primitive mental functioning.

In point of fact, the explanation of projection through phantasy is a two-tier account. On the first tier, there is the initiating phantasy which, as we have already seen, is entertained on the occasion of some emotion or feeling that the person wants either to rid himself of or to retain and preserve. Fear of, or fear for, the emotion stimulates anxiety, and it is in order to allay this anxiety that projection is set in train. The initiating phantasy represents the emotion as being expelled from the body and then spread or smeared across some part of the world, and the primitive nature of the mental functioning to which projection belongs is revealed in the highly physical or corporeal way in which (as this description of its content makes clear) the expulsive phantasy envisages mental phenomena. Emotions are in effect envisaged as bits or products of the body which can be spewed out or excreted and then deposited in the world. But the primitive nature of projection is also revealed in the enduring effect that the initiating phantasy has over the person who invokes it. This enduring effect is also rooted in phantasy. Here we have the second tier of the explanation of projection in terms of phantasy. For having, in phantasy, expelled the emotion, the person then finds set up in himself a disposition to phantasize which leads him to experience the world a certain way. He is led to experience the world as permanently modified by this event. The expulsive phantasy dyes the world, and it is this dye that gives the world its new projective properties.

3. There is a confusing feature about the way we talk about projection, which carries over to when we talk about expression, and which can, and in some recent thought does, distract the way we think about these topics.

If we start with projection, the feature is this: As we have seen, with complex as opposed to simple projection, the property that the person ends up experiencing the world as having is not the same as the property that he started off having and then projected. However, in the vast majority of cases, the same predicate, which is, of course, invariably a psychological predicate, is used to pick out the second property as well as the first. So, in the example I have been employing, the person who is sad and then projects his sadness on to the world is said to experience the world as sad, though he evidently does not experience the world as being in the state that he was in: he does not experience it as on the edge of tears.

When the same predicate is used to pick out both the original psychological property and the subsequent projective property, I shall say that it 'doubles up', and it is this *doubling-up of the predicate* that has proved a distracting element. For this comparatively unimportant linguistic fact has been idealized.[26] Doubling-up has been thought to hold the key to the nature of projection − and to the nature of expression.

To dispel this idealization, an immediate antidote is to remind ourselves that, though doubling-up occurs in the vast majority of cases of complex projection, it does not occur in all cases. For instance, when a person is depressed and he projects his depression on to the world, he is not said to experience the world as depressed. If we now add to this fact the further fact that there is no principled difference between the cases where doubling-up

is appropriate and those where it isn't, doubling up should recede in significance. It should come to seem a mere quirk of usage.

Doubling-up, as I have said, carries over from projection to expressive perception both of the world and of art. So if a piece of the world or a work of art corresponds to sadness, then we are said to experience it as sad. But, again, though this doubling-up occurs in the vast majority of cases, it does not occur in all cases. And, once again, depression provides a counter-example. In fact the context of expressive perception is a good place in which to show that, not only is doubling-up a linguistic usage of no great significance, but its idealization can progressively lead to damaging consequences.

The first step in this progression is in itself harmless enough. It consists in thinking of doubling-up as giving us the core of expressive perception, so that now the principal task for anyone wishing to understand this form of perception is to classify the kind of meaning that predicates have when used in this way. One plausible answer is to say that they are given metaphorical employment. So when a person finds that some part of the world corresponds to sadness and he is said to experience it as sad, 'sad' (on this view) is used metaphorically.

So far, so good. But the reason why this first step is generally harmless is just because so far we do not have an account of expressive perception. To get one we must insist that the predicates that double-up — or, if we don't think that doubling-up is universal, whatever predicates are used in their place — not only are applied to the world metaphorically but guide or structure our experience of it.

Accordingly, for someone over-impressed by doubling-up, there opens up the possibility of a further step, and this step clearly takes us into error, and it is to think that doubling-up is not only the core of expressive perception, it is absolutely all that there is to it. On this view, expressive perception just *is* the metaphorical application of psychological predicates to the world. That expressive perception is a form of seeing is now implicitly denied.

A further step, which further idealizes doubling-up, and which in fact involves something of a *volte-face*, but which has its followers, is to insist that, when doubling-up occurs, the predicate is used in exactly the same way in the two cases: it is used in exactly the same way when it describes the world as the person who has projected his emotions on to it perceives it, and when it describes the original psychological condition of the person. In both cases it is used literally. This conclusion in effect commits expressive perception to anthropomorphism. For, if it is true that, when a person experiences the world as sad, he expresses it as literally sad, then he must believe that the world can think and feel like the rest of us.

Idealization of language can lead, by the steps I have indicated, to views of expressive perception which have in themselves little or nothing to recommend them. But what is most important about this linguistic turn is that it diverts attention from the phenomenon in which, I contend, expressive projection and expression ultimately find their explanation: that is, projection. If expressive projection is a form of seeing in which projective properties are experienced, then to leave projection itself unexamined is to ensure that expression is unintelligible. The fact remains that projection itself must always remain less than perspicuous.

4. Expressive perception stands to expression in much the same way as seeing-in stands to representation. Expressive perception precedes expression, both logically and historically, and, when expression arrives on the scene, what marks its arrival is that there is now imposed upon expressive perception a standard of correctness and incorrectness. This standard, like the standard set for representation, goes back to what the artist intended and achieved. When we take our stand and look at some particular stretch of

69 Caspar David
Friedrich
*The Large Enclosure, near
Dresden* 1832

countryside, there is no one correct expressive way in which to see it: even if it so happens that everyone sees it in the same way. But, when we stand and look at landscape paintings – for instance, when we look at two of the greatest, Caspar David Friedrich, *The Large* 69 *Enclosure, near Dresden* (Gemäldegalerie, Neue Meister, Staatliche Kunstsammlungen, Dresden) or John Constable's harrowing masterpiece, *Hadleigh Castle* (Yale Center for 70 British Art, Yale University, New Haven, Conn.) – there is a right and a wrong way to look at them, and in each case the right way ensures an experience that concurs with the fulfilled intentions of the artist. This in no way conflicts with the fact that neither how the picture is to be looked at nor what the artist intended can be formulated within the resources of language to any degree of precision.

And now the point, considered in the context of representation, must be repeated, that the artist's intention, in supplying the criterion of correct perception, must not be understood narrowly. It is not enough for the artist to set himself to mark the canvas with the mere aim that the spectator should see it in a certain way or as having these rather than those projective properties. Intention must be understood so as to include thoughts, beliefs, memories, and, in particular, emotions and feelings, that the artist had and that, specifically, caused him to paint as he did.

The correctness of a broad interpretation of the artist's intention undoubtedly carries more immediate conviction in connection with expression than in connection with representation. For why, it might be thought, should an artist want his audience to perceive his painting as expressive of particular feelings and emotions, unless those feelings and emotions had, through the way they caused him to paint, led the painting to be as it is?

86

70 John Constable
Hadleigh Castle 1829

However, despite its appeal, there is an objection which has been persistently urged against the view that what a work of art expresses is what causes it.[27] A standard way of formulating the objection is to say that this view implies that, if a work is to express sadness, it must have been painted by an artist in a bout of gloom, or that, for a painting to express gaiety, the artist must, in the course of making it, have been wreathed in smiles, or that, for the work to express depression, it must have been a long and painful time in the making. Such requirements would be obviously absurd, but they do not follow from the view I advocate.

What is fundamentally wrong with this objection is that it assumes that, if the relationship between emotion and the picture that expresses it is causal, then it would have to be exactly like either the relationship between an emotion and its bodily expression or the relationship between an emotion and an action which it motivates. This is an unwarranted assumption, and in fact there is room for large differences between pictorial expression and either bodily expression or action, even though all three are causal. Three differences are significant. First of all, in the case of pictorial expression, the emotion does not have to be currently experienced for it to be causally effective. The emotion can operate at a distance, and this is because the artist does not rely upon the experience to guide or shape his activity. This is in turn because — and here we have the second difference — pictorial expression is controlled, and boosted, by reflection upon, and by recollection of, the emotion. Even as the artist paints, this activity stirs such reflection and recollection. And, thirdly, pictorial expression, unlike the other two forms of outlet, is not elicited by either an internal stimulus or an external event. It is not reactive to circumstances. It occurs within a pattern established by a career or a form of life.

Colere melée de crainte

Colere melée de rage *Extreme Desespoir*

13

5. Considerable though the differences are between pictorial expression and bodily expression, there is a powerful analogy between the perception of pictorial expression and the perception of bodily expression[28] which has exercised a considerable influence over the theory, perhaps even over the practice, of pictorial expression.

Both forms of perception are examples of expressive perception, but there is additionally a significant structural resemblance between them. For in both cases the perception is answerable to two different factors: on the one hand, to the look of the picture or of the body, more specifically to how this look corresponds to certain emotions or feelings, and, on the other hand, to what has caused this look. The perception is answerable to correspondence and to cause, and it stands to be corrected or adjusted in the light of either. This dual answerability is made possible by the fact that the initial perception, when the person first sets eyes on the picture or the bodily expression and sees it as of a piece with some particular emotion, is always likely to be underdetermined. There is always likely to be in the spectator's mind uncertainty, vagueness, or ambiguity, about the corresponding emotion, and this is where appeal to the cause comes in. In both cases there is room for our causal beliefs to act as arbiter, selecting out of the various expressive ways in which the picture, or the part of the body, can be seen the way in which it is correctly seen.

However, at a certain point the parallel between the perception of pictorial expression and the perception of bodily expression comes to a halt, and the point at which it does so is further informative about the difference between pictorial and bodily expression.

The spectator of an expressive picture, in trying to fit cause to correspondence, has the satisfaction of knowing that what he is trying to do is the mirror-image of what the artist tried to do when he made the picture. For what the artist tried to do was to give the picture a look which a spectator – and here he relied on the spectator in himself – would see as of a piece with the emotion that was currently causing him to paint as he did. In other words, the artist tried to fit correspondence to cause: something, which I have suggested, the traditional posture of the artist facilitates. However, in the case of the perception of bodily expression, there is little or nothing of this. The spectator, in trying to fit cause to correspondence, cannot fortify himself with the thought that he is doing in reverse what the agent did when he initially fixed the expression on his body.

This is not to exclude from bodily expression all element of feedback. There is some, but it follows a different route. When the agent lets happiness or sadness express itself across his body, innervating the limbs, creasing the face, the only norm to which he might be expected to make the result conform is what those around him do when they express that very emotion. In trying to anticipate how others will experience the look that he

71

What the spectator sees

assumes, he assumes the look that he believes they would find themselves adopting in similar circumstances. That is the best he can do, but, in the case of pictorial expression, this would be about the worst course open to the artist. It would only enfeeble expression.

6. Finally it might be argued that, though expressive perception is prior to expression, and expression then exploits expressive perception, expression can never be fully explained in terms of expressive perception, even with the standard of correctness derived from fulfilled intention thrown in. And this is because expression, unlike representation, accrues to a painting along two independent routes: there are two ways in which the artist can make his work expressive. One, which is the one we have been considering, starts from the state of mind of the artist, proceeds via the look of the painting, which is conceded to be the result of convergent forces, and terminates on how the painting is to be expressively perceived. But the other route, which seems like a less strictly visual route, starts from the same point of departure, passes through the gestural activity of the artist, and terminates on the physical traces of this activity as they accumulate on the pictorial surface: these traces serve as the raw material from which the spectator may reconstruct in his imagination the artist's intention in so far as it was realized in the picture.[29]

I do not want to deny that, at any rate for a sizeable stretch of painting, the hand also makes its contribution to the painting's expressive meaning. But I do not think that it does so — or does so in anything except a peripheral fashion — by leaving a deposit from which the mission of the hand, and so by extension the state of mind that sent the hand on its mission, can be reconstructed. In so far as the hand is the agent of expression, it is the hand in the service of the eye.[30] In the case of the painter who is an artist the expressive gesture of the hand comes to adapt itself to the look of the mark it will deposit, and the look of the mark to the expressive way in which the eye will perceive it. Of course, none of this self-monitoring is deliberate or conscious, and the true history of how the hand enters into the service of the eye, and how, once enlisted, it can, in the case of the great artists, obtain legendary promotion is something that I made reference to in the last lecture: it is incorporated into the story of how an artist forms his style. It is because it attempts to probe those hidden depths — to do so, it must be said, with a modesty that is partly its own undoing — that the most traditional mode of art-history remains to my mind the most profound: connoisseurship,[31] the study inaugurated by Jonathan Richardson, advanced by Giovanni Morelli, and temporarily discredited by Bernard Berenson, who made it serve profit and the self-aggrandizement of the rich.

D. 1. If both representational seeing and expressive perception are, within pictorial art, required to conform to a standard of correctness, and this standard of correctness goes back to the intentions of the artist in so far as they are fulfilled, then it appears to follow that a spectator will not be able to see a painting properly unless he independently gets hold of a mass of evidence about how it came to be made.

Put in precisely this form, the conclusion doesn't follow. The word 'independently' is out of place. And that is because of an important truth, which is easily lost sight of: that often careful, sensitive, and generally informed, scrutiny of the painting will extract from it the very information that is needed to understand it. It is a kind of bootstrap operation. But the general point remains: a spectator needs a lot of information about how the painting he confronts came to be made. He needs a substantial cognitive stock.

But, once we allow information in, is there any principled way in which we can decide that some information is legitimate, and some illegitimate?[32] The first point to make is that we cannot do so by referring solely to the source of the information: for instance, by

72 Sassetta
*St Francis giving his
Cloak to a Poor Knight*
c. 1437–44, panel

saying that it must be information that we could have – not, of course, that we did, but that we could have – gleaned from the picture itself just by looking at it. For the question immediately arises, By looking at it in conjunction with what other information? To this question we have two possible responses. Either we can say, In conjunction with information that could itself have been derived from the picture just by looking at it, or we can allow ourselves a sudden and unexplained relaxation of standards and can say, In conjunction with any available information. If we go for the latter response, why wait until this moment to do so? If however we go for the former, the question immediately re-arises, Just by looking at the picture in conjunction with what other information? Along this route no information ever gets the clearance that we demand for it.

Another way of trying to curtail what can legitimately go into the spectator's cognitive stock is to do so by reference, not to the source, but to the content, of the information. Only information that refers to aesthetic features of the painting or that is aesthetically relevant may be utilized. But the difficulty with this proposal is that there is no way of identifying what information is aesthetically relevant except as that which allows us to discern the meaning or content of the picture. And this is no idle point. For information that might on general grounds seem aesthetically irrelevant can suddenly, in a particular case, prove crucial to understanding the work. As an example of such information, consider the market-price of the artist's materials: surely, we might think, information of no aesthetic relevance. Yet some years ago Michael Baxandall showed otherwise in considering part of the Sassetta St Francis cycle.[33] If we take, say, the *St*

What the spectator sees

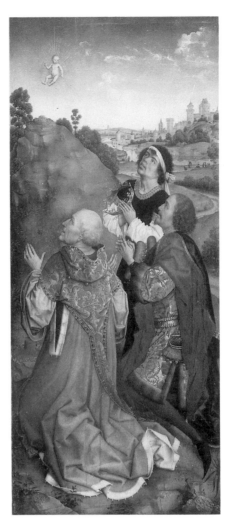

73 Rogier van der
Weyden
Vision of the Magi (right
wing of the *Altarpiece of
Pierre Blaedelin*) mid 15th
century, panel

72 *Francis giving his Cloak to a Poor Knight* (National Gallery, London), it is to be noted that
for the saint's cloak the painter has used lapis lazuli, which is the costliest of pigments.
This fact about the painting would have registered with a spectator of the period, and
there can be little doubt but that Sassetta presupposed acquaintance with it. For, used as
background information, it moulds our perception of the picture. It enhances the
liberality, it ensures the grandeur, of the saint's gesture. Therefore, despite its *prima facie*
irrelevance, it is information that we need.

Indeed there seems to be only one limitation that should be placed upon what
information can be drafted into the spectator's cognitive stock. It relates, not to the source
from which the information derives, nor to its content, but to the use to which it is put.
The information must be such that by drawing upon it a spectator is enabled to
experience some part of the content of the picture which otherwise he would have been
likely to overlook.

This point is best illustrated from, though its application is certainly not confined to,
pictures that give rise to rival perceptions dependent upon what cognitive stock we
employ. A case in point, which I owe to Erwin Panofsky,[34] is Rogier van der Weyden's
73 Blaedelin altarpiece (Preussischer Kulturbesitz, Berlin-Dahlem). For someone ignorant of
the conventions that governed the representation of religious apparitions might gravely
misperceive the right wing of the triptych. Noticing the little child-figure in the sky, he
might see the infant Christ, who in fact is directing the royal procession on its way to
Bethlehem, as serving as a claypigeon for the Magi.

What the spectator sees 91

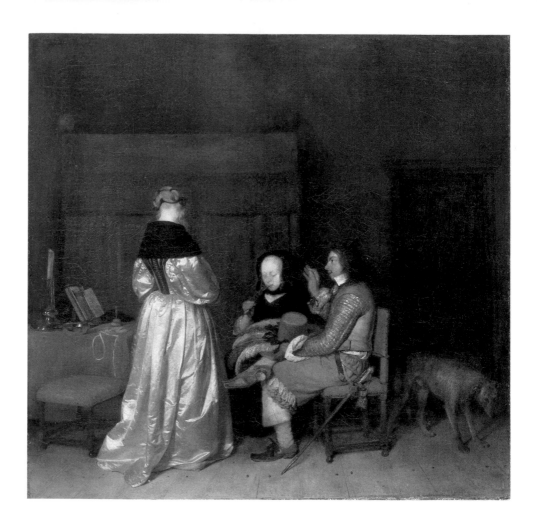

An actual or historical example of such a misperception, which in turn was general at the time, is incorporated into Goethe's strange and disturbing novel, *Elective Affinities*.[35] The novel narrates how the sprightly domineering Luciane, arriving with a whole house-party of friends at her mother's castle, in her determination to ward off boredom organizes the company into mounting *tableaux vivants*, which are to be modelled on famous paintings, or rather on reproductive prints after the paintings. One of the pictures chosen is a painting by Gerard Terborch, known then and sometimes now as *L'Instruction* 74 *Paternelle* (Preussischer Kulturbesitz, Berlin-Dahlem; and Rijksmuseum, Amsterdam). Luciane plays – these are Goethe's descriptions – 'the gentle daughter', who is 'suffused with delicate shame' as her father, a 'noble knightly' figure, admonishes her for some minor transgression, while her mother looks down into her glass to conceal her embarrassment. In playing this becoming part, Luciane is at her best. She wins universal applause for her touching portrayal of the young girl, a wag shouts out *'Tournez s'il vous plaît'*, which is a play of words on the instructions at the bottom of the page of a letter, 'P.T.O.', and the company is blissfully unaware, as was Goethe himself, that the picture which is being brought to life for their pleasure represents a young aspirant whore coolly bidding up the price for her favours, while the beady-eyed madame of the brothel looks on with simulated indifference.

The Sassetta, the van der Weyden, and the Terborch are all cases where we need to know something in order to see in the picture something else, and my claim is that, so long as the something else is actually there to be seen in the picture – that is to say, provided that it concurs with the artist's fulfilled intention – the use of the information is

legitimate, no matter how we come by it. Sometimes however the information that we need is not just information that will, in conjunction with what we already know, enable us to see what is to be seen in the picture, but is information that details or makes explicit what is to be seen in the picture. The knowledge that we require in such cases has to function not so much as cognitive stock but as perceptual cash.

The claim that such information is ever requisite provokes widespread resistance. The objection is that if, without being told what is there to be seen, we cannot see it, then, when we are told what is there to be seen, we equally shall not see it. The information will not alter what we see: the most it will do is to alter what we say. The situation where this objection is most widely employed is in the case of attributions. How often have we heard it said that, if someone needs to be told that a picture is by Rembrandt before he can see it as a Rembrandt, then, if he is told that it is by Rembrandt, and he now says that he sees it as a Rembrandt, we have every reason to distrust him. Feeding spectators with information of this sort, it is said, ministers only to snobbery.[36]

The materials for an effective answer to this objection lie within the early experience of most of us. I am thinking of those childhood puzzles which are made up of line drawings in which, or so we were told, rabbits and fish and fishermen lie concealed. But, turn them this way, turn them that way, we managed to see nothing, until someone pointed out to us the rabbit delineated in the bole of the tree, or the fish standing on its tail amongst the bulrushes. Then miraculously we could see it all, just as we were told. We didn't simply

75, 76

75 *Children's Puzzle*

76 *Children's Puzzle: Key*

93

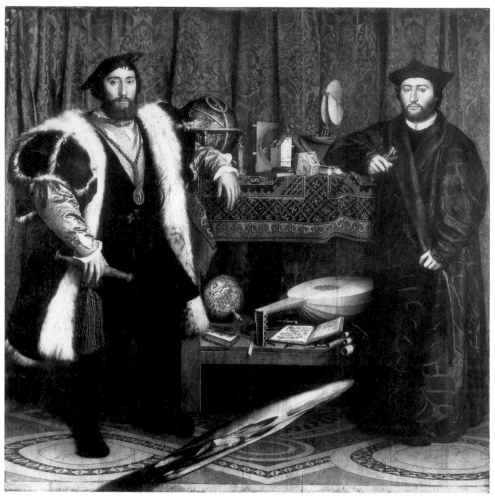

77, 78 Hans Holbein the Younger *The Ambassadors* 1533, panel. Below, detail

say that these things were there, now they were securely in our field of vision. A more sophisticated example of the same phenomenon is provided by Holbein, *The Ambassadors* (National Gallery, London). I suspect that no one, standing at the proper viewing-point, will be able, innocently, to see anything in the smear that runs diagonally under the table. But once again the moving finger comes to the rescue, and, shown how the smear anamorphically, or in a perspectively highly distorted fashion, represents a skull, most people will see a skull in the smear. They will see it, they won't just say that there is one there.

All the cases so far considered are cases where the information required allows us to grasp the representational meaning of the picture, whether it does so by functioning as cognitive stock or as what I have called perceptual cash. But the same situation can arise for expressive meaning. I wish to introduce two examples where, with the growth of information, the expressive meaning of a work becomes fully perceptible. They are both by Claude Monet, and they date from the winter of 1879–80. One is *The Seine in Thaw* (University of Michigan Museum of Art, Ann Arbor, Michigan), and the other, *Still Life with Spanish Melon* (Kimbell Art Museum, Fort Worth, Texas), showing overripe fruit. The relevant information is that these pictures were executed in the first few months after Monet's wife, with whom he was less than happy, had died in great pain: an event which Monet had already linked with painting when he painted her on her deathbed. Once we have this information, then, I believe, we are likely to start perceiving these pictures as of a piece with the emotions that filled Monet's life at this period. We shall see these pictures as expressing sorrow, and regret, and the slow recovery from sorrow sustained by the abandonment of old regrets.[37] We shall see them as works of mourning, which is what I take them to be.

The point that cannot be too strongly emphasized is that, whether it bears upon representational meaning or expressive meaning, whether it is to serve as cognitive stock or as perceptual cash, any information of which the spectator has need must be information that affects what he sees when he looks at the picture: because it is only through what can be seen when the picture is looked at that the picture carries meaning. What is invariably irrelevant is some rule or convention that takes us from what is perceptible to some hidden meaning: in the way in which, say, a rule of language would. This is why when, in the case of the Rogier van der Weyden, I insisted that the contemporary convention about the representation of apparitions was indispensable information, I did so, not on the grounds that it allows us to infer from the presence of the child in the sky to the Infant Jesus, but because (and this is something quite different), if we use the convention as cognitive stock, we are then enabled to see the Infant Jesus in a certain part of the marked surface.

2. There is one piece of information whose claim to belong to the spectator's cognitive stock deserves separate consideration. It does so because the opinion we reach will determine the place of pictorial art within the general theory of symbolism.

But, first, I must go back. In discussing the artist's intention, I have contended (section B.3) that, if we are to think of it as the determinant, or partial determinant, of what the painting means, intention cannot be equated with the volition to mark the surface in such a way that a spectator could not fail to appreciate what experience he is supposed to have. No: the artist must be concerned that the spectator should have this experience, and have it because of the way that he, the artist, marks the surface. Indeed, I have held that some part of the rationale of the traditional posture of the artist, on which I have laid such weight, derives from this fact. The posture is adopted so that the artist can in his own person anticipate the experience that he expects the spectator to have in front of the painting on which he is currently working.

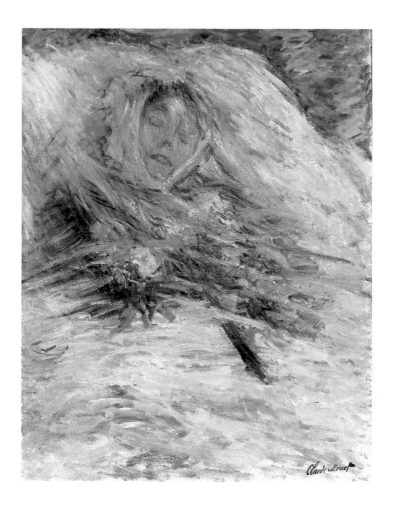

79 Claude Monet
*Camille Monet on her
Deathbed* 1879

However, if the artist is concerned with how the spectator will view the picture, care needs to be given to the form of this thought. The thought is not categorical, it is hypothetical. It is of the form, 'If there is a spectator, let him have such-and-such an experience', rather than of the form, 'Let the spectator have such-and-such an experience'. In other words, the thought does not presuppose the existence of a spectator, nor does it necessarily carry with it the desire that there should be a spectator. For this reason it is wrong to think of painting, or at least the art of painting, as inherently a form of communication.[38] A particular painting may be a communication, but no painting has to be. Necessarily communication either is addressed to an identifiable audience, as when a speaker answers a question put to him by another or when an orator harangues an audience, or is undertaken in the hope that an audience will materialize, as when a shipwrecked sailor raises a signal of distress.

Given, then, that an artist's intention must include such a thought, which is hypothetical in form, the question arises whether this thought can be, or must be, part of the spectator's cognitive stock when he looks at the artist's painting. The right answer is, I believe, that it can be, but that it does not have to be.

It can be: for, as we have seen, there is no upper limit set to the amount of information upon which the spectator may licitly draw in ensuring for himself the experience appropriate to the picture he is looking at. But it does not have to be: for, if the spectator has, in front of the picture and caused by it, the experience that the artist intended him to have, this is enough. There is no reason why recognition of the artist's intention should have to play a part in this causal story. The spectator's experience must concur with the artist's intention, but it does not have to do so through knowledge of it.[39]

What the spectator sees

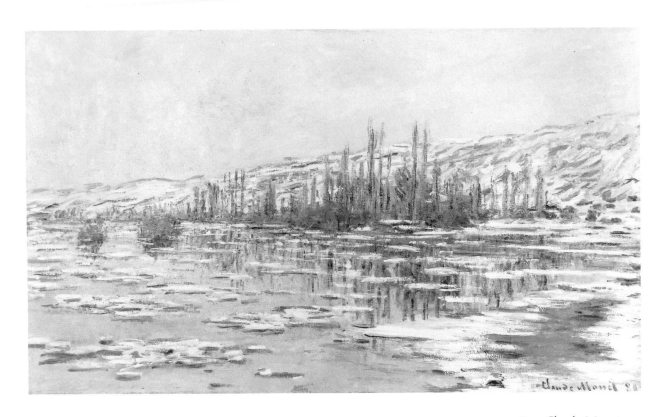

80 Claude Monet
The Seine in Thaw 1880

81 Claude Monet
*Still Life with Spanish
Melon* 1880

E. 1. Finally, I turn to visual delight. I have little to say on this subject. Nevertheless I am
convinced that it is an important subject on which to have something to say if only for
this reason: that a large part of the *cultural* (I stress this word) value of painting practised
as an art, as of any other art, is that it transforms our capacity to experience pleasure. It
transforms it: it does not mutilate it, or etherealize it. It retains, in other words, its
sensuous, its sensual, character.

I shall ignore the strictly philosophical question, What is visual delight? What is the
nature of pleasure as we take it in painting? Instead I shall concentrate on the question
more germane to the understanding of painting, What is the source of visual delight?
What aspect of painting gives us the pleasure that we characteristically derive from it?

2. Thinking about the sources of visual delight we might initially think of them as
heterogeneous, or as lying on a spectrum that runs from the case where we enjoy the
representation of that which we enjoy in real life to the case where we enjoy the
brushwork used to represent something of which we don't even have to know what it is.
But is this the best we can do?

Proust, in his revelatory essay on Chardin,[40] makes a suggestion which goes some way
towards undermining the view that painting provides a simple pleasure in subject-matter.
Proust writes:

> If, looking at a Chardin, you can say to yourself: This is intimate, this is congenial, this
> is full of life like a kitchen, then you will be able to say to yourself, walking round a
> kitchen: This is strange, this is grand, this is beautiful like a Chardin.

In this passage Proust asserts that the transfer of pleasure must, in a lover of painting, go

What the spectator sees

both ways. It cannot simply go from domesticity to Chardin, it must also go from Chardin to domesticity.

It cannot simply go from domesticity to Chardin – though (Proust insists) it must *start* from domesticity. 'You have already experienced it unconsciously', he writes:

> this pleasure one gets from the sight of everyday scenes and inanimate objects, otherwise it would not have risen in your heart when Chardin summoned it up in his marvellous commanding tones.

But pleasure must also return from Chardin to domesticity, and, in doing so (and this is central to Proust's essay), pleasure now seeks something with which it was not originally concerned: not because originally this thing was overlooked, but because originally it was not within our grasp. Pleasure now seeks a Chardin-like quality in domesticity, or a quality which can be discerned only by having looked at Chardin: more generally, a quality which can be discerned only by having looked at representation. Proust makes clear, without making explicit, that this quality is to do with expressive perception. It is to do with projection controlled by a great artist. We now have access to the 'unnoticed life of inanimate objects': unnoticed, but not contingently unnoticed. Since Chardin's art is 'the expression of what was closest to him in his life', it is (Proust contends) 'our life that it makes contact with'.

If Proust is right, and if the pleasure connected with subject-matter is not simple, but depends upon a contrast, upon a fluctuation of interest, between painting and reality, so also, I believe, the pleasure connected with *matière*, with the stuff, rests upon contrast. But this time the contrast occurs within the picture. It occurs between nearer and more distant views of the paint surface.

What the spectator sees

Important loci in the tradition of art criticism are those passages where the critic's admiration for the representational skill of the artist he is considering takes the form of pointing out how what at one moment seems an image at the next moment dissolves into a paint surface without meaning. I am thinking of Vasari on Titian, Reynolds on Gainsborough, Zola on Manet's *Olympia*.[41] These passages are often taken as a denial of the possibility of twofoldness: they are recruited in the interest of a theory of Illusion, as, for instance, by Ernst Gombrich. They do not have to serve in so misguided a cause. For they can be taken as tributes to the power these pictures have to evoke visual delight – as well as offering a hypothesis about where the visual delight in *matière* is generated. It lies in the perception of what is apprehended as detail: detail relative to a more comprehensive, a more distanced, view of the marked surface.

What comes out of these fragmentary remarks on pleasure is that, like so much else connected with painting, pleasure rests on matching, on bringing together, on deriving something out of juxtaposing, two experiences or two aspects of a single experience. But I cannot help feeling that it is no coincidence that two of the finest, the most percipient, accounts that we have of pleasure in painting – Proust's slender essay on Chardin, which I have been referring to, and Ruskin's monumental study of his formation as an aesthete, *Praeterita* – both end on an unfinished sentence.

3. At an earlier point in this lecture I suggested that Lessing in identifying painting as the art of the visible took too narrow a view of the visible. There are a number of ways of amplifying this point, but one is in the context of pleasure. For it is a demonstrable fact about the pleasure that painting is capable of giving that it draws upon synaesthetic associations to what we see: that is, the way in which the motifs and images of painting can stir remembered sensations of smell, taste, and hearing. Much of Venetian painting depends on remembered sound, much of Courbet depends on remembered silence.[42] Lessing's error might be neatly expressed by saying that for him visible meant visible by the disembodied eye. The spectator that the artist presumes is an embodied eye: a fact that he himself makes clear when, the original spectator, the model for all later spectators to come, he adopts the traditional posture, standing in front of the support on the side of it that he marks, with his eyes open and fixed upon it.

What the spectator sees

III

The spectator in the picture:

FRIEDRICH, MANET, HALS

A. 1. Representation, I have claimed, depends upon a highly specific visual capacity that we humans have and which there is reason to believe is innate. I call this capacity 'seeing-in', and what is unique to seeing-in is the kind of visual experience in which it manifests itself. For when (say) I see a face in a picture, the experience that I have has two aspects, which are distinct but inseparable. On the one hand, I recognize a face: on the other hand, I am visually aware of the surface of the picture. I call this all-important characteristic of the experience 'twofoldness'.

I say 'when I see a face in a picture' by way of example. But a picture of a face is, of course, a representation, and my claim has been that seeing-in is prior to representation: prior to it, both logically and historically. Logically, in that I can see objects in things that neither are nor are believed by me to be representations — such as clouds, or damp stains on walls, or the silhouettes of cast shadows: and historically, in that I am sure our remotest ancestors could do this before they thought of adorning their caves with the images of animals they hunted.

Representation comes into being when someone — an artist, for short — marks a surface intending that a spectator should see something in it: say, a face. The difference that representation makes to the natural capacity of seeing-in is that it imposes on it a standard of correctness and incorrectness. For, if the artist succeeds in his intention so that a face can be seen in the surface, then the spectator sees the surface correctly if he sees a face in it: otherwise he sees it incorrectly.

What a particular picture represents can now be defined in terms of seeing-in plus a standard of correctness, where this standard invokes the intentions of the artist in so far as they are fulfilled. Holbein's famous portrait which has come down to us in many variants is a portrait of Henry VIII because two conditions are satisfied: Henry VIII can be seen in it, and, even though others may also be visible in it — Charles Laughton to old film buffs — seeing Henry VIII is the visual experience that Holbein was interested in our having. In other words, Henry VIII can be correctly seen in it: hence it represents Henry VIII.

And let me remind you of a final point on representation and seeing-in. The cases that I have cited are cases of seeing a figure in a surface or of figurative representation. But figuration is not a requirement either of seeing-in or of representation. I can see a mere shape in a surface, and most abstract paintings are representational.

2. In this lecture my claim is that there are certain paintings that have a representational content in excess of what they represent. There is something which cannot be seen in the painting: so the painting doesn't represent that thing. But the thing is given to us along with what the painting represents: so it is part of the painting's representational content.

An analogy may familiarize the idea. Every visual experience is of something: there is something that the person who has the experience, or the subject, sees through having it.

But additionally there is the subject himself: the visual experience is not of him, but he is surely an integral part of the experience. For instance, the visual experience that I have while uttering these words in front of an audience permits me to see the audience. It does not permit me to see myself. So it is not of me as well as of the audience. But, since I am given along with what the experience is of, I am part of the content of the experience.

This analogy, if it serves to familiarize the distinction between what a painting represents and (a broader notion) its representational content, has the further advantage of suggesting what that part of a painting's representational content which is in excess of what it represents might be. For what stands to a representational painting as the unperceived subject stands to a visual experience? It is, of course, an unrepresented spectator, and the claim of this lecture is that there are certain paintings that contain an unrepresented spectator.

This however is only a rough way of stating the claim, and refinements will have to follow.

The first refinement is this: In talking of a spectator that the painting contains, we need to distinguish between two kinds of spectator. There is the *spectator of the picture*, and there is the *spectator in the picture*: the external spectator and the internal spectator. The two differ in where they stand and in what they see. The external spectator is located in the actual space that the painting itself occupies in the room or gallery where it hangs: he is to be found in the National Gallery of Art, or the Louvre, or the church of San Salvatore in Venice. The internal spectator is located in the virtual space that the painting represents: he is to be found in nineteenth-century Paris, or in Tudor England, or in mythological Thessaly. The external spectator can be, and normally is, aware of the marked surface: he will move within the actual space to ensure that this is so. For the internal spectator the marked surface does not exist: it is not visible from the virtual space.

My claim does not concern the spectator of the picture. He cannot be what a picture contains, if only for the reason that, were he so, then every picture with a spectator internal to it would vary in content with the person looking at it, he being, for the time that he looked at it, part of its content. That my claim has nothing to do with the external spectator is a point that it is necessary to make just because there is a long-standing tradition of making claims that are very similar to, or variants upon, mine, but made on behalf of the external spectator. I doubt if such claims are ultimately even coherent: a point to which I shall return at the end of this lecture (section E.3).

My claim then is that some paintings contain an internal, an unrepresented internal, spectator. That a representational painting contains a represented internal spectator would be no great claim, for any painting automatically does so if it represents a person and that person is neither sensorily deficient nor unconscious. However not any unrepresented internal spectator will satisfy the claim that I am urging. A spectator who stands in the represented space but cannot be seen because he is off in the wings, or because he is hidden by an obstacle that is itself represented will not do: such a spectator, whom I call a wayward spectator, is not to be thought of as a spectator in the picture. What the issue turns on is how much of the represented scene he can see and in what perspective: what matters is how his visual field relates to the picture's representational scope, or (the same thing) how his standpoint relates to the picture's point of origin. I shall start by imposing upon the spectator in the picture the toughest requirement in this regard: that is, that he must be so located in the represented space that he can see everything that the picture represents and he can see it as the picture represents it. He sees face-to-face just what the spectator of the picture sees in its surface. He is, I shall say, a total spectator. Later this constraint will seem in need of modification, but I do not intend to suggest how this should be done until the point of the constraint, or indeed of any constraint laid upon the spectator in the picture, has emerged. It will do so shortly. I

anticipate this discussion only to say that any constraint upon the spectator in the picture is justified solely to the extent that it makes him better able to fulfil his function: it must make it easier for him to do for the spectator of the picture what is expected of him.

And now I must repeat that my claim is that *some* paintings contain a spectator in the picture. Some do: some don't. More precisely, some do, most don't. The topic of this lecture is then a special category within representational painting. It is a category that has long been thought to exist, though there has been no agreement – indeed there has been massive disagreement – about which paintings fall into it, and why. My aim is to clarify the category, and to do so through discussing certain paintings that belong to it.[1]

3. But by now the analogy between paintings that contain an internal spectator and visual experiences which contain a subject is beginning to wear thin. And that is because, as I have just reaffirmed, whereas all visual experiences contain a subject, only some pictures contain an internal spectator. So I propose to substitute a new analogy, which will turn out to be more than an analogy, but, before I can do so, I must again distinguish. This time the distinction is within – for the analogy is with – visual imagination, and the distinction is one that we should be able to recognize readily from our own experience.[2]

When I visually imagine, or visualize, an event, there are two modes of doing so. I can imagine the event from no one's standpoint: it unfolds frieze-like, across a divide. Or I can imagine it from the standpoint of one of the participants in the event, whom I then imagine from the inside. This latter mode I call *centrally imagining*, and, when I centrally imagine an event, the person whom I imagine from the inside I shall call the *protagonist*, and I shall say that I imagine the other participants *peripherally*. The former mode, when there is no one whom I imagine from the inside, I call *acentrally imagining*.

So, for instance, on the occasions when I anticipated this lecture by visualizing it, sometimes (I suppose) I may have visualized it from no one's standpoint. I simply imagined its happening, or I imagined it acentrally. But, surely, all but invariably I visualized it from a standpoint: from, in fact, my standpoint. I imagined from the inside my giving it. I centrally imagined the lecture, and I was the protagonist in my imaginings.

There is a feature of imagination which may obfuscate the distinction to which I am drawing attention. When I visualize an event, there will be mental imagery that acts as the vehicle of imagination. Now inevitably this imagery will, in presenting what I imagine, display it as from a certain point of view, or at least as from a certain direction. That is what visual imagery is like: it is inherently perspectival. But it does not follow that the point of view from which the event is visualized, or the perspective in which it is presented, is itself imagined as occupied. And it is only if it is imagined as occupied that, in imagining the event, I imagine from the inside someone seeing it, hence that I centrally imagine that event. If I don't imagine the point of view as occupied, then, no matter that my mental imagery is perspectival, the event that it presents is imagined acentrally. What this consideration brings out is that, here as elsewhere, mental imagery, taken in isolation, abscinded from the thoughts and intentions that motivate it, is no sure guide to the mental processes of which it is the vehicle. My mental imagery is no sure guide to what I imagine.[3]

And now for a further possible error – an error we could put down to lack of imagination: and that would be to think that, when I centrally imagine an event, the person whom I imagine from the inside must be me, or that I must be the protagonist in my imaginings. On the contrary, in visualizing this lecture, I could have imagined from the inside not me giving it but one of my friends listening to it, taking it in, turning it over in his mind. Ranging further afield, I could imagine from the inside Napoleon surveying the smoking field of Austerlitz, or I could imagine from the inside Julius Caesar mounting

the Capitol on the Ides of March, or I could imagine someone watching Julius Caesar mount the Capitol that fatal day. Julius Caesar, Napoleon, the anonymous spectator, could be my protagonists. The truth is that anyone can be my protagonist provided only that I know enough about that person to keep him, her, constant in my thoughts. Indeed not only does the protagonist not have to be me, it doesn't have to be a particular person at all. It can be merely a person of some particular kind, the kind being more or less specific. So, in centrally imagining someone watching the assassination of Julius Caesar, I could take as my protagonist a Roman citizen with strong republican feelings; a Roman citizen; a man of the period; a man; or it could be just someone or other, it could be (as we say) any old person. I can identify with any one of these protagonists

This leads up to the new analogy I propose. The analogy, which will turn out to be more than an analogy, is one between pictures that contain a spectator and centrally imagining. The appeal of this analogy lies in what we stand to learn about the spectator in the picture from comparing him with, indeed from comparing him to, the protagonist in imagination.

4. When I endow my imaginings with a protagonist, what I do may conveniently be thought of as falling into two stages.[4] Stage one is to select a protagonist. Stage two is to attribute to the protagonist I select a repertoire: by which I mean a body of dispositions that will generate and constrain the outer life (lines, actions) and the inner life (perceptions, thoughts, memories, feelings) that I then go on to imagine, to imagine from the inside, this person having or leading.

The artist who endows his painting with a spectator in the picture — and this is, of course, the only way a painting can acquire one — may be thought of as also working in these same two stages.

First, then, the artist determines the identity of the spectator in the picture. In doing so he has the same options open to him as I have when I engage in centrally imagining. He can choose between a spectator who is a particular person and a spectator who is merely a person of a particular kind, the kind itself varying in specificity. The spectator in the picture, who is unrepresented, turns out to be subject to precisely the same classification as in the last lecture we saw holds for individuals whom the picture represents.

(In actuality, the choices of the imaginer and the artist are likely to go in divergent directions. The imaginer is likeliest to select as protagonist a particular person: more specifically, himself. The artist is likeliest to select as spectator in the picture someone who is merely a person of a particular kind and the least specific kind at that: that is, any old person. But it is crucial to recognize that, in both cases, other possibilities are open and in certain circumstances will be actualized.)

Secondly, the artist, having fixed the identity of the spectator in the picture, will go on to assign him a repertoire. He will assign him dispositions that will generate and constrain his outer life and his inner life.

However the two cases, imagination and painting, differ greatly in the reasons why, in the one case the protagonist, in the other case the spectator in the picture, is assigned a repertoire. In both cases it turns out that what is really significant is that part of the repertoire which controls the inner life.

First, then, centrally imagining, and the need of the protagonist for a repertoire. If the protagonist does not have an outer life made available to him, then he will be no more than a mere passive spectator of the imagined events. But, if he does not have the materials for an inner life, there will be no imagined events. Nothing will be imagined. In centrally imagining, the inner life of the protagonist may be thought of as the window through which each and every person and thing must clamber if it is to make an appearance in the imagined sequence: rather as, in a first-person novel, every character,

The spectator in the picture

I Edouard Manet *Madame Brunet* 1860

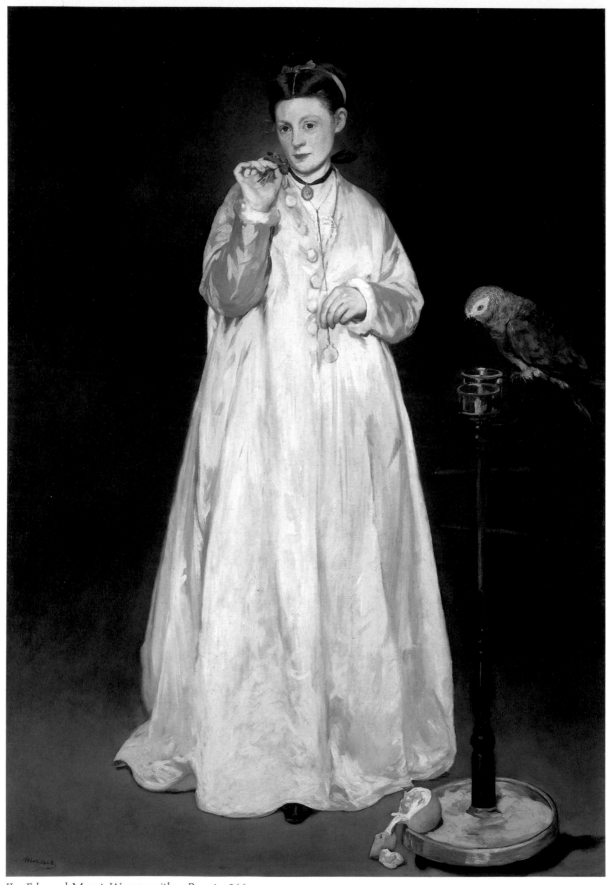

II Edouard Manet *Woman with a Parrot* 1866

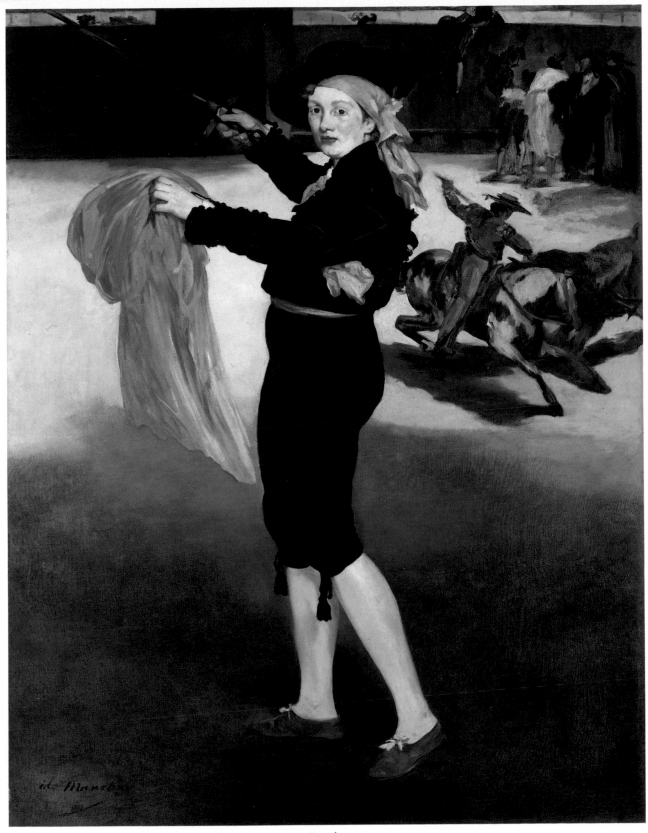

III Edouard Manet *Mademoiselle V. in the Costume of an Espada* 1862

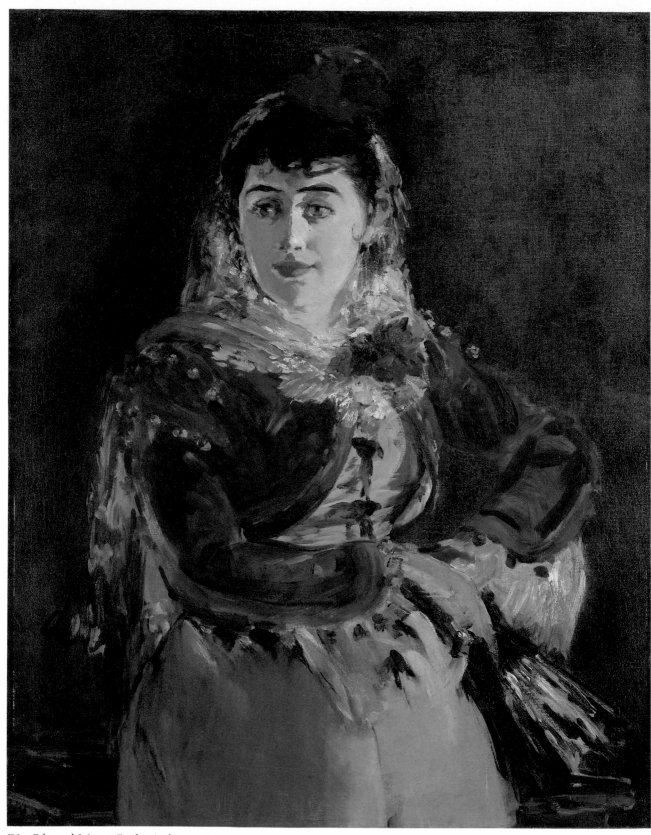

IV Edouard Manet *Emilie Ambre as Carmen* 1880

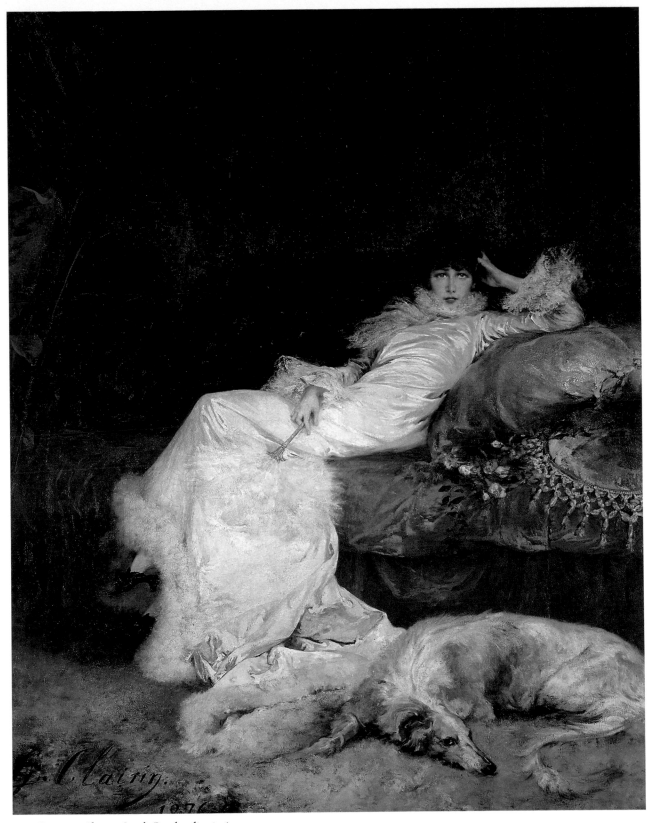

V Georges Clairin *Sarah Bernhardt* 1876

VI Frans Hals *The Company of St George 1616 (The St Jorisdoelen) 1616*

VII Giulio Romano *The Fall of the Giants* 1532–4

OPPOSITE

VIII Nicolas Poussin *Rinaldo and Armida* 1629

IX Nicolas Poussin *Cephalus and Aurora* 1631–3

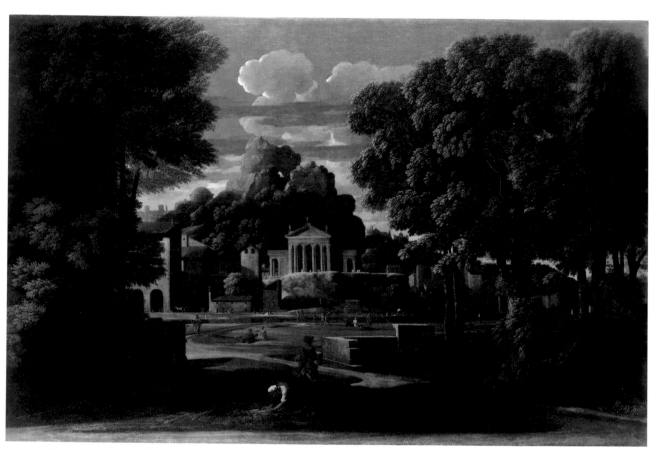

X Nicolas Poussin *The Ashes of Phocion collected by his Widow* 1648

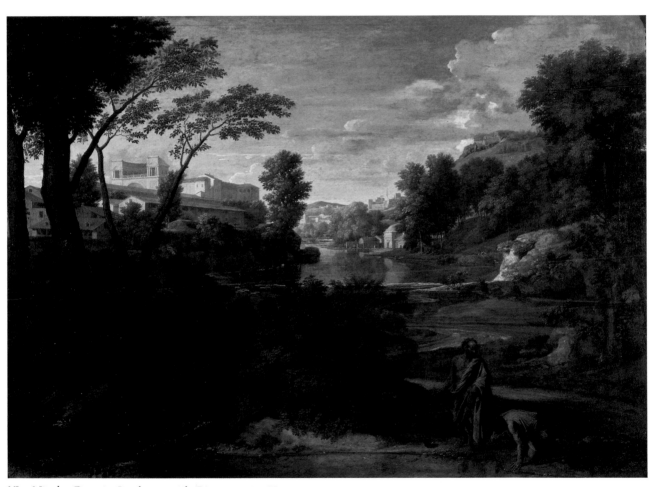

XI Nicolas Poussin *Landscape with Diogenes* 1658(?)

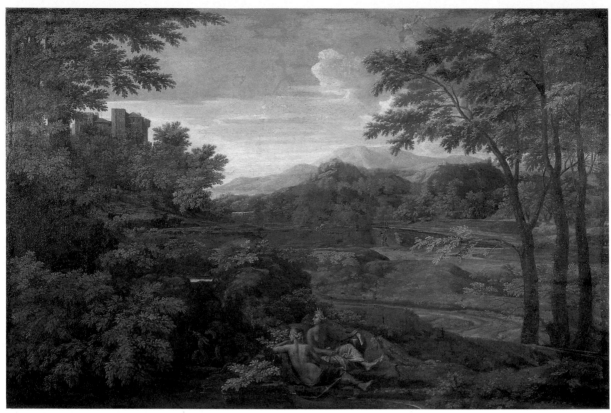

XII Nicolas Poussin *Landscape with two Nymphs and a Snake* 1659

XIII Nicolas Poussin *Winter, or The Flood* 1660s

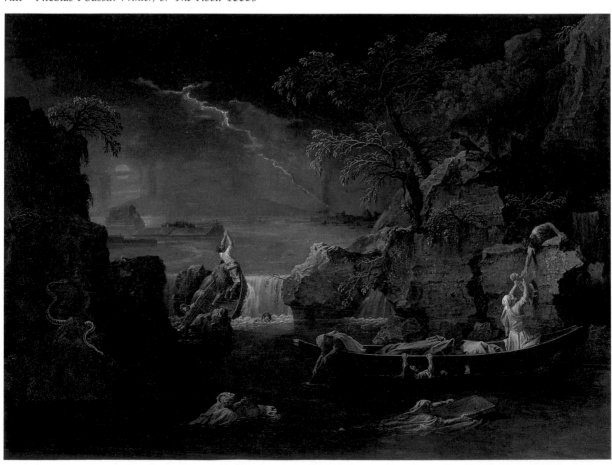

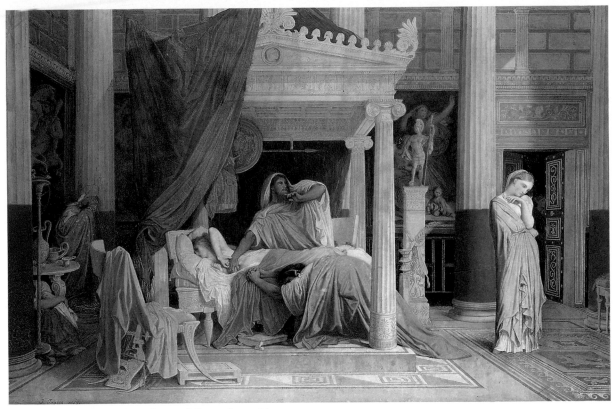

XIV J.-A.-D. Ingres *Antiochus and Stratonice* 1866

XV J.-A.-D. Ingres *Death of Leonardo* 1818

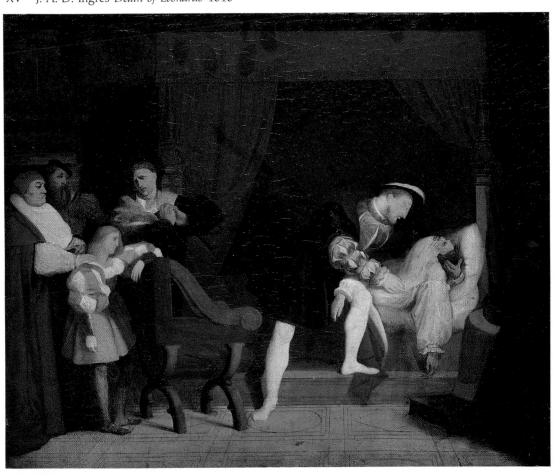

XVI J.-A.-D. Ingres *Joseph Ingres* 1804

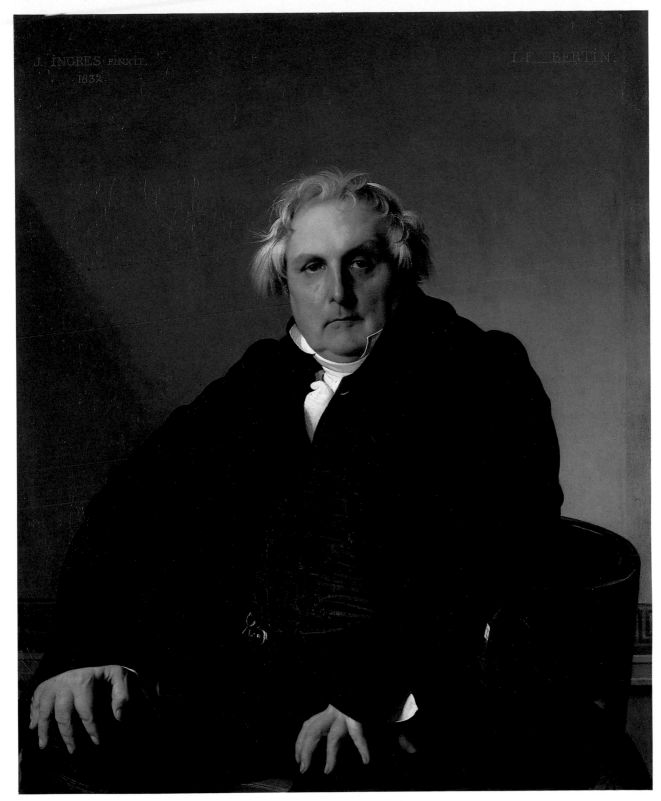

XVII J.-A.-D. Ingres *Louis-François Bertin* 1833

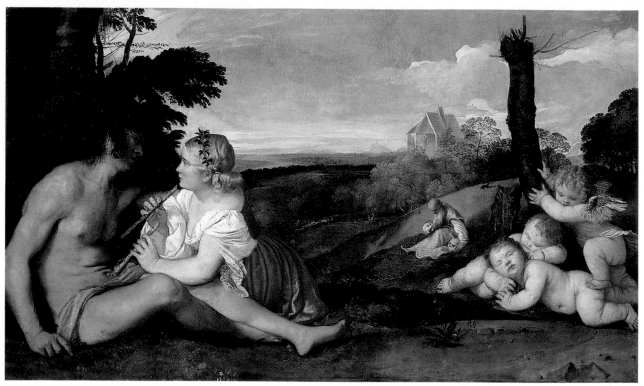

XVIII Titian *The Three Ages of Man* 1513–14

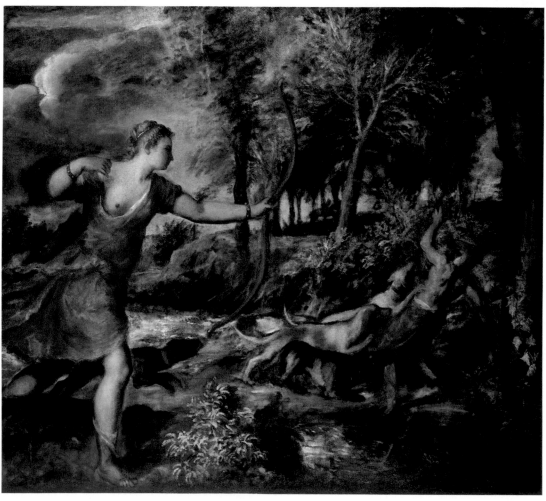

XIX Titian *The Death of Actaeon* begun around 1560

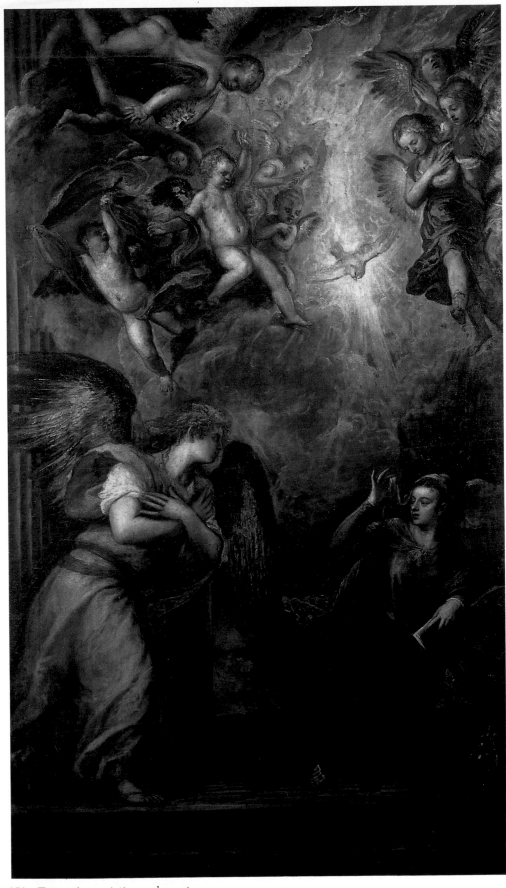

XX Titian *Annunciation* early 1560s

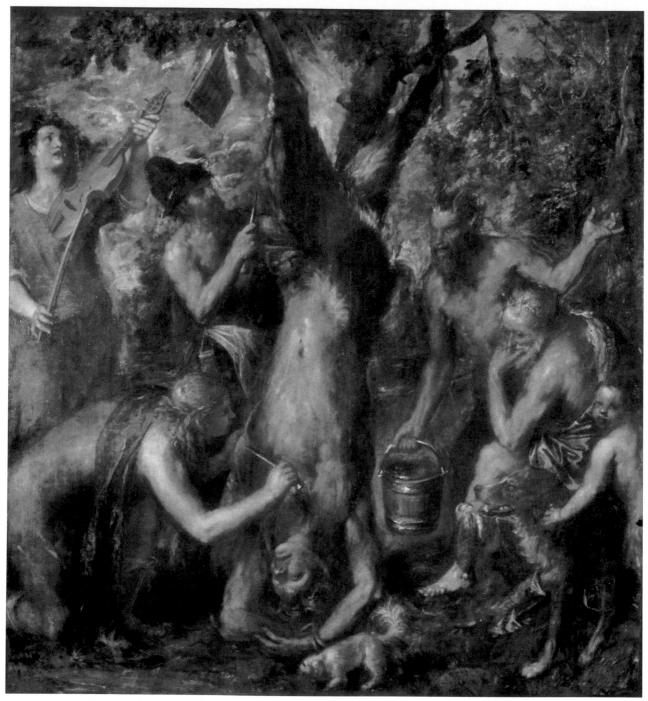

XXI Titian *The Flaying of Marsyas* 1570s

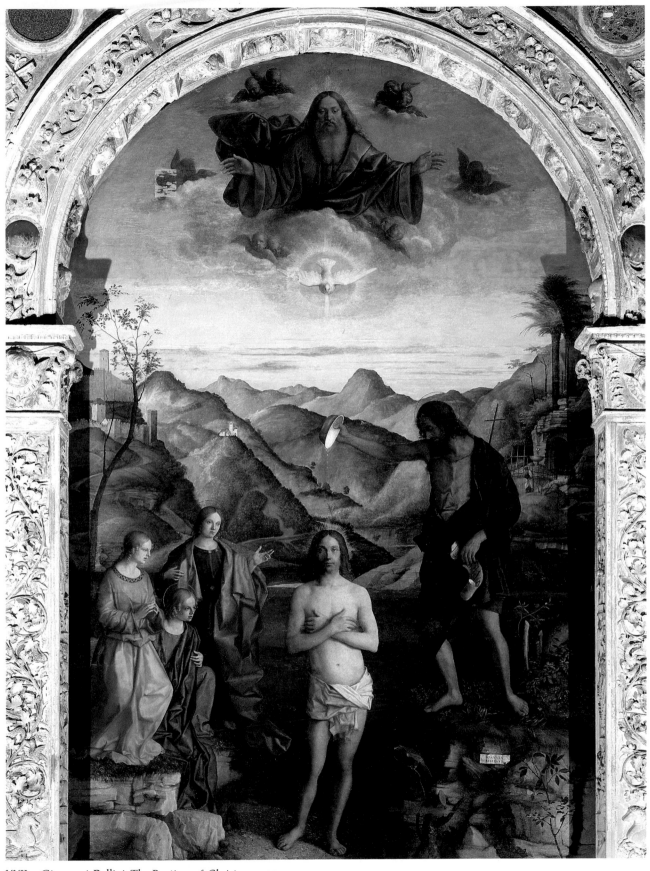

XXII Giovanni Bellini *The Baptism of Christ c. 1500*

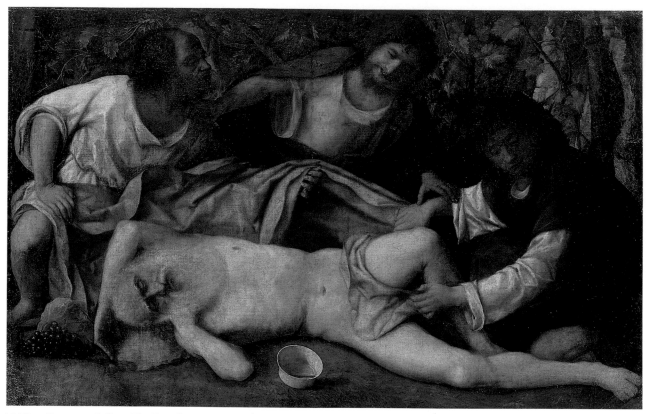

XXIII Giovanni Bellini *The Drunkenness of Noah* 1516(?)

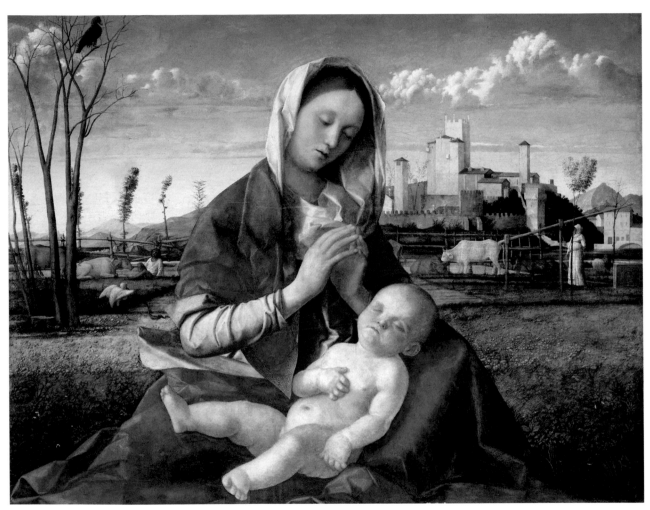

XXIV Giovanni Bellini *The Madonna of the Meadow c. 1505*

XXV Thomas Jones *Buildings in Naples (with the north-east side of the Castel Nuovo)* 1782

XXVI Thomas Jones *Rooftops, Naples* April 1782

XXVII Bernardo Bellotto *View of Schloss Königstein from the South* late 1750s

XXVIII Bernardo Bellotto *View of Schloss Königstein from the West* detail, late 1750s

XXIX Willem de Kooning *Untitled III, 1977*

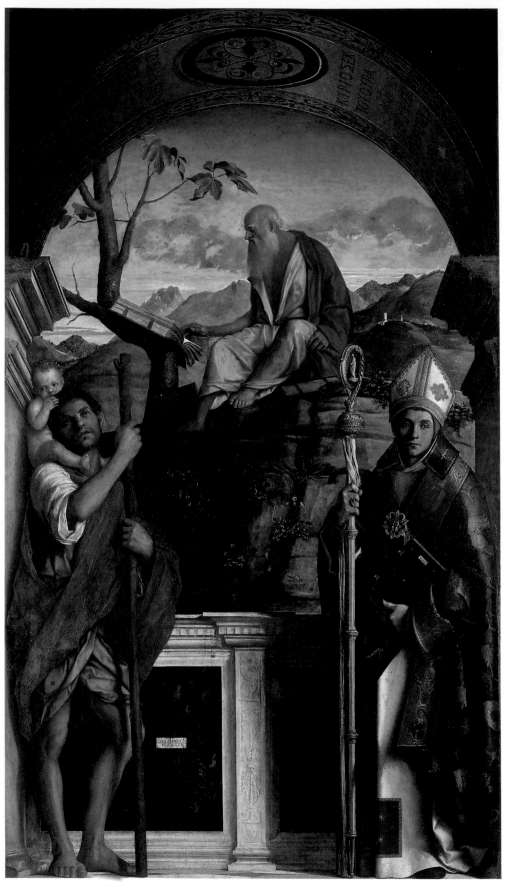

XXX Giovanni Bellini *St Jerome with St Christopher and St Louis of Toulouse c.* 1513

every event, must impinge upon the consciousness of the narrator if it is to form part of the story that the novel tells.

But when we turn to representational painting and the spectator in the picture and his need for a repertoire, it is all different. It is manifestly not the case that the only way in which a representational painting that contains a spectator in the picture can gain content – more precisely, can gain further content – is through the internal spectator: let alone through the inner life of the internal spectator. There are ways in which content can and will accrue to the painting that are totally independent of the internal spectator. Content can, for instance, accrue through what the external spectator sees in the picture, or how he expressively perceives it.

Why then must the internal spectator be assigned a repertoire? Why specifically must he be assigned a repertoire that will grant him an inner life? The answer is – we have been here before – so that he can better fulfil his function, so that he is able to do for the external spectator what is expected of him. So now is the time to ask, What is expected of him? What is his function? It is in the course of answering this question that I shall justify my claim that the analogy between paintings with a spectator in the picture and centrally imagining is more than an analogy.

5. The function of the spectator in the picture is that he allows the spectator of the picture a distinctive access to the content of the picture.

This access is achieved in the following way: First, the external spectator looks at the picture and sees what there is to be seen in it; then, adopting the internal spectator as his protagonist, he starts to imagine in that person's perspective the person or event that the picture represents; that is to say, he imagines from the inside the internal spectator seeing, thinking about, responding to, acting upon, what is before him; then the condition in which this leaves him modifies how he sees the picture. The external spectator identifies with the internal spectator, and it is through this identification that he gains fresh access to the picture's content. In a licensed way he supplements his perception of the picture with the proceeds of imagination and does so so as to advance understanding. It is because the artist requires that, if the external spectator is fully to understand the picture, he should draw upon centrally imagining in the way that I have suggested, that centrally imagining is more than analogous with paintings that contain an internal spectator: centrally imagining is partly constitutive of them.

The better to grasp the way in which the external spectator can benefit from what he imagines when he identifies with the internal spectator, I propose to look more closely at centrally imagining and consider its inner mechanism. Two features need detain us. One, which I call 'plenitude', is this: As I centrally imagine the protagonist acting in this or that way, so I shall tend to imagine on a scale in excess of what is needed merely to keep the imaginative project going, his perceiving, thinking, feeling, this or that. In other words, I shall liberally intersperse his outer life with his inner life in my imaginings. The other feature, which I call 'cogency', is this: As I centrally imagine the protagonist perceiving, thinking, feeling, this or that, so I shall tend to find myself in that condition in which really having had such perceptions, thoughts, feelings, might be expected to leave me. Though imagining from the inside someone's inward responses doesn't require me actually to have these responses myself, the upshot of the imaginative project, or the condition in which it leaves me, is that it is for me as if I had responded in these ways. Imagination, without inducing the experience I imagine, delivers the fruits of experience.

So much for centrally imagining in general. When we now turn back to paintings with a spectator in the picture and consider how imagining this spectator from the inside gives distinctive access to their content, cogency is the immediately relevant feature. For it is cogency that secures the trickle-back of experience from the imagined life of the internal

spectator into the mind of the external spectator, whose understanding of the picture before him is correspondingly enhanced. It is the condition in which imagination leaves him that leads him to experience the picture in a more precise fashion. But cogency is not feasible without plenitude. The imagined life, the imagined inner life, of the internal spectator has to be sufficiently rich if the external spectator is to benefit from it. And this answers our question about the repertoire. For the only way in which such an inner life can be assured is through a repertoire that will generate and constrain it: a repertoire which the artist constructs and inscribes into the painting, from which the external spectator retrieves it so as then to draw upon it in his imaginative project. Examples will make this process clear.

If the internal spectator's need for a repertoire stems from the function that he has to discharge, the same, I now want to argue, goes for the other requirement that I have imposed upon the internal spectator. It too permits the internal spectator to fill his role. This is the requirement that he should be a total spectator. If the first requirement is imposed so that the external spectator should get that distinctive access to the content of the picture he is looking at which the internal spectator can give him, what the second requirement is designed to secure is that – and now note the change of emphasis – the picture to whose content he gets this special access is the very picture he is looking at: it is that picture, and no other.

Let us see how the requirement is supposed to secure this.

Let us return to the case of a picture which contains an unrepresented figure who is unrepresented because he is off in the wings: he stands to one side of what can be seen in the picture, but his existence is established beyond a doubt by, say, the way some of the represented figures turn to look at or address him. Now let us suppose that the external spectator adopts this wayward spectator as his protagonist. He identifies with him. It is clear that such an imaginative project could not give him access to the content of the picture in front of him. It will give him access to what the picture represents but not to it as the picture represents it. It might seem that what it can best give him is access to another picture that might have been, or might yet be, painted of the same thing or event but from a different point of origin. I have said that the total spectator requirement, or the requirement that the internal spectator should have a field of vision coincident with what can be seen in the picture, is probably too stringent: nevertheless enough has been said, surely, to show that some such requirement is in order, and any departure from the strict version of the requirement must be consistent with the consideration that made it in the first instance seem necessary.

I shall, as I promised, come back to this requirement at the end of this lecture (section E.2).

6. A final point, before I come to examples. The point concentrates much of what I have been saying.

The spectator in the picture need not be a particular person. He may be merely a person of a particular kind. If he is merely a person of a particular kind, he need not be a person of any very specific kind. The spectator in the picture may be, indeed he is highly likely to be, just anyone: he may be any old person. But – and this is the point I am making – what he must be is a person. He must be a perceiving, thinking, feeling, acting, creature. What he cannot be is a mere disembodied eye. He may be a person who is primarily a perceiver, but unless he can do more than perceive, as a person can, he cannot offer, through identification with himself, distinctive access to the content of the picture. And it is only if he does this that he discharges his function, and it is only if he discharges this function that there is reason to believe in his existence, or to hold that the painting actually contains a spectator in the picture.

The spectator in the picture

84 Caspar David Friedrich *Landscape with an Obelisk* 1803, pen and wash

85 Hendrick Goltzius *View near Haarlem* 1603, pen drawing

B. 1. The first artist whom I want to consider in this context is the German Romantic artist, Caspar David Friedrich, whose international standing has been assured only in recent years. The works that I have in mind form a series, beginning with an early sepia drawing (Ashmolean Museum, Oxford) of 1803, and culminating in Friedrich's masterpiece *The Large Enclosure, near Dresden* (Gemäldegalerie, Neue Meister, Staatliche Kunstsammlungen, Dresden), of 1832, which still hangs in the city where it was painted. This body of work invites comparison with work of an earlier tradition with which Friedrich was familiar and by which he was in certain superficial respects influenced. The influence accounts for the similarities, and the peculiarities of Friedrich's pictorial aims account for the difference or differences. The tradition I have in mind is that of the extended or panoramic landscape of the Dutch seventeenth century. Originating (it has been proposed) in some remarkable late drawings of Goltzius,[5] this tradition reached its

The spectator in the picture

peak in the mature work of Jan van Goyen and Philips de Koninck. (Jacob Ruysdael, a far
greater artist, I place outside this tradition.)

I begin with the similarities between the two bodies of work. They include: the oblong
format; the high or rather high viewpoint and the consequent low horizon, which is often
unbroken or without superimposition; the extended view over land and water that the
picture offers; the elimination of flanking features or wings (characteristic of slightly
earlier Dutch painting), which would act to concentrate or control the gaze; the uniform
degree of attention that is given to all such detail as is admitted into the picture; and,
finally, the absence of clear transition – I shall return to this later – between the position
from which the landscape is represented and the nearest part of the foreground as this
runs along the bottom edge of the picture. And there is this profound difference: that
Friedrich's landscapes contain a spectator of the scene internal to them; the landscapes of
van Goyen and Koninck do not.

Why do I say this? How is this difference in representational content, as I have called it,
disclosed?

Suppose we ask of both groups of paintings the question, Why is the high viewpoint
chosen? Was it selected for the view that it offered of the landscape, in that the artist
thought that, by showing the particular expanse of earth and sky as it would appear in this
perspective, or to someone occupying this position, he would do it best justice – this
being his paramount concern? Or – and this is the alternative – was the artist primarily
interested in some person who occupied this position, and did he choose to represent the
landscape in the perspective that this position offered because this is how such a person

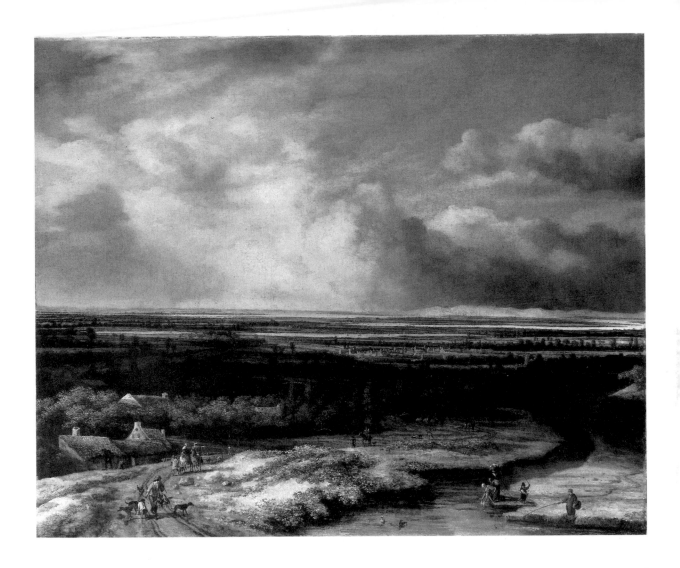

would see it? In other words, are we to think of the high viewpoint as primarily identified by the view that it offers, which then privileges it aesthetically, or are we to think of it as primarily the locus of some identifiable person, who lends aesthetic privilege to it, and hence to whatever view is obtained from it?

My answer is that, if we can think of the Dutch landscapists in the first of these two ways, or as going from view to viewpoint, we should think of Friedrich in the second way, or as going from viewer to viewpoint to view. In Friedrich's work the high viewpoint is essentially occupied. In the Dutch paintings this is not necessarily the case.

If we accept this, the next question to ask of Friedrich's paintings, which is, Occupied by whom?, is not hard to answer. The occupant of the high point is the artist as Friedrich conceived him: the nature-artist of early-nineteenth-century Pietism.[6] He is a person, or a kind of person, who, disentangled from the exigencies of material life, gains a certain detachment from nature, which he then makes use of only so as to return to nature and make it the object of profound and devout contemplation. Through study and meditation he arrives at the secrets of nature, which are in effect the secrets of its maker. And these are, it will be recognized, secrets, not in the sense that they have been encoded in riddle and await decipherment, but in that they call for humility, patience, careful observation, and long hours of dedicated, painstaking toil before they deliver themselves up. And then they do.

87 Philips de Koninck
An Extensive Landscape with a Hawking Party
c. 1665–75

The spectator in the picture

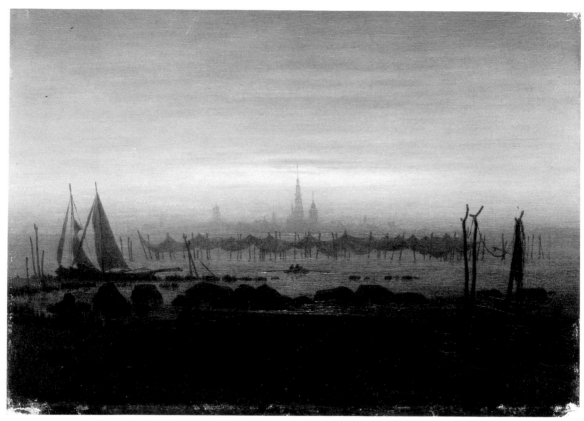

88 Caspar David Friedrich *Greifswald in Moonlight* 1816–17

89 Caspar David Friedrich *Meadows near Greifswald* after 1820

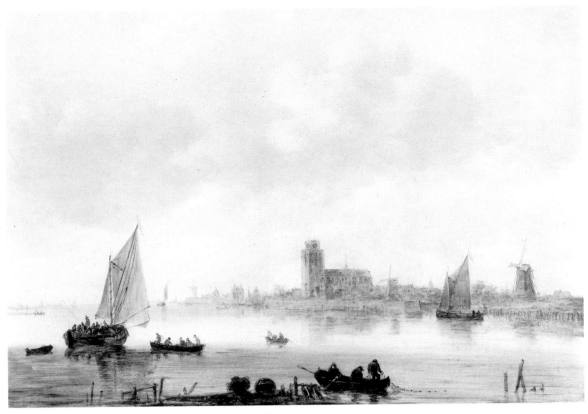

90 Jan van Goyen *View of Dordrecht* 1649, panel

91 Jan van Goyen *View of Arnhem c.* 1645–8, panel

92 Caspar David
Friedrich
*The Large Enclosure, near
Dresden* 1832

There is a visual aspect of Friedrich's work, brought into relief through comparison with the Dutch landscapes, that confirms the association between the high viewpoint and the locus of the Friedrichian nature-artist. For, though it is true that both bodies of work exhibit no clear transition between viewpoint and foreground, there is a revealing difference in attitude towards this discontinuity.

In the case of van Goyen and Koninck, the question is simply left open, as though it was a matter of no significance, how the viewpoint is related to the immediate foreground. Nothing precludes the possibility that the viewpoint is located on a high bridge, or on a viaduct that transects the landscape, or on some unexpected promontory or hump that the terrain throws up, of a kind which Dutch artists liked to introduce into the represented space. In Friedrich's art it is different. Any attempt to connect up landscape and viewpoint, or to offer a naturalistic explanation of how the viewpoint rises out of the landscape, is rejected, and the hiatus between what is seen and where it is seen from is emphasized. The impression is deliberately induced that the landscape somehow runs on under the point from which it is represented. In *The Large Enclosure*, Friedrich, in 92 the course of indicating a point of view that is distanced from a terrestrial site, goes so far as to render the phenomenal curvature of the earth. Writing of the first major work of Friedrich's, the Tetschen altarpiece (Gemäldegalerie, Neue Meister, Staatliche 93 Kunstsammlungen, Dresden), the critic Friedrich Wilhelm Basilius von Ramdohr said that it required the spectator to be suspended in mid-air.[7] Ramdohr intended the remark disparagingly. In *The Large Enclosure* it is as though Friedrich embraces the description, and he sets out to make it conspicuously true. It is testimony to Friedrich's success in this attempt that, when *The Large Enclosure* was engraved, Johann Philipp Veith, the print- 94 maker, took it upon himself to avoid the embarrassment that such a point of view must cause, and he rectified the perspectival effect – and made the picture totally banal.[8] If we now ask why Friedrich chose to paint the scene in this perspective, the answer is that such a physical viewpoint coheres with the spiritual vision of the nature-artist, which Friedrich wished to capture. To do so, or to secure the view as well as the viewpoint for his picture, he introduced the nature artist into the painting as viewer or internal spectator.

The spectator in the picture

93 Caspar David Friedrich
The Cross in the Mountains
(The Tetschen Altarpiece)
1807–8

94 Johann Philipp Veith
after Friedrich
The Large Enclosure, near
Dresden 1832, engraving

But precisely how did Friedrich do this? For I have contended that the presence of a spectator in the picture is not exhausted by the fact that what the picture gives us is the visual field of such a spectator. The spectator in the picture must have more than a narrowly visual repertoire if he is to fulfil his function: it is only if he has a more extended repertoire that, in taking him as protagonist, the spectator of the picture will gain fresh access to the content of the picture. Indeed in the absence of such a repertoire the case for crediting the picture with an internal spectator lapses. So we must ask, first, What would this extended repertoire be?, and, secondly, How does Friedrich indicate it?

For the answer to the first question let us start with one of Friedrich's aphorisms:

> The artist should paint not only what he sees before him but also what he sees within him. If however he sees nothing within him, then he should also omit to paint that which he sees before him.[9]

But how is an artist who is capable of this dual vision to paint? How does he do justice to it in his work? And the answer must be that, first, he projects what he sees inwardly on to what he sees outwardly, so that his thoughts and feelings are allowed to colour his perception of nature, and then, as he starts to paint, this perception of nature becomes his subject-matter. He paints nature as this perception colours it. He paints it expressively, and what he expresses is the attitude to life that Pietism inculcates in him.

Any expressive painter will ask of his spectator expressive perception. However I have been contending that Friedrich facilitates this by inserting into his picture an internal spectator. The repertoire that Friedrich gives this internal spectator must in effect be that which he would expect the external spectator to have if the external spectator was to be capable, unaided, unfacilitated, to see the picture as Friedrich would have him. Here then we have the answer to our first question, so that now the second question arises: How does Friedrich indicate this repertoire to us?

To answer this question I take a step back and consider a body of hermeneutic literature that has of recent years grown up around Friedrich's work, the special character of which is its method. The method is this: First, distinct senses are attributed to discrete representational elements in a painting. So, a ship means this: an anchor means that: the sun means something else. Then, the way these elements are put together in the picture being equated with structural principles, complex thoughts are assigned to whole pictures on the basis of the simple senses plus the principles that combine them – rather in the way in which a sentence gains its propositional content on the basis of what the individual words mean, and of how they are put together. So, of *The Large Enclosure*, 92 Helmut Börsch-Supan, the chief of this school, writes:

> But the ship drifting over the shallow water where it is in danger of being stranded, and the abruptness with which the avenue of trees comes to an end in the open country, are images of approaching death.[10]

And of *Afternoon*, (Niedersächsisches Landesmuseum, Hanover) Börsch-Supan writes: 95

> The informal composition, which is derived in its entirety from a study, expresses an affirmative attitude towards nature. Nevertheless, the field of corn set beside the ploughed-up fields alludes to the threat of death.[11]

Such a method must be at fault if it is supposed to account for the expressive meaning of Friedrich's paintings. For the method misconstrues expression in painting. It treats pictorial expression as though it rested upon a lexicon linking represented elements to emotions and feelings. As we saw in the last lecture, it doesn't. Expression rests upon expressive perception, in which emotion, aroused by what we see, comes to colour our perception of what we see.

The spectator in the picture

In a recent book, Charles Rosen and Henri Zerner have similarly criticized any such misguided conception of expressive meaning.[12] But they have not gone on to ask themselves whether there might not be an alternative use for what Börsch-Supan tells us. I believe that there is. I believe that it provides us with the material from which we can reconstruct the repertoire of the internal spectator in Friedrich's work. And here it is necessary to guard against a misunderstanding. Börsch-Supan's material certainly does not capture any kind of expressive perception from the inside: it does not convey what such perception would actually be like for the pietist. But that is not required. For in centrally imagining someone perceiving a certain way, it is not necessary, I have contended, actually to engage in such perception ourselves. Hence knowledge of what it would be like from the inside, which is often unobtainable, is also unnecessary to get us launched on our imaginative project. Knowledge from the outside, which is what Börsch-Supan provides, suffices. And then, once we are launched, the trickle-back from spectator in, to spectator of, the picture, which is what cogency ensures, should keep us on course.

All that now needs to be pointed out is the obvious fact that, if what Börsch-Supan says is justified, this is so only because it goes back to what Friedrich shows. For Friedrich, in introducing into his pictures things such as anchors, ships, cornfields – things which we know the internal spectator perceives expressively – aims at doing two things. He aims at showing us what the internal spectator sees, but he also aims at showing us the expressive manner in which the internal spectator views what is before him. In other words, he allows us to reconstruct the internal spectator's visual experience, but he does so, or such is the claim that must be made out, in such a way that we, with the aid of whatever background information we may happen to need, can also reconstruct the internal spectator's repertoire, from which his experience of the picture takes on its distinctive colouring. In taking on this colouring, his experience is assured of being more than narrowly visual.

95 Caspar David Friedrich
Afternoon late 1820s

The spectator in the picture

96 Edouard Manet
The Absinthe Drinker
1858–9

The last question that remains is, Can we guess why Friedrich should have wanted to build into his paintings this specific mode of access to their content? I think that we can see a reason. It is connected with what Friedrich expected of his paintings: nothing less than to convert the spectator. Imaginative, if vicarious, immersion in their chosen subject-matter is calculated to do this: particularly if another ambition of Friedrich's, which concerns the way they should be viewed, is assumed satisfied. This is not the way we now take for granted as the norm: that is to say, infrequently, singly, and in a gallery. Friedrich's paintings were made to be viewed in a way we have lost: continually, and all together or in series. I shall make further use of this last point when I return to Friedrich.

140

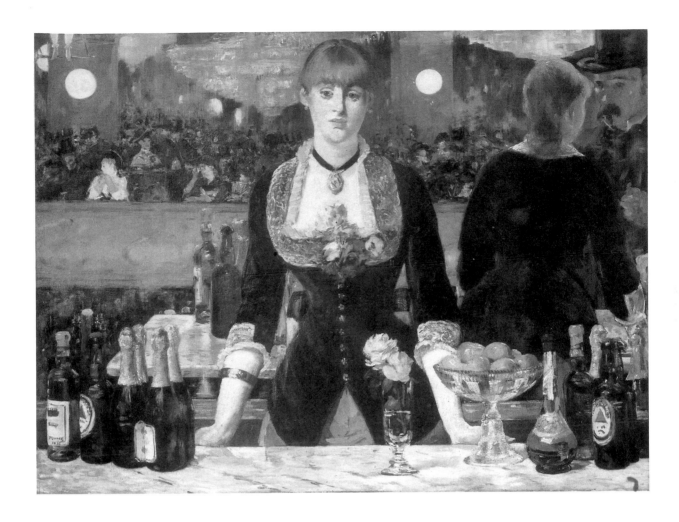

97 Edouard Manet
Bar aux Folies-Bergère
1882

C. 1. The second group of pictures that I want to consider are certain single-figure
compositions by Edouard Manet. They are mostly full-length, and they come from all
96 periods of Manet's career. Chronologically they range from *The Absinthe Drinker* (Ny
Carlsberg Glyptotek, Copenhagen), of 1858–9, Manet's first independent work,
97 displaying a figure of Baudelairean spleen, to the late masterwork, the iridescent *Bar aux
Folies-Bergère* (Courtauld Institute Galleries, London), which, finished in 1882, was
intended to initiate a whole series of large paintings of Parisian life. The next year Manet
was dead at the age of fifty-one.

What is common to the works that I propose to consider is a shared psychological
subject-matter: they present us with figures characterizable in the same mental terms.
They are figures who, at the moment at which we see them, are turned in upon
themselves by some powerful troubling thought: they are figures who are temporarily
preoccupied, figures who have retained and cherish, who cosset, a secret, to which their
thoughts have now reverted.[13] A moment later and the mood may dissipate, but, until it
does, they are absent from the world.

Now the paintings that form this group not only come from every phase of Manet's
career, which for all its brevity exhibits development, but they belong to a wide variety of
broad pictorial types, and this diversity is worth considering. The greater number of such
paintings are, in Manet's reconstructed use of the category, genre paintings, or paintings

The spectator in the picture 141

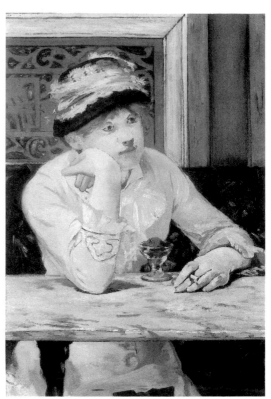

99 Edouard Manet
La Prune c. 1877

98 Edouard Manet
The Street Singer 1863

that set out to capture distinctive aspects or modes of modern life, ranging from *The Street* 98
Singer (Museum of Fine Arts, Boston), of 1863 to *La Prune* (National Gallery of Art, 99
Washington, D.C.), of the late 1870s. I am sure that it is right to think of this type of
painting as corresponding to the most fundamental conscious aim of Manet's work.[14] As
an extension of this type there are paintings that were undertaken in direct competition
with the Old Masters, but in which Manet sees his task as that of finding an up-to-date

142 *The spectator in the picture*

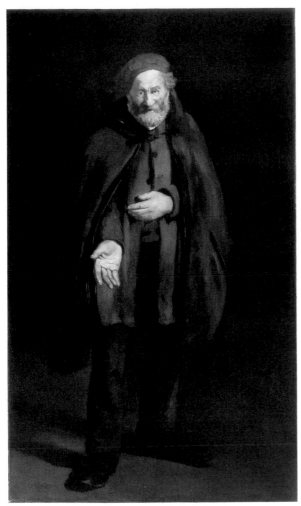

100 Edouard Manet
Philosopher with a Beret 1865

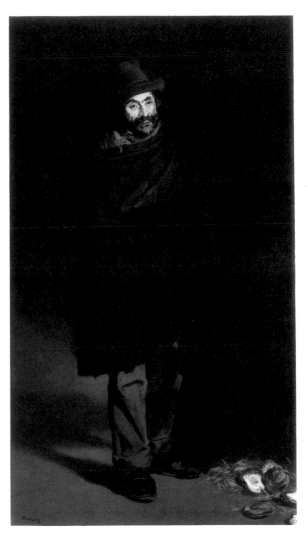

equivalent for what his predecessors had done. Conspicuous examples would be the two
101 *Philosophers* (Art Institute, Chicago), of 1865, which derive from Velázquez's imaginary
portraits of Aesop and Menippus. By 'philosopher' Manet meant a kind of garrulous
tramp familiar in the streets of Paris.[15] These figures possess a rough canny joviality, but
we can see that this has been abruptly dissipated: their self-confidence deserts them, they
falter, and vagueness takes over. Next, there are paintings that were inspired by the

101 Edouard Manet
Philosopher 1865

The spectator in the picture 143

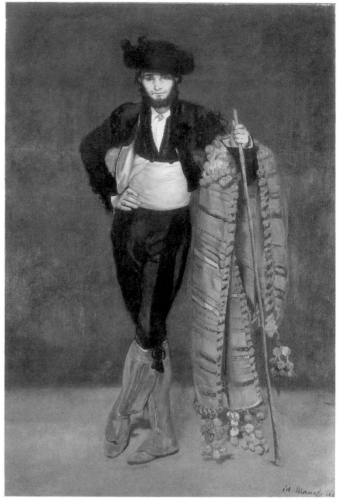

103 Edouard Manet
Young Man in the Costume of a Majo 1863

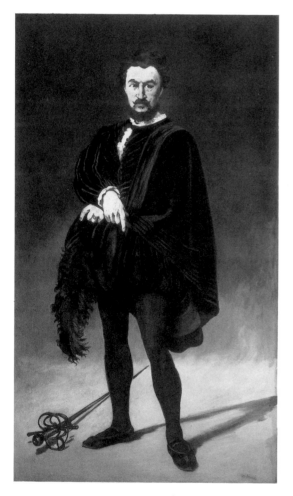

102 Edouard Manet
The Tragic Actor (Rouvière as Hamlet) 1865–6

theatre, or that are costume paintings or involve dressing-up, like *The Tragic Actor* 102
(National Gallery of Art, Washington, D.C.), of 1865–6, and the *Young Man in the* 103
Costume of a Majo (Metropolitan Museum of Art, New York City), of 1863. In these
pictures the fancy dress itself, or the assuming of it, seems to induce a moment of reverie.
And, finally, this mood of preoccupation, of self-absorption, dominates paintings that
were conceived of as, and indeed are, portraits. Striking examples are two portraits of

144 *The spectator in the picture*

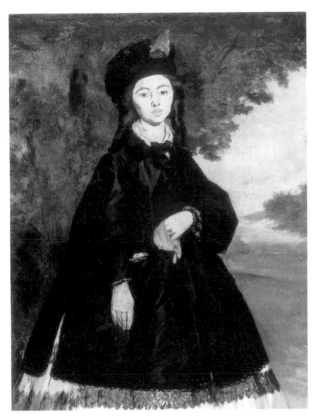

104 Edouard Manet
Madame Brunet 1860

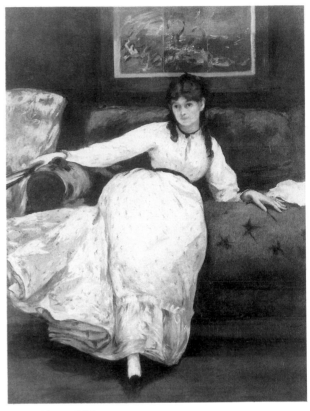

105 Edouard Manet
Le Repos (Portrait of Berthe Morisot) 1870

104 women: the stark portrait of *Madame Brunet* (private collection), painted as early as 1860 but altered over the next few years, though not to the satisfaction of the family, and the tense, melancholy portrait of Manet's future sister-in-law, Berthe Morisot, known as *Le* 105 *Repos* (Rhode Island School of Design, Providence, R.I.), painted in 1870. These two figures are just as secretive as any of their fictional counterparts. And in case it is assumed, understandably, that this mood derives from the sitters themselves, it must be pointed out that we also find it in the portraits of two men neither of whom we think of as prone to distraction or lack of concentration. On the contrary they were men who were famously 106 energetic and demonstrative. We find the same momentary *absences* in the *Émile Zola* 107 (Musée d'Orsay, Paris), of 1868, and in both portraits of Clemenceau (Musée d'Orsay, Paris, and Kimbell Art Museum, Fort Worth, Texas), which Manet worked on simultaneously in the winter of 1879–80.

108 (I exclude from consideration the single-figure pictures of women, peculiar to the last years, extremely loosely painted, in which the body seems about to dissolve in a flurry of brushstrokes, and which clearly come out of Manet's work in pastel. They have a quite different subject-matter. There is no preoccupation, no secretiveness, no sudden inwardness. In these pictures all is show.)

The spectator in the picture 145

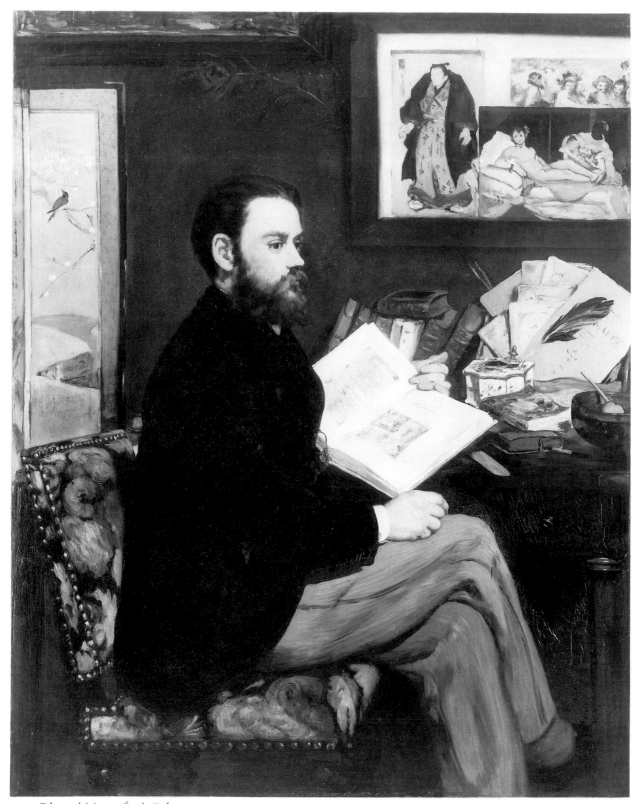

106 Edouard Manet *Émile Zola* 1868

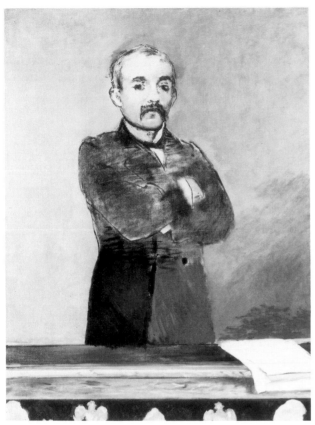

107 Edouard Manet
Georges Clemenceau 1879–80

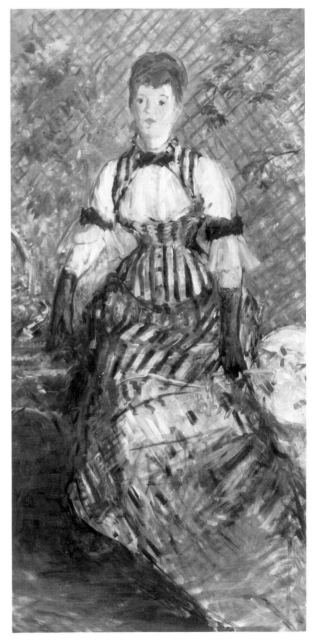

108 Edouard Manet
Woman in Evening Dress 1877–80

147

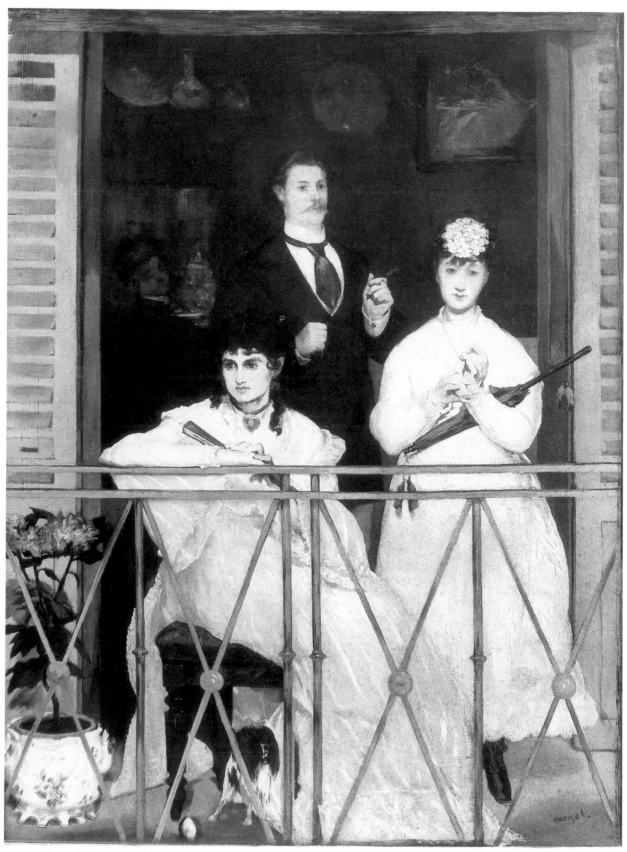

109 Edouard Manet *Le Balcon* 1868

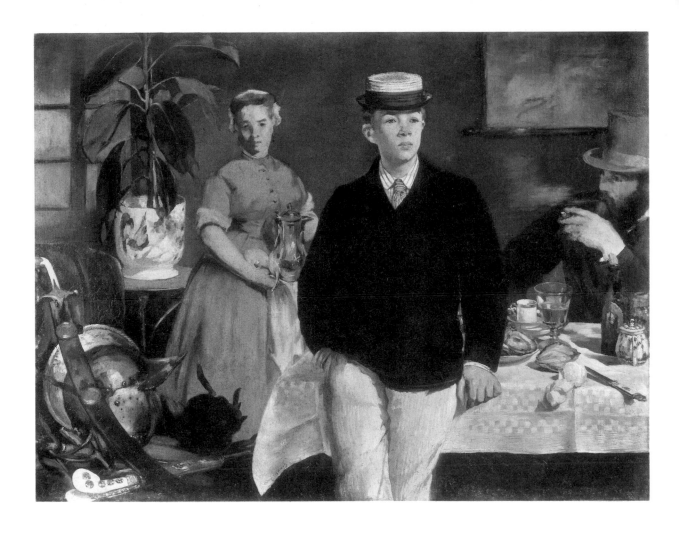

2. Now one way of thinking about these pictures – and a way that will take us to their 110 essential character – is to regard them as distillations of the spectacular multi-figure compositions that occupy such a central place in Manet's *oeuvre*. Examples of such work, and amongst the greatest of them, are *Le Balcon* (Musée d'Orsay, Paris) and the resplendent *Déjeuner dans l'Atelier* (Bayerische Staatsgemäldesammlungen, Munich), both painted in 1868 and shown in the Salon of the following year. Taking these examples as typical, what do we see when we look at such pictures?

These pictures too have a common psychological subject-matter. We see a group of people who are in close propinquity – in *Le Balcon*, crowded together as if they were inside some transparent capsule – but who, for all their physical closeness, fail to make contact. More precisely, contact between them has been broken. Something has impinged upon them with the effect that, for the duration of the picture, for that special time, they are locked up in their own private thoughts.

To see the justice of this characterization, of the mood and its likely cause, we may contrast the effect that these group pictures make with that produced by the early multi-figure compositions of Degas, of which a highly characteristic example would be the great double portrait of the *Duc et Duchesse de Morbilli* (Museum of Fine Arts, Boston), Degas's sister and brother-in-law, which dates from *c*.1867. For a moment, to the casual glance, the mood may seem the same. There is the same overall effect of disengagement, of remoteness. But a difference forces itself upon us. For we recognize that in Degas the cause lies not in something that has just happened to the figures, it lies in the figures

109
110

111

110 Edouard Manet
Déjeuner dans l'Atelier
1868

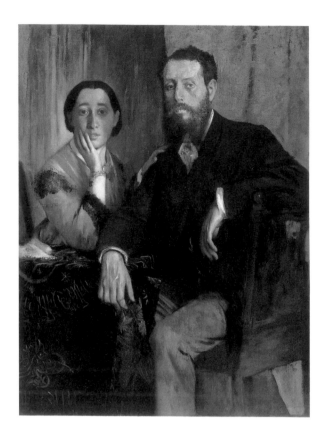

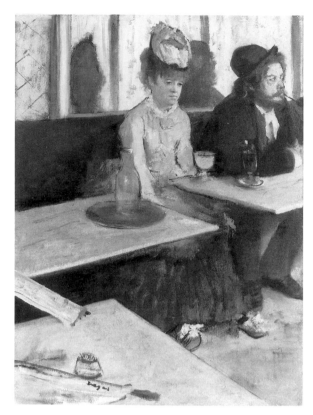

111 Edgar Degas
*Duc et Duchesse de
Morbilli c.* 1867

(Above right)
112 Edgar Degas
Au Café 1867

themselves, who in consequence are revealed as chill, indifferent, etiolated: there is, we are led to sense, a deep, persistent inhibition of feeling. If the Degas figures, like Manet's figures, fail to make contact with one another, the explanation is very different: it is beyond their emotional resources to do so. And in case it is thought that what we have here is just another example of the artist's fidelity to the reality that he represents, so that in the Morbilli portrait Degas captures the stiff social milieu that his sitters inhabited, we can turn to Degas's scenes of low life and find there an identical psychological content. In, for instance, the familiar *Au Café* (Musée d'Orsay, Paris), of 1867, the two broken-down 112 figures, painted from models, appear to be prey to the same emotional malaise, to the same wanness, as their social superiors. And at the same time Degas in these pictures convinces us that there is nothing special about the moment at which he has caught his sitters: that is all that there is to it, it is a moment of time, and as such it is as good as, or no worse than, any other for revealing the figures as they really are. They are as they momentarily seem to be. But, the eyes show us, that is not how we are to think of Manet's figures. One thing that the juxtaposition of Manet and Degas brings home to us is how physical, how vibrant, how full of sexual presence, Manet's figures are in themselves, from which we must conclude that their failure to connect has a transient explanation. It must be put down to some more urgent, more pressing, more troubling, concern which has erupted into their lives and weighs upon them there and then. Manet versus Degas is the abstraction of the moment as against life's alienation.

Once again, with these multi-figure compositions, it is interesting to see how a single characterization of Manet's work, now secured by comparison, holds across paintings that belong to very different broad types.[16] Moving outward from *Le Balcon* and the *Déjeuner dans l'Atelier*, we discover preoccupation in paintings whose subject matter pronounces it a most unexpected, a most unwelcome, intruder. So, for instance,

The spectator in the picture

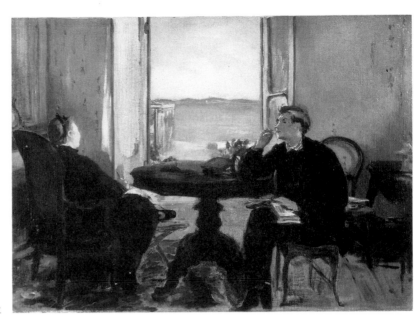

113 Edouard Manet
Interior at Arcachon 1871

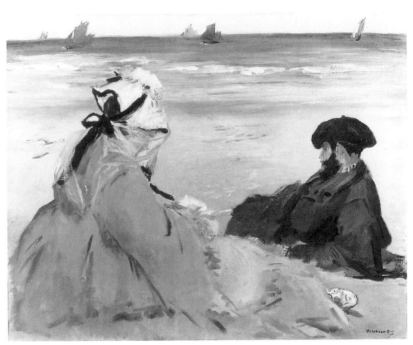

114 Edouard Manet
On the Beach 1873

113 preoccupation invades family scenes or scenes of quiet domesticity – like the *Interior at*
114 *Arcachon* (Clark Institute, Williamstown, Mass.) or *On the Beach* (Musée d'Orsay, Paris),
both painted in the early 1870s. Mother and son, husband and wife, start to read or to
relax together, only to find themselves carried off on eddies of private thought. More
surprising, more unnerving, is to find just the same thing happening in the two great river
115 scenes of 1874, *Boating* (Metropolitan Museum of Art, New York City) and the
116 spectacular *Argenteuil* (Musée des Beaux-Arts, Tournai). For these are pictures which
jubilantly parade the new conceptions of leisure and informality, of delight in exercise
and the open air, which were so self-consciously prominent both in Impressionist
painting and in the contemporary fiction of the Goncourts and Maupassant. Yet in each
of these paintings, at the very moment that they record, the shared pleasure comes to a
halt. It stops, even if only, who knows?, to start up again the next moment. Preoccupation,

The spectator in the picture 151

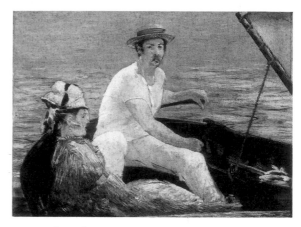

115 Edouard Manet
Boating 1874

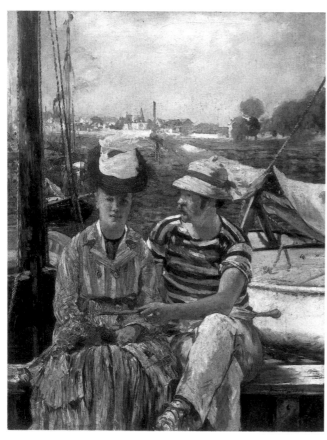

116 Edouard Manet
Argenteuil 1874

abstraction, the harbouring of a secret, also confront us in two imposing works of a
narrative character, illustrating quintessential moments in the life of the high-bourgeois 117
family, the *Gare Saint-Lazare* (National Gallery of Art, Washington, D.C.), of 1873, and 118
Nana (Kunsthalle, Hamburg), of 1876–7: the young mother (or so she seems) taking out
her elegantly-dressed child, the elderly dandy clutching his cane and looking forward
apprehensively to the little, frisky whore who will rumble him. Maternal love, the
dependency of the child, greed, sexual lust – all powerful springs of action, we might
think, but in neither of these two dramas do they prove strong enough to hold the
protagonists together. What both the mother and the dandy seem to reveal – though my
point does not require such specificity – is that, just when their desires are about to be
fulfilled, when what they set most store by is upon them, they are deflected, and they
phantasize the very moment that it is within their power to experience. Finally, I believe

The spectator in the picture

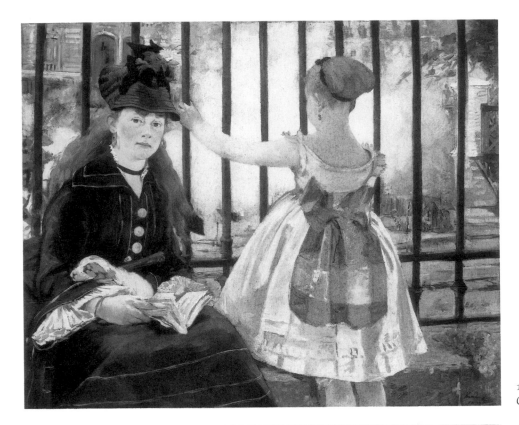

117 Edouard Manet
Gare Saint-Lazare 1873

118 Edouard Manet
Nana 1876–7

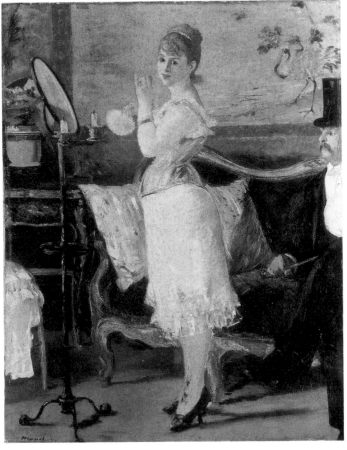

The spectator in the picture

153

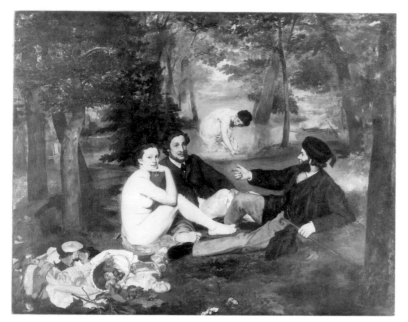

119 Edouard Manet
Le Déjeuner sur l'Herbe 1863

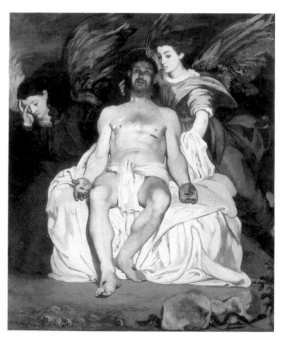

120 Edouard Manet
Christ with Angels 1864

that we should be prepared to attach to this group two more multi-figure paintings whose representational content makes them the unlikeliest locations for secretiveness and reverie. These are the two most ambitious paintings that Manet attempted: one is a work of great modern beauty, the other a heroic disaster. They are the *Déjeuner sur l'Herbe* 119 (Musée d'Orsay, Paris) and the *Christ with Angels* (Metropolitan Museum of Art, New 120 York City). An occasion of high-spirited bohemian pleasure, a scene of searing tragic intensity – in each case the event succumbs to a totally unpredicted fate. At a crucial moment, or when concentration seems called for, it is not forthcoming, and one or more of the participants – the naked woman, the far man at the picnic, in the case of the *Déjeuner sur l'Herbe*, the right-hand angel in the *Christ with Angels* – go absent. Idle thoughts invade them, without warning it seems: they too are lost to the world, if only momentarily.[17]

154 *The spectator in the picture*

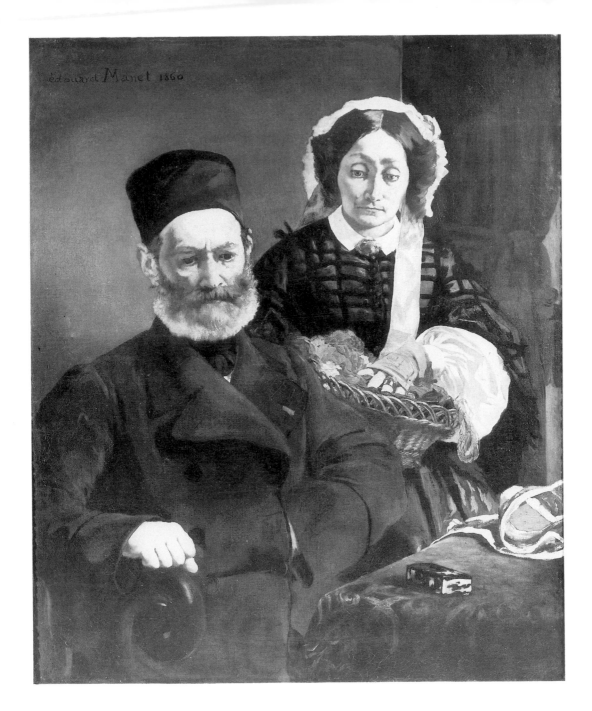

A fact that is, I believe, of major importance for the understanding of these multi-figure compositions is that the painting that clearly establishes this whole tradition within Manet's *oeuvre*, that which ushers in the great sequence of suspended encounters, is the sombre, deeply disturbing double portrait of Manet's parents (Musée d'Orsay, Paris), executed in 1860. The image of intimacy as a transient moment of intense, shared isolation must have stamped itself early on in Manet's mind, and many of the features of this painting, material and psychological, persist in a generalized form throughout Manet's work. They survive the colouristic changes that announce the final phase. They reappear with revived clarity in the last great example of the multi-figure composition: the powerful study of preoccupation, anxiety, and domesticity, which Manet painted in 1879, *Dans la Serre* or *In the Winter Garden* (Preussischer Kulturbesitz, Berlin-Dahlem). In

121 Edouard Manet
Monsieur et Madame
Manet 1860

121

122

The spectator in the picture 155

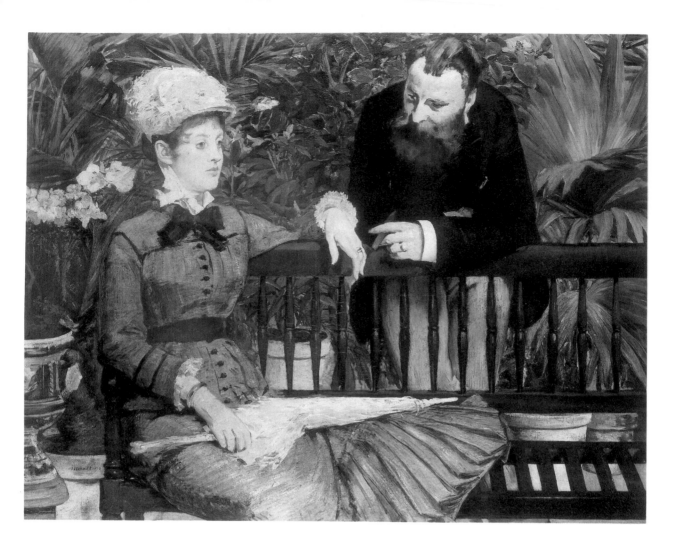

this picture two transformations of the original parental image deserve attention: I do not
believe them to be independent. In the first place, Manet has chosen as the model for the
male figure someone whose features, as was noted at the time, remarkably resembled his
own: he has stepped into his father's shoes. And, secondly, the roles of man and woman
have been reversed. It is now the woman who is brooding, and it is the man who in his
distracted way is solicitous. He would like to do better. But the two remain apart. And
once again the mood of preoccupation does not diminish the heavy physicality of
presence that Manet was able to bring to his figures. We experience the well-cared for,
middle-aged bodies inside their fashionable clothes. We sense the creak of material, of
moiré and broadcloth, and the heavy cigar smoke, and we anticipate the vehemence with
which, once their heads clear, the two protagonists will re-enter the moment.[18]

3. In calling the single-figure compositions of Manet's that exude preoccupation
distillations of the great multi-figure compositions, I had two things in mind. I had in mind
the similarity of psychological content between the two groups of paintings, but I also
wanted to identify a specific problem which clearly confronted Manet in making the
single-figure pictures, and which derives from this psychological content. It is in fact his
solution to this problem that brings him, and them, into this lecture.
 The problem may be formulated in the following way: In his group pictures Manet was
able to convey the sense of momentary withdrawal, of abstraction, of secretiveness,

123 Edgar Degas
Girl in Red c. 1866

(Above right)
124 Edgar Degas
Diego Martelli 1879

along with a strong register of physical presence, by the particular way in which he captured the fleeting relations – the non-relations, we might say – between the members of the group. Transient mood was established by the oblique gaze, the averted look, the failure of one pair of eyes to look into another – with the implicit sense that all this could change from one moment to the next so that, as concentration returned, communication would be re-established. In consequence, when it came to the single-figure pictures, where this resource was unavailable, Manet had to re-think how the mood he sought could be conveyed. What resource could take the place of the mutual evasions, which at once implicated and dissociated the *dramatis personae* of the group compositions, if the single figure was to emerge as a figure of preoccupation?

To sharpen the issue, the contrast, once again, with Degas is helpful, for another way of putting Manet's problem is to say that it is one that couldn't have arisen for Degas. Why it couldn't have arisen for Degas is that, since Degas established the mood that he sought not by reference to what occurs, or, more to the point, what doesn't occur, between the different members of the group but by revealing something internal to each member, this resource remained fully available to him in his single-figure pictures. He had no need to look beyond it. This can be seen very clearly from such pictures as the *Girl in Red* (National Gallery of Art, Washington, D.C.), or the *Diego Martelli* (National Gallery of Scotland, Edinburgh), or Degas's awesome representation of his sister, *Thérèse de Gas* (Musée d'Orsay, Paris), a picture which recreates the elegant iciness of a Bronzino court-portrait.

However this kind of alienation was, I have claimed, not what Manet sought, and the portrait of Thérèse provides us with a chance of satisfying ourselves on this score. For if we compare it with a Manet portrait we have already considered, that of Madame Brunet, a big difference between the two shows up. Manet's sitter too is lost in her thoughts, but Manet encourages us to think that the thoughts themselves are far from pale: they are headstrong, steamy, fleshy, uninhibited. It is barely surprising that the young wife was not well pleased with a portrait in which, even as her mind goes absent, her thoughts become more present to the spectator.

The spectator in the picture

125 Edgar Degas *Thérèse de Gas* 1863

126 Edouard Manet *Madame Brunet* 1860

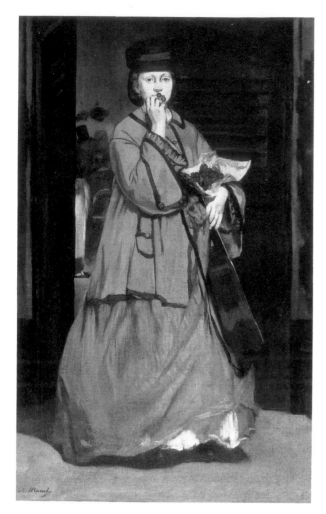

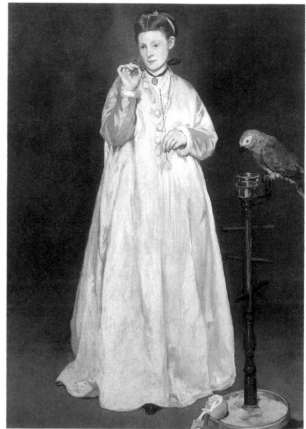

127 Edouard Manet
The Street Singer 1863

(Above right)
128 Edouard Manet
Woman with a Parrot
1866

How then did Manet achieve the effect he was after? If he couldn't do this by producing a picture that was equivalent to a fragment of one of his multi-figure compositions – the way open to Degas – if he had, as I have put it, to distil the multi-figure composition, to extract its essence, what was the method of distillation?

As we look carefully at these single-figure pictures, and prime examples here would be *The Street Singer* or, a picture of three years later, the *Woman with a Parrot* (Metropolitan Museum of Art; New York City), an answer forces itself upon us. Manet does not invoke a strictly perceptual solution of the problem. His solution involves the imagination, and it is this: Get the spectator to imagine someone in the represented space, someone who tries, tries hard, tries importunately, and fails, to gain the attention of the figure who is represented as there in the space; get the spectator moreover to imagine this person from the inside so that, this imaginative entry into the picture over, it will then be for him as if he had himself experienced some of the tedium, some of the frustration, some of the sense of rejection, that must attend any attempt to establish contact with the represented figure – and then the content of the picture will be brought home to him with clarity and cogency. In other words, Manet's ruse is to introduce a spectator into the picture, whose bafflement will trickle back into the spectator of the picture as he identifies with him.

It is not hard to see how such a solution would fit in well with Manet's needs. What, we must ask, is the evidence for thinking that he employs it?[19]

127,

The spectator in the picture

4. In Manet's pictures, unlike Friedrich's, the chosen point of view furnishes no direct evidence for the presence of a spectator in the picture. We cannot say that this is precisely where an internal spectator of the sort that Manet requires would be stationed. But then, on reflection, this is what we should expect. Manet's internal spectator is essentially a mobile spectator. He must be free to prowl through the represented space: questing, probing, prying, endeavouring to trap the figure into some momentary contact – and therefore there could not be one point of view exclusively associated with him. With a spectator of the sort that Manet's solution requires, the only way in which the picture's point of view could support his presence would be if it gave the impression of being totally arbitrary – and thus representative of each and all the indefinitely many viewing points through which he would pass on his wanderings through the represented space. However it is just such indirect support that Manet gets the viewpoint to provide when, time after time, he employs a centralized or near-centralized composition: when he places the represented figure in the middle of the canvas, facing outwards, and standing or sitting more or less parallel to the picture-plane. The frontal view of the figure is generated by what is the arbitrary viewpoint *par excellence*: head-on.

In point of fact frontality, or near-frontality, has a further interest for us. For it is one of a group of features in Manet's work, which operate in a similar fashion, and deserve better understanding than they standardly receive. They operate, I shall say, provocatively, by which I mean that they provoke a particular complex response. Initially they are likely to be thought of as a result of ineptitude. There is much in the way the picture is painted to support this thought. The feature, then, provokes the thought of ineptitude, and my suggestion is that, in each case, if the spectator first entertains this thought, and then rejects it, he is likeliest to be led on to find out just what role this specific feature does, is supposed to, play. In following such a train of thought the spectator will be conforming to the artist's intention, and it is some kind of left-handed tribute to Manet's strategy how reluctant many even of his most sympathetic expositors have shown themselves to be to reject the initial, the provoked, explanation of ineptitude.[20] Manet sets the spectator a test of faith, and he is confident that, if the spectator emerges from this test with his faith intact, he can be relied upon to give the picture, and in particular the seemingly inept feature of the picture, the hard, interpretative attention that it requires. My claim, then, is that Manet intentionally – intentionally, though not consciously – inserted these provocative features into his work, and one of them is frontality. However I am certainly not denying that these provocations most likely exploited Manet's technical weaknesses. The truth is that every strong artist builds on his weaknesses: it is only weak artists who deny them.

To resume then: If frontality, or near-frontality, is not to be dismissed as mere ineptitude, we must look for its role. And its role is, I suggest, that it provides, along the lines I have indicated, circumstantial evidence for the presence of a spectator, a peripatetic spectator, in the picture.

Another provocative feature, and another feature that is relevant to the hypothesis of an internal spectator, is Manet's treatment of the background in the single-figure paintings. In actuality there are in these paintings two different treatments of the background, but they come together, or Manet brings them together, in the common role that he imposes upon them.

In *The Street Singer* we see the first type of background, which is primary in a sense to be explained. It is a highly patterned background, with an accumulation of detail, sometimes hard to make out, though of little intrinsic interest, and to which the central figure stands in no readily determined relationship, spatial, thematic, or formal. A background of the same type is found in the *Lola de Valence* (Musée d'Orsay, Paris). A special, highly refined version of the background, which approximates to a variant upon it, is to be found in the

127

129

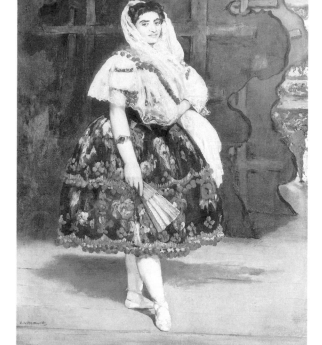

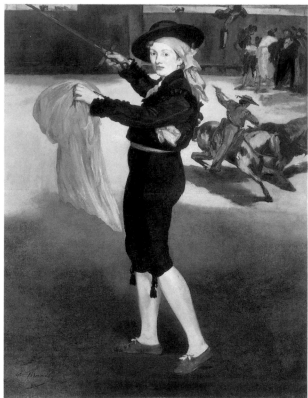

129 Edouard Manet
Lola de Valence 1862

(Above right)
130 Edouard Manet
Mademoiselle V. in the Costume of an Espada 1862

Bar aux Folies-Bergère. But the most often cited, most often criticized, most provocative, 97
example of this first type is the background to *Mademoiselle V. in the Costume of an Espada* 130
(Metropolitan Museum of Art, New York City). It is not hard to see what features of the
background to this picture have motivated critics of Manet to regard it as inept: the
sudden elevation in the viewpoint as we pass from the foreground to the bullfight itself,
the false attachment of the horse to Mlle V.'s back, the enlargement of the bullfighters at
the rear, the diminutive size of all middle-ground and background figures relative to the
central figure – all these are provocative features. Looking at this fractured background,
we find ourselves asking ourselves the question, If we don't put all this down to
ineptitude, what function can we see it performing? It is only the eye situated in front of
the picture that can answer this question, and it has a proposal to make. For, as we
continue to stare at these pictures, something happens. I am speaking now of an optical
effect, and the effect is this. The background starts to detach itself from the figure, it peels
back, and, as it does so, it opens up an undefined or irrational volume of space in which a
perambulating internal spectator might insert himself. Beginning as mere observer,
transforming himself into agent, the internal spectator circulates, up and down,
backwards and forwards, in and out of the various encumbrances which, littering the
space around the central figure, embody the difficulties that he has in effecting the
encounter on which he has set his heart. And, all the while, as the internal spectator
moves through this space, he has the assurance that he will not erupt into the field of
vision of the external spectator: the very lack of definition, the irrationality, of this space
is his cover.

The second type of background is strikingly represented by the *Woman with a Parrot*. 128,
Other examples are *The Tragic Actor*, the two *Philosophers*, *The Saluting Matador* 100,
(Metropolitan Museum of Art, New York City), and *Faure in the role of Hamlet* (Folkwang 145
Museum, Essen).[21] It recurs, on an altogether different scale, in the small portrait of
Théodore Duret (Petit Palais, Paris), to which I shall return. This second type of background 139

The spectator in the picture

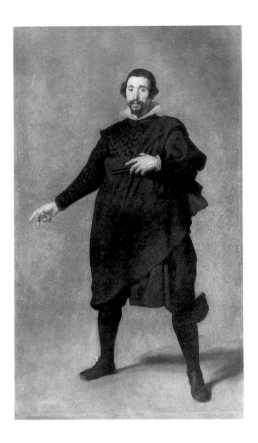

131 Diego Velázquez
Pablo de Valladolid
mid 1630s

is, on the face of it, the diametric opposite of the first. It is a monochrome ground, which, in its most progressive form, self-consciously lacks all differentiation between flat and upright. The horizon has been deleted. Various sources for this treatment of the background have been proposed, but without a doubt its authority for Manet was established by the example of Velázquez. But what is instructive is to compare Manet's use of the undifferentiated background with that to which his hero of the period put it. In, for instance, the portrait of the jester *Pablo de Valladolid* (Prado, Madrid), Velázquez uses this type of background to assert the monumentality, the deathlessness, of the figure who stands out so securely, so positively, in front of it. Manet saw this picture on his visit to Madrid in the summer of 1865: he admired it extravagantly, and in a letter to Fantin-Latour he described it as 'perhaps the most astonishing piece of painting ever done'.[22] But Manet turned the undifferentiated ground to ends all his own.

He used the undifferentiated ground, I contend, in order to wrap around the central figure the kind of indefinite space into which an internal spectator could vanish to good effect. In other words, Manet establishes a functional equivalence between two types of background which are in appearance very different indeed. It is in the establishment of this equivalence that the primacy, as I have called it, of the cluttered ground asserts itself. For, if both the backgrounds serve the same use, for the identification of this use the best clues are provided by the cluttered ground. It is pictures like *Mademoiselle V.* that make the use apparent.

And now we can, I believe, take the interpretation of the two grounds and what they have in common a stage further. At this stage the undifferentiated ground takes over primacy. The suggestion that I am about to make is, I am aware, speculative.

Let us ask, Where else in our experience, or where outside the work of Manet, does the equation between an undifferentiated ground and a highly cluttered ground hold true? One answer is irresistible, once it occurs to us. The equation also holds within a highly familiar domain of experience. It holds within the nocturnal dream.

The spectator in the picture

In the attempt to characterize the elusive phenomenology of dream-experience, use has been made of the concept of the dream-screen, or the surface in front of which the narrative presented by the dream unfolds.[23] The usual account given of the dream-screen is that it is totally blank – its blankness reproducing the infantile experience of that against which our first dreams were dreamt, the mother's breast. My own sense of the matter is that, though this is generally true, and the empty dream-screen gives us our best grasp of the phenomenon, at other times a highly complex ground, which is nevertheless dissociated from the events of the dream, occurs and functions interchangeably. My suggestion is, then, that, in these single-figure pictures, Manet, through his treatment of the ground, and, more specifically, through his treatment of two types of ground as interchangeable, is mobilizing our memories of what nightly goes on in our heads. For though these memories are highly accessible to us all, Manet does not take it for granted that we shall bring them to the perception of these pictures. In order to arouse these memories and to have them at his disposal, Manet once again resorts to provocation. In pictures with the cluttered type of ground, Manet paints this ground in a way that we are likely to think of as inept until, asking ourselves why it should be as it is, first we connect this ground with the other, the undifferentiated, ground, and then we connect both grounds with the dream. It is in this way that the undifferentiated ground now assumes primacy.

The question remains, Why is Manet concerned that we should make this last connection? Undoubtedly the assimilation of painting to dream enhances the uncanny permeability of the space. It turns the space into a form of cover. But it also adds to the mysterious stature, to the looming presence, of the figure who inhabits this space. From that moment onwards, or as soon as this effect is registered, the space seems not merely to accommodate, it invites, it lures, a spectator into its orbit.

5. And now I want to develop the topic of this lecture by looking at pictures that fail, that set out but fail, to contain an internal spectator. I choose two single-figure paintings of the same date as Manet's, by minor artists. They are both portraits: *Mademoiselle de Lancey* by Carolus Duran, and *Sarah Bernhardt* by Georges Clairin (both Petit Palais, Paris). They are dated 1876. Both have a certain flair, a certain charm, but it is relevant that they are works of slight aesthetic interest: except in the context of this discussion.

These paintings too have a strong element of invitation. The intimacy of the setting, conventionally refined in the one case, extravagantly bizarre in the other, the allure of the sitter, the informality of the occasion, the beguiling nature of the pose, all promise a meeting, dangled in front of – it would have to be – the spectator in the picture. But, if the spectator of the picture vicariously avails himself of this, so that he starts centrally imagining someone in the picture who takes up this invitation, what will happen? Nothing. There is nothing that he can find out about these two women which he could not be expected to have found out simply by looking at the pictures and seeing what is there to be seen in their surfaces. That distinctive access to the picture's content which I have been talking about in this lecture is here unavailable. And this is because the internal spectator has not been endowed with a sufficiently rich or instructive inner life for anything to trickle back from it into the mind of an external spectator who attempts to take him as his protagonist.

And why do I say this? Once we set these two pictures beside any of the Manet single-figure pictures that I have been considering, the reason begins to emerge.

It must from the start be recognized that the only way in which an artist can endow an internal spectator with experiences, or, more fundamentally, with a repertoire, is through the way in which the artist depicts whatever it is – in these cases, a figure – that this spectator confronts. What the unrepresented spectator is to see, or think, or feel, must be

132
133

The spectator in the picture

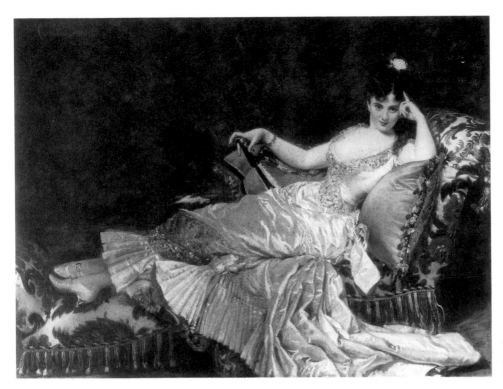

132 Carolus Duran
Mademoiselle de Lancey
1876

133 Georges Clairin
Sarah Bernhardt 1876

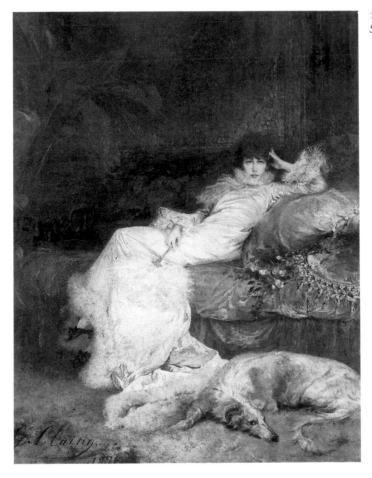

reconstructed from how the represented figure is represented. And how does such reconstruction proceed? At the outset the represented figure must be shown as demanding – demanding from the internal spectator – a particular form of attention. The attention must be intense. And this form of attention must be demanded in that, not only without it will the represented figure be less than fully comprehensible, but with it some measure of comprehension is feasible. When this condition is satisfied, the stage is set for the reconstruction of the internal spectator's inner life. For we can credit him with as varied experiences, with as rich a life, with as acute a sensibility, as will enable us, through identification with him, to grasp whatever the represented figure has to offer us.

At first this may seem circular. It isn't. What I have been saying simply reflects the fact that the spectator in the picture, and what such a spectator could gain from what confronts him, are necessary conditions of each other. They are given together. And this recapitulates what I spoke of at the beginning of this lecture as the reason that we have for regarding the spectator in the picture, when there is one, as part of the representational content of the picture. Though he is unrepresented, he, or, as we can now say, he and his repertoire, are given along with what is represented.

So to go back to the Carolus Duran and the Clairin: In each case the way in which the sitter is represented does not justify us in ascribing some particular inner life to a spectator who shares the space with her. Nothing would be gained from such an ascription. Therefore there is no reason to believe in such an inner life. Therefore there is no reason to believe in the existence of such a spectator.

In characterizing these paintings as paintings that fail to have a spectator in the picture, I had in mind that the artist intended to endow them with an internal spectator but failed. And that characterization advances our understanding of the pictures. This exemplifies the point made in Lecture I, when I said that the artist's intention is crucial to the understanding of a painting just in case the intention was operative in its construction: but its indispensability for the understanding of the painting does not entail that it was fulfilled.

D. 1. Paintings that contain a spectator in the picture are potentially in deep trouble. They face a very real difficulty. Indeed we might want to wait until we notice an attempt on the artist's part to extricate himself from the difficulty before we say of a painting that it belongs to this category. Awareness of this difficulty completes the artist's intention to endow his picture with an internal spectator.

The difficulty comes from the fact that, once the spectator of the picture accepts the invitation to identify with the spectator in the picture, he loses sight of the marked surface. In the represented space, where he now vicariously stands, there is no marked surface. Accordingly the task of the artist must be to recall the spectator to a sense of what he has temporarily lost. The spectator must be returned from imagination to perception: twofoldness must be reactivated. Otherwise the distinctive resources of the medium will lie untapped.

There are different ways in which this recall can be attempted, and an advantage of conjoining Friedrich and Manet in this discussion is that the two artists resort to radically different strategies. Friedrich uses strictly representational means, Manet exploits the medium itself.

2. The strategy that Friedrich uses to return the spectator of the picture to his proper role will in itself be familiar enough to anyone acquainted with his work, but it may not have been recognized as serving this purpose. It involves the most distinctive image in his work. This is the famous *Rückenfigur*, or the figure seen from the back, who stands just within the represented part of the pictorial space: such as we see in the *Cliffs of Rügen* 134

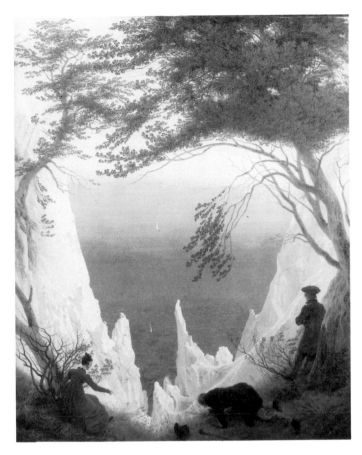

134 Caspar David Friedrich
Cliffs of Rügen 1818–20

135 Caspar David Friedrich
Two Men by the Sea at Moonrise c. 1817

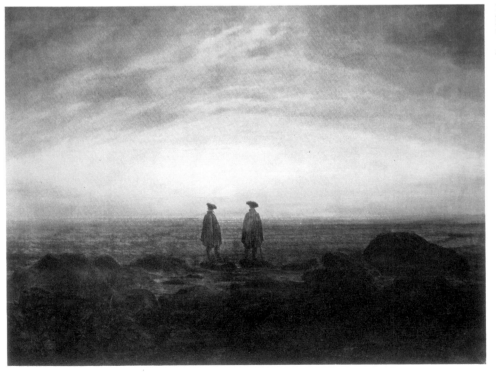

(Stiftung Oskar Reinhart, Winterthur) or *Two Men by the Sea at Moonrise* (Preussischer 135
Kulturbesitz, Berlin-Dahlem). This figure, or these figures, for they often come in pairs or
triples, stand in some highly intimate relationship to the spectator in the picture. They are
not he, but they have been cloned from him, so that he may be thought of as feeling
himself drawn — drawn, as it were, ahead of himself — deeper into the space to which he
belongs: out of the unrepresented part into the represented part. The spectator of the
picture, once alerted to what is taking place, responds. The shock of identifying with
someone who is in effect precipitated into his, the external spectator's, field of vision sets
up a signal. And the signal tells him to relinquish his identification and to pull back to a
position from which the marked surface regains visibility. He retreats from imagination to
perception — specifically to seeing-in. Anyone can try out this effect of the *Rückenfigur* in
front of paintings where it appears.

An obvious question to ask at this stage is, How does recourse to the *Rückenfigur* help
us in our perception of those paintings of Friedrich's that do not contain such a figure? —
since most do not. What I believe to be the right answer takes us back to a point I made
earlier. Friedrich's paintings were not intended to be seen separately. They essentially
form a series. There is an intended transfer from the pictures that contain a *Rückenfigur* to
those which do not.

And in case this last point seems gratuitously ad hoc, I should point out that it is only
because of a self-imposed limitation that these lectures are concerned solely with
paintings in so far as they claim to be the atomic objects of aesthetic attention. Within
Western art, particularly since the emergence of the easel painting, this has been the
norm, but even then it is not, has not been, universal. Certain paintings, certain painters,
demand to be seen in series if they are to be understood. Friedrich is such a painter.

3. In the case of Manet the strategy of recall is different, and what he relies upon is, I
wish to suggest, the elaboration, the embellishment, of the marked surface. Such
embellishment consists in the heightening of colour, the subdivision of tone, the deposit
of mixed pigment that the brush leaves at each touch, and the shortening of the mark — it
was Manet's reliance upon variation in mark across the pictorial surface that did most to
preclude him, even at his most instantaneous, from being properly thought of as an
Impressionist.

Manet has often been admired for the passages of sumptuous paint that are to be found
in his work. In his still lives this virtuosity enjoys an autonomous existence, but, if I am
right, in the single-figure pictures that we have been considering, it finds, additionally, an
instrumental employment.

My claim is then that, in those pictures of Manet's which contain an internal spectator,
the prominence of the *matière*, the emphatic thematization of the brushstroke, are to be
seen partly as a strategy on his part to recall the external spectator to twofoldness, from
which he had been induced to depart. Specifically Manet seeks to activate the aspect of
twofoldness that imagination occludes: that is, awareness of the marked surface.
Embellishment is deployed so that imagined entry into the picture-space is cut short and
the spectator is returned to ordinary seeing-in.

If my claim is correct, it would be natural to expect that this instrumental use of the
medium is something that Manet reached only through a process of trial and error: it
represents an achievement. This is what we find. Embellishment arrives on the scene later
than the problem to which it becomes the solution. In two early works, the *Boy with Dog* 136
(private collection), probably of 1860, and the somewhat more advanced *Gypsy with a* 137
Cigarette (Art Museum, Princeton University, Princeton, N.J.), probably of 1862, which
are both heavy with reverie, there is no compensatory use of embellishment. In this
connection the *Madame Brunet* portrait has, once again, something to show us. For, if we 138

The spectator in the picture

136 Edouard Manet
Boy with Dog 1860–1

137 Edouard Manet
Gypsy with a Cigarette 1862

look at this picture carefully, we become aware how differently it would have been executed only a year or so later. By 1863 or 1864, by which time his strategy of recall had evolved, Manet would almost certainly have arranged, say, a little millinery bird in Madame Brunet's bonnet, or he would have placed something ornamental in the area of the neck or bodice, and thus have provided himself with an opportunity to disturb the more or less evenly weighted paint surface that is exhibited by the picture as we have it. And to return once again to the comparison I have been employing, it seems no coincidence that in the contemporary work of Degas the look of the marked surface is altogether different and the paint is applied in more or less uniform flat strokes.[24] Depicting alienation rather than preoccupation, Degas had no time for lure, and consequently no need for a strategy of recall. Degas was by nature technically adventurous, but that which made impasto imperative for Manet was irrelevant to Degas.

Théodore Duret, critic, collector, friend and champion of the painter, has left us a remarkable account of being painted by Manet.[25] The portrait (Petit Palais, Paris) was painted in 1868. Duret's account not merely coheres, as far as it goes, with my hypothesis about embellishment, but, where his account stops short, it needs another injection from my hypothesis to complete it.

The account opens at the moment when the portrait was more or less finished. It showed a man standing against an indeterminate horizon-less ground, and the picture was, Duret tells us, in unbroken grey. Manet seemed for some reason dissatisfied with the result, and, on the day which was supposed to be the final sitting, he got Duret to resume the pose and started making additions to the composition. First, he placed next to Duret a small table with garnet red upholstery, which he then painted in. Next he got hold of a loose-leaf album with a light green cover, and he placed it under the table, and then he painted it. Then he put on top of the table a lacquer tray, with a carafe, a glass, and a knife, and he painted them. As a final touch, he added a lemon and he painted that. The portrait was now finished.

139

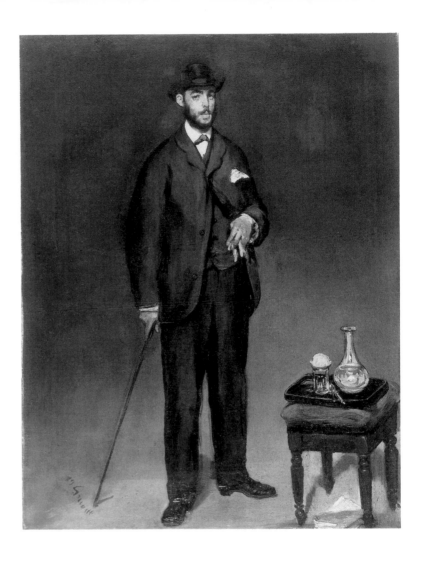

Duret recognized that something special was happening and that it called for a special explanation. But he failed to understand exactly what was happening, and, though he was convinced that it had something to do with Manet's 'instinctive, as it were physiological, way of seeing and feeling', the explanation he comes up with is trivial: Manet, Duret suggests, felt the need for a touch of colour. Nevertheless Duret's description of the process Manet engaged in, corrected at just one point, takes us, I believe, to its essence, and so suggests the proper explanation that he failed to provide.

Manet, Duret makes clear, in rectifying the picture altered nothing. He left everything as it was and added something. And there is the implication to what Duret says, though Duret does not draw it out, that, until the moment when Manet started to rectify the picture, he was not in a position to do so. In other words, Manet wanted the picture to make a certain initial effect, and it was only when he saw that it could – that is, it was only when it had made this very effect upon him – that he set about, indeed that he knew how to set about, counteracting the effect: counteracting it, not annihilating it. If Duret in broad terms sensed this, he went wrong only when he came to characterize the effect that Manet wished to supersede. He describes it as monochromaticism, and in consequence he represents Manet as trying to overcome it by adding colour: the garnet red, the light green, the lemon yellow. But one omission in Duret's description of the picture before Manet started to adjust it is significant. Duret omitted the brilliant blue tie, which is still, even with the adjustments that Manet made, so striking a feature of the picture.[26] The

139 Edouard Manet
Théodore Duret 1868

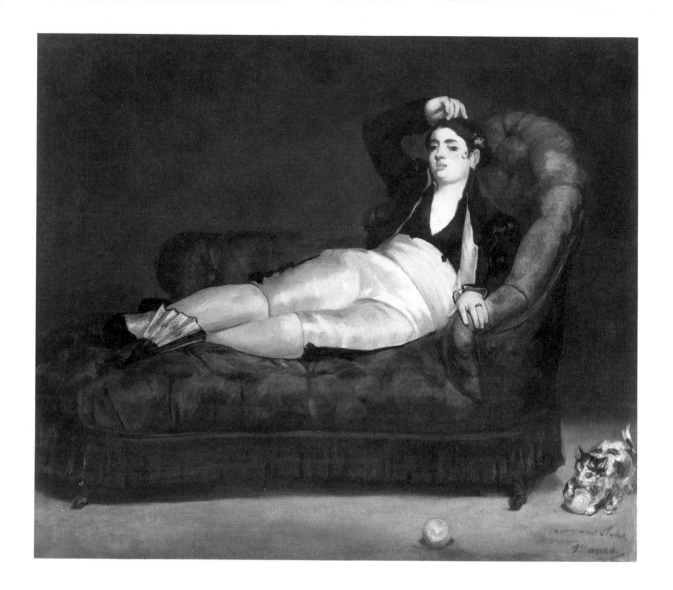

140 Edouard Manet
*Young Woman in
Spanish Costume* 1862

picture was not all grey, and therefore it was not an all-grey or monochromatic effect that
Manet set himself to supersede. What the picture lacked was not brilliance of colour, it
was brilliance of texture, of brushstroke, of *matière*, and it was this that Manet added in the
final session, though he did so through providing it with colour. Why brilliance of
brushstroke was needed was to counteract the very effect that Manet had until that
moment been carefully constructing: the effect of lure.

It goes without saying that there is a danger to a strategy of recall such as I attribute to
Manet. The danger is that the strategy will get ahead of itself and so inhibit the very effect
that it is intended merely to counteract: it might make the initial invitation to depart from
twofoldness one only too easy to refuse. It was, I believe, so as to avoid this danger that
Manet, in adding embellishment, was careful to follow certain principles of distribution.

In the majority of cases Manet distributed embellishment in such a way as to keep it off
the body of the central figure. An extreme example of this restraint, atypical in the total
segregation of the embellishment, atypical too in the direct erotic appeal of the figure –
and the two features are probably linked – is the *Young Woman in Spanish Costume* (Yale 140
University Art Gallery, New Haven, Conn.): there embellishment is segregated to the
right-hand corner of the picture, to the cat and the orange it plays with. This localization
of conspicuous brushwork to detail that is not focal is reminiscent of the great

The spectator in the picture

141 Edouard Manet
Woman with a Parrot,
detail, 1866

142 Edouard Manet
The Street Singer, detail,
1863

143 Edouard Manet
Émile Zola, detail, 1868

seventeenth-century masters on whom Manet formed himself, and it allows the central figure to float free: perhaps too free for Manet's requirements. In more typical cases Manet brings embellishment into close, into telling, conjunction with the single figure, which it now nails down, but it is careful not to cross over its confines. A highly
141 characteristic example is the *Woman with a Parrot*. If we look at the exquisite assemblage of brushstrokes which make up not only the bouquet of violets that the woman holds to her nose but a more or less complete anthology of the painterly effects of which Manet was capable, we notice that the gesture with which the flowers are held has been carefully organized so that this whole passage lies adjacent to, but does not interrupt, the silhouette of the figure. Another example of embellishment distributed in this way is to
143 be found in the portrait of Zola, in the treatment of the thick, figured velvet in which the chair on which Zola sits is upholstered: the treatment is highly enriched, but this is arrested abruptly at the contour of the sitter, who is then left to be painted in a more simplified manner. Finally, there is a borderline example, where such restraint is just about
142 to be abandoned. This is *The Street Singer*, and here the bunch of cherries, which have been crystallized by the sugary paint surface, and the heavy waxed paper in which they have been wrapped, are hugged just within the defining silhouette. The integrity of the figure, so carefully preserved in the pictures we have been considering, is here breached.

The spectator in the picture

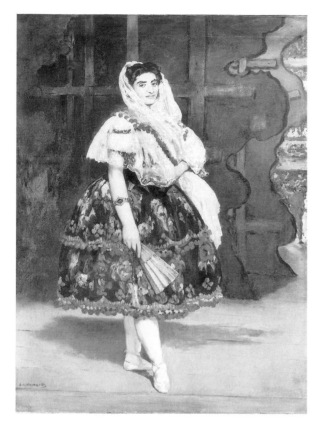

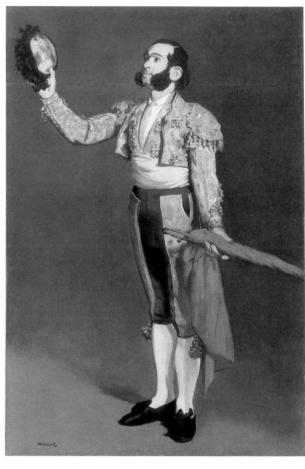

144 Edouard Manet
Lola de Valence 1862

(Above right)
145 Edouard Manet
The Saluting Matador
1866 or 1867

And then there are the cases, the minority cases, where this restraint is not observed at all. Embellishment on a massive scale now floods in on to the single figure. It encrusts the body or the costume with limpets of broken paint. Two examples of the opulence that this engenders are the *Lola de Valence* and *The Saluting Matador* (Metropolitan Museum of 144, Art, New York City). And when this happens, the danger I spoke of as implicit in Manet's strategy of recall seems realized. The strategy is the victim of its own success, and Manet has now to go back and reactivate the lure of the single figure: the credibility of the presence of the spectator in the picture must be re-established. How is Manet to do this? What counter-strategy is open to him?

In those paintings where the encrustation of paint reaches on to the body of the figure we notice a development in an area where Manet's art has often been found defective. Critics, sympathetic and unsympathetic, have commented adversely on Manet's treatment of the face.[27] They have found it inept, curiously inept, and, in line with what I have found to say, this comment should suggest to us that here something may well be afoot: that the depiction of the face has a special role to play. I believe that, in general, Manet's underdefinition of feature, apparent in such paintings as *The Street Singer*, the 127, *Woman with a Parrot*, or *Olympia,* and often brought about by a form of low frontal

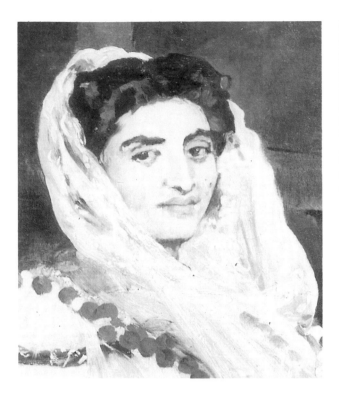

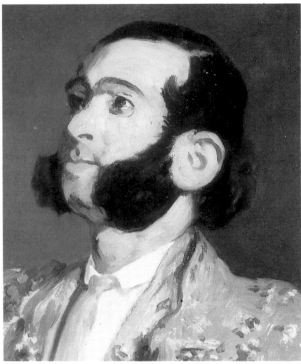

lighting,[28] helps to establish lure. So it is to be expected that, in those pictures in which lure is under threat, Manet should re-consider the face. In paintings where the body is invaded with embellishment, this, we can observe, is just what he does. He mobilizes the face afresh. But the question must arise, Precisely how in such cases is the face to be put to work? A more naturalistic, a more lifelike, treatment would hardly achieve the end that Manet was after. It would hardly restore the element of invitation. But, if in these pictures Manet avoids naturalism, he seeks something that is often associated with the naturalistic effect: physiognomy. As we can see, it is not standard physiognomy that Manet pursues. It is enacted physiognomy, mimicked physiognomy. What Manet in such cases imposes upon his models — and, of course, the chosen subject-matter in each case colludes — is the face of the actor, something at once stronger and weaker than the face it enacts. Stronger in what it promises, weaker in what it is.

Enacted physiognomy re-creates the dream-effect, and the dream-effect is something that I have associated with the aspect of invitation in the single-figure composition. In this respect enacted physiognomy is a brilliant and startling resolution of his immediate problem. Lure has been saved.

But enacted physiognomy has, I think, a further, a profounder, significance for Manet. This takes us beyond the context of the spectator in the picture and how to ensure his presence. It takes us momentarily into deeper issues. For, if we scrutinize the histrionic heads that Manet presents us with, we are struck by something that is, in fact, in reality, never all that far away from the physiognomy of the great actor: ambiguity of gender. In *The Saluting Matador* we can discern an effeminate masculinity: the pursed lips, the flaring nostrils, the taut skin, the roguish look in the eye. In the *Lola de Valence* we confront a mannish femininity: the great bee-sting lips, the bushy eyebrows, the powerful bone structure, the bold stare. Whether Manet consciously appreciated what he was doing or not, the effect, at any rate in the second painting, was not lost on his contemporaries. A

147
146

148 G. Randon, caricature of *Lola de Valence* from *Le Journal amusant*, 29 June 1867

caricature of *Lola de Valence* was entitled *Ni homme ni femme*, and a moustache was inked 148
in.[29] The evocation of bisexuality is at its most florid in one of the very great paintings of
Manet's later years, the neglected *Émilie Ambre as Carmen* (Museum of Art, Philadelphia), 149
where the features have a transvestite eroticism. They are at once winsomely seductive
and provocatively bold. Man and woman lurk inside one another.

An explanation suggests itself, and I give it.

If I am right in tracing back the theme of the preoccupied figure in Manet's work, rapt in
thought, nursing a secret, through the various uncommunicative pairs and groups, to its
source in the bleak image of the parents, separated by what they share, perhaps we can 121
find in this genealogy of the theme something that will account for the lineaments of
sexual impersonation, of *travesti*, of drag, with which in its more extreme variants this
figure is endowed? Might it not be this? Might it not be that this bisexuality of
physiognomy was a late attempt on Manet's part to effect a reconciliation between these
persisting, monumental presences from the past? If it is, it would not be the only time, or
the only way. I suggest that in the *Émilie Ambre* we can see Manet attempting to achieve
through fusion, through merging, the very thing that, only a few months earlier, in the
great *Winter Garden* picture, he had set himself to do through reversal. 122

E. 1. I want now to connect what I have been saying with one of the major precedents that
we find in art-historical literature for the kind of analysis that I have been offering: I have
in mind that great classic, *The Dutch Group-Portrait*, by the Viennese scholar, Aloïs
Riegl.[30] Riegl's monograph, which appeared in 1902, is a fiercely difficult work.

176

The spectator in the picture

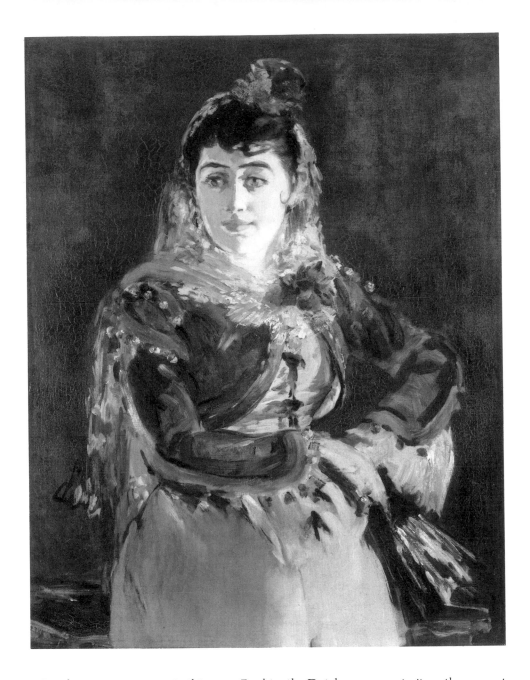

Riegl came at our topic in this way. For him the Dutch group-portrait, or those great painted arrays of syndics, or militiamen, or doctors, which still adorn the museums of Holland, was from the start saddled with two problems, which its practitioners had to confront. The first was how to combine the various represented figures into a unity, given that the group-portrait as a genre denied itself the most obvious device for welding figures together, which is narrative. The second problem was how to preserve within such large groups the effect of a number of distinct portraits, which is, after all, what the genre specifically set out to achieve. Both problems call for a form of unity, but it is a different form in each case. The first problem calls for, in Riegl's terminology, an *'inner unity'*, or a way of combining the figures we see in the picture. Inner unity is contrasted with *'outer unity'*, and outer unity, which is what the second problem calls for, is a form of unity that involves the spectator by bringing him into some relationship with one or more of the represented figures.

149 Edouard Manet
Émilie Ambre as Carmen
1880

The spectator in the picture 177

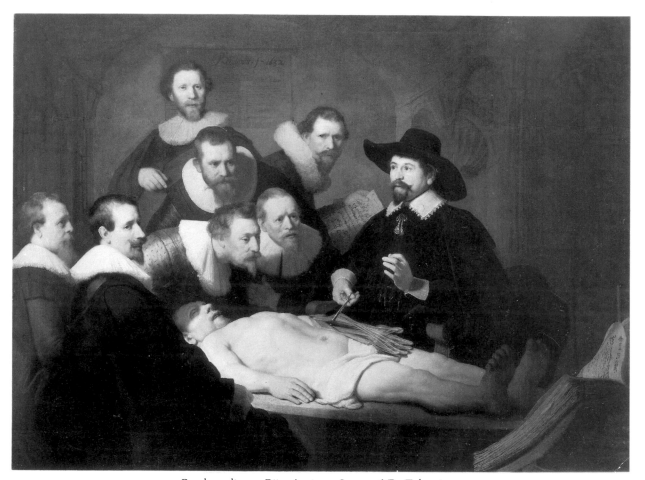

150 Rembrandt van Rijn *Anatomy Lesson of Dr Tulp* 1632

Within the Dutch tradition Riegl identified a strong solution to these problems, which in effect solved the two in one. He called it '*subordination*', and he associated it with the Amsterdam school, which enjoyed a natural ascendancy over the other provincial schools. What is characteristic of subordination is that the various figures are united by looking up to one of their number, on whom they are in some way dependent, and this figure in turn looks outward to the spectator for recognition of his authority. The recognition, when he receives it, lends legitimacy to the respect that the other figures show him. But this mode of composition, though it organizes some of the great masterpieces of the genre, like Rembrandt, *Anatomy Lesson of Dr Tulp* (Mauritshuis, The Hague) and *The Night Watch* (Rijksmuseum, Amsterdam), is for Riegl fundamentally flawed. It is flawed because the kind of inner unity to which it is committed surreptitiously re-introduces narrative, which the group-portrait is, in the interests of portraiture, supposed to have abandoned. In this respect subordination is an ultimately self-defeating solution.

Riegl however suggests another reason why subordination is unsatisfactory, and that

150
151

The spectator in the picture

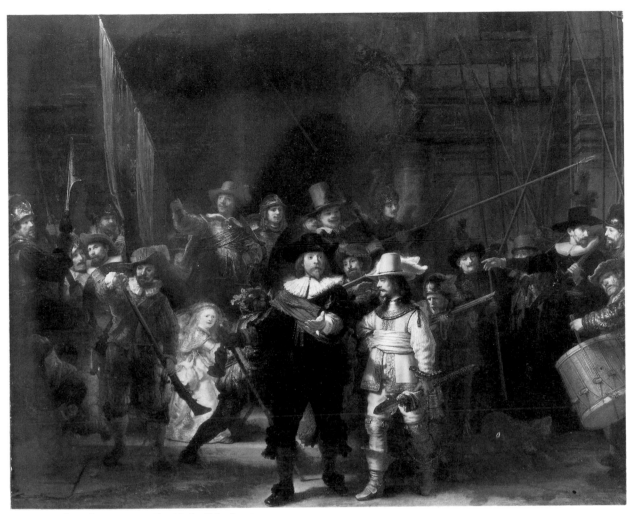

151 Rembrandt van Rijn *The Night Watch* 1642

is because it is a solution that requires inner unity and outer unity to be too closely entwined. They interpenetrate. I have made it clear how the inner unity that subordination seeks is incomplete until the outer unity is forged. But equally the outer unity cannot be attempted until the inner unity is well on its way: the only means by which the spectator can tell who it is to whom he must afford recognition is by observing who it is whom the represented figures hold in respect. It is in the Haarlem school, of which the chief representative was Frans Hals, that Riegl found greatest sensitivity to what we are now in a position to think of as the third, and in some ways the crucial, problem for the group-portrait: that of keeping the two unities in some appropriate balance. The mode of composition by which the Haarlem school achieved this is more improvisatory than subordination and it admits of less ready definition. It may be called '*co-ordination*', and by juxtaposing two of Hals's great militia portraits, five of which decorate the central hall of the Haarlem museum, and by contrasting what Riegl has to say about each, we can get a fair idea of how he thought the Haarlem School went about the problem of balance.

The spectator in the picture

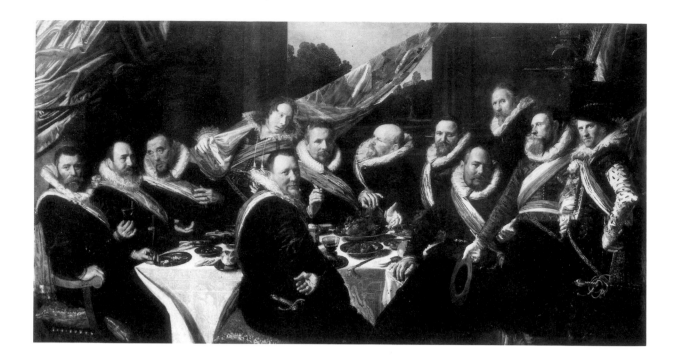

152 Frans Hals
*The Company of St
George 1616 (The St
Jorisdoelen)*

The two pictures, which are nearly twenty years apart, are *The Company of St George*, or 152
the *St Jorisdoelen*, dated 1616, and *The Company of St Adrian*, or the *Cluveniersdoelen*, for 153
which the date of 1633 is traditional (both Frans Halsmuseum, Haarlem). In the later of the
two pictures Riegl detected some resort to subordination: the pull of the Amsterdam
school was proving hard to resist altogether. In the earlier picture, by contrast, Hals is
more Haarlem, he is more himself. Let us see by what means Riegl draws this contrast.

In neither picture is there, Riegl concedes, any very rigid or peremptory inner unity. It
is true that in the later picture Hals for the first time gets rid of the traditional Haarlem
device of the feast as the *mise-en-scène*, and he replaces it with something in the nature of
an action which narrative might capture. However the action is not overly assertive as it
would be with the fully Amsterdam mode of composition. Hals splits the action into two
halves, and the only link between them is through two figures in the right-hand group
who look across to their companions on the left-hand side of the picture. The major
concession that this picture makes to inner unity as subordination understands it lies in
the figure of the captain, who has been brought to the front of the picture, and is seated,
while those around him stand: he reveals his claims to authority instantaneously. In the
earlier picture, organized around the feast, there is even less centralization, and Hals in his
determination to achieve an inner unity that is independent of outer unity, or that does
not call for recognition, relies solely upon the small intimate details of social exchange to
link together the participants. Rank is not pulled.

But for Riegl the big compositional difference between the two pictures lies in the way
in which the outer unity is achieved, or (what he sees to be the same thing) in the role, or
kind of role, that the spectator is asked to perform. In stating and in elaborating this
difference Riegl introduces an interesting distinction. In so far as the 1633 picture reverts
to subordination, the role that the spectator is asked to fill is, Riegl points out, essentially
an *active* role. There is something that he is required to do: to afford recognition. He must
act, if the mode of composition is to be realized. However, when we look at the 1616
picture, in which co-ordination is the compositional mode employed, we see that the
spectator, who is no less indispensable, has a more finely graduated role to fulfil. It is not
enough for him to be purely active. There is a whole gamut of reactive responses that he is
called upon to make. He must learn how to be the recipient of attention, he must

The spectator in the picture

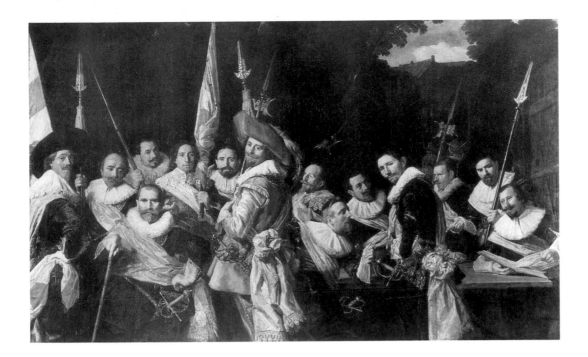

experience what it is to be the object of curiosity, he must be drawn into the conversation of his comrades-in-arms. And Riegl takes the specificity of the spectator's role a step further when, with a characteristic eye for the detail of the picture, he points out how the spectator has to take note of, and then to rise to, the welcoming gesture of the hand that the third man from the right extends in his direction. Riegl calls this, perhaps misleadingly, but by way of contrast with the active nature of the spectator of the subordinational mode, *'passivity'*, and he goes on to insist that the spectator upon whom co-ordination depends must be an expert in fine shades of passivity. It is only through his being so that the relevant form of outer unity is achieved.

153 Frans Hals *The Company of St Adrian 1633(?) (The Cluveniersdoelen)*

2. *The Dutch Group-Portrait* is full of brilliant *aperçus*. I hope I have said enough to make that clear. I have however introduced it into this lecture because of the congruence between much of what Riegl finds to say about the Dutch group-portrait and what I have been claiming for the nature-paintings of Caspar David Friedrich and certain single-figure pictures of Manet.

The presupposition of Riegl's argument is that there are some pictures whose structure we have to understand before we can grasp their meaning, or before their meaning discloses itself. Superficially this view might seem to resemble certain proposals put forward in recent years, which in fact have a very different motivation. These are proposals based on the ill-considered analogy between painting and language. This analogy first foists upon painting something akin to grammar,[31] and then, from the well-entrenched premiss that in our understanding of grammar knowledge of syntax precedes knowledge of semantics, concludes that, in the case of painting, knowledge of composition is a pre-requisite of knowledge of meaning. Riegl's view has no such motivation. Rather it is a view which bases itself on how certain particular pictures, of which the Dutch group-portraits are characteristic, came to be constructed. They were constructed, Riegl tells us, in such a way that they contain at least one figure over and above those which they represent: there is an unrepresented spectator in their midst. This is the structure that we have to recognize if we are to understand these pictures.

Two observations that Riegl makes on this score establish that for him too there is a difference between the external spectator and the internal spectator, and that it is

therefore the latter, not the former, that he is talking about. The first observation relates to the psychology of the spectator he proposes, the second to his location. In the first place, the spectator as Riegl conceives him has a fixed psychology and a fixed set of responses. He has what I have been calling a repertoire, and in this respect he differs from the body of actual spectators of the picture, each of whom will bring to his perception of the picture his own psychology, his own responses, his own repertoire. Secondly, Riegl's spectator exists in the same space as the represented figures rather than in the space occupied by the picture. This we can see from the fact, heavily insisted upon, that he interacts with them, maybe actively, maybe passively, for where else but in the represented space could this interaction occur? It could not occur in the gallery or room or church where the picture hangs.

These two observations lead up to what is in fact the most important point of congruence between Riegl's discussion and mine, which is that he too treats the existence of an internal spectator as inseparable from a role that he must play within the represented scene. Riegl in fact sets out various feasible roles, each one of which defines a particular kind of spectator, and the different kinds of spectator in turn determine different kinds or modes of pictorial composition. The terms 'active', 'passive', and what are evidently gradations between them play a major part in this classificatory system. But the crucial point is that, if there is no intimation of such a role, then, Riegl leaves us to conclude, there is no reason to believe in the existence of an internal spectator. And it is totally in keeping with this last point that Riegl, in classifying pictures according to the mode of composition they exemplify, thinks of himself as retrieving the fulfilled intentions of the artist. In analysing the structure of a painting, Riegl sets out to expose how the painter structured it. He is not simply thinking up interesting or provocative ways in which we might think of the picture: he is not playing to our sense of invention or to our desire for novelty. He reveals how the pictures are in reality.

Nevertheless there is one manifest discrepancy between the conditions that Riegl requires his spectator to meet and the requirements that I have thus far imposed upon the spectator in the picture. I have thus far required – though I have also said that the requirement might need to be relaxed – that the spectator in the picture should be a total spectator, or that his field of vision should be coincident with what the spectator of the picture can see in the picture. It is clear that such a requirement is no part of Riegl's thinking. There are various ways he shows this. For instance, as we have already seen, Riegl, in discussing the *Company of St George*, assumes that his spectator not only is aware 152 of, but is in a position to respond to, the outstretched hand of the figure on the right. But in order to be able to do so the spectator would, if he is man-sized, need to be some way over from the point of origin. Again, in talking of the later *Company of St Adrian*, Riegl 153 hypothesizes a plurality of internal spectators. If there are multiple spectators in the picture, a maximum of one can be at the point of origin. Accordingly Riegl's discussion of the internal spectator provides a good opportunity for rethinking my requirement that he should be total.

When I introduced the requirement at the beginning of this lecture, I pointed out that an unrepresented internal spectator who was unrepresented because he was, say, off in the wings could not possibly serve as the protagonist in the imaginings of an external spectator who was intent upon gaining, through such imaginings, fuller access to the content of the picture in front of him. For an imaginative project that involved a wayward spectator of this sort was likelier to give the external spectator access to some different, hypothetical picture, which represented the same scene as the picture he was looking at but did so in the perspective appropriate to this wayward spectator. An internal spectator whose location gave him a completely skewed perspective on to the represented scene could not be what I call a spectator in the picture.

However it might seem one thing to say that such a wayward spectator cannot be a spectator in the picture, and a further thing to insist that the spectator in the picture cannot deviate an iota from the point of origin, or that any such deviation disqualifies him.[32] So the question must arise whether, and when, an internal spectator who is in any respect short of being a total spectator still has an adequate contribution to make, via imagination, to the external spectator's overall understanding of the picture.

This last way of putting the matter touches upon the crucial consideration. Any requirement upon the spectator in the picture is ultimately answerable to the needs of understanding. Accordingly, if the hard-line insistence that the spectator in the picture must be at the point of origin is to be justified, this must be so by appeal to some underlying requirement upon pictorial understanding which any other location would violate. So, what acceptable requirement could there be which has as its consequence that, if we are to achieve understanding of a picture through — that is, partially through — centrally imagining, the protagonist must be a total spectator?

There is one way of defending such a constraint, which sets about doing so by making a contrast between what can rightly be expected of an external spectator and what can rightly be expected of an internal spectator. Once this defence is turned, the appeal of the hard-line requirement vanishes with it.

The contrast I have in mind goes like this: It does not matter, within reason, where the external spectator places himself if he wants to gain understanding of the picture he confronts. This is because, wherever he places himself, there is no possibility of his seeing anything different in the represented scene from what he is able to see from the standard viewing-point: a different perspective on to the picture will not allow him a different perspective on to what the picture is of. But this, the defence continues, is not true for the internal spectator. If the internal spectator were to depart even minimally from the point of origin, his view of what the picture represents, or of the represented scene, would start to diverge from the way the picture represents it. He would, for instance, begin to see the sides of objects that the picture represents head-on. He would indeed gain a new perspective on to what the picture is of. It is for this reason he cannot be allowed the latitude which we have no reason to deny to the external spectator.

This way of defending the requirement is illuminating. For, by bringing out one particular assumption that any such defence will make, it allows us to break the deadlock. What the defence clearly assumes is that any contribution that identification with an internal spectator makes to pictorial understanding is bound to be fundamentally perceptual. Throughout this lecture I have been contending that this is not the case, and that at least as important as the perceptual contribution is the affective or emotional contribution.

In point of fact pictures that contain an internal spectator are likely to be ordered in this last respect. In some cases the affective contribution that identification with an internal spectator makes to pictorial comprehension will be much greater, in other cases it will be comparatively less, though it will always be sizeable. Now it is as we move towards the end of the spectrum where the affective contribution is greater that, I suggest, we should adopt a more relaxed attitude towards the precise location of the internal spectator. We — by which I mean, of course, the external spectator following the lead of the artist, who in turn follows the lead of the spectator in himself — can allow the internal spectator to drift. The test for any proposed location always remains whether the fruits of centrally imagining a spectator at that point can or cannot be fed back into the pictorial understanding of the picture. But on this issue nothing can be mechanically predicted.[33]

3. I return, as I promised, to a final but fundamental question about the spectator in the picture, and that is how he stands to the spectator of the picture. I have already talked of

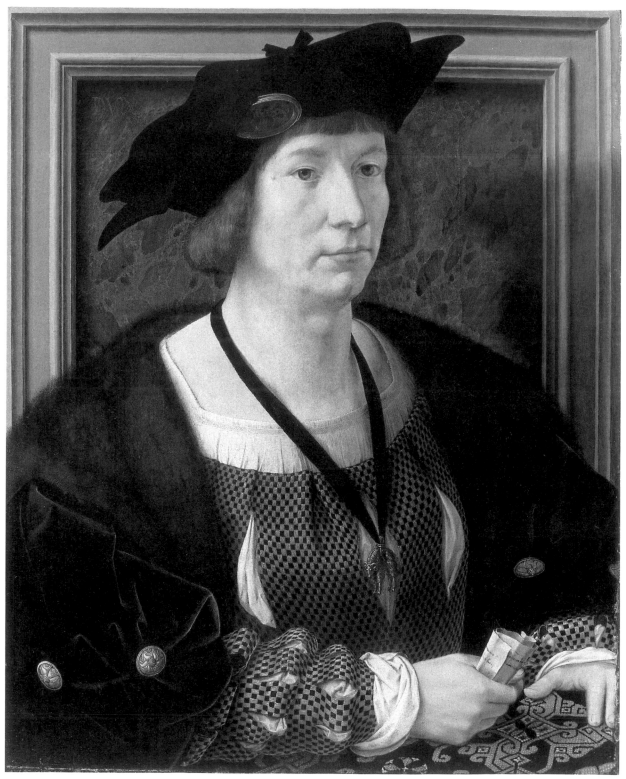

154 Jan Gossaert, called Mabuse *Count Henry III of Nassau-Breda* 1516–17, panel

the difficulties that I see in the way of thinking that they could ever be identical, or that the spectator of the picture might be what the spectator in the picture is of necessity: that is, part of the content of the picture. But I have also suggested a stronger thesis: namely, that claims that the spectator of the picture is, or might be, or, for that matter could have been – that is, would have been if the artist had not taken special steps to stop it – part of the content of the picture are incoherent.[34]

The basic reason that I have for thinking that the spectator of the picture could not conceivably be part of the picture's content, hence could not conceivably be the spectator in the picture, is that, for this to be so, the picture would have to gain content after it left the hands of the artist and without any concomitant alteration to its marked surface. Of course there are changes that a picture can undergo after it has left the artist's hands: the paint can crack. And some of these changes can occur without there being any concomitant alteration to the picture's surface: a painting can come to be admired by a great poet, or it can fall into the hands of a crafty dealer. But I do not see, nor is any explanation ever offered, how, or what the mechanism would be by which, such changes could include change in content or meaning. And if there were such a mechanism, there is a very special difficulty in seeing how it could coincide with the attempt that the spectator of the picture makes to grasp the existing meaning or content of the picture. Yet this is just what would be required if the spectator of the picture were to become, even as he stood in front of it and tried to understand it, the spectator in the picture. We may well ask, What would have to go on in the spectator's head for this to happen, and what conception of pictorial meaning would we be subscribing to in so far as we found this transformation credible?[35]

F. 1. I have not used the word 'illusion' in this lecture. I have not done so because I do not think that the pictures that I have been talking about trade on illusion. They do not require subversion of belief on the part of the spectator of the picture. They involve, in a supplementary role, imagination: that is, a specific kind of imagination, for I recognize that 'imagination' is a hopelessly loose term. Imagination and illusion are quite different.

But there are pictures which could unthinkingly be confused with those I have been talking about, and these generally do involve illusion to some degree. These are pictures which do not ask us to identify with someone entering the represented space: rather we are expected to believe on the basis of what we see that a represented figure enters our space.[36] Much discussion of the phenomenon I have been considering in this lecture is vitiated by confusing these two quite distinct requirements. I ask you to consider two pictures which trade to different degrees on the belief that our space is being invaded.

154 One is Mabuse, *Count Henry III of Nassau-Breda* (Kimbell Art Museum, Fort Worth,
155 Texas), the other is a section of Giulio Romano's famous wall painting, *The Fall of the Giants* (Sala dei Giganti, Palazzo del Té, Mantua). In both cases illusion is engaged with: though this is certainly not the whole appeal of the picture. For more unambiguous examples, for more far-reaching cases, we have to go to two areas not all that far apart from one another: to crudely devotional imagery, the Virgin or Saints descending, visual *bondieuserie*, or to its modern secular counterpart, to the invasive images, at once arousing and climactic, of hard pornography. I offer no examples of either kind.

155 Giulio Romano *The Fall of the Giants* 1532–4, fresco

IV

Painting, textuality, and borrowing:

POUSSIN, MANET, PICASSO

A. 1. In the last lecture I considered a device by means of which the content or meaning of a painting can be reinforced or augmented. Recourse to this device may introduce new content into a painting, but what it does not do is to introduce a new kind of content. What the presence of a spectator in a picture characteristically, distinctively, does for a picture is to enable its existing content to be divulged in a new way and to more potent effect.

But in this lecture I want to consider two ways in which new kinds of content may enter a painting. I call them *the way of textuality* and *the way of borrowing*. What are these ways, when do they work, and to what effect?

2. First, the way of textuality.

When the way of textuality works, *a text* enters the content of a painting. The painting gains *textual meaning* or *content*. And by a text what I mean is something propositional: furthermore it is something propositional that has, and is partially identified by reference to, a history. Examples of a text as I think of it would be a religious doctrine, a proverb, a cosmological theory, a moral principle, a metaphor, a world-view. I avoid the gallicism – though not because that is what it is – whereby a work of literature is called a text: my reason being that a work of literature invariably exceeds, far exceeds, its propositional content.

Initially there might seem to be an inconsistency between my now claiming that something propositional can become part of the meaning of a painting and my maintaining, as I have done in the first two lectures, that pictorial and linguistic meaning are totally different things. For propositional meaning might seem to be peculiarly connected with language. There is however no inconsistency in my overall claim. For, to maintain that pictorial and linguistic meaning are quite unlike is not to claim that a painting can never mean what a piece of language means. Indeed we have already seen that this can happen, though we have not considered it as such. Portraits and proper names can agree in what they refer to. My claim insists only that, when a painting and a piece of language mean the same thing, they do so along totally different routes. Totally different accounts must be given of how Ingres's portrait of Madame Moitessier and how the name 'Madame Moitessier' inscribed underneath it gain their common reference.

Secondly, the way of borrowing.

When the way of borrowing works, then *a borrowing* enters the content of a painting. A painting acquires *historical meaning* or *content*, I shall say. And by a borrowing I mean the fact that a certain motif or image has been borrowed from earlier art. I do not mean the borrowed motif or image itself – that, after all, invariably belongs to the painting that borrows it as well as to the work from which it is borrowed. I mean something about the borrowed motif or image: specifically where it comes from. And this fact belongs only

sometimes to the painting that borrows the motif or image — that is, when the way of borrowing works — and it never belongs to the work from which the motif or image is borrowed.

3. But if this is what happens when the two ways work, when, or under what conditions, do they work?

There is implicit in current art-historical practice a view about the conditions under which the two ways work.[1] The view is wrong about each. It is wrong about each for the same reason. And the common error makes an instructive starting-point.

The way of textuality and its operation are viewed like this: A particular painting represents (say) an event; this event for some reason, natural or conventional, is connected with — for instance, it illustrates or, more specifically, it allegorizes — a certain text; then just this connection is sufficient for the text to become part of the content of the painting. And the way of borrowing is viewed as working in an even simpler fashion. Whenever a painting borrows a motif or an image from some earlier art, this act suffices for the borrowing — that is, the fact that the motif or image has been borrowed — to join the content of the painting.

An obvious feature of this current view is its permissiveness. It makes it very easy for a text or for a borrowing to get into the content of a painting: a point which is indifferent to, indeed it is lost on, those, of whom there are many, for whom it is not a substantive question whether something is or is not part of the content of a painting. For me it is a substantive question. It matters. The question indeed is crucial.

However what is really wrong with the prevailing view, of which the permissiveness is only a symptom, is that it allows a text or a borrowing to enter into the content of a painting without necessarily passing through the mind of the artist or addressing itself to the mind of the spectator. The pre-existent link, by which I mean the link that holds, in the one case between represented event and text, and in the other case between borrowed element and earlier art, and that in both cases pre-exists the making of the painting, does the trick unaided. It is reckoned sufficient to ensure textual or historical meaning. In this respect the view goes right against the psychological account of meaning that I have been urging. Pictorial meaning, I have been claiming, always rests upon a state of mind of the artist, and the way this leads him to work, and the experience that the product of this work brings about in the mind of a suitably informed and sensitive spectator. The view that I am opposing depsychologizes both the way of textuality and the way of borrowing.

To repsychologize the two ways I propose the following: First, that a text enters the content of a painting only if, in representing some event that is connected with that text, the painting also reveals what the text means to the artist. Secondly, that a borrowing enters the content of a painting only if, in putting to new use some motif or image from earlier art, the painting reveals what this borrowing means to the artist.[2] If these conditions are not met, then the text or the borrowing remains outside the content of the painting: it is a mere association to it, perhaps of great historical, or sociological, or biographical, but of no aesthetic, significance.

These proposals psychologize, or repsychologize, the ways of textuality and borrowing in two stages. For, in the first place, they insist that, if a text or borrowing is to enter the content of a painting, then an appropriate spectator can be expected to have, on looking at the painting, an experience that is modified by the text or borrowing. Then, secondly, they go on to require that the way in which the spectator's experience is modified by the text or the borrowing is that the experience will reveal what the text or the borrowing means to the artist. Note, not what the text or the borrowing means, but what it means to the artist: the former is outside the mind of the artist, the latter is within

Painting, textuality, and borrowing

it, and it is by tying the experience of the spectator to the latter, as well as by insisting that the look of the picture mediates the two, that these proposals of mine bring textual and historical meaning within the general account of pictorial meaning that I have been urging.

However, if appeal to what the text or the borrowing means to the artist helps to make the two ways uniform – it helps to make them uniformly psychological – it also points up how they diverge. For, though there is something in common, there is a lot that is different, between saying that a text means something to an artist and saying that a borrowing means something to an artist. In fact there are two big differences: the first difference lies in the kind of thing to which we ascribe meaning, the second difference lies in the kind of meaning we ascribe to it.

The first difference is then a difference in the kind of thing that a text and a borrowing are. The relevant difference is a difference in complexity. A text is a simple thing, and to talk of what a text means to an artist is to talk of what this simple thing conveys to him. By contrast, a borrowing is a complex thing, and to talk of what a borrowing means to an artist is to talk of what one constituent of this complex thing – the borrowed motif or image – conveys to him when it is seen in the light of the other constituent of this complex thing – the context from which he borrows it: it is to talk not just of what one thing, but of what one thing in so far as it is related to another thing, means to him.

And there is more to the complexity of a borrowing: more to separate a borrowing from a text. For, in any adequate account of the way of borrowing, the second constituent of the borrowing, or the context, must be recognized to have a certain flexibility: it cannot, for instance, be automatically equated with the actual source from which the borrowed motif or image is drawn. There are two reasons why this straightforward equation does not hold. In the first place, the context cannot be identified independently of the artist's beliefs. If historical meaning is concerned with what a certain pictorial element conveys to an artist relative to a certain background, this background must be the source as the artist, rightly or wrongly, believes it to be. If the artist has false beliefs about the source from which an element derives, there is no such thing as what this element means to him relative to the source as it truly is. But, secondly, within the framework provided by his beliefs, the artist can choose how much or what part of this background is to be taken into account in considering the motif or image. The crucial consideration here, which the artist can exploit, is that, as its background is allowed to expand or contract, so a given motif or image will vary in what it conveys. A schematic example: A borrowed image will convey different things if the source from which it comes, hence the background against which it is to be seen, is thought of as, successively, something classical, something Roman, a Roman sarcophagus, a Roman sarcophagus depicting the labours of Hercules. This last point may be put by saying that, in borrowing a motif or image from a certain source, the artist always does so under a certain description of that source. This description fixes the second constituent of the borrowing, or what I have called the context. For all its importance this point is systematically overlooked by art-historians. Later on in this lecture I shall illustrate it.

The second difference between saying that a text means something to an artist and saying that a borrowing means something to an artist lies in the different things that we thereby say of the text or the borrowing. To talk of what a text means to an artist is to speak generally of the feelings, thoughts, emotions, that it sets up in him. However to talk of what a borrowing means to an artist is to speak of the feelings, thoughts, emotions, that it sets up in him in so far as he is certain that it will convey these same reverberations to others who are suitably sensitive and informed. In consequence, when the artist resorts to the way of textuality, he has then to find some means of conveying to others the reverberations that the text arouses in him. In trying to do so, he is on his own. He

156 Nicolas Poussin
The Death of Germanicus
1627

experiments, he improvises. However, when the artist resorts to the way of borrowing, he is spared the task of finding means of onwardly conveying the reverberations of the borrowing. For what a borrowing means to an artist is something that is essentially public. But the corollary of this is that, when an artist introduces a borrowing into the content of his painting, he does not do so – standardly, at any rate – for its own sake, as he would with a text, but he uses its public meaning so as to reinforce, or to amplify, some other, some already established, part of the painting's meaning. The way of borrowing has an inherently instrumental aspect, which the way of textuality does not have. It generates fresh meaning, but does so in order to reveal or consolidate existing meaning. Examples will make this clear.

But before I turn to the examples, a final point. So far I have put forward my account of these two ways in explicit contrast to a more permissive view of how they work. But the permissiveness of this view is not, I have said, what is really wrong with it, and this we can see from the fact that, as well as a more permissive, there is a more restrictive, view than mine that also depsychologizes meaning. This is the view that text and borrowing must always lie outside the content of a painting, remaining mere associations to it, no matter how the artist relates to them. This is a reductionist view, and I am against it too.[3]

B. 1. So to the examples: and for the application of what I have been saying about the acquisition of content, I shall look at the work of Nicolas Poussin, initially his early work.[4]

By the early work of Poussin I mean that which he did during his first stay in Rome, which he reached in 1624, when he was already thirty but without a formed style, and

157 Nicolas Poussin
Extreme Unction
1638–40

which he left, reluctantly, in 1640, for Paris, to work under the patronage of Louis XIII and
Cardinal Richelieu. His return to Paris turned out to be brief, and two years later he was
back in Rome where he lived and worked for the rest of his life. For our purposes Poussin's
156 early work may be taken as running from *The Death of Germanicus* (Minneapolis Institute
of Arts, Minneapolis), which is his first independent painting, done in 1627, to, say,
157 the first *Extreme Unction* (collection Duke of Rutland), which is characteristic of
the work Poussin was doing immediately before he left Rome for Paris. A fact, apparent
in these two pictures, is that within Poussin's early work there are in turn two
phases, with the dating of a number of individual works still in reasoned dispute.
There is a first phase, predominantly Venetian in influence, and there is a second phase in
which (to use the critical terminology, the critical slogans, we might say, of the day) the
values of *disegno*, or drawing, win out over those of *colore* and *colorito*. The watershed is
158 established by a picture like *The Triumph of David* (Dulwich Picture Gallery, Dulwich,
London), of 1633, which is forward-looking, in that in it the prevailing influences are no
longer Titian and the baroque, but are Raphael, Domenichino, and the antique or Roman
frieze. Instead of sombre lighting, rich colouring, the use of a red ground, and the
predilection for the diagonal in composition, we now have a clearer palette, a steady light,
well-modelled figures, and planimetric organization. The transition is effected not, of
course, without occasional regression.

　　To illustrate the ways of textuality and of borrowing, I shall be considering in some
detail two paintings, but these paintings belong to, and stand in for, a larger group of
paintings, and this group may be defined by two common characteristics. In the first

158 Nicolas Poussin
The Triumph of David
1632–3

place, these paintings represent themes of love. They show love unrequited, love frustrated, love cut short by death: sometimes, rarely, they show love as a condition of bliss. This erotic subject-matter derives from two principal literary sources: Ovid's *Metamorphoses* and Torquato Tasso's *Gerusalemme Liberata*. Secondly, on behalf of this whole group of paintings the claim has been made – and I accept it – that they have a textual content.[5] In addition to representing certain events taken from Ovid or Tasso – more precisely, through representing these events – they illustrate a text, or perhaps an overlap of texts, treating of the relations between the virtues and the vices. The textual content is to the effect that reason should triumph over sexual desire or concupiscence.

In support of the claim that these paintings have a textual content, two considerations have been advanced by those who make it. On my view of the matter, neither consideration makes the point it is supposed to. The first consideration is that, in the case of both literary sources, there is a very strong tradition of allegorical reading going back to the poet himself. The second consideration is that these paintings, despite the erotic or sensual character of the scenes they represent, are not themselves erotic or sensual: they are, it has been said, the 'reverse of erotic'[6] (whatever that may be).

It should be clear why for me neither consideration is cogent. The first consideration, or the venerability of the allegorical interpretation, bears only on the question whether the events that these paintings represent have a textual content: it establishes that they do, but it does not reach to the further question, which is our question, whether the paintings themselves inherit this content. The second consideration, or the alleged non-sensuality of the paintings, bears even more remotely on our question. Were it already established that these paintings had a textual content, then the chillness with which they

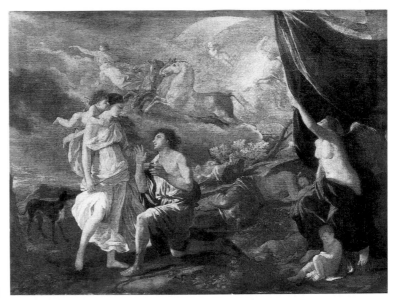

159 Nicolas Poussin
Diana and Endymion 1631–3

160 Nicolas Poussin
Tancred and Erminia 1633–4

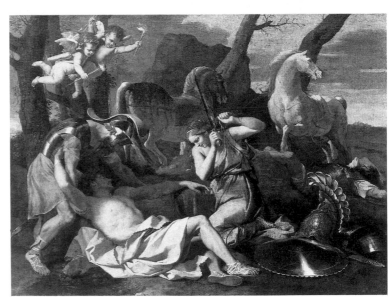

are said to represent the mediating event might – might, no more than that – do something to show what the text meant to the artist. But one thing is indisputable: it cannot be a general requirement that, if a painting gets textual content through some event that it represents, it has to represent that event in a less than whole-hearted fashion.

However it just is not true that these paintings are chill or lack sensuality. The eye provides no warrant for saying so. I hope to establish this in detail with the two paintings that I shall consider at length. But if we take, more or less at random, two other pictures out of this body of early work, paintings of excellent quality but also highly characteristic, 159 one illustrating Ovid, the other Tasso, the *Diana and Endymion* (Detroit Institute of Arts, 160 Detroit) and the *Tancred and Erminia* (Barber Institute of Fine Arts, University of Birmingham), we can surely see that they are heavily sensual works. They are the reverse of the reverse of erotic: even though it is another matter what they have to tell us about the proper place of eroticism in human life. It is another matter what their textual content is, indeed whether they have one. I return to this question and to how I believe it is to be settled. In doing so, I focus, as I said I would, on two paintings.

Painting, textuality, and borrowing

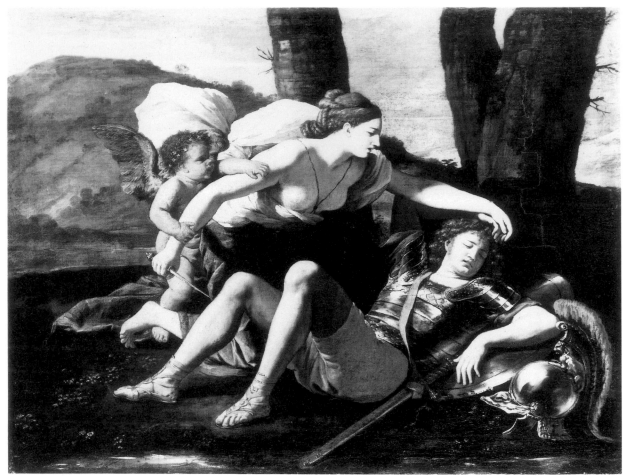

161 Nicolas Poussin
Rinaldo and Armida
1629

162 Gustave Courbet
Le Sommeil 1866

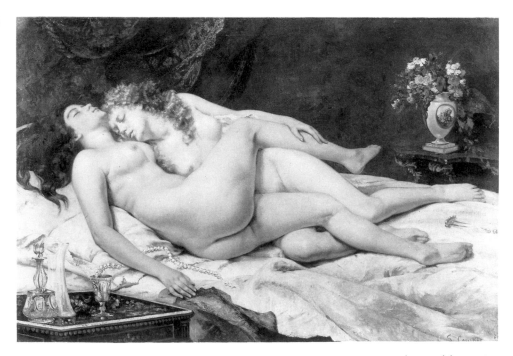

Painting, textuality, and borrowing

2. The first is a Tasso painting: it is the *Rinaldo and Armida* (Dulwich Picture Gallery, Dulwich, London), of 1629. It is one of two paintings in which Poussin represented the moment when the heathen Armida, about to kill the sleeping Rinaldo, a Christian knight, holds back, overcome by his beauty. This event, as it occurs in the epic, allegorizes – and the lead here comes from Tasso himself – the triumph of reason over concupiscence: reason symbolized by the young Crusader, concupiscence by the infidel sorceress. If we ask, now recognizing it to be a further question, And does the painting too, as well as the event itself, allegorize the text?, then, on my view of the matter, we are required to look at the picture to see if, in representing the triumph of Rinaldo over Armida, Poussin revealed how he conceived of the victory of reason over sexual desire, or what this theme meant to him.

(Above left)
163 Nicolas Poussin
Rinaldo and Armida,
detail, 1629

(Above)
164 Gustave Courbet
Le Sommeil, detail, 1866

If we look at this painting, what do we see?

We see a woman of mask-like appearance, in sharp profile, with drapery floating behind her, her breasts bare, kneeling in front of a sleeping young man, her left hand reaching across his head, in her right hand a long stiletto. The young man, whose face is somewhat turned towards us, lies on his armour under a tree. One arm is crooked behind his head, with the hand resting upon a mass of curly hair, reddish in hue with flickering lights. With the other hand he feels the mound of the shield on which he sleeps. His lips are parted. His knees are raised. A plumed helmet stands by his side. The woman hesitates. A winged putto with tiny stellate flowers in his hair pulls back her arm, and stares past her, solicitously, at the sleeping Rinaldo.

The young man, at whom both the woman and the putto marvel, is not, I suggest, the austere and intrepid knight of religious epic, whom at this stage in the narrative we might expect. The relaxed limbs, set off against the burnished armour, the thick furry plume, the breeches of a shot yellowish-orange, which hang invitingly loose around the young man's thighs, tell a different story. They speak of a luxuriant sensuousness. Rinaldo sleeps on his shield, we notice, as though he were sleeping on a woman's breast. And if, coming

163 yet closer to him, we ask ourselves as we do so, Where have I seen this face before?, and then allow our thoughts to wander freely through the tradition of high European art, looking not for borrowings or influences but for physiognomic echoes, for coincidences, for affinities, then a surprising answer, but an answer of surprising precision, comes into

164 consciousness. We have seen this very face in one of the sleeping *bacchantes* of Courbet, over whom high waves of passion must have broken, leaving them cast up on a strand of white sheet, drenched in lassitude. I am speaking (let me remind you) only of an impression, an impression of the moment. But, within the duration of that moment, Rinaldo and *la jolie Irlandaise*, Courbet's model, Whistler's mistress, float in the same subaqueous sexuality. We cannot use this as evidence for, but we might use this as a guide to, what, freed from prior conviction, the young knight's features show us.

Painting, textuality, and borrowing 195

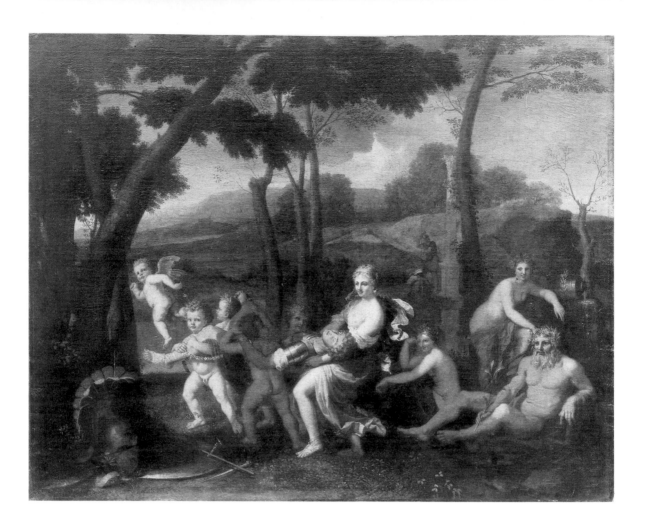

165 Nicolas Poussin
*Armida Carrying off
Rinaldo c. 1637*

All this is to identify one character in Poussin's drama, and to bring the drama itself into focus we must reassemble the eroticized Rinaldo with his opponent, whom, I next suggest, we can see as the neutered Armida. And if 'neutered' seems too strong a word, I propose another experiment. I suggest that we look at another painting by Poussin, *Armida Carrying off Rinaldo* (Gemäldegalerie, Staatliche Museen zu Berlin, East Berlin), 165 which represents the immediately subsequent moment in the epic when Armida, having spared Rinaldo, takes him away, still sleeping, to her enchanted castle. I concede every methodological difficulty that is inherent in comparing, as though they were neighbouring frames in a strip cartoon, two paintings painted seven or eight years apart, one of which, the new picture, is doubtfully autograph, though it surely preserves an original composition of Poussin's, and to which the arbitrariness of power politics makes access difficult. I have not seen the painting myself, whereas I have pored over the other. Nevertheless I believe that the content of the later picture provides us with some evidence for the content of the earlier picture. In the East Berlin picture Armida, directing her triumphant procession, is restored to her natural state, and what is it? She is wreathed in voluptuousness, sexuality has flowed back into her, and, at the same time, as a further piece of evidence, the heavy eroticism of Rinaldo has deserted him. He is a young knight, asleep, and captive. It is hard to resist the inference that the sexuality that Rinaldo exudes in the Dulwich painting he there possesses at the expense of Armida.

If that is how we are to see the Dulwich picture, then, I suggest, not only does the represented drama illustrate a certain moral text, but its representation shows, and for anyone to see, what this text meant to Poussin, and in this way the requirements of the

Painting, textuality, and borrowing

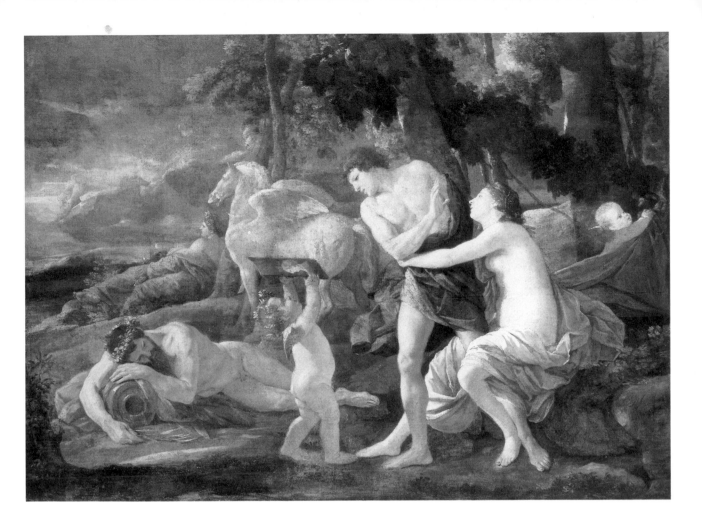

way of textuality are met. The text enters the content of the painting. For, if it is the case that, before Rinaldo can conquer Armida, he must assume her sexuality, thereby at once enfeebling her and fortifying himself so that her loss is his gain, then we may reasonably conclude that for Poussin the victory of reason over concupiscence is achieved through reason borrowing the resources of concupiscence. For him the defeat of desire by reason is experienced as the victory of one kind of desire over another.

In point of fact, in order to convey the inner nature of this moral conflict, of this *psychomachia*, the Dulwich picture draws on more than the representation of the two central figures. It puts to use the third figure, who must be the incarnation, or the external agent, of Rinaldo's reason in its struggle with Armida's desire. For, as the putto, who holds back the arm which holds the dagger, surveys the scene, his childish puckered face is suffused with that same sexuality which, on my perception of this picture, Rinaldo has found himself taking over from Armida in order to ensure her moral discomfiture.

3. My second painting is an Ovidian painting, whose subject-matter, it has been claimed, and I have no reason to doubt the claim, allegorizes the same text as *Rinaldo and Armida*, and again the interesting question is whether the text enters the content of the picture. The picture is *Cephalus and Aurora* (National Gallery, London), one of the so-called 'blonde' pictures, works of great delicacy, which bring to a close the Venetian phase.[7] It is therefore a slightly later picture than the *Rinaldo and Armida*, and the likeliest dating is 1631–2.

166 Nicolas Poussin
Cephalus and Aurora
1631–2

166

Painting, textuality, and borrowing

This painting represents the attempt by Aurora, goddess of Dawn, to suborn the young mortal, Cephalus, whom she has abducted, but who loves his wife, Procris. Poussin has chosen the moment when day is about to break: Aurora's mount, signifying the morning star,[8] stands harnessed: but Aurora dallies, and Cephalus struggles to disengage himself from the embrace of the goddess. He will succeed, and my suggestion is that, once again, we are made to feel that the strength necessary to overcome desire comes, and necessarily comes, from desire – though, in this case, it is not desire borrowed from another, as Rinaldo borrowed desire from Armida, it is desire that rises up from within the moral actor himself. It is not the desire of another, it is desire for another. In order to resist the charms of the exquisite Aurora, Cephalus recruits his love for Procris, and he does so by summoning up, through the agency of a putto, who again may be thought of as the incarnation of the rational faculty in its struggle for moral ascendancy, a physical picture of his wife, which is presumably a materialization of a mental image. The demonstration of Procris's portrait to her husband's eyes does not occur in Ovid, it is Poussin's own contribution to the drama, and its introduction is surely so as to signify the source to which reason has recourse in order to arm itself against sexuality. It indicates the source to be sexuality itself, and the archaic style of the image, modelled as it is upon a Quattrocento profile portrait,[9] hints, we might think, at a particular feature of this source to which some of its power is due. It hints at the conservatism of the instincts. Sexuality hankers after its old objects, and, in this case at least, this works to the benefit of duty. Through the represented scene Poussin shows us that it is not open to Cephalus that he should first rationally reject Aurora and then return to the love of Procris: he needs the love of Procris in order to fight off Aurora. For it is thus that reason, love, and sexual desire interact in man's pursuit of virtue.

Cephalus and Aurora then coheres with *Rinaldo and Armida* in instantiating the way of textuality as I see it: repsychologized. Both paintings gain a text in the very same way, and, as chance would have it, they gain the very same text. However *Cephalus and Aurora* is of further interest to us because it also – as I shall show in a minute – instantiates the way of borrowing. It gains a borrowing as well as a text as part of its content, and, as chance would further have it, in this painting the way of borrowing co-operates with the way of textuality. What I have in mind is this: I have said that, when a borrowing enters the content of a picture there is, all but invariably, some part, some further part, of the picture's content that the borrowed motif or image, bringing with it recollections of its context, reveals or reinforces; it is in this respect that the way of borrowing functions instrumentally. If we now ask of *Cephalus and Aurora* what part of its content it is that is consolidated in this way, it turns out to be that very part of its representational content through which the painting appropriates its text: that is, that very part of the painting in which Poussin discloses how he experiences, how he conceives of, the victory of reason over concupiscence. There is, of course, no reason why the ways of textuality and borrowing should co-operate, but it is neat when they do, and it provides a highly concrete example of that drive towards pictorial unification of which so many aesthetic theorists have spoken.

So I now turn to the way in which this painting instantiates the way of borrowing. In point of fact, in the *Cephalus and Aurora* there are two borrowings, and both co-operate in this fashion with the way of textuality.

In the first place, in deciding to interpolate into the Ovidian story the device of the portrait, Poussin, it has been pointed out,[10] re-employs a conceit which had previously been used by Rubens in the Marie de Medici cycle in the painting called *The Presentation of the Portrait to Henri IV* (Louvre, Paris), which shows Hymen and Cupid presenting Henri IV with a picture of the young princess to whom he is now betrothed: an ingenious invention. I believe that it is plausible to think of this as not just a repetition but a

Painting, textuality, and borrowing

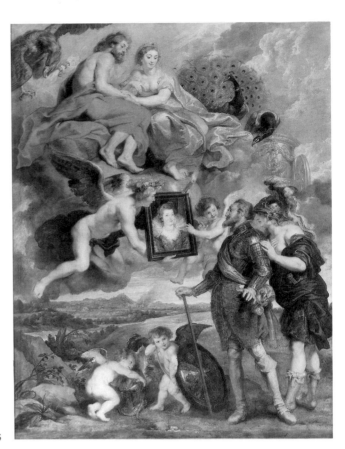

167 Peter Paul Rubens
The Presentation of the Portrait to Henri IV 1623

borrowing. The *Presentation of the Portrait* was almost certainly amongst the first lot of paintings in the cycle to be completed, and these, nine in number, were installed personally by the artist in the Luxembourg in May 1623.[11] In consequence Poussin, who was working in the Luxembourg[12] just before he left Paris for Italy in the summer or early autumn of that year,[13] might well have had the chance to see it there, and he is likely to have remembered at any rate the invention – and the invention itself is all that is at issue. Secondly, for the pose that Cephalus adopts as he gazes at the portrait, Poussin clearly went to a picture that we know he knew well from the time he first arrived in Rome: that is, to Titian, *Bacchus and Ariadne* (National Gallery, London), then in the Aldobrandini collection in Rome, and he borrowed from this painting the image of Bacchus as he leaps from his chariot to embrace Ariadne.[14]

6, 170

Now both these borrowings are, I contend, part of the content of *Cephalus and Aurora*, and not mere associations to it, and that is because, in each case, Poussin exploits the history of the borrowed image to underscore what it is that this image represents. Poussin exploits the Titian borrowing to show us that, when Cephalus rejects Aurora in favour of Procris, he is not merely a man following the call of reason, he is a man transported by the same enraptured desire, the same passionate abandon, as fired the young drunken god when he hurled himself upon a fresh conquest:[15] and he exploits the Rubens borrowing to show us that, when Cephalus responds to the picture of his wife, he does not do so out of an abstract sense of duty, he is as infatuated as a young suitor who catches sight of his future bride in an image cunningly designed to enflame his feelings. By taking us deeper into the mind of Cephalus – deeper, that is to say, into the mind of Cephalus as Poussin envisaged it – these borrowings show us how, according to Poussin, the conflict between reason and desire is there fought out. It is fought out, they show us, they remind us, ultimately as a battle between desire and desire.

Painting, textuality, and borrowing

199

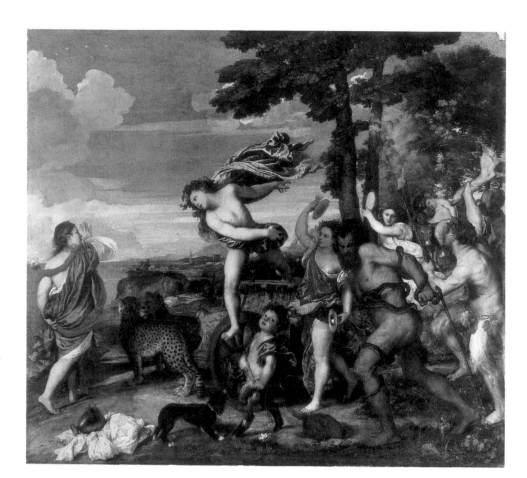

168 Titian
Bacchus and Ariadne
1523

(Below left)
169 Nicolas Poussin
Cephalus and Aurora,
detail, 1631–2

(Below right)
170 Titian
Bacchus and Ariadne,
detail, 1523

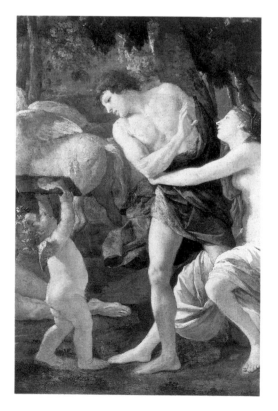

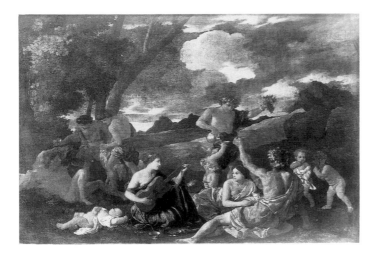

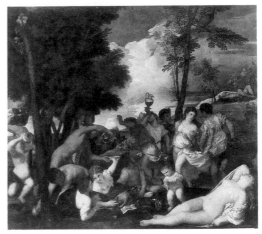

Now the fact that Poussin has in each case used the history of the borrowed image to make the image more emphatic earns the borrowing a place in the total content of the painting. In each case the condition upon which the way of borrowing depends is met, and so the way operates. But when we further concentrate on what specifically it is that in each case the borrowed image emphasizes, we see that in both paintings the borrowing serves to confirm how Poussin conceived of the proper ascendancy of reason over desire. The borrowing confirms the textual meaning of the painting, as well as cementing the place of this text within Poussin's painting. The way of borrowing not merely operates: it co-operates with the way of textuality.

(Above left)
171 Nicolas Poussin *Bacchanale with Lute-Player* 1630

172 Titian *The Andrians c.* 1518

4. Any conception of how reason relates to sexual desire – particularly a complex conception like Poussin's, which portrays reason mobilizing desire against desire – belongs inside a larger conception of instinct and of the place it occupies within human nature. Poussin, I believe, had such a larger conception, he gave it expression in his art, and the place where he found to do so was – and where else? – the representation of nature. Poussin's representation of nature corresponds to the way, and hence to shifts in the way, in which he conceived of instinct. This is a claim I wish to explore.[16]

A preliminary point: Such a claim presupposes that in his art Poussin afforded nature a distinct recognizable identity or that he gave it a separate status. He did, and one way of seeing this is to contrast his art with that of the artist to whom at any rate in his earliest paintings he tried to approximate: Titian. Let us juxtapose Poussin, *Bacchanale with Lute-Player* (Louvre, Paris) and Titian, *The Andrians* (Prado, Madrid). The two paintings share a subject-matter, for both are attempts to actualize one of the imaginary pictures invented and described in some detail by the rhetorician Philostratus: and Poussin surely thought of Titian's painting in painting his own. Poussin's painting has even been spoken of as a copy of Titian's.[17] Now in the Titian nature is like an atmosphere which reflects the mood of man. It emanates from the figures. In the Poussin, by contrast, man is part of a frieze stretched out in front of nature: for all the thinness of the representation, nature makes itself felt as a contrastive presence. Later on this apartness of nature is confirmed and reinforced by the way in which, as has been justly observed,[18] Poussin uses light so as to illuminate nature from the outside. Light does not infiltrate nature. Nature resists. The role of light is to model nature, as we can see from a detail of a painting that I shall consider at greater length.

Its presupposition satisfied, I return to the question, What underlying conception of instinct is it that Poussin's representation of nature reveals?

Painting, textuality, and borrowing 201

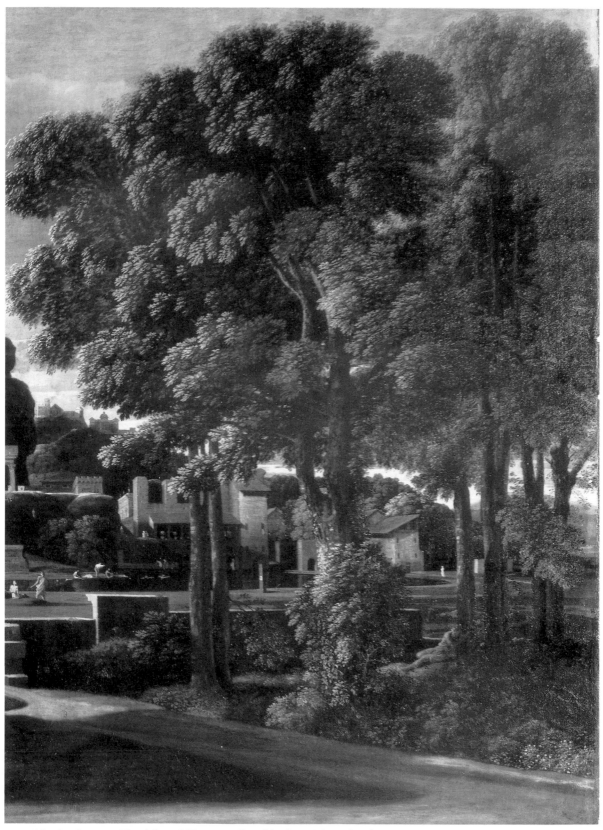

173 Nicolas Poussin *The Ashes of Phocion collected by his Widow,* detail, 1648

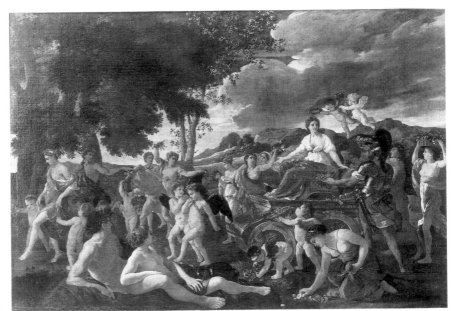

174 Nicolas Poussin
The Triumph of Flora 1627

175 Nicolas Poussin
Kingdom of Flora 1630–1

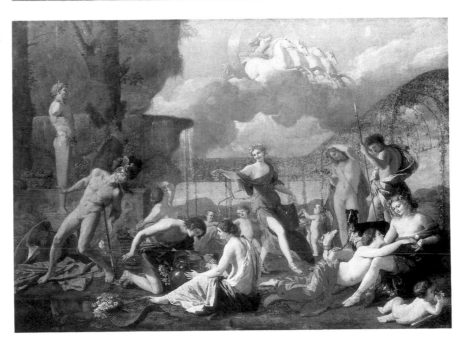

An important clue is provided by the Ovidian pictures, and by the highly selective use, noted by scholars, which they make of their literary source.[19] Of the several kinds of metamorphosis that Ovid recounts, Poussin illustrates only the transformation of human into flower. There is no painting of his that illustrates the transformation of human into animal, or into star, or into mineral. That this was deliberate we can confirm from the two large anthology pictures that Poussin prepared from the *Metamorphoses*: the early *Triumph of Flora* (Louvre, Paris), of 1627, and the magnificent *Kingdom of Flora* (Gemäldegalerie, Alte Meister, Sächsische Landesbibliothek, Dresden), another of the blonde paintings. For here Poussin collected a cast of characters exclusively from the floral metamorphoses, and indeed in the Dresden painting he assembled all the floral metamorphoses of which Ovid makes mention: Ajax, Narcissus, Clytie, Crocus, Smilax, Adonis, Hyacinthe. In individual paintings he never moved outside this cast.

175

Painting, textuality, and borrowing 203

What are we to make of this self-imposed limitation?

Undoubtedly various motives are at work here. For instance, it can be no accident that the floral metamorphoses readily lend themselves to allegory upon the death and resurrection of Christ.[20] In so far as Poussin puts them to this end, they comment on the doctrine, and thus the doctrine enters, via the way of textuality, into the content of the picture. Indeed in the case of two metamorphic paintings, *Venus with the Dead Adonis* (Musée des Beaux-Arts, Caen) and *Echo and Narcissus* (Louvre, Paris), the way of textuality is again reinforced by the way of borrowing, for, in depicting both the dead Adonis and the dead Naricissus, Poussin employs a pose familiar from a pietà. By disposing the limbs of the two mortal lovers after those of the dead Christ, Poussin raises the power of the pagan myth to convey to a spectator his particular sense of a Christian mystery.

In point of fact, seen as examples of the way of borrowing, these two pictures are of further interest because they bring out an aspect of historical meaning that I have mentioned and said that I would illustrate. When an artist borrows a motif or an image from an earlier source, there is (I have said) so much of the setting and no more that he expects the borrowed element to bring with it. He expects the borrowed element to bring with it just as much of the setting as it needs in the way of background for it to have the meaning the artist wishes it to carry. I have put this point by saying that meaningful borrowing always occurs under a certain description of the source, and this description isolates that part of the source knowledge of which was intended by the artist to make, and is actually capable of making, a significant difference to the way in which we perceive the borrowed element. It establishes what I have called the context for the borrowed element. I believe that both the *Venus with the Dead Adonis* (Musée des Beaux-Arts, Caen) and *Echo and Narcissus* (Louvre, Paris) illustrate this point very well. For it is clear that, to the extent that these pictures were intended to have the doctrine of the resurrection as some part of their textual content, Poussin did well to borrow, and to make us aware that he had borrowed, the pose of a pietà. Knowledge that the source is a pietà, some pietà or other, allows us to see the bodies of Adonis and Narcissus in ways that heighten their capacity to carry what this text conveyed to Poussin. But it is not at all clear how knowledge of the particular pietà from which Poussin derived the pose could deepen our perception of the picture, or, for that matter, how Poussin could have thought that it would, or could have intended it to do so. Therefore any such further information is, despite the efforts made by art-historians to assemble it, likely to provide no more than mere associations to the picture. It does not help to define the context.[21]

However, looking at the Ovidian pictures, we are likely to feel that, in explaining Poussin's preference for the floral metamorphoses, pride of place goes to the fact that it allowed him to portray nature — or, more precisely, nature in so far as it is benign — as a place of boundless richness and fecundity. Two examples of the early work, neither metamorphic, reveal, in their different ways — and do so the more powerfully because they have little else in common — this conception of nature as a prolific force. One is the *Acis and Galatea* (National Gallery of Ireland, Dublin) from the Venetian phase, an opulent work, to whose intimations of turbulent sexuality Yeats in some remarkable lines responded so powerfully:

> Foul goat-herd, brutal arm appear,
> Belly, shoulder, bum,
> Flash fishlike; nymphs and satyrs
> Copulate in the foam.[22]

Painting, textuality, and borrowing

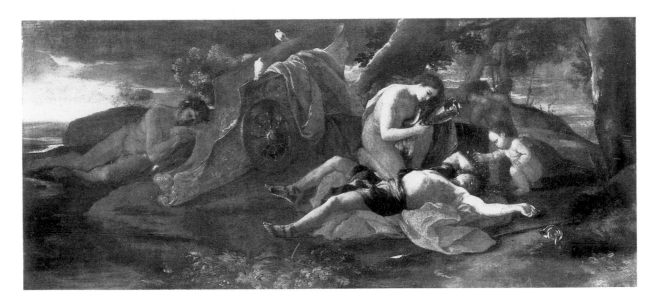

176 Nicolas Poussin *Venus with the Dead Adonis c. 1630*

177 Nicolas Poussin *Echo and Narcissus c. 1630*

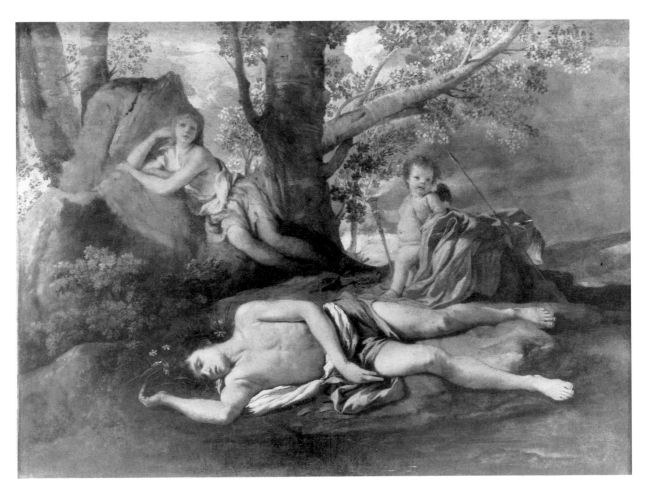

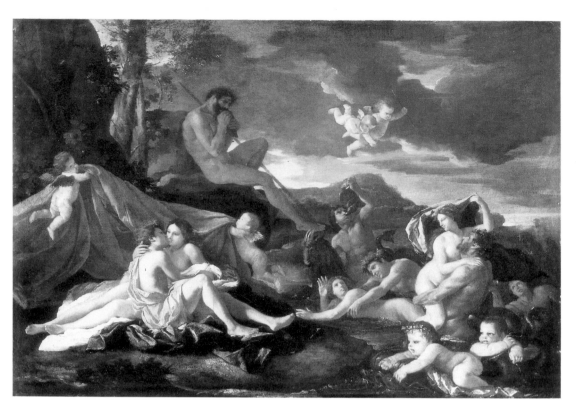

The other is the exquisite *Nurture of Jupiter* (Dulwich Picture Gallery, Dulwich, London), of the late 1630s. *The Nurture of Jupiter* is an extremely subtle work, and it makes its point in a correspondingly subtle way. For its structure comes into focus only once we visually identify something which is in fact one of the traditional symbols of nature's fecundity. At the very moment at which the eye makes out the fine swarm of bees hovering to the right of the central tree, the picture reorientates itself, and it does so with such force as to convince us that it is now correctly perceived.[23]

But the floral metamorphoses not only celebrate fecundity, they conjoin fecundity and death. Fecundity is bought from nature at the price of death, and in the eery *Echo and Narcissus* Poussin explicitly makes the point that death can reward even the sterile — sterile Echo, sterile Narcissus — with fertility. The generative force of nature is a regenerative force.

If we now interpret, as I have suggested that we should, Poussin's depiction of nature as expressing a conception of instinct, we get this: that there is within human nature an autonomous force of instinct which in its beneficial operation retains its link with birth, with propagation, with self-renewal, a link which, in turn, involves an acceptance of death — an acceptance, I suppose, both of the fact of death, and of our own deathly or destructive side. And this conception permeates the whole of Poussin's work, with time acquiring elaboration, subtlety, and the stain of pessimism.[24] It requires us to think of Poussin as someone very different from the stern portraitist of rationalistic man which scholarly tradition has held him to be.[25]

179

177

Painting, textuality, and borrowing

(Opposite above)
178 Nicolas Poussin
Acis and Galatea 1630

(Opposite below)
179 Nicolas Poussin
The Nurture of Jupiter
1635–6

180 Nicolas Poussin
The Triumph of Neptune
1635–6

181 Nicolas Poussin
Landscape with St John on Patmos 1640–2

The connection forged by Poussin between nature and fecundity is perceptually so powerful that it would not be surprising if we were to find him sounding variations upon it. He does. One such variation is, I suggest, a correspondence between nature – nature considered broadly as the backdrop to human action – and what might be called mental fecundity. By mental fecundity I mean that unbounded capacity of the mind, of which we become aware in moments of reverie or inattention, to generate an indefinite profusion of thoughts, memories, images, wishes, hopes, fears. What cements this correspondence is a new compositional device in Poussin's work, of which we need to take stock. We first encounter this device in such paintings as *The Triumph of Neptune* (Philadelphia Museum of Art, Philadelphia), of the mid-1630s. It is strong in a work like the *Landscape with St John on Patmos* (Art Institute, Chicago), painted just before or just after Poussin's visit to Paris,[26] and it comes fully into its own in the 1640s and 1650s. It is found in paintings with a landscape, and the device is this: at a certain plane in the receding vista, around the point when detail starts to lose acuity, there is a reversal, the landscape suddenly renews itself, and we are treated to a remote vision of classical buildings and diminutive scenes of ancient life. There is a landscape behind the landscape. A developed example is the second *Finding of Moses* (Louvre, Paris). This was painted in 1647. Another example, from the following year, is the lyrical *Eliezer and Rebecca* (Louvre, Paris). The device is forced upon our attention when we start to contrast characteristic pictures of this middle period with earlier paintings where, in the most natural way, visual interest and visual acuity

180

181

182,

183,

Painting, textuality, and borrowing

182 Nicolas Poussin *The Finding of Moses* 1647

183 Nicolas Poussin *Eliezer and Rebecca* 1648

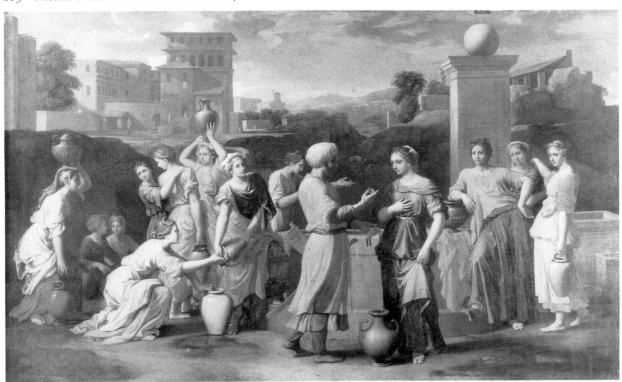

184 (Top) Nicolas Poussin *The Finding of Moses*, detail, 1647

185 (Above) Nicolas Poussin *Eliezer and Rebecca*, detail, 1648

186 (Opposite above) Nicolas Poussin *The Plague at Ashdod* 1630–1

187 (Opposite below) Claude Lorrain *St Philip baptizing the Eunuch* 1678

peter out as we go back into the represented space; an example would be *The Plague at* 186
Ashdod (Louvre, Paris), of 1630–1. But there is another and much more powerful way of
bringing the landscape behind the landscape into focus. For, if we want to isolate for
ourselves the essential difference between Poussin and his great contemporary Claude as
painters of nature, we can, I believe, do no better than try to imagine Claude introducing
into his work this kind of background, and see how it would have jeopardized the uniform
recession of tone and detail which, for deep reasons, he seems to have valued above all 187
things. For Claude the landscape is as a whole distant. Even the foreground is remote, as
remote as the world of reverie to which it is the gateway.

210 *Painting, textuality, and borrowing*

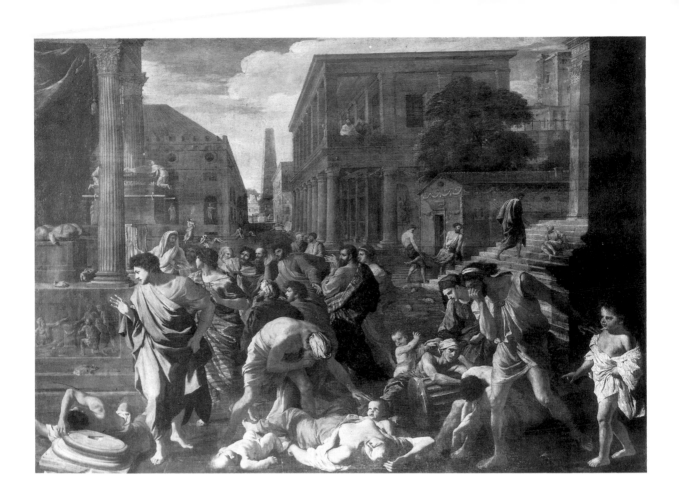

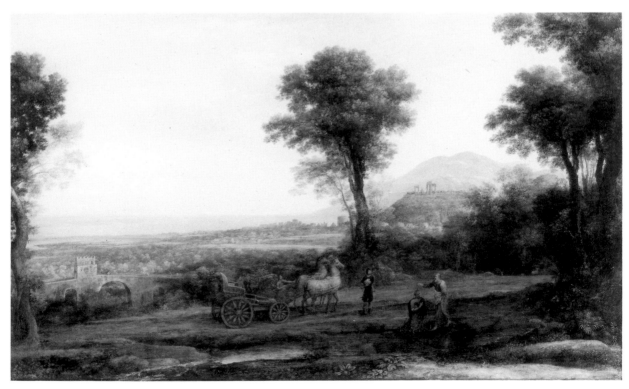

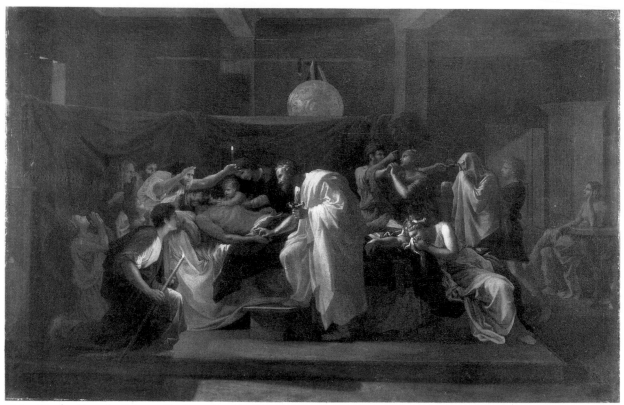

188 Nicolas Poussin *Extreme Unction* 1644–8

189 Nicolas Poussin *Marriage* 1644–8

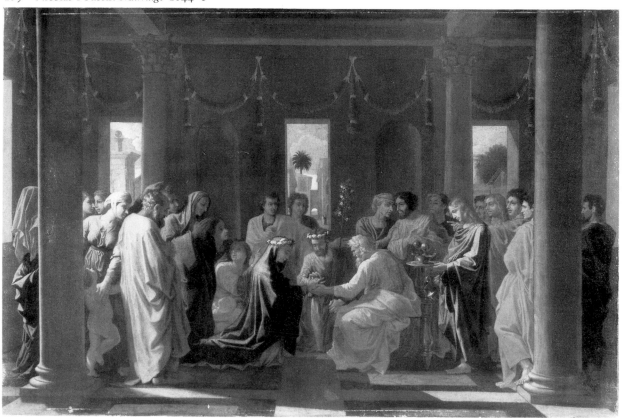

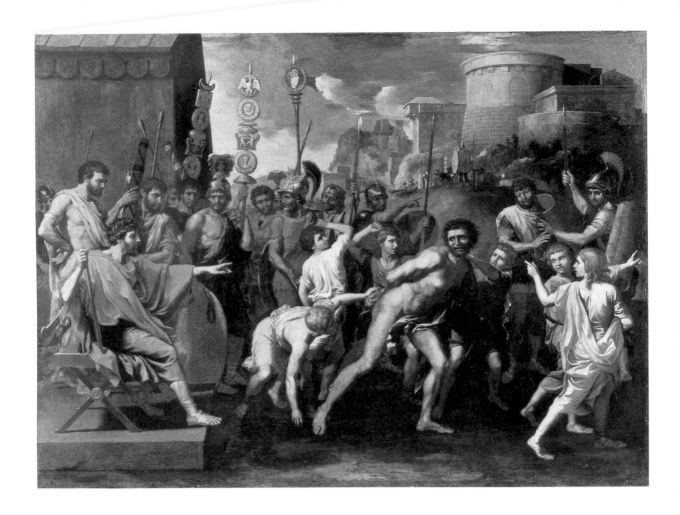

My suggestion then is that this new device corresponds to mental fecundity, and we can test this correspondence in front of the paintings I have in mind. Thoughts and feelings that lie unattended to on the edge of consciousness are successively aroused and becalmed, soothed and teased.

190 Nicolas Poussin
*Camillus and the
Schoolmaster of Falerii*
mid 1630s

5. Poussin's major achievement of the 1640s is the great set — the second set — of *Sacraments* (collection Duke of Sutherland: on loan to the National Gallery of Scotland, Edinburgh), painted for Chantelou. They are amongst the grandest paintings in the world. A look at the sacrament of *Extreme Unction* and the sacrament of *Marriage* should satisfy us on this score. But towards the end of the decade and at the beginning of the next, Poussin painted some pictures the current view of which makes them run counter to what I have been saying. These are the so-called heroic landscapes, which the interpretative work of Walter Friedlaender and Anthony Blunt has led to our seeing as allegorizing the world-view of Stoicism.[27]

The heroic landscapes are, in fact, part of a larger group of paintings and large-scale drawings, executed from the mid-1630s onwards, all of which are concerned with Stoicism. The others relate to Stoicism straightforwardly, for they represent characteristic events in the lives of famous figures of antiquity, who either were Stoics or were appropriated by the Stoics for their austerity and nobility of character. Such pictures include the two versions of *Camillus and the Schoolmaster of Falerii* (Louvre, Paris; and The Norton Simon Foundation, Pasadena), celebrating a general's refusal to take advantage even of the treachery of an enemy, *Coriolanus* (Hôtel de Ville, Les Andelys), and *The*

Painting, textuality, and borrowing 213

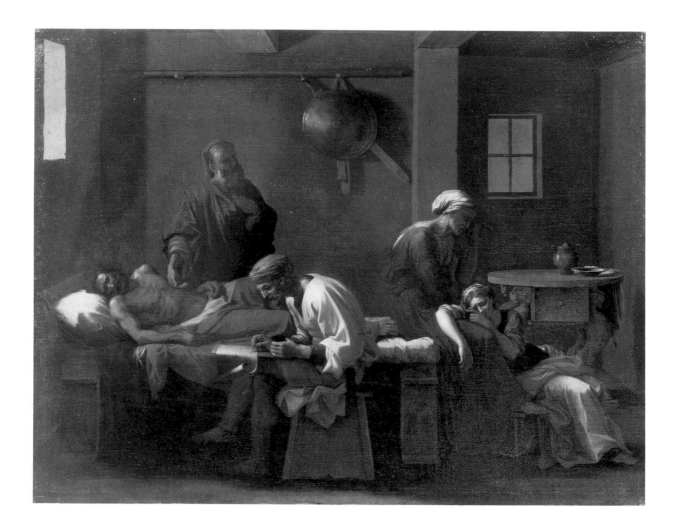

191 Nicolas Poussin
*The Testament of
Eudamidas* 1643–4

Testament of Eudamidas (Statens Museum for Kunst, Copenhagen), a picture so exemplary 191
for later generations.

However, the heroic landscapes, or the pictures which are supposed to cause a difficulty for my account, relate to Stoicism in a more complex way. In point of fact, they relate to Stoicism in a way that duplicates the complex relationship in which, according to the Stoics, the Law of Nature, or the supreme principle of the universe, stands to the universe. For the Law of Nature relates one way to man, another way to natural phenomena. It relates to man normatively, in that it tells man what he ought to do. It relates to natural phenomena constitutively, in that it describes what they cannot but do: obeying the Law of Nature makes them what they are. Accordingly the heroic landscapes show us two different things. They show us some event, or the trace of some event, in which an outstanding human being endeavours, by an exercise of the will, to bring his conduct into conformity with the dictates of nature – hence they are heroic – and they also show us – hence they are landscapes – non-human nature conforming to these same dictates by the necessity of its being.

And this brings us to the difficulty that the heroic landscapes could be thought to present for what I have been saying about Poussin's representation of nature and the way it delivers us his conception of instinct. In fact, there are two possible difficulties. For, in

Painting, textuality, and borrowing

the first place, in so far as these pictures illustrate the Stoic world-view, then they cannot represent nature as a force of powerful fecund energy. They must represent nature severely, geometrically. And, secondly, if, by some lapse, here and there nature is represented as a powerful or unruly force, this force cannot be meaningfully correlated with instinct, for, within the Stoic world-view, instinct has no moral role to play. A Stoic painter can have no interest in disclosing a conception of instinct.

Quintessential to the heroic landscape are the two Phocion paintings, both executed in 1648, and let us see what light they throw on this issue.

These two paintings tell the story of the Athenian general Phocion, as Plutarch recounts it. In the confusion surrounding the collapse of the Macedonian empire, Phocion, an enemy of popular rule — like Poussin himself — was, at the age of eighty, unjustly arraigned by the party of democracy on a charge of treason, and put to death. As a traitor he could not be buried on Athenian soil, and in the first painting, the *Landscape with the Body of Phocion carried out of Athens* (collection Earl of Plymouth: on loan to the National Gallery of Wales, Cardiff), we see his corpse being carried out of Attica to the neighbouring city-state of Megara where, as the second painting, *The Ashes of Phocion collected by his Widow* (Walker Art Gallery, Liverpool),[28] shows, his widow — or according to a mistranslation of Plutarch, on which Poussin, who had little linguistic learning[29] would have depended, a woman of Megara[30] — gathered up his ashes so that they could be buried later. I shall concentrate on the second painting, because it is on its behalf that the claim to illustrate Stoicism in a way that runs most directly counter to what I have been saying has been made. 'Never', writes Blunt of this picture, 'have the order and harmony of nature been more impressively depicted'.[31] He writes of 'the geometry of the whole design', of 'nature reduced to architectural order'. It goes without saying that, in a picture of which this description was true, an artist who used nature to express his view of human nature could not have disclosed the motive force of action, *a fortiori* of morality, as lying in instinct.

But I do not find that this description, with which, to the best of my knowledge, all students of Poussin concur,[32] tallies with the evidence of the eyes, and let me resort to the tactic of describing what I see.

The painting falls, compositionally, thematically, and expressively, into three distinct zones, the relations between which turn out to be crucial to the meaning of the picture.

In the foreground the woman — widow or mere citizen, whichever it is — is crouched over her act of piety. She scrambles up all that is left of a great man. Her companion, who stands guard, turns on her heel, and, the fingers of one hand tensed parallel to the ground, she looks round anxiously towards the city of Megara, which lies half in shadow, stretched out across the middle distance. A range of rustic palaces and large granaries with arcades and loggias runs parallel to the picture plane and is dominated and embellished by the Corinthian portico of a large temple. On the plain in front, the citizens go about their lives with absorbed serenity: young men practise archery, a horse is groomed, old women sit and gossip, a man walks reading from a papyrus, there are swimmers in the stream, a couple make music, and in the dark embrasures of the buildings tiny blobs of saturated colour indicate spectators, or laundry, or pots with flowering plants. No one, except for the foremost figure, a young watchful man seated against a tree in the grove on the right, spares a thought for what the woman is doing. And then, in the background, immediately behind the line of buildings, and accounting for the shadow in which it partially lies, undomesticated nature reasserts itself, and the shaft of a mountain thrusts upwards from out of the thick curly forest that clings to its root. It disrupts the life of the city, which resumes in scattered grandiose buildings the far side of it. An air of untamed mystery attaches to the mountain, and this is intensified by its irrational shape, which its silhouette does not reveal: no accidental or chance effect since in the *Christ*

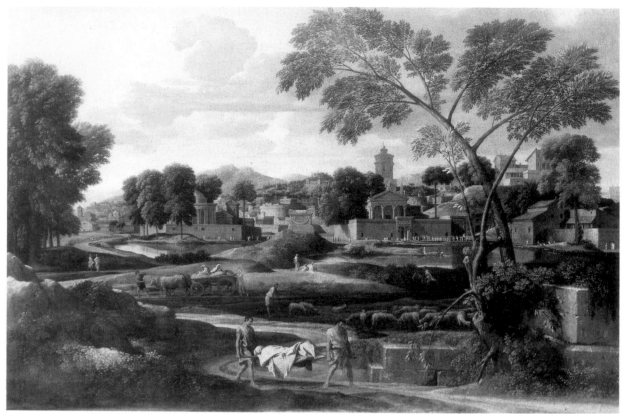

192 Nicolas Poussin *Landscape with the Body of Phocion carried out of Athens* 1648

193 Nicolas Poussin *The Ashes of Phocion collected by his Widow* 1648

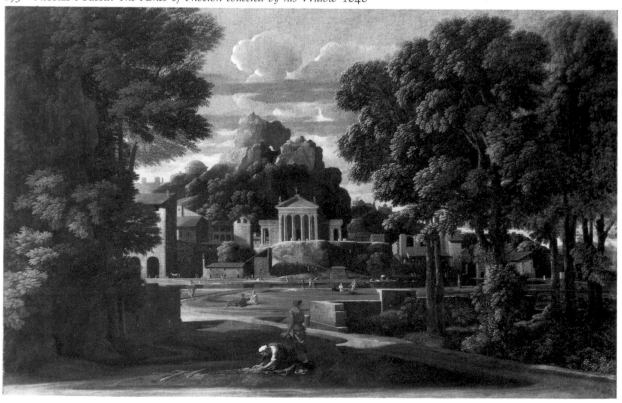

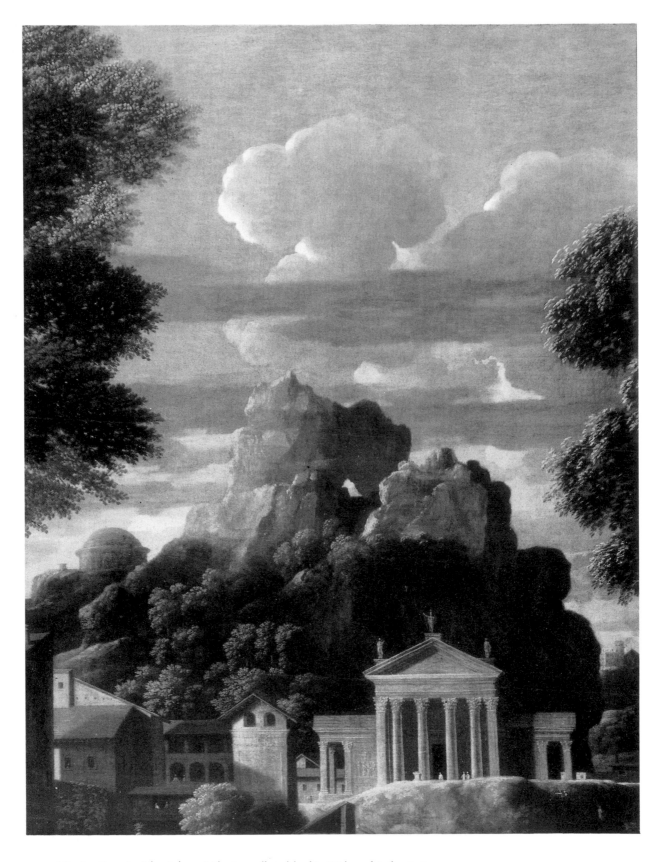

194 Nicolas Poussin *The Ashes of Phocion collected by his Widow*, detail, 1648

Healing the Blind Men (Louvre, Paris), painted two years later, Poussin repeats this 195 conjunction of clear silhouette, obscure volume, and achieves the same expressive value. Nothing could be further away from Raphael, whose influence is otherwise so strong in both these paintings. Recent cleaning of the Phocion painting confirms that Poussin 196 cultivated the effect of mystery, for pentimenti show that he enlarged the stone mass both sideways and upwards. This mystery is then taken up in the foreground by the unexplained breeze which sways the massive ilexes, enlarged surely beyond anything that Poussin could have observed in a Mediterranean climate. The wind causes the foliage to rise and fall, so that each clump of leaves is an elusive variation upon a common form: the variation baffling the eye somewhat more than the common form satisfies it. It is not true, at any rate of this cleaned picture, that, as Blunt asserts, the trees are 'as immobile as if they were carved out of stone'.[33] At least one quintessential heroic landcape does represent nature as a dark mysterious force, whether it should or shouldn't.

And why shouldn't it? Let us return to the objections and consider their force.

The first objection is that any such representation would be incompatible with the Stoic view of nature as falling under the governance of law. I doubt this. For though, indeed, Stoicism does say that nature is, throughout, rationally ordered, it does not say that this is how nature appears to us, or that this rational order is manifest to our human faculties. Given that our faculties are clouded by emotion and by partial experience, it is highly unlikely to be so. If Stoicism does not guarantee the geometric perception of nature, which it does not, it cannot enjoin the geometric representation of nature.

This is important for an overall understanding of the heroic landscape and its meaning: because, if a painting of Stoic inspiration does not have to represent nature in any one particular way, then the actual way it does so can become expressive. Specifically, it can become expressive of how the painter conceived of instinct, which may in turn be part of how he conceived of Stoicism.

At this point the second of the two objections will be brought in. It is that it cannot be of interest to an artist of Stoic inspiration to express his conception of instinct, because instinct has no real part to play within the Stoic world-view.

But to raise this as a difficulty shows only a misunderstanding of what I have been saying. I hope this is apparent: anyhow let me clear it up. For, in talking so far of what a text means to an artist, of what Stoicism meant to Poussin, I have not been talking about what would be some further text: a second text to gloss the first text. No, I have been talking about how Poussin experienced Stoicism or what reverberations it set up in him. So Stoicism in its moral teaching could have been experienced by Poussin as pitting instinct against instinct, even though Stoicism itself, for better or for worse, makes no explicit reference to instinct.

I return to the second Phocion painting.

Just how this painting does disclose what Stoicism meant to Poussin, and what it discloses, are in fact implicit in the redescription I have given of the painting and of the zones into which it divides itself. In the foreground, by the side of a rustic fountain, the great moral act unfolds, and the look of apprehension with which the attendant figure regards the life of Megara serves to disjoin the foreground from the middle ground. A veil of suspicion falls between them. But the foreground, disjected from the middle distance, now associates itself with the background. Poussin has made the near trees, as they part to reveal the city, rhyme with the distant shape of the mountain: their silhouettes repeat one another. But the strongest link between the two bands of landscape is the elemental force that animates both. Rising in the deserted mountain-top, circumventing the protected, placid life of the city, it rustles the enormous trees that stand above the woman's improvised shrine. The leaves as they sway above her turn and catch the downward rays of the sun.

Painting, textuality, and borrowing

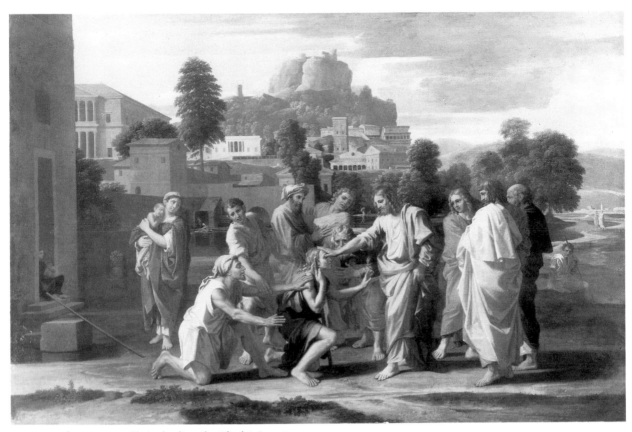

195 Nicolas Poussin *Christ healing the Blind Men* 1650

196 Nicolas Poussin *The Ashes of Phocion collected by his Widow* 1648

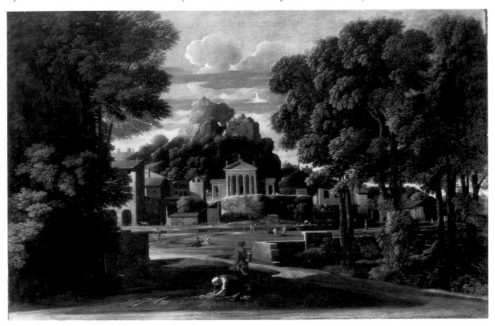

In her stubborn act of piety the woman has placed herself beyond the world of custom and civic obligation: complacent *sittlichkeit* has nothing to offer her. But she is not alone or unaided. The wind, the little stream that oozes its way into, or out of (we cannot tell which), the darkness of the wood, and the ominous trees that shelter her – these are her accomplices. The energy for such transcendent acts of probity, this picture shows us, comes not from conventional morality, it comes from the natural stirrings of instinct.

6. To confirm this perception of the Phocion painting I propose to turn to the great *Landscape with Diogenes* (Louvre, Paris), whose relevance to the issue is assured by its 197 subject-matter. For Poussin here illustrates the well-known story of how Diogenes, having reduced his possessions to a cloak and a drinking-bowl, sees a young man drinking water out of his cupped hands, and thereupon throws away his bowl as the superfluity he now recognizes it to be. In a painting which concentrates upon the moment when a man of great moral intensity, whom the Stoics were later to appropriate, questions what it is to live according to nature, and which invokes nature on a grand scale for its *mise-en-scène*, the representation of nature cannot be silent. It must have something to tell us about how Poussin envisaged the life of nature – about both how he envisaged this life from the outside, or the demands that it made on human action, and how he envisaged it from the inside, or the forces upon which it drew in meeting these demands.

And this painting does not disappoint us.

For Poussin's thoughts about the outward aspect of the life of nature we need only to look to the depicted drama and its immediate setting, confined to the bottom fringe of this large canvas: for there the sand, the pebbles, the clear water, reminiscent of the foreground of a great painting of which we shall hear more in two lectures' time, Bellini's Santa Corona altarpiece, provide the landscape of refined austerity. But to grasp how Poussin conceived this life on the inside or motivationally, we need to spread our attention over the rest of the picture, which, perched on this narrow pale ledge, is then banked up in an enormous pile of prolific blue-green foliage. The untamed side to nature, shot through with mystery, already disclosed in what must now with hindsight seem subtle, muted, elusive, ways in the *Phocion* painting, is here dominant across the picture.

This pervasive effect of fierceness and mystery is enhanced by what will prove to be two recurrent devices in Poussin's late work and which here make an early appearance. The first device is a tendency to all-over colour. In the early period, and in both sets of *Sacraments*, Poussin uses a wide and brilliant palette. But increasingly he went in for large expanses of a single colour – green mostly – and in Poussin's hands this does not produce, as it does in the great silvery landscapes of Claude, such as the very late *Ascanius Shooting* 198 *the Stag of Sylvia* (Ashmolean Museum, Oxford), a sense of peace and harmony. On the contrary the all-over colour irradiates the picture with a sense of threat or encroachment. This registers fierceness, or the untamed side to nature and the life of nature, and for the mystery we must now look to the other 'late' device. I have spoken of the landscape beyond the landscape in Poussin's mature work, and now I have to point out how in some of the late work there is a development in this area. The far landscape retains its identity – it remains a second landscape – but now it gets entrapped in the main picture. The effect is uncanny. It is like a fly caught in a spider's web. Its own distinctive form of life still circulating within it, it offers a disquieting alternative to the central drama. The *Diogenes* provides us with a good example of what I mean. The lake is recaptured for the main picture by the trees which encircle it. Then, as we peer into it, we notice that its smooth surface is cut by a line of swimmers. They swim across it, in single file, from left to right, at about its widest point. They are engaged, we have to believe, in some highly purposeful activity, but whose end is concealed from us. The activity responds to a form of rationality that we can glimpse but cannot grasp.

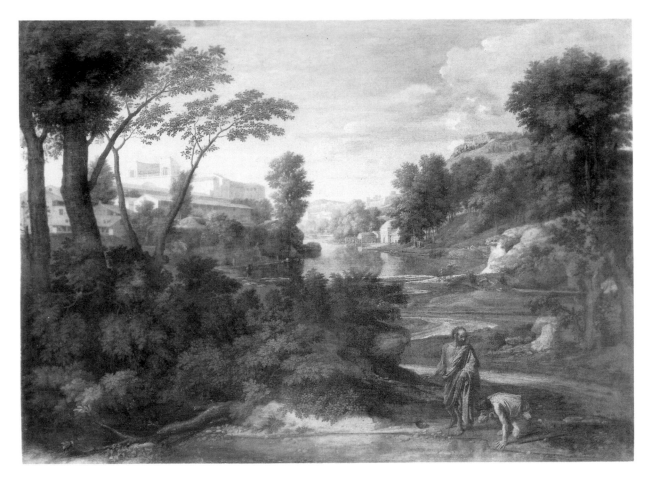

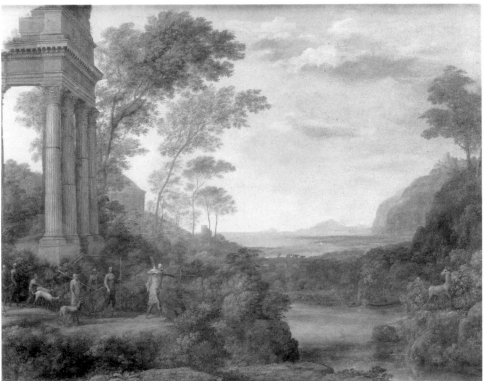

197 Nicolas Poussin
Landscape with Diogenes
1658(?)

198 Claude Lorrain
*Ascanius Shooting the
Stag of Sylvia* 1682

I have been using the *Diogenes* to confirm my perception of the second *Phocion*. The legitimacy of this argument might be thought to depend on the two paintings' being more or less contemporary. Traditional scholarship claims that they are, dating both (and a number of other great pictures) to 1648. The authority here is Poussin's early biographer: Félibien.[34] But recently, basically on stylistic grounds, a date in the late 1650s has been proposed for the *Diogenes*.[35] What sort of difficulty would this proposal, which I find plausible, create for my argument? I say, None. None, for, given that we have, as I claim, independent evidence, or the evidence of the eyes, for the dynamic conception of nature in the second *Phocion* painting, my argument can only be confirmed by a yet more dynamic conception in the *Diogenes*, whether we then go to explain the difference in degree by the later date of the *Diogenes*, or by its more explicit subject-matter, or by both, or by something else. It isn't, after all, as though the *Diogenes* were original or primary evidence for my interpretation of the *Phocion* painting; for in that case the date would have mattered. My primary evidence for the interpretation of the *Phocion* painting is the *Phocion* painting itself.

7. As Poussin's work moves towards its close — he died in 1665, a year after he left the great *Apollo and Daphne* (Louvre, Paris) unfinished because he felt he could no longer control his shaking hand — there is a shift, not a break, but an important shift, in his representation of nature, indicating to us, as I see it, a shift of a kind for which I have suggested that we should be prepared in the way he conceived of instinct and its place in human life. But it is not that shift in the representation of nature which modern scholarship would derive from the overall interpretation it has forced upon the mature work of Poussin. It is not a shift from an abstract or geometric representation of nature to one that is emotionally charged. It is a shift in the emotional charge.

For, if in the early paintings nature is represented as flourishing in the guise of fertility, with fertility standing in stark contrast to sterility, increasingly in the late work fertility is revealed as itself an ambivalent force. It is to be experienced as at once benign in its profusion and yet dangerous and destructive in its excess, with profusion always falling over, or about to fall over, into excess.

In point of fact this expressive shift is connected with another change which comes over Poussin's work around the same time and which in part paves the way for it. It is a change that has largely gone unremarked. It was first commented on by Charles Dempsey,[36] who also proposed an interpretation, but his ideas have not been absorbed into the understanding of Poussin. The change that Dempsey discerned and the shift in emotional charge to which I refer are connected in two ways. In the first place, the change, or what lies behind it, accounts for some of the content of the shift in charge: it accounts for what it is that from now onwards the representation of nature will express. Secondly, the change enlarges and enhances the power of represented nature to express this new charge: it facilitates the shift.

The change itself is this: Up to some moment in the 1650s, the mature Poussin set himself, in depicting classical or Biblical scenes, to provide, within the limits imposed by the written or physical evidence, as archaeologically accurate a setting as could be achieved. To this end Poussin read widely, he amassed historical evidence, he did drawings after pieces in various collections, he modified and combined images from ancient sources, and he tried to construct a vision of antiquity that would be not only correct in material detail but also authentic in the general effect that it conveyed. Then at a certain point, or about three-quarters of the way through his career, Poussin seems to have changed course. Manifestly the ambition is no longer to reconstruct the past as it actually was. New concerns emerge.

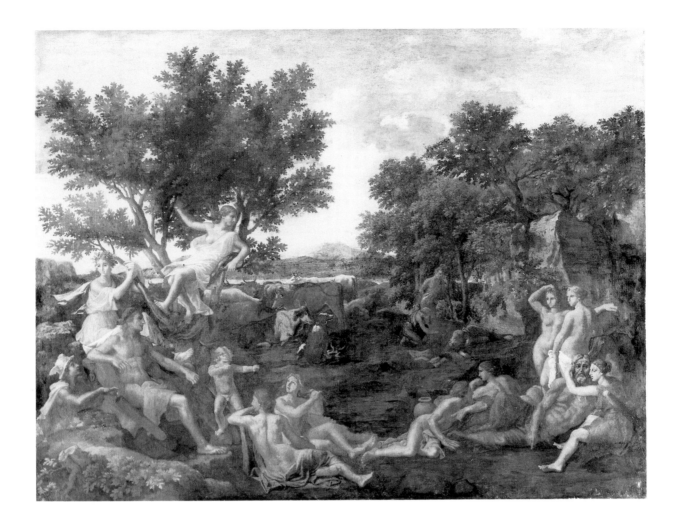

Dempsey, who establishes the change through a consideration of Poussin's Egyptian
paintings, concentrates upon two major paintings of the mid-1650s: *The Exposition of*
Moses (Ashmolean Museum, Oxford), of 1654, commissioned by Jacques Stella, and *The*
Holy Family in Egypt (Hermitage, Leningrad), of 1655–7, comissioned by Chantelou, the
patron of the second set of *Sacraments*. The two paintings exhibit the retreat from total
antiquarianism in rather different ways. In the later picture, which also happens to be the
more conservative, the foreground and the middle distance are still committed to
historical and geographical reconstruction, and it is only as the eye peers into the
background that authenticity is seen to falter and that Egypt, Egypt as Poussin conceived
it, gives way to an unmistakable, unapologetic vista of Rome. In the earlier, and more
progressive, picture the departure from fidelity to time and place had already gone much
further. The arid landscape, which Poussin habitually associated with Egypt, has been
replaced by a landscape of dense luxuriance. Only a single palm tree and the river-god of
the Nile, clasping a statue of the Sphinx, are left as souvenirs of the land of the Pharaohs.
And then, across the river, and in this picture no longer confined to the background but
protruding into the middle ground, stretch the monumental splendours of Rome. Such
sublime indifference to fact argues a turnabout in aim.

Description is accompanied by interpretation: Dempsey produces an explanation why
this change came about. His argument is that Poussin's commitment to archaeological

199 Nicolas Poussin
Apollo and Daphne 1664

reconstruction lasted just so long as for him the essential significance or importance of the narratives that he illustrated lay in their claim to recount what actually happened at some precise moment in space and time. As confirmation of this close connection in Poussin's mind between antiquarianism and an insistence upon the actuality of the sacred or secular events, Dempsey notes that hand in hand with the pursuit of historical accuracy went the pursuit of common-sense explanation: the archaeologizing tendency is accompanied by a rationalizing tendency, whereby details that were miraculous in the original accounts from which Poussin worked are replaced by their naturalistic counterparts. On a broad front Poussin set himself to represent events from our cultural past in such a way as to maximize their probability for the spectator.

Accordingly, when Poussin ceases to pursue historical plausibility at all cost, when reconstruction is no longer a priority and the archaeological commitment begins to fail, it is reasonable to assume that this is because he now felt a dissatisfaction, a growing dissatisfaction, with such a narrow or localized view of what the Bible or history has to tell us. Biblical and historical narratives are no longer to be thought of as referring primarily to events that occurred in space and time and that make them true. The events spill over. In the more retardataire *Holy Family in Egypt*, Egypt, which occupies the foreground where the action is, gives way to Rome on the horizon so as to make the point that the future, or the triumph of the Church, is already foreseen in one of the earliest recorded moments in the life of Christ. However in *The Exposition of Moses* Poussin's new indifference to factuality is more extreme. It takes him far beyond the juxtaposition of different and distinct historical times in the same representational frame. The past, and to a lesser degree the future, are revealed as inserted into, or as part of, the present. If the *Holy Family in Egypt* is, in its sophisticated way, an exercise in time-travel, *The Exposition of Moses* shows us that, remaining within the present, we are still exposed to the multiplicity of temporal experience.

I have contended that this departure from antiquarianism, and its meaning for Poussin, feeds into the expressive shift betrayed in his late work in two distinct ways. Poussin's ahistoricism at once encourages a different perception of the world, and makes its expression easier, and both fit in with the new ambivalence.

In the first place, this sense that the past survives within the present, or that the present is heavy with the future, fosters in a general way the view that nothing is, for better or for worse, just what it appears to be. Disturbing forces, not fully assimilated, not fully anticipated, lurk within the most placid settings. An ambiguous perception of the world we inhabit is thus encouraged. It is encouraged and then intensified when, this perception gaining its own dynamic, the spectator starts to transfer the sense of the infiltration of the present by the past, or the germination of the future within the present, from the life history of the species, where it arises, to the life history of the individual, where undoubtedly it is more ominous and more at home. And, secondly, once the representation of nature is cut free from the constraints of antiquarianism, it is able to serve as a more effective vehicle of human expression. The point may appear to be a repetition of what I said earlier about the greater expressive value of represented nature once it is no longer constrained by Stoicism to present a geometricized appearance. But there is a difference. For the present point is made not, as the earlier point was, against a false interpretation of Poussin: it is made so as to introduce a new stage in his artistic development. For a time Poussin's art did indeed experience the constraints of antiquarianism, whereas it never experienced the constraints of geometricization. Furthermore the point is stronger. Nature, now represented as holding within itself different layers of time, of culture, of instinct, becomes not merely a more flexible, it becomes a vastly more potent, a vastly more disturbing, vehicle of expression. It is now a vehicle admirably suited to express the new ambiguity of feeling.[37]

(Opposite above)
200 Nicolas Poussin
The Exposition of Moses
1654

(Opposite below)
201 Nicolas Poussin
The Holy Family in Egypt
1655–7

Painting, textuality, and borrowing

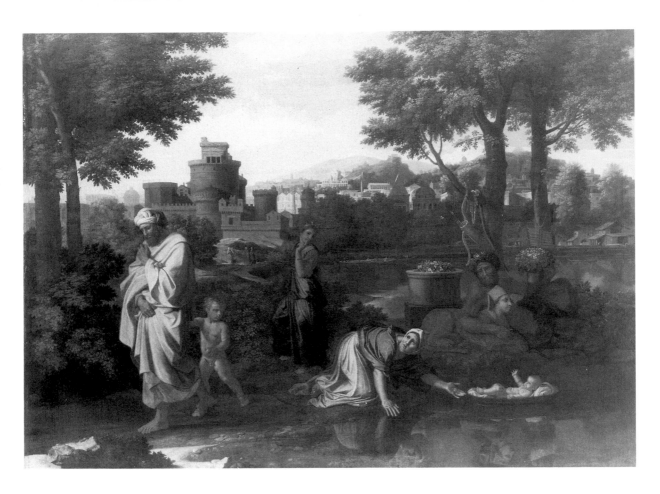

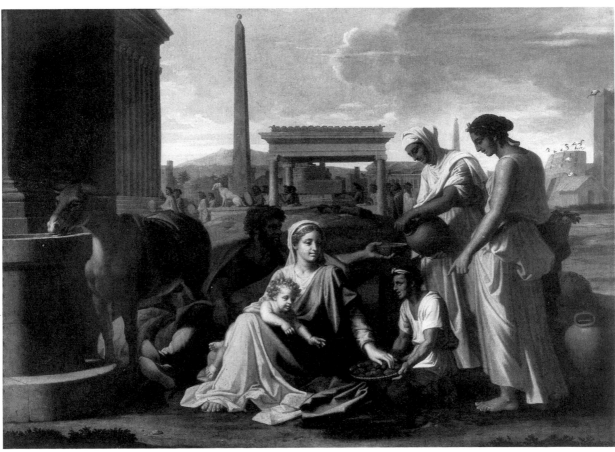

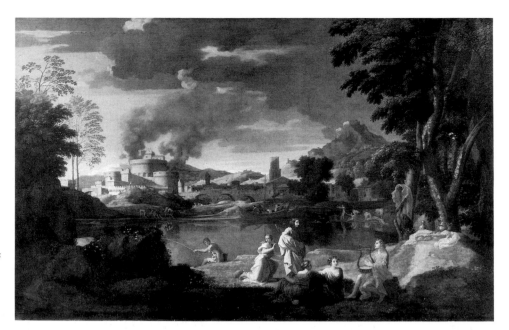

202 Nicolas Poussin
*Landscape with Orpheus
and Eurydice* 1648

203 Nicolas Poussin
Rape of Europa c. 1648,
pen and brown ink

8. The first forceful reference to nature's ambivalence in Poussin's work is made representationally. It occurs from the middle period onwards. It is the recurrent presence of the snake,[38] the hidden danger which chooses the richest vegetation for its habitat: the snake is the traditional guardian of the well or spring, and also a sinister intruder on hot summer days.[39] And what gives the appearance of the snake in these mature pictures such significance is that, apart from the *Landscape with Orpheus and Eurydice* (Louvre, Paris), it 202
lacks a straightforward explanation. And there is one here only because of the unusual moment in the cycle that Poussin has chosen to illustrate: he has passed over the more familiar deliverance of Eurydice from Hades, and Orpheus's famous weakness of will. Elsewhere one or other of two things: either iconography is forced into manoeuvres that even it has to admit are ungainly, as in the case of the marvellous drawing preparatory for a *Rape of Europa* (Statens Kontmuseer, Stockholm National Swedish Art Museums), in 203
which Eurydice makes a mysterious reappearance,[40] or it throws up its hands in despair,

226 *Painting, textuality, and borrowing*

for there is no identifiable pretext in myth or scripture or history, as in the case of the
204 *Landscape with a Man killed by a Snake*[41] (National Gallery, London). These are all works
circa 1650, and as we enter the last phase we have in the same vein the sublime *Landscape*
205 *with two Nymphs and a Snake* (Musée Condé, Chantilly), of 1659, a work whose beauty far
transcends its present condition. The picture appears to show us the primordial condition
of the earth, and here again the presence of the snake is without iconographical permit.
What the snake does in this picture is to urge upon us the ominousness of nature: a lesson
reflected in the incredulous admiration by which the two nymphs are transfixed as they

Painting, textuality, and borrowing

204 Nicolas Poussin
*Landscape with a Man
killed by a Snake* 1648

205 Nicolas Poussin
*Landscape with two
Nymphs and a Snake*
1659

206 Nicolas Poussin *Landscape with Polyphemus* 1659

(Opposite above)
207 Nicolas Poussin *Spring, or The Garden of Eden* 1660s

(Opposite below)
208 Nicolas Poussin *Winter, or The Flood* 1660s

regard the massive contortions that the snake adopts in its efforts to trap and swallow a bird.[42] For a moment the prowess of the snake unsettles their sculptural calm.

In these last paintings the expressive power of the two devices that we encountered in the *Diogenes* is, if anything, intensified. The entrapment of the distant landscape continues to add mystery to nature, as in the *Landscape with Polyphemus* (Hermitage, Leningrad), 206 where the old giant, seated with his back to us on the distant mountain, piping to an invisible Galatea, is a subject of bafflement even to the foreground figures. But for the even more emphatic rendering of nature as an untamed destructive force Poussin extended the new all-over colouring. Large monochromatic expanses formulate the threat involved in luxuriance and fecundity. In the Chantilly picture nature is coloured an irresistible engulfing force, which promises to carpet over the whole of the earth's surface with a tight cover of vegetation, to which Poussin attributes an uncanny texture.[43] It is hybrid of fur and feather. And in *Spring, or The Garden of Eden* – one of Poussin's last cycle 207 of paintings, the *Four Seasons* (Louvre, Paris), executed in the 1660s – the ambivalence of nature is taken further. Poussin chooses to represent Spring by the Garden of Eden, and now nature figures additionally as a force of confusion. It is destructive mentally as well as physically. The diminutive Eve sits on nature like a parasite on a body, and it is impossible not to feel that it is her very closeness to nature that makes it difficult for her to follow, indeed to discern, its injunctions. That God turns His back upon her can be seen not just as an expression of His, but as a projection of her, unwillingness to know. In all this there is no evil: just the distempering, the disorientating, the blinding, effect of richness and abundance. The opulence of nature confuses Eve. And this effect Poussin then

Painting, textuality, and borrowing

ingeniously re-creates in the mind of the spectator through the dazzle induced by the tiny flowers, white and sometimes blue, barely perceptible, which have been cunningly sown amongst the nearest foliage, across the more distant lawn and bushes, and, significantly, in the tree within whose profusion the fruit of knowledge still hangs.[44]

But the most extreme example of monochromaticism pressed into the representation of nature as a sinister, engulfing force is another member of this last cycle: *Winter* which 208 Poussin depicted by the Flood. Here it is not green that pervades. It is blue-grey. Only small touches of warm colour break the terrifying monotony of this nightmare. In saying that evil was not present in the *Spring*, partly I had in mind the absence of the snake from the scene where he is most expected. In this picture the snake returns. 209

Snake and water: I am inclined to think – though I am sure that many will not want to follow me here – that the power of this legendary painting comes partly from the way it presses upon some of the most unsavoury memories in the history of the individual: our memories – our unconscious memories, that is – of infantile sadism.[45] For snake and water commemorate, like the trophies assembled on the traditional war-memorial, the two resources of destruction, of terror, that the infant once had at his disposal for his phantasized attacks upon the parental bodies, whom he has loved as well as hated: biting gums or teeth, and burning urine.

But all, I think, will be ready to concede that much of the pathos of this work comes from the way in which for Poussin in old age water is totally transvalued. Hitherto it had been the most benign element in nature. It was that which rewards the fisherman with his hook and line, the recurrent example in Poussin's landscapes of Vergilian contentment: it was that whose glassy surface can be expected to return to nature the true image of itself.[46] Now water figures as the supreme destructive agent. Nothing, however

Painting, textuality, and borrowing

appealing or virtuous, can resist its power. None of which means that we ought to overlook the cleansing, the redemptive, element that has also been discerned in the unfolding drama.[47] What I speak of merely casts this parable in a more sombre light.

– I have talked on at length about Poussin for two reasons. One, because I wanted to. But, two, because Poussin illustrates better than I can explain the notion, crucial to my account, of a painting *disclosing what a text means to an artist*. I like to think that this is what the great Bernini had in mind when, looking at Poussin's second set of *Sacraments* one by one, pulling back a curtain to look at each in turn, changing spectacles, he said of the *Extreme Unction*, 'This picture has upon me the effect of a sermon . . . you carry away its impression in your heart'.[48]

C. 1. At the beginning of this lecture I introduced into the discussion the ways of textuality and of borrowing as though they were on a par. And from one point of view they are, in that they both contribute to the meaning of a picture, and in structurally somewhat similar ways.

But from another point of view they are very different. They are very different (I shall say) subjectively, or in that resort to them is likely to mean something very different to the artist. And this difference can in turn give rise to a difference in secondary meaning that accrues to the paintings themselves. Both ways bring the artist into a kind of dependency. In the one case it is a dependency upon a proposition, in the other case it is dependency upon earlier art. But the dependency in which borrowing places the artist is more fraught. It is more exposed to anxiety.

2. It is the literary critic Harold Bloom who, in a series of remarkable books beginning with *The Anxiety of Influence*, has drawn contemporary attention to a profound issue which the title of his seminal work captures.[49] I disagree with the way Bloom conceptualizes the problem, but there is no doubt at all that there is something here that the objective study of painting must, but has not, come to grips with.[50]

Let me first say in the broadest terms how I think that the psychology of the issue should be seen.

The anxiety of influence comes about through the conjunction of various factors.

There is, first of all, the underlying sense of rivalry – rivalry between the present and the past – which is the natural condition of art, and which derives from its essential historicity: by which I mean the authority of past art to define, or to define in part, what art is. Secondly, there is the fact that the artist – and perhaps this is particularly so of the pictorial artist – is likelier to borrow from those artists whom he admires. I once heard a painter-friend of mine disclaim that he was an admirer of some Old Master by saying that he had never had a book of reproductions of his work open in front of him while he painted.[51]

Borrowing, then, occurs in the context of rivalry, often accompanied, and, if so, presumably intensified, by admiration, and the risk is that these two factors, admiration and rivalry, conjoined will lead to a third factor – envy.[52] Envy in this connection has a highly specific meaning. It is a deeply entrenched instinct, and it is the desire to attack what is thought good and to attack it – this is the important thing – just because it is good. Envy is fanned by fear, and the fears that fan it are that this goodness will dry up, or that it will prove too much to respond to, or that it will produce a humiliating indebtedness. It is the difficulties inherent in experiencing gratitude that precipitate envy. Envy, it is crucial to see, will not arise from rivalry alone: it requires admiration – finding the rival good – as an additive. But whether any particular mixture of admiration and rivalry will, in the case of a particular artist, give rise to envy depends on the rest of the psychological constitution.

Once envy arises, anxiety follows in train. Envy gives rise to anxiety for two distinguishable reasons. One is fear of retaliation. The envied person will strike back. The other relates to something deeper-seated. Envy, dividing the envious person against himself, getting him to hate what he loves, is experienced as tearing him in two. The deep anxiety that envy releases is nothing less than the prospect of disintegration.

To such anxiety there are two responses. One, longer-term, is the attenuation of envy through the establishment of good relations with the envied person. The other, shorter-term but more widely available, is defence against the anxiety that envy gives rise to, while leaving the envy itself intact. In this situation the commonest defence is the manic defence. The envious person denies that there is anything good on which he is dependent. He has no gratitude to acknowledge. On the contrary, he himself is the source of all goodness, he is immune to all attack, and he is beyond need. He bathes himself in radiance that must be borrowed from the very person whom he disavows.

So much for the psychology of the matter, schematically put.

3. It goes without saying that we shall not find powerful chronic envy within the orbit of art. Envy of such an order makes creativity impossible.[53] Nevertheless art is compatible with moderate envy, giving rise to moderate anxiety, and borrowing is the likeliest context in which all this will manifest itself.

I want to look at the work of two artists in this connection, and the first is Edouard Manet, one reason being that he has left some paintings which are in effect representations, totally intriguing representations, of rivalry. I do not know quite what we would conclude from these paintings in isolation, but the direction in which they sway the mind is confirmed by what we know from elsewhere.

In 1879 Manet wrote to the prefect of the Seine offering to undertake for the new Hôtel de Ville in Paris a series of paintings depicting the public and commercial life of the day. Of the five themes he proposed one was the racecourses and the gardens of Paris. The letter received no reply.[54] But the offer shows how significant an element in modern life Manet thought the races to be. They are therefore a topic around which deeper feelings might be expected to crystallize.

Manet painted the races on two occasions, and these are the representations of rivalry I spoke of.

The first occasion, which was in the mid-1860s, resulted in a composition of which it may confidently be said that four, though some would say five, realizations have come down to us. The four are (one) a watercolour fortified with gouache, *Racecourse at Longchamp* (Fogg Museum, Harvard University, Cambridge, Mass.), (two) a painting, *Races at Longchamp* (Art Institute, Chicago), (three) a lithograph, *The Races*, and (four) a drawing touched with wash, *Races at Longchamp* (Cabinet des Dessins, Louvre, Paris).[55] 210 211 The parent work, a painting executed in 1864, entitled *View of a Race in the Bois de Boulogne*, was cut up by Manet himself in 1865, and, if (as most agree) the Chicago painting is not part of it, just two fragments survive (Cincinnati Art Museum, Cincinnati, Ohio; and location unknown). But all the four realizations we have preserve the original composition with certain variations, and it is the composition itself that is of interest to us. It is of interest to us for the very reason that gives it a special place in the history of art. For it is claimed to be the first pictorial representation of a horse-race head-on. There is no painting, no sporting print even, that provides a precedent for such a treatment.[56] It innovates the composition.

And now we must ask, And what is special about such a composition? Is there something that it shows us that other compositions are less likely to reveal? Alternatively, is there something that other compositions show us that it is likelier to conceal?

Painting, textuality, and borrowing

210 Edouard Manet
Races at Longchamp
1867(?)

211 Edouard Manet
Races at Longchamp
1867–71, drawing with
wash

212 Edouard Manet
Races in the Bois de Boulogne 1872

There is one of each.

The head-on composition has two consequences. On the one hand, it facilitates the depiction of the spectators, who can readily be shown on both sides of the course. On the other hand, it makes it maximally difficult to discover who wins, who loses. The upshot is that the composition disguises the outcome of the race while displaying all the eagerness, all the excitement, all the suspense, that the outcome arouses – and we must wonder whether this ambiguity, this deferment of knowledge, this potential confusion, is not in some large measure the appeal of the composition. In the Louvre drawing Manet, it is 211
true, extends one pair of front legs noticeably farther down the sheet than any of the others, and, in doing so, exploits the only sure resource that the composition permits for showing the winner. But, having done this, Manet then compensates for the disclosure, for the indiscretion we might feel, by fusing the bodies. As we trace the legs up the page, we lose the horse. There is a winner, we are shown, but we are not shown who it is: we are left in the dark.

Manet returned to the subject of the races in 1872, and this time painted one painting, *Races in the Bois de Boulogne* (collection Mrs John Hay Whitney). It is an inferior work, 212
partly for reasons connected with the topic of the last lecture, but also in a way that the representation of rivalry partially explains. Undoubtedly Manet in this picture redeploys some of the elements that I connected with lure: note the fractured background, and, incomprehensibly, the enrapt looks on the faces of the jockeys. But here these elements are mechanically employed, and they are at loggerheads with the rest of the picture. However no explanation is adequate that does not also take account of the emotional charge that Manet, I have been claiming, associated with the topic of the races.

In the 1872 painting Manet had reverted to the conventional side view. This more or less obliged him to reveal the winner, but two twists that he gave to the format still permitted him to conceal the loser. In the first place, he cropped the picture so as to mask the rear of the field. This device, which plays on suspense and concealment, Manet took

Painting, textuality, and borrowing

over from Degas, and Manet, evidently in gratitude for what the device did for him, and as if to make certain that its employment was not thought to be accidental, placed Degas himself in the picture amongst the spectators.[57] Secondly, he brought the winner to the near-side. A study of sporting-prints, which provided the French nineteenth-century painters with much of their inspiration, reveals that print-makers, like Samuel Henry Alken and John Frederick Herring, and his son Benjamin, who were in effect chroniclers of the races, did from time to time adopt this lay-out: presumably because the facts of the case, and therefore the expectations of the race-goers, required it of them. But, when they did, they then struggled against the indeterminacy that this imposed and added what additional information about the field they could. Two paintings by print-makers bring this out clearly: John Dalby, *Racing at Hoylake, 1851* (Walker Art Gallery, Liverpool), and Samuel Henry Alken, *The Finish of the 1853 Derby* (collection HM Queen Elizabeth the Queen Mother, London). By contrast Manet seems to have embraced the indeterminacy. He exaggerates concealment. And in doing so he goes even against the art-tradition to which he subscribed. Specifically he goes against the example set by a work which he knew and emulated – Géricault, *Epsom Downs Derby* (Louvre, Paris), which had been bought by Napoleon III for the Louvre in 1866 – where we find the lateral composition combined with an unobstructed view of the field.

4. What these paintings suggest about Manet the painter - 'suggest' is the word – is not so much envy, which would find its natural expression in hatred of the winner, as fear of envy. By fear of envy, I mean in effect fear either of being, or of making someone else, the loser as though these were situations that would release destructive feelings (in the one case) in himself against another or (in the other case) in another against himself. To allay this fear in either form, the obvious means would be the cultivation of indeterminacy, ambiguity, confusion, and Manet, as we have seen, uses them. Fear of envy, as opposed to envy, shows a measure of solicitude, and one reason why I believe we can accept this suggestion is that it does not postulate wishes or impulses incompatible with creativity. Another, more specific, reason is because it fits in with Manet's practice of borrowing, to which I now turn.

This practice has two aspects to it.

The first aspect is constituted by Manet's relations with the actual images that he recycled. An older view held of this relationship was that Manet borrowed, and borrowed on the scale that he did, in order to compensate for the poverty of his imagination.[58] Now that this view is no longer found tenable, views which have replaced it seem still inadequate just because, even when they admit, they fail to come to terms with, a central fact about Manet's borrowings, which is that all but invariably he introduced a deviance, an obliquity, a loop, into the line that ran from the source from which he borrowed to his own painting.[59] There are at least three ways in which Manet did this.

In the first place, Manet regularly went not to the original paintings themselves but to reproductive prints. Failure to appreciate this fact enabled earlier critics to claim that Manet reversed the original composition in order to cover up his tracks.[60] Later critics, who recognized the fact, then assumed that Manet consulted a vast range of different graphic sources, and it was left to Theodore Reff to identify the crucial role played in Manet's Old Master borrowings by the line illustrations to Charles Blanc's *Histoire des Peintres*.[61] Though the first volume of this encyclopaedic work was not published until 1861, it had come out in instalments since 1849. In an artist for whom the medium of paint was so important, it requires explanation that Manet should have employed as an intermediate source works that bore no register of the medium. Furthermore he used Charles Blanc as a source even when the original works were in Paris and accessible.

213 John Dalby *Racing at Hoylake, 1851*

214 Samuel Henry Alken *The Finish of the 1853 Derby* oil on canvas laid down on panel

Secondly, when Manet had selected a source in this way, he then frequently got a live model to re-create in the studio the pose that he wanted to borrow, and then he drew the model. By this means, even as he further distanced himself from the original, he took physical possession of the pose. Thirdly, and as a further complication, and as a further appropriative step, there is Manet's tendency to borrow from more than one source at a time and to blend them in a single painting. His borrowings display massive condensation,[62] often beyond the point at which his paintings could continue to extract historical meaning from them. It is not simply that the spectator could not be expected to recognize the historical source under this disguise — indeed in some cases there was nothing to make him suspect that there was an historical source — but, more to the point, even if the spectator had this knowledge in his cognitive stock, it would be beyond his powers to bring it effectively to bear upon his perception of the picture. The task would be too complex.

215 Théodore Géricault *Epsom Downs Derby* 1821

216 Edouard Manet
Nymphe Surprise 1859–61

(Below left)
217 Rembrandt van Rijn
Bathsheba 1654

218 Edouard Manet
La Sortie de Bain 1860–1, India ink wash

Painting, textuality, and borrowing

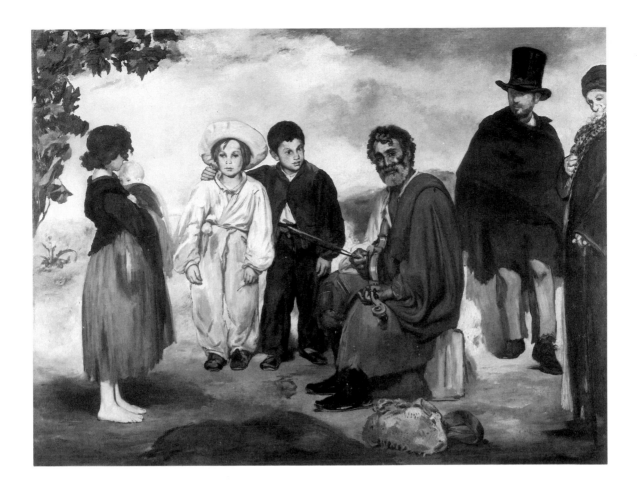

219 Edouard Manet
The Old Musician 1862

Let us consider two paintings in which these mediations are employed, indeed
216 employed and combined. The first picture is the *Nymphe Surprise* (Musẽo Nacional de
Bellas Artes, Buenos Aires). This picture derives from compositions by Rubens,
Rembrandt, and Giulio Romano,[63] and in each case filtered through Charles Blanc. To
capture these different images and to fuse them, Manet got Suzanne Leenhoff, his model
218 and his mistress, to adopt composite poses, in which he drew her.[64] In doing so, she
219 contributed her own eroticism to the subject. Secondly, there is *The Old Musician*
(National Gallery of Art, Washington, D.C.), which is like an anthology of Manet's
favourite sources,[65] but let us concentrate on the central figure who gives the picture its
title. The principal source for this figure is a Hellenistic statue of the philosopher
, 221 Chrysippus (Louvre, Paris). We possess a sanguine drawing, *Homme Assis* (Cabinet des
Dessins, Louvre, Paris), of an old man whom Manet posed after the statue. The model
himself, we now know, was a gypsy, well known amongst artists, of whose powerful
222 physiognomy we have independent evidence.[66] Undoubtedly the statue, the model with
his impressive personality, and the fact that he was a gypsy, all contribute to the outcome
– though whether the independent contributions they make can be, or were intended to
be, perceptually disentangled is another matter.

So much for the first aspect of Manet's borrowing practice as this is constituted by his
relations with the borrowed images. The second aspect has to do with his relations with
the original makers of these images or the artists from whom he borrowed. And, if the
first of these relationships is, as we have just seen, invariably oblique or mediated, this is
more than made up for by the directness, the immediacy, the intensity, with which he
relates, or endeavours to relate, to those of his predecessors in whose debt he places
himself.

Painting, textuality, and borrowing

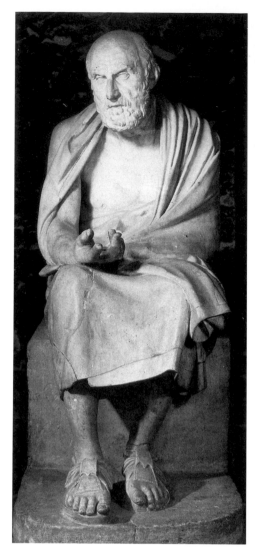

220 Hellenistic
sculpture
Chrysippus

(Above right)
221 Edouard Manet
Homme Assis before
1862, drawing

222 Philippe Potteau
Père Lagrène 1865,
photograph

In two early works – and it is natural that this should be the period when he borrowed most – Manet can be seen expressing a strong identification with the artist from whom he borrowed. One of these is *La Pêche* (Metropolitan Museum of Art, New York City), of 1860, another work of multiple sources, in which Manet drew upon two paintings by Annibale Carracci and two paintings by Rubens, and once again – though he had seen all four pictures in reality, and the Carracci paintings were in the Louvre – through the mediation of Charles Blanc. The two Rubens paintings are the *Landscape with a Rainbow* and the *Park of the Château of Steen* (both Kunsthistorisches Museum, Vienna).[67] In the latter picture Rubens had included a double representation of himself and Hélène Fourment, his mistress, later to be his wife. What Manet does is that he first takes over the schema that Rubens employs for the double representation and he then substitutes into it his features and those of Suzanne Leenhoff, his mistress whom he was about to marry and a compatriot of Hélène Fourment, and he thus expresses the relationship he sought with Rubens. It has been suggested that *La Pêche* was a kind of engagement present to Suzanne Leenhoff after the years she had lived with him.[68] This may well be true, but, if it is, it is significant that, in the very act of bringing her closer to him, Manet seized the opportunity to bring himself closer to Rubens.

223

224

225

Painting, textuality, and borrowing

223 Edouard Manet *La Pêche* 1861–3

224 Charles Blanc after Rubens
Park of the Château of Steen, engraving by Lavielle after drawing by
V. Beaucé, from Charles Blanc, *Histoire des Peintres*, 1868

225 Edouard Manet
La Pêche, detail, 1861–3

226 Edouard Manet *La Musique aux Tuileries* 1862

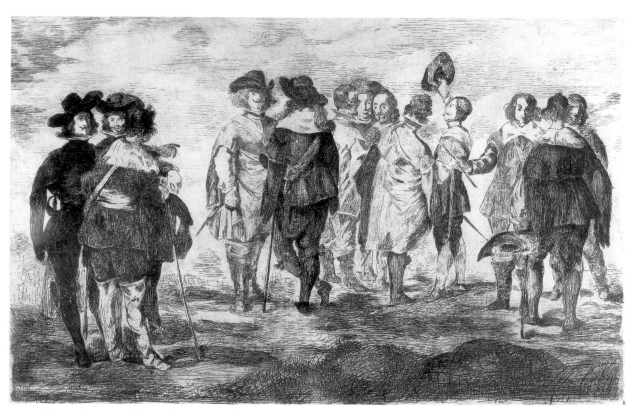

227 Edouard Manet, after Velázquez (attrib.) *Les Petits Cavaliers* 1861–2, etching, and drypoint

226 Two years later, in 1862,[69] in *La Musique aux Tuileries* (National Gallery, London), through a similar transformation of his source Manet expressed an identification with Velázquez, his hero of the moment. Over the previous years Manet had been copying in a variety of media a painting in the Louvre which had been recently acquired, and was regarded by the authorities of the day as a masterpiece of Velázquez.[70] The picture was called *Les Petits Cavaliers*, and it was taken to portray a group of Velázquez's friends, all artists, with Murillo and Velázquez himself at the extreme left. When Manet came to construct *La Musique aux Tuileries*, which was planned as a tribute to the rich varied life of

227 the modern city, he embedded the left-hand side of his print, which, incidentally, had been made without reversal, into the composition, inserting his friend and studio-companion, Albert de Balleroy, into the place occupied by Murillo and with his own features slotted into the silhouette of Velázquez. Through this act Manet acknowledged the depth, the intimacy, of his relations with Velázquez in the most public way open to him: that is to say, in the midst of an animated Parisian crowd, among friends and gossips, and on a canvas which, for all its modest scale, was monumentally ambitious.[71]

 What these early paintings show is, I have said, absolutely of a piece with what the racecourse pictures, taken as representations of rivalry, suggest. For they manifestly owe their existence to an artist who at once borrows and continues to admire those from whom he borrows. However he is anxious that indebtedness should not turn into inferiority: and to bring this about he tries, with whatever means are at his disposal, to strengthen his ties with the person from whom he borrows, while, all the while, if not weakening, at least complicating, ramifying, obscuring, his relationship to the image he borrows. He is not envious, but he is certainly fearful of envy.

5. Barely surprisingly, when we turn to the work of a great modern artist in whom, or so we have reason to believe, the factor of envy was very powerful, though the triumph over envy was no less spectacular, the pattern of borrowing and identification takes a further turn. With Manet the identification compensates for the borrowing: with Picasso the borrowings are the excuse for the identification. He borrows so as to be able to identify. Indeed, when we consider any one of the great sets of variations that Picasso did upon his predecessors – Cranach, El Greco, Velázquez, Delacroix, Courbet, Manet – and we begin to take stock of the way in which Picasso borrowed, what strikes us is how little there is to the borrowings over and above the identification. The way in which Picasso borrowed has been well described as that of 'pushing on beyond the point at which some other man stopped'.[72] In other words, Picasso would do precisely what 'the other man' didn't do, but, in the course of doing it, he securely established that other man within himself. If this is so, it ceases to be paradoxical that Picasso should have done these great set-pieces of borrowing, not in youth, like Manet, but in old age. For, if at this period he could have had little left to learn from his predecessors, it was also a time of his life when, with the weakening of his body and with the neglect of his work by the public and by other artists,[73] envy returned to plague him. He wished to make his peace at least with the past.

 It is overdetermined that the set of variations I should choose to look at is that upon

228 Manet's *Déjeuner sur l'Herbe*. For Picasso the appeal of this picture would seem in large part to have lain in the fact that in it Manet tried to reach out to Giorgione the painter in the very same way in which he, Picasso, in his variations upon it, would try to reach out to Manet the painter. In a way, that is, that permitted him, perhaps that required him, to take massive liberties with the older painter's painting.[74] Ever since it became public knowledge that Manet derived the composition of his painting from an engraving by Marcantonio Raimondi,[75] the *Déjeuner sur l'Herbe* has been looked at as though Manet intended it as homage to a minor Central Italian print-maker and not to the great

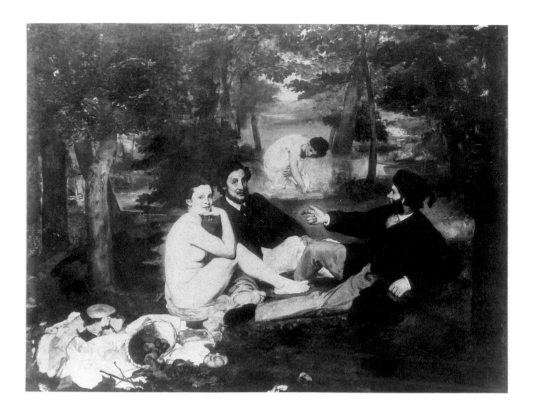

innovator of early Cinquecento Venetian art, whom he held to be the author of the *Concert Champêtre* (Louvre, Paris). In this regard Picasso, as he worked from Manet's 229 masterpiece, trying to bring himself closer to the master, revived, and restored to it, something of its original aim.

Picasso started work on the *Déjeuner* presumably without returning to look at Manet's painting[76] – he was working at Vauvenargues at the time – and in the course of the two years during which he executed the series, which was from August 1959 to August 1961, he is said to have consulted reproductions very little if at all.[77] Work began on 10 August 1959, and, by the time Picasso had reached the fourth and last drawing of the day, he had 230 already done away with the second man in Manet's original group. He was not slow to innovate.

Picasso's *Déjeuners* is not, despite its neglect, a negligible body of work. It consists of two hundred drawings, twenty-seven paintings, and five linocuts. It is Picasso's most sustained and most important engagement with the great art of the past.

The work falls into four sequences, successively undertaken, though with one break in the middle of the first sequence, and another, rather longer, of about a year, between the first sequence and the second, and I shall consider these first two sequences in what are taken to be their definitive versions. The first of these, which was completed in August 231 1960, still represents a picnic, but half-way through the second sequence, Picasso switched from a picnic to a bathing scene, incidentally reverting to what Antonin Proust, who records the connection of the *Déjeuner* with Giorgione, remembers as Manet's original, rejected subject-matter.[78] But even in the earlier picture the major expressive characteristic of Manet's painting has been totally transformed. The air of preoccupation, of abstraction, of secretiveness, the averted look, of which I spoke in the last lecture, have all been abandoned in favour of the characteristically Picassoan celebration of the

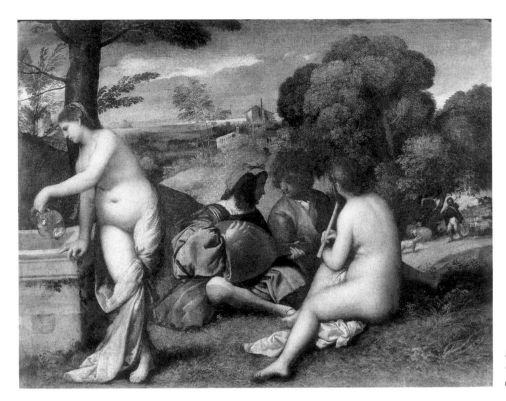

229 Titian
Concert Champêtre
c. 1510

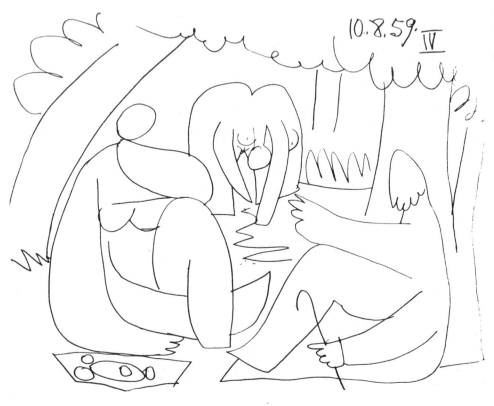

230 Pablo Picasso
Déjeuner sur l'Herbe
10 August 1959,
drawing

(Opposite above)
231 Pablo Picasso
Déjeuner sur l'Herbe
(definitive of 1st
sequence) 3 March–
20 August 1960

(Opposite below)
232 Pablo Picasso
Déjeuner sur l'Herbe
(definitive of 2nd
sequence) 10 July 1961

piercing stare. Then in the later picture, the intentionally indeterminate, dream-like space, 232 which I regard as also intrinsic to Manet, and which Picasso had, only a year before, in the earlier picture, done something to conserve in the effect that he had created of a vast medieval tapestry, with the principal characters trapped in the great woven tendrils, is abolished in favour of what is visually its opposite. For, throughout much of this second sequence, we are confronted by some of the most heavily, certainly some of the most assertively, spatial painting in Picasso's *oeuvre*. It is not at all surprising that contemporaneously Picasso projected some large sculpture on the *Déjeuner* theme.[79]

By the time we reach the third sequence, which consists of six canvases, rightly 233, 2 described as 'phantasmagoric',[80] nearly all of the major Manet themes have been reversed. Instead of horizontality, pleasure, the pursuit of modernity, and momentary preoccupation, we have verticality, unrefined austerity, timelessness, and the remorseless demands of the gaze.

The last theme, of which we shall hear more in the next lecture, alerts us to the most overall transformation that Picasso effects in this series. He has reconstructed the *Déjeuner sur l'Herbe*, which shows painters relaxing from their work, around his favourite theme: the work of the painter, the strenuousness – not the seriousness, the strenuousness – of painting. Characteristically for Picasso the intervals between work are filled with harder work. It is only in such a way that art can take over, can apprehend, life. In the fourth sequence, which consists of a number of classicizing drawings, reminiscent of the great 235, 2 Vollard suite of the thirties, all this is out in the open. If we follow through these drawings as a sequence, which we often have to do with Picasso's work in order to grasp the meaning of the individual drawings, we see that the concentration that art calls for from the artist is credited with the power to send the model to sleep. Beauty, which the model stands for, is not itself art: it is a vulgar error to assume their identity. Beauty is innocent of art, it is indifferent, irritatingly indifferent, to it. It is what art must capture, and there is a logic to the fact, recently discovered from the examination of Picasso's notebooks, that, after completing the *Déjeuner* series, Picasso went straight on, with the same cast of characters, to represent a bucolic rape.[81] Art gets even with beauty by the only means it trusts. It snatches it, seizes it: it makes it submit to the will of the penetrating gaze.

I began my discussion of the *Déjeuner* series by saying that its fundamental meaning for Picasso was to establish, and then to assert, an identification with one of the past masters of his art, and that this is effected through, rather than despite, the radical transformations that Picasso applied to Manet's composition. This should now be clearer. If the very liberties that Picasso takes with Manet's art are experienced as bringing him closer to Manet the artist, this is because for Picasso the core of art, or the benign core of art, lies in work. It lies in work rather than in what the lover of art often puts in its place: mere contemplation. Contemplation is the eyes idling: and art shows itself when it puts the eyes to work, to hard labour – though all this is not without its dangers. I shall revert to this theme in the next lecture.

D. 1. In distinguishing between the way of textuality and the way of borrowing from the point of view of what they mean, or can mean, to the artist, I introduced the term 'secondary meaning'. It might be thought that this was idleness, looseness, of expression. In a series of lectures largely devoted to pictorial meaning, loose or idle use of the term 'meaning' would be unforgivable. Painting can acquire meaning, additional meaning, indeed an additional kind of meaning, through what the act of bringing it into being means to the agent who does so, to the artist, and that is secondary meaning. Here is a very important development within pictorial meaning, none the less so for the fact that most forms of secondary meaning are unconscious. In the next lecture secondary meaning will come to the fore.

Painting, textuality, and borrowing

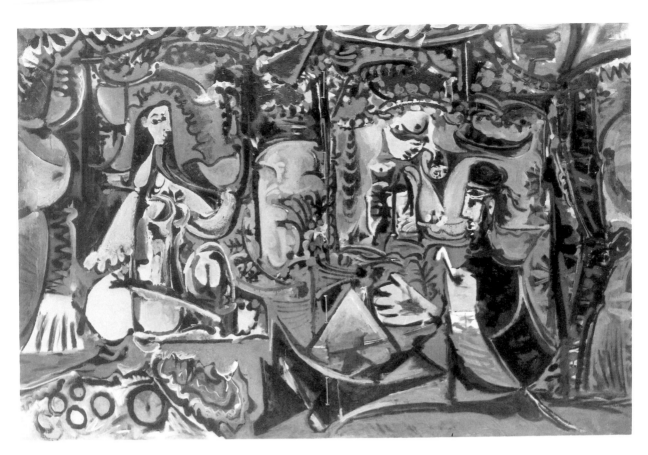

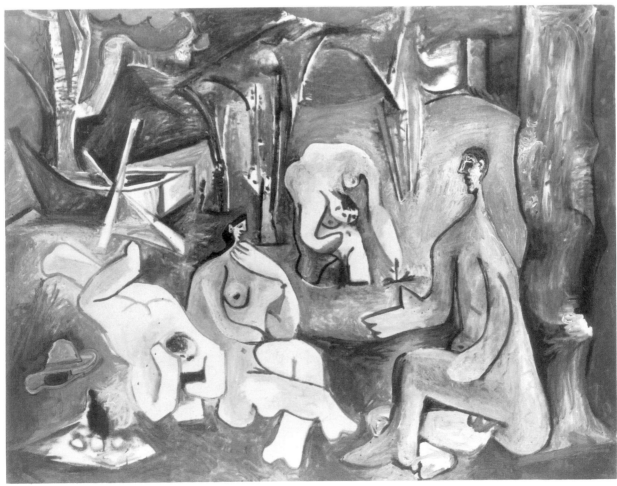

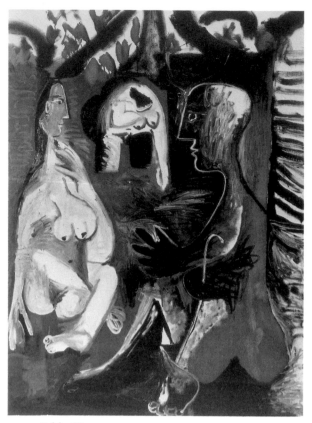

233 Pablo Picasso
Déjeuner sur l'Herbe 30 July 1961

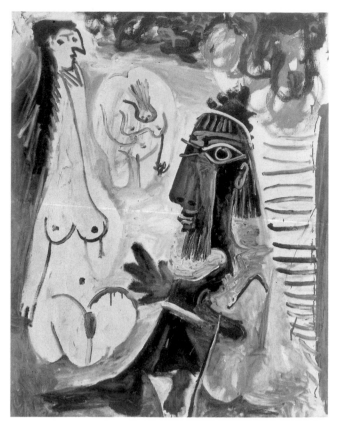

234 Pablo Picasso
Déjeuner sur l'Herbe 31 July 1961

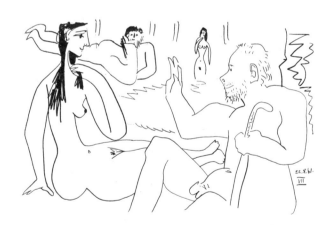

235 Pablo Picasso
Déjeuner sur l'Herbe 22 August 1961(VII), drawing

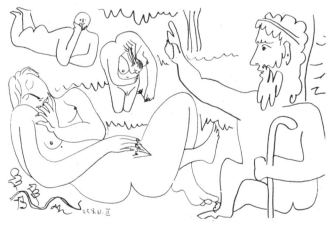

236 Pablo Picasso
Déjeuner sur l'Herbe 25 August 1961(II), drawing

Painting, textuality, and borrowing

V

Painting, omnipotence, and the gaze:

INGRES, THE WOLF MAN, PICASSO

A. 1. In these lectures I have been upholding a real distinction, or a distinction in the nature of things, between what a painting means and what falls outside its meaning, between what is, and what is not, part of its content. The point may seem obvious. It isn't, nor is the distinction widely respected. Nor is the explanation for this hard to find. For, when the objective study of painting takes on a predominantly historical character, as has happened in contemporary culture, so that the nature of individual paintings and the interrelations between individual paintings compete for interest and attention, it is totally understandable that the distinction I emphasize should come to seem less important, less interesting, than it is. It gets lost.

What makes the distinction a real distinction is that it is grounded in the way the painting comes about. The meaning of a painting derives from how it is made, or the creative process. In earlier lectures I have shown this in the case of representational meaning, expressive meaning, textual meaning, and historical meaning. These may be thought of as forms of *primary meaning*.

Then, at the end of the last lecture, I introduced the term *'secondary meaning'*. The *secondary meaning* of a painting also derives from how the painting is made. But there is an important difference. A painting's secondary meaning derives from a special aspect of the creative process. It derives from what making it, from what the act of making a picture, means to the artist: what it means to the artist, note, not what it means *tout court*. In other words, the artist makes a painting: the way he makes it gives it a meaning: but this act of making can itself have a meaning for him quite distinct from the meaning that he gives the painting through the way he makes it. If so, and if what the act means to him causes him to paint in such a way that a suitably sensitive and informed spectator will respond to this, then his painting has secondary meaning. Secondary meaning is secondary in that it accrues to a painting in virtue of something about the process that gives it primary meaning. I shall consider at the very end of this lecture another feature of secondary meaning which makes it, some might argue, second-class meaning, or, perhaps, not meaning at all.

There is, of course, no one thing that the act of painting must mean to the artist. On the contrary, there is a variety of things that it might mean to him, and correspondingly there is a variety of secondary meaning. In the last lecture I discussed – though not in those terms – what is in fact an example of secondary meaning: when painting comes to mean for the artist an identification with earlier artists.

The particular example of secondary meaning that I shall pursue in this lecture is a deep form, and I shall pursue it through an extended account of one of the oddest and most moving of artists: Jean-Auguste-Dominique Ingres. Working within what is to me the least congenial of the great period styles of Europe – neo-classicism – Ingres suffused his work with the imperiousness and the melancholy of what we must believe were his own

unattainable desires. On the outside, he was the model of conformity and conservatism. Ingres was, in his cantankerous way, a 'pillar of society'. But there is an indomitable strangeness to him. What, for instance, are we to make of someone who, on the death of the most persistent opponent of his claims to official recognition, joined the funeral cortège, walked behind the coffin through the streets of Paris to the cemetery as if in silent homage to the departed, but in reality so as to make certain beyond all doubt that his enemy, his 'anti-moi' as he called him, was indeed dead and buried? He peered into the grave, and said, '*Bien! bien . . . ! C'est bien! Il y est, cette fois; il y restera!*': 'Good, he's there, this time, and there he'll stay.'[1]

B. 1. In 1859, at the age of seventy-four, aware of the charge regularly brought against him – and, he concedes, with some justice – that in his work he repeated himself too often, to the detriment of new achievement, Ingres came to his own defence. 'Here is my reason', he writes – and the passage comes from a collection of Ingres's miscellaneous writings:

> The great number of those works, which I love because of their subject, have, it has seemed to me, been worth my while making better either by re-doing them or by retouching them. When through his love of art or through hard work an artist may hope to leave his name to posterity, he can never do enough to make his paintings more beautiful or less imperfect.[2]

2. For all its aphoristic character, this passage contains, I am convinced, a number of themes which, once correctly identified and then assembled in the right order, will take us to the core of Ingres's motivation as an artist. They will also – more to the present point – familiarize us with the mind of an artist whose painting additionally gains meaning through what making it meant to him.

The themes are these three: (one) repetition – and the scale on which Ingres repeated himself is something of which we shall need to take full stock; (two) the difference between what a particular painting is actually like, and what it could be like or its potentiality – a difference expressed here, in this passage, in degrees of beauty, but elsewhere, and more fundamentally (Ingres tells us), in degrees of truth; and (three) the affection, *l'inclination*, in which he held the works to which he reverted. '*L'inclination*' is a favourite word of Ingres's to express what he felt for the compositions that engrossed him. All three themes, as Ingres expresses them, require to varying degrees interpretation.[3] And, then, looming above them, and transcending the scope of this lecture, is a fourth theme, which is the question of the proper relation of an artist to posterity, and so, by extension, of the way in which he should stand to the work of his predecessors. I shall refer to this question only briefly.

I start with the last of my three themes: the most approachable, though it also contains a difficulty.

3. In his own day and in ours, much of Ingres's renown has rested upon his portraits, indeed upon his portrait drawings, of which characteristic examples, though they are also of exceptional quality, would be *The Family of Lucien Bonaparte* (Fogg Art Museum, 237
Harvard University, Cambridge, Mass.) and *John Russell, 6th Duke of Bedford* (St. Louis Art 238
Museum, St. Louis, Missouri). But this was not either how Ingres thought of himself or how he wished himself thought about. In the idea that he was someone who could be hired to produce a likeness that was intended to please he always professed to find something deeply offensive.[4] What he prided himself on being was a history painter. He was, he said, not a *dessinateur de bourgeois*, but a *peintre d'histoire*.[5] And not just that: for he singled out within history-painting what he called *le genre de la haute histoire*, or *la haute*

Painting, omnipotence, and the gaze

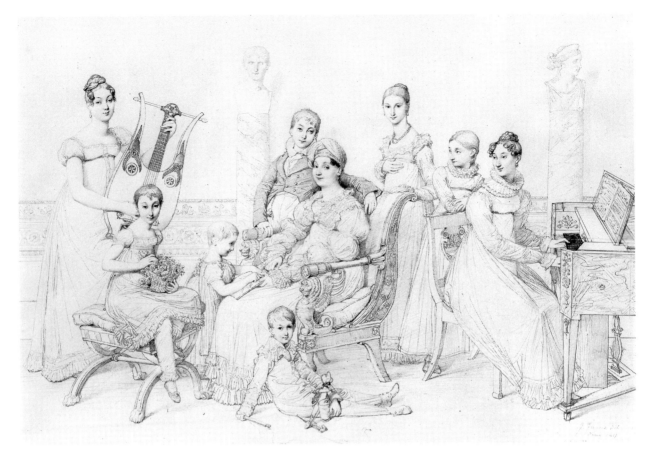

237 J.-A.-D. Ingres
*The Family of Lucien
Bonaparte* 1815, drawing

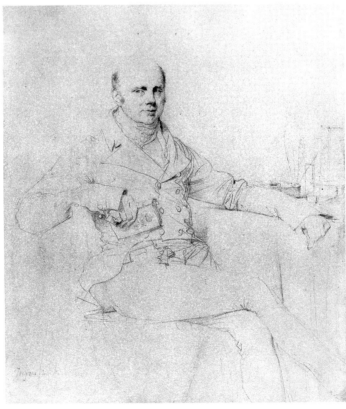

238 J.-A.-D. Ingres
*John Russell, 6th Duke of
Bedford* 1815, drawing

peinture d'histoire,[6] and it was to this category that he claimed his work belonged. All this records the conventional rhetoric of post-Renaissance theory with its commitment to a hierarchy of genres, but there is no reason to believe that it does not also give us Ingres's own view of the matter. I see no need to look outside history-painting, or high history-painting, for the works whose content enthralled Ingres.

But this is where an initial difficulty arises.

With the new social conditions instituted, first by the Revolution, then by the Restoration, the demands upon history-painting had changed considerably. In response to these demands there were changes in format, and there were changes in content, and these changes were consolidated in the emergence of the troubadour painting: a small, immaculately executed representation of some historical event, carefully researched, which was instructive in general intent, and with sentimental overtones. However there remained two residual features of history-painting which were constant: they were the importance of convention, and the dependence upon commission. This being the case, how could there be room within the genre for personal preference, let alone personal expression?

Such an issue is never simple. The history of art teems with artists who can be fully themselves only after they have made some form of initial submission. (It is in virtue of this fact that the history of patronage can sometimes become part of the history of art.) But in Ingres's case the issue is complicated by the fact that all but invariably he managed to appropriate what he was asked to do, in some cases contriving to turn this in the direction of something that had been germinating in his mind for some time. At some point along the line pictures that he worked on became *his*.[7]

What then are the pictures, the compositions, to which he was particularly drawn? For Ingres the kind of *histoire* that was imbued with the deepest appeal was one where a revelation occurs. It occurs within a family: it involves the confrontation of an emotion that has long been kept in check, but can be no longer: and the emotion, once revealed, calls for a massive change of heart. Sometimes such an accommodation may be hoped for, sometimes it is too much to expect. What is constant is that a father must melt.

Such a characterization of Ingres's chosen subject-matter effectively places at the centre of his *oeuvre* two compositions. They are the *Antiochus and Stratonice* and *Vergil* 239, 2 *Reading the Aeneid to Augustus*, each of which has several versions. Quite apart from their content, the strange vicissitudes of these two compositions, and the frequency with which Ingres returned to them, and the time and emotion that he allowed them to consume, confirm their centrality in Ingres's private world.

Of *Antiochus and Stratonice* four versions have come down: there was a fifth, which is now missing. There are more than a hundred sheets of drawings, giving a total of about three hundred individual sketches. The definitive version may be identified with that 239 commissioned by the duc d'Orléans in 1834 (Musée Condé, Chantilly): it was completed, only after much torment, in 1840, though Ingres had executed a comparatively finished version in the very year of the commission (Cleveland Museum of Art, Cleveland, Ohio). 240 But neither the time that Ingres took to complete the picture, which led him to call it at one moment '*cette éternelle Stratonice*',[8] nor the numerous complaints that he made over the years about the suffering that the work had caused him – it had, he said, been 'inspired by some evil genius', it had made him 'the unhappiest of men'[9] – should be allowed to conceal from us the deep attachment that he had to this theme, or the pull that it exerted over him. Ingres, I believe, deposited within the picture a moving tribute to the bittersweet nature of the toil that he was prepared to put into it. It has been noted that Ingres introduced into the sumptuous decoration of the royal chamber, in which the drama unfolds, ancient frescoes depicting the life of Hercules, and these have been taken, surely rightly, as an allusion to the arduous nature of the enterprise. But the point is lost when

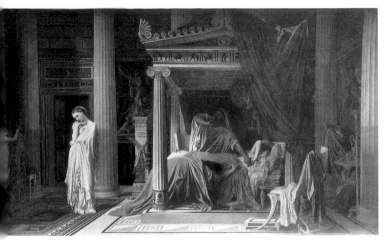

244 the claim is then made that these frescoes do not appear until the final version of 1866,[10] so that the allusion would then be to work thankfully over and done with. In fact, after initially experimenting with a fresco of Theseus, which we can see in the 1834 version, Ingres introduced the Hercules cycle into the commissioned project at an early stage, and panels showing Hercules strangling the serpents of Hera and riding with Pallas Athena in her chariot are fully visible in the Chantilly picture.[11] This suggests that a fairer way of looking at the frescoes is as an earnest on Ingres's part of work that was to come, or as declaring what he thought the composition deserved of him. He lived up to it.

The Chantilly picture, then, originated in a commission, and it was a very specific commission, for Ingres had been asked to produce a companion-piece, of precisely the 241 same dimensions, to a banal troubadour work by Paul Delaroche, *The Assassination of the Duc de Guise* (Musée Condé, Chantilly). However this is a clear case where the commission corresponded to something that had been occupying Ingres's mind for some thirty, perhaps forty, years, and the history of its germination is comparatively well documented.

Ingres, we know, had completed a version of *Antiochus and Stratonice*, which is the version now missing, by 1825, when Amaury-Duval, his pupil, who has left us a lively account of the master, saw it in his studio: this version almost certainly had a different disposition of the *dramatis personae*.[12] However as early as 1807 Ingres was writing to his prospective father-in-law, Jean Forestier, speaking of the 'inclination' he felt for the 242 Stratonice theme,[13] and work on the project goes back at least to a drawing (Musée des Beaux-Arts, Boulogne-sur-Mer) datable between 1802 and 1806, when Ingres was, or had just finished being, a student of David's.[14] At this period Ingres could not have been ignorant of David's own *Antiochus and Stratonice* (École des Beaux-Arts, Paris), his prize-winning entry for the Prix de Rome of 1777, which had heavily influenced an earlier generation of David students such as Girodet, to whom Ingres was close. But another likely influence upon Ingres, indeed a possible source of inspiration, was the opera *Stratonice* by Étienne Méhul, who was to become one of Ingres's favourite composers.[15] Commentators have noticed similarities between Ingres's treatment of the drama and that to be found in the opera.[16] Years later, in a letter,[17] Ingres traced his admiration of Méhul back to his student days in Toulouse when, from 1794 to 1797, to support himself, he played second violin in the orchestra of the local opera house, the Capitole, and he took part, he tells us, in a performance of an opera by Méhul. Ingres does not say which opera it was, but there is evidence to show that *Stratonice* was performed at Toulouse during these years,[18] and we may therefore conclude that this was the opera. The significance of this event is that, if, as the evidence suggests, memory of it remained in Ingres's mind, it furnishes a source for the composition outside the pictorial tradition that Ingres inherited, and so it confirms the personal appeal that the topic had for him.

(Above left)
239 J.-A.-D. Ingres
Antiochus and Stratonice
1834–40

(Above)
240 J.-A.-D. Ingres
Antiochus and Stratonice
1834

Painting, omnipotence, and the gaze

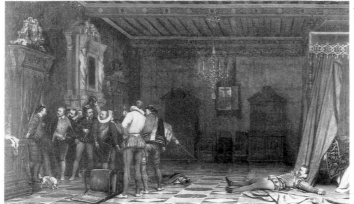

241 Paul Delaroche
The Assassination of the Duc de Guise 1834

242 J.-A.-D. Ingres
Antiochus and Stratonice 1802–6, drawing

(Below)
243 J.-A.-D. Ingres
Antiochus and Stratonice 1858–60

(Below right)
244 J.-A.-D. Ingres
Antiochus and Stratonice
1866

The Chantilly *Antiochus and Stratonice* had an enormous success, and it was this work that finally secured Ingres's public reputation and it led him to return to France permanently. In later years Ingres repeated the composition twice more: once, in a considerably simplified version (collection Mrs Rudolphe Meyer de Schauensee, 243 Philadelphia), of 1858–60, and then again, towards the very end of his life in 1866, in a version that reversed and slightly reduced the Chantilly composition (Musée Fabre, 244 Montpellier). Both these later paintings are deeply emotional works and betray no diminution in Ingres's involvement with the subject.

245 J.-A.-D. Ingres
Vergil Reading the Aeneid to Augustus first completed
1812, unfinished at death

246 J.-A.-D. Ingres
Vergil Reading the Aeneid to Augustus c. 1819

Vergil Reading the Aeneid to Augustus reaches us in three versions, though – and this is
not unique in Ingres's *oeuvre* – counting them has its difficulties. Ingres painted the
245 original version (Musée des Augustins, Toulouse) to the order of General Miollis, the
Napoleonic Military Governor of Rome: he completed it probably in 1812, but he
bought it back in the mid-1830s, he heavily reworked it with the aid of assistants, and it
remained unfinished at his death. We have no means of knowing how the present state of
the work relates to its original condition. Miollis was a besotted admirer of Vergil. During
his time as military governor of Mantua, he had opened up the Piazza Virgiliana, and he
had built, and then, after the ravages of war, had rebuilt, a statue to the poet, and it is
highly likely that the commission was entirely of his invention.[19] If it was, its unusualness
rules out any prior anticipation on Ingres's part, but the topic was evidently congenial to
Ingres, and he went on to work on the composition in two further versions. A second
246 version (Musées Royaux, Brussels), showing only three figures and omitting Vergil and
the architectural background, is an enigma. Is it cut down, or does it reflect a simplification
of the original composition? If it is cut down, how closely does it reproduce some part of
the original composition? Evidence is inconclusive.[20] Ingres certainly continued thinking
about the composition, making changes and additions as drawings show, all of which add
to the drama of the scene, and some of these ultimately find their way into a late version
247 (La Salle College Art Museum, Philadelphia), dated 1865, in which, as in the two late
versions of *Antiochus and Stratonice*, the level of intensity has in no way dropped.

Painting, omnipotence, and the gaze 255

247 J.-A.-D. Ingres
Vergil Reading the Aeneid to Augustus 1865, oil over
engraving on wood

But, if the persistence with which Ingres returned to these dramas is evidence of the power they held over him, what precisely is there in the dramas themselves that accounts for this? What secured their ascendancy over Ingres's imagination?

The history of Antiochus and Seleucus occurs in Plutarch's *Life of Demetrius*, and we find the story transcribed in Ingres's handwriting in Notebook I. Seleucus, king of Syria, took as his second wife the young and beautiful Stratonice. Soon afterwards his son, the prince Antiochus, appeared to fall ill. He took to his bed, and refused all food and water. He came close to death. The court physician Erasistratus, suspecting the true nature of the illness, took up his position at the prince's bedside, and carefully watched his expression each time a woman of the court came into the bedchamber. There was however nothing to observe until the young queen entered and thereupon the prince displayed, Plutarch tells us, all the signs of love as Sappho has described them: and it is this very moment, with Antiochus writhing in passion, Seleucus stretched out in despair on his son's bed, seeing nothing, Stratonice standing demurely aloof at the far end of the room, and Erasistratus drawn up to his full height and, with a massive gesture, enjoining silence upon himself, that Ingres has chosen to paint. Plutarch goes on to tell how, when the king eventually realized the truth, so great was his love for his son that he made Stratonice over to him. Ingres refrained from taking the story beyond the moment of revelation.

An analogous drama is to be found in the second core composition, *Vergil Reading the Aeneid to Augustus*. It too is built around a revelation. Once again the burden falls upon a father. Vergil has been summoned into the presence of the Emperor to read his epic. He does so, and he has reached the passage in the *Aeneid*, Book VI, where Aeneas in the underworld has pointed out to him by his father, Anchises, the spirits of his descendants, the Romans to be. At the end of this vast array Aeneas discerns a young man of great beauty and evident valour, whose eyes are cast down. Aeneas asks who he is. In reply Anchises apostrophizes the young man. 'You will be Marcellus', '*Tu Marcellus eris*', he says, and then he bursts out despairingly, '*Si qua fata aspera rumpas*', 'If you could but break this harsh fate'. For Anchises has foreseen the young man's tragic death. At this point in the poet's reading, Octavia, the sister of Augustus, falls forward in a faint. Marcellus, of whom Anchises speaks, was her son, who had been adopted by Augustus as his heir, and then murdered on the orders of Livia, the wife of Augustus, in order to advance the prospects of her own son. Livia is the fourth figure in this drama, which Ingres has her survey with icy detachment. Augustus raises his hand, Vergil pauses, and he waits for the command to resume his reading. What will Augustus do? What can he do? What act of reparation can he make so as to undo the past which now threatens to erupt into the present through a work of art? Augustus pauses like the statue that (we might think) he must not become: while, in the later conceptions of the work, intensifying the anguish of the moment, the statue of Marcellus is about to come to life.

These two *histoires* form, then, a thematic core, to which we should, perhaps, assimilate a third work, the monumental *Jupiter and Thetis* (Musée Granet, Aix-en-Provence), of 1811, the great celebration of the subornment of the father.[21] This picture illustrates a story recounted in the *Iliad*, Book I. Ingres, who had no classical learning, would have known it from the translation by Bitaubé. The Trojan war is on. The Greeks are encamped outside Troy, and Achilles, son of Thetis, and the greatest of the Greek warriors, has been insulted by his commander, Agamemnon. Achilles seeks revenge, and he begs his mother to intercede with Jupiter, who was once her suitor, for nothing less than a Trojan victory. Twelve days pass, and, knowing that Jupiter has returned to Olympus, Thetis rises 'like a dawn mist from the sea'. She kneels before Jupiter, she places one hand on his knee and with the other she fondles his chin, and, as she does so, she begs him by the love he once showed her to redeem her son's honour. Her prayer is heard, Jupiter will help her, though he knows that it will arouse Juno's jealousy. He bows his head, and Olympus trembles.

Jupiter's fears instantaneously prove well founded, for Juno has already observed, slipping past her, the 'silvery-footed Thetis, daughter of the Old One of the Sea'. As the left-hand side of the giant canvas shows, Juno obtrudes upon the scene and observes, behind the god's forbidding exterior, the changes that she can recognize are already at work in his affections.

If we think of these three compositions as forming the centre of a family drama, then it becomes inviting to organize the rest of Ingres's historical output into different groups around this centre, each of which presents some fragment of, or variation upon, or sequel to, the drama.

The first group consists of paintings which are noticeably less complex: less complex in subject-matter, and less complex in the treatment that they receive. They are works of a gothicizing delicacy, and they show the siblings engaged in scenes nominally of love and death, but to which Ingres has given the air of children at play. Two compositions of this

sort occupied a great deal of Ingres's energies: *Roger and Angelica*, where a knight rescues a young woman, and *Paolo and Francesca*, in which a young man falls in love with his brother's wife. In both cases an act of liberation is performed: in the one case from an unearthly monster, in the other case from a deformed and unloving husband. But in neither case does Ingres seem even to aim at carrying conviction. Roger, mounted on his hippogriff, is like a boy on his rocking-horse, and in all the various versions of *Paolo and Francesca* the young adulterous wife seems without erotic response to a kiss which is itself devoid of passion. Only the book, Dante's *galeotto*, is aroused. And if for a moment it might seem that a more obvious explanation than what I am suggesting is called for, and that the innocence of these escapades reveals a prudishness, a sense of propriety, which it was not in Ingres's nature to overcome, this does not survive reflection. It does not survive the fact that, during his first years in Rome, which he reached in 1806, by now in his twenties, Ingres did a considerable number of erotic drawings after sixteenth-century originals, which are incorrectly but understandably catalogued as after the so-called Giulio Romano, *Loves of the Gods*.[22] If these drawings vary very much in quality, they indicate beyond a doubt the sexual explicitness that was certainly within Ingres's range, but of which we see not a trace in the 'sibling' pictures. These drawings are now sheltered in the museum at Montauban.

249 J.-A.-D. Ingres
Paolo and Francesca date unknown

251 J.-A.-D. Ingres
Erotic Drawing date unknown,
drawing

250 J.-A.-D. Ingres
Roger and Angelica 1819(?)

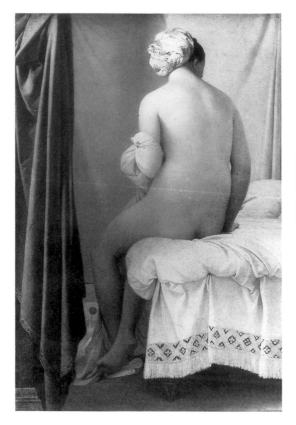

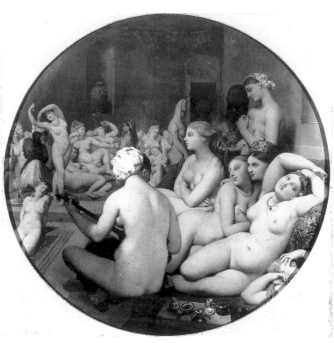

252 J.-A.-D. Ingres
Valpinçon Bather 1808

253 J.-A.-D. Ingres
Le Bain Turc first
completed 1859,
reworked 1863

A further group of paintings stands to the family drama in a very special relation. A radical resolution of the drama is proposed. For these paintings deny, or profess to deny, its basic presupposition. They do not just show the father, the progenitor, as temporarily absent, but they erase his role. He is deleted. These works, to which Ingres was famously attached, are the single- or multi-figure compositions showing women apart.

Historically, or within Ingres's *oeuvre*, these paintings form a progression: though not, of course, since we are talking of Ingres, without many repetitions or recapitulations. The series progresses through repetition and recapitulation. The second of these pictures in time, which dates from 1808, and for which the very first, the *Half-Length Bather* (Musée Bonnat, Bayonne), of the preceding year, was in the nature of a preparatory sketch, is the celebrated *Grande Baigneuse* or *Valpinçon Bather* (Louvre, Paris), and the Valpinçon bather, 252
the figure herself, becomes, several decades later, during which time she has attracted a host of companions into her orbit, the central figure of the sumptuous *Le Bain Turc* 253
(Louvre, Paris). *Le Bain Turc*, first completed in 1859, was then recovered by Ingres, reworked, and finished in 1863. With its completion the series, begun fifty-six years earlier, and now numbering fourteen paintings, comes to an end. Arranged by topic, it divides itself into three comparatively distinct groups: the bathers, the harem, and the odalisque with a slave.

The subject-matter of these pictures, or what they introduce us to, is the dream-like world of indistinguishable women, released, even if only temporarily or fictitiously, from the overbearing exigences of men. That these women have been corralled ultimately for the pleasure of men – more precisely, for the pleasure of one man – is, of course, relevant: but it does not, I believe, form part of the subject-matter of these pictures. It is relevant only because the pictures deny it. For the duration of the represented moment – no matter what lies outside that moment – it is held not to be true. In this regard Ingres finds support in his source. In Notebook IX, he had copied out two extracts from the letters of Lady

Painting, omnipotence, and the gaze

Mary Wortley Montagu – 'Lady Montague', as the French translation upon which Ingres depended called her – describing life in a Turkish harem. One passage recounts a visit to a bath where there were two hundred bathers.[23] The scene, as it is described, is one of playful innocence, protected by the direst penalties: the passage contains the chilling sentence, *'Il ne va pas moins que de la mort pour tout homme qu'on trouverait dans un de ces bains de femme.'* 'Nothing short of death awaits any man who might be found in one of these women's baths.' Ingres devised a striking correlate to the freedom that these women enjoyed from male sexuality in the holiday, often remarked upon, that he gave their bodies from the constraints of female anatomy. At the time these anatomical liberties were criticized as incompetent: nowadays they are admired as recruiting Ingres for the modern movement. Both responses seem to me equally hasty.[24]

Ingres's religious paintings are, as a group, something that I do not intend to broach, 254 but in the present context there is one painting that repays brief consideration: *The Vow of Louis XIII* (Cathédrale Notre Dame, Montauban), of 1824, which was Ingres's first success with the French public. It encouraged him to return to France, but the success was short-lived, and Ingres felt it necessary to go back to Italy in late 1834. As we have seen, it was *Antiochus and Stratonice* that finally brought Ingres back to France and a life of honour and repute.

Now if *The Vow of Louis XIII* is placed alongside the harem pictures, a new way of looking at it suddenly seems plausible. For in this picture Ingres seems to be showing us a challenge to, possibly a transcendence of, the condition that the harem pictures celebrate. Under the protection of a subject-matter with undoubtedly its own profundity – though, it must be said, Ingres had a hard time resolving what this might be[25] – he shows us the very eventuality that the harem pictures forbid under penalty of death. We see the encroachment of a man, a young man, upon the domain of women apart. The challenge is arresting, and, in showing us how it is met, Ingres ultimately denied it none of the drama to which it was entitled, making heavy use of modelling by shadow which he had always forsworn.[26]

But the psychological drama sits upon the religious subject-matter to an effect that Ingres could hardly have consciously contemplated. The royal supplicant, with hands barely materializing around the symbols of office that he offers up to the Virgin, quivers with passion: the outstretched arms are painted with a sensuousness of facture that recalls the shimmering drapery of Veronese. In response to the king's prayer, the Virgin turns away with a look which would have amazed Raphael, who is otherwise the inspiration.

We know that Ingres had a lot of difficulty in establishing the precise pose for the Virgin. Having first tried to get his friend, the miniaturist Constantin, to adopt it, he finally in despair climbed upon the dais and, holding a top hat or a bundle of laundry (the sources differ) as a substitute for the Child, he modelled the pose himself, and he then got Constantin to draw him.[27] The drawing is in Montauban. Explicitly Ingres's problem was to get a pose that was a compromise between a seated pose, which he thought undignified, and a standing pose, which he thought excessively High Renaissance.[28] It was this compromise that eluded him until he acted as his own model. Imagined from the inside, the Virgin's attitude, we may assume, suddenly became cogent for Ingres, and the incongruous result – incongruous as far as the manifest subject-matter is concerned – is that the Virgin now surveys her royal suitor with an air of total disdain.[29] It is a gesture that would be comprehensible enough within the drama of the harem. In the celebration of legitimacy and the sanctification of the throne it is woefully out of place. Meanwhile the right-hand angel, who is a barely disguised odalisque, casts a solicitous glance in her direction. Her eyes beg the Virgin to return to the universe of women. Years later Ingres 253 re-employs her. She is to be observed in the right-hand corner of *Le Bain Turc*, where she is being caressed by the girl in a diadem.

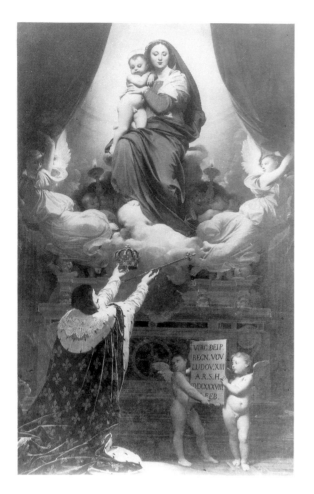

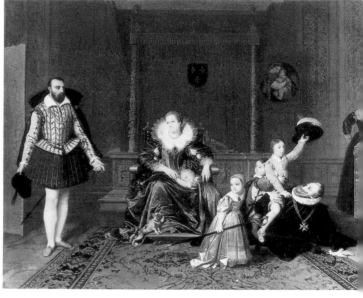

254 J.-A.-D. Ingres
The Vow of Louis XIII
1824

255 J.-A.-D. Ingres
*Henri IV playing with his
Children* 1817

My claim is not that *The Vow of Louis XIII* is a straightforward reassertion of what the harem pictures deny. For the man who is poised to erupt into the domain of women is not identical with the father. Rather, he is someone who has learnt from the father. He has learnt from the father twice over. He has certainly learnt to want from women what the father demands from them, but he has also learnt not to demand it. He has learnt to beg for what he wants, and it is on the strength of this lesson that he is ready to take the father's place. It is totally in keeping with my perception of this figure that Ingres, who for a long time had had great difficulty in deciding how to clothe him, should suddenly have found his difficulties fall away when he came across Frans Pourbus, *Portrait of Henri IV* (Uffizi, Florence), from which he appropriated the costume. Henri IV was the father of Louis XIII. As Ingres explained to his friend Gilibert, he felt able 'without scandal [*sans rien choquer*] to dress the son in the clothes of the father'.[30] I am suggesting that this solution, when it proposed itself, must have pleased Ingres just because it stood in his mind for the reconciliation that he sought, and that meant so much to him, between the old desires inherited from the father and a new sensitivity brought to their expression by the son, and which I believe to be the real subject-matter of this picture.[31]

The final group of paintings that I want to consider as illustrative of the family epic are the most revealing of all. They are compositions that are neither fragments (like the sibling pictures), nor denials (like the harem pictures), of its central drama. Invariably conceived on a small scale, and in many cases executed with an unexpected painterliness, these pictures are sequels to the drama, happy endings — and therefore highly illuminating as to what had really been at stake. If there was a moment of revelation, it has

Painting, omnipotence, and the gaze

now come and passed. Crucially a change of heart has occurred. The old patterns of life
have dissolved – and we see the father, in the guise of a monarch, humanized. Freedom of
touch, against which Ingres railed,[32] but which is apparent in several of these paintings,
accords with this new sense of the world transformed, the monumental dissolved. Hung,
as they sometimes are, by the side of conventional troubadour paintings, these works
exude strangeness.

255 The most direct depiction of such a transformation is the composition *Henri IV playing
with his Children*. There are two variants of this composition. If there is some uncertainty
which is earlier in conception, there can be little doubt which is more effective. One
variant, of which there are three versions (Petit Palais, Paris; location unknown; private
collection), depicts both the king and the queen, and so by implication it shows the
parents as rivals for the affections of the children. The natural advantages that the mother
possesses in this situation, of which the replica of Raphael's *Madonna della Sedia* on the
rear wall is there to remind us, severely limit the father's capacity to unbend. We note his
stiffness as well as his desire to discard stiffness. In the other variant, of which just one
256 version (Victoria and Albert Museum, London) exists, the mother is absent, and the father
attains a degree of informality which the painterly surface of the picture struggles to
reproduce. A little-acclaimed work of Ingres, it represents a distinctive breakthrough.

In the Victoria and Albert painting the figure who surprises the king is Don Pedro, the
Spanish Ambassador, and therefore we can now see as a companion-piece to this
257 composition, as a sequel to the sequel, the truly astounding composition – astounding
once we have grasped the crude symbolism at work – in which Don Pedro, observing the

257 J.-A.-D. Ingres
Don Pedro kissing the Sword of Henri IV 1832

258 J.-A.-D. Ingres
Death of Leonardo 1818

sword of Henri IV being carried through the palace by a young page, falls on his knees and presses it to his lips. 'Let us honour the most glorious sword of Christendom', he is reported as saying. Under this new dispensation, there is no attribute, no instrument, of the king humanized that does not deserve the kiss of adoration. In a letter about this composition Ingres makes the telling point that the ambassador's gesture gains in poignancy when we reflect that it marks the healing of an historic enmity.[33] Against all comers Ingres defended this picture ferociously.[34]

Closely connected with *Henri IV playing with his Children* are two other compositions in the same tender vein, in which, in addition to the father being played by a king, the child, whom the father now finds himself able to befriend, has become an artist of genius. These compositions are the *Death of Leonardo*, in which Leonardo dies in the arms of 258 François I, and *Louis XIV and Molière*. The first subject is taken from Vasari, but to it Ingres 259 has added the motif of the king venerating the dying man. The second subject is taken from a popular memoir of Marie-Antoinette by her first *femme de chambre*.[35] The memoir concludes with anecdotes of the earlier life of the court, and out of this material Ingres chose a story in which the famously self-aggrandizing Roi Soleil, having appointed Molière to some minor office, and hearing that his courtiers would not eat with a man who had acted on the stage, is suddenly moved to entertain the great playwright, and the painter shows him saying to the highest officials of the court as they are admittted to the *petit lever*, 'You find me attending to Molière's meal: my other *valets de chambre* do not consider him good enough company for them.'[36]

Painting, omnipotence, and the gaze

4. Of Ingres's own family circumstances we know enough to recognize how the subject-matter of these various compositions, to which he returned so tenaciously, could easily have summarized some of his earliest wishes. If we put together just three facts about his life, we seem to have sufficient reason to account for the enduring appeal they held for him.

First, then, there is the presence of the father, Joseph Ingres, craftsman, miniaturist, local portrait painter, small-town dandy, a man of slight education, whom Ingres idealized. In a tribute to his father, which he wrote many years later, Ingres spoke of him as a man 'with a rare genius for the fine arts', and added, 'Had Monsieur Ingres père had the advantages that he gave his son of being able to go to Paris and study with our greatest master he would undoubtedly have been the first artist of his day.' He went on, 'Through his amiable character, his kindness, and, always supremely the artist, he won the sympathy and praise of all.'[37] Secondly, we hear the voice of the mother, a peasant woman, breaking through we do not know what barriers of decorum, docility, ignorance, and finding expression in a barely literate deposition to the *procureur* of Montauban, in which she asks for a separation from her husband, citing his infamous conduct, his constant ill-treatment of her, and his abusive language. The document dates from early 1803.[38] And, thirdly, there is the wish, laid by the mother upon the son soon after the father's death, that, 'honouring his ashes', 'keeping his hopes alive', they should cling to his deathbed faith that the son would more than compensate for all the sacrifices made by the parents for his sake. She wants him to be a great artist, and a father to his sisters. The

259 J.-A.-D. Ingres
Louis XIV and Molière
1857

letter, which was written in August 1814,[39] and is of a literacy that the deposition of 1803 would not have predicted, betrays unmistakably the intervention of a friend – a friend rather than a professional scribe – but there need be no doubt about who inspired it. Through the manipulative phrases, through the worn expressions of sentiment, the widow reaches out to manoeuvre the son whom she has not seen for seventeen years into a position, half filial, half paternal, that she has fashioned for him out of an experience of life that could have given her little sense of either. Needless to say, Ingres's response to these demands was only partial.

Yet, tempting though it is to deepen the meaning of these paintings by arguing from their representational meaning to desires and wishes that they express – along the lines made familiar to us by the interpretation of dreams, systematically replacing manifest with latent content – I think that we should resist the temptation to do so: at any rate, in any except the broadest terms. By and large we lack what is essential to such an interpretation – the artist's associations to what the pictures represent.

There are two other factors which counsel caution. One I shall mention later (section B.8), and the other is that both the full-blown family dramas, *Stratonice* and *Vergil*, are as much about concealment, and the manner and cost of concealment, and perhaps the hidden luxuriance of concealment, as they are about desire and revelation. Now I do not simply mean by this that, in each case, the desire that is represented is represented as concealed, nor that the desires that the picture most likely expresses through what it represents are themselves concealed, indeed repressed. All that is true, but it is not what I am saying. It would not constitute a reason against, for it is a presupposition of, any kind of interpretation akin to dream-analysis. The fact to which I am drawing attention is something different: it is that these pictures indicate, indeed represent, the very mechanism by which the concealment in question occurs, which is in effect the most primitive of all the processes by which the mind defends itself against unwanted desires and beliefs, or against desires and beliefs that cause anxiety. This mechanism is projective identification,[40] and what happens in such cases is that the subject splits off the targeted desires and beliefs from the rest of the mind's contents, and then phantasizes that these rejected elements have been inserted, have been stuffed, into another figure. One consequence of this phantasy, which is very corporeally entertained, even more thoroughly so than the phantasy which is the vehicle of projection, whose character I touched on in Lecture II, is that the other figure, who serves as container for these unwanted parts of the self, is experienced as controlled by what has been hidden inside him. The subject can now feel that he has mastered not only himself but also another. This experience, and the relief from anxiety that it brings, is likely to be short-lived. In saying that these pictures represent this mechanism, I mean that they represent the content of those phantasies which are its vehicle. In the *Vergil* composition, in which it is safe to hazard that all three imperial personages are engaged in such a process, the poet is evidently the receptacle for the split-off parts of their minds. In *Antiochus and Stratonice*, it is Erasistratus who is charged with keeping the secrets of others.

In the case of *Stratonice* it is indeed possible for us to reconstruct the lengths to which Ingres was prepared to go, in the full publicity of his studio, in order to capture the authentic portrayal of secrecy. Using his pupil Hippolyte Flandrin as model, he made more than fifty drawings for the arm of Antiochus and the great dissimulating gesture in 260, which it is contorted. Ingres himself posed for Seleucus, having first decided to abandon the Davidian composition in which Seleucus is a full spectator of the scene and to return to the requirements of classical decorum, according to which the misfortunes of the son would be concealed from the eyes of the father. Ingres adopted the pose, got his students to draw him, and then copied their drawings. Charles Blanc, whom we have already come across in these lectures as the principal intermediary in Manet's borrowings from the Old

Painting, omnipotence, and the gaze

260 J.-A.-D. Ingres,
Drawing for the arm of
Antiochus 1834–40,
drawing

261 J.-A.-D. Ingres,
Drawing for Antiochus
1834–40, drawing

Masters, was a biographer of Ingres, and he has given us his own estimate of the ridicule that Ingres was prepared to incur in the interests of psychological accuracy as he presumably experienced it. 'And what a fund of simple good faith there was in this little man, short and fat, who, without worrying about the comic aspect of what he was doing, without even suspecting it, entered into the passions that he set himself to depict, to the point of miming the despair of an ancient hero: he braved ridicule in order to obtain, if he possibly could, the highest beauty.'[41] Beauty, we must remember, is, in the Ingres creed, another word for truth. But, when it came to the doctor, the keeper of secrets, and to that massive premonitory finger-to-lip with which he tries to reimpose the regime of ignorance, towering over knowledge like an eagle, forcing others into silence by first silencing himself, a gesture for which Ingres made more than thirty drawings, the model whom Ingres selected to pose the gesture, as though this was the person most experienced in containing the secrets of a family and therefore likeliest to understand the true nature of concealment, was his wife.[42] The importance of concealment as the subject-matter of this picture is confirmed when we turn back to Antiochus. For Antiochus, it seems, is dying not just of love, which he tries to dissimulate, but of dissimulation itself and its processes. He chokes upon it, like a young consumptive poet choking upon expectoration.

Totally in keeping with the suggestion that these paintings represent, amongst other things, a process of concealment in which unwanted thoughts and feelings are phantasized as being expelled and then housed within another figure, is the overall emotional character that the paintings bear. For, though projective identification brings some relief from anxiety, though (as we have seen) it may be a way of seeming to gain control over external figures, it also gives rise to a variety of persecutory anxieties, which are characteristically intense. These anxieties derive directly from the phantasies that are the vehicle of projective identification. Most marked is the subject's fear of being trapped or imprisoned inside the other figure into whom he has placed some part of himself, particularly as this figure starts to be experienced as slipping away from his control. Here are the beginnings of claustrophobia, and the *Vergil*, with its strained lighting and (in later drawings and the last painted version) the vast shadow cast by the statue of Marcellus, 247 and the *Stratonice*, with its cluttered architecture and its accumulation of acid hues, are studies in claustrophobia. The power of the *Stratonice* in this regard becomes striking when, standing in front of the Chantilly version, we compare what Ingres managed to 239 compress into the represented space at his disposal with the flaccid use of the very same format in the Delaroche *pendant*, which hangs directly across the room. 241

Once we recognize the powerful commitment that these pictures have to concealment, it is hard to know just how far concealment patterns itself over the rest of their content, unsettling any easy ideas about what they mean. Nevertheless I believe that these pictures are susceptible to a deep interpretation. But it is a form of interpretation that takes as its starting-point, not the content of these pictures, or not at any rate their primary content, but something else: it starts from their repetitiveness, or the second theme in Ingres's self-justification of 1859. This theme will lead us into the secondary meaning of much of Ingres's work.

5. It was, I said in introducing the theme of repetition, crucial to recognize the scale on which it occurs in Ingres's work. When he had finished a particular work, Ingres often showed himself willing straightaway to start on another version of the same composition. Of the pictures we have considered in most detail, or the core pictures, there were, if we count only finished oils (and the borderline is murky), five *Stratonices* and three *Vergils*. But I give further figures – some for pictures which are as yet just titles. There are three versions of the *Death of Leonardo* (Petit Palais, Paris; Smith College Museum of Art,

Painting, omnipotence, and the gaze

Northampton, Mass.; location unknown): four of *Don Pedro kissing the Sword of Henri IV* (location unknown; private collection; private collection; Louvre, Paris): five of *Roger and Angelica* (Louvre, Paris; Institute of Arts, Detroit; National Gallery, London; Musée Ingres, Montauban; Harari and Johns, London): seven of *Paolo and Francesca* (Musée Condé, Chantilly; Musée d'Angers, Angers; collection Hyde, Glens Falls, N.Y.; Barber Institute, Birmingham; Musée Bonnat, Bayonne; private collection; Harari and Johns, London): three of *Oedipus and the Sphinx* (Louvre, Paris; National Gallery, London; Walters Art Gallery, Baltimore): five of *Raphael and the Fornarina* (destroyed; Fogg Art Museum, Harvard University, Cambridge, Mass.; collection Kettaneh, U.S.A; Gallery of Fine Arts, Columbus, Ohio; Chrysler Museum, Norfolk, Va.): and seven of the *Grande Odalisque* (Louvre, Paris; Musée d'Angers, Angers; private collection; location unknown; Musée de Cambrai, Cambrai; Musée de Grenoble, Grenoble; Metropolitan Museum of Art, New York City).[43] Furthermore, apart from these distinct versions of the same composition, Ingres in some cases repossessed the original version and reworked the canvas into, in effect, a different painting. I have mentioned this in connection with the Toulouse *Vergil*. A no less extreme example is *The Dream of Ossian* (Musée Ingres, Montauban), which Ingres had completed to commission in 1813, and then bought back in 1835, so as to redevelop it, with the help of a student, from an oval to a square picture. Both pictures were left unfinished at his death.

Sometimes the desire, or even the need, for money partially explained the repetition. This must be the case, for instance, with the twenty or so versions that Ingres and his studio did of the *Duc d'Orléans* portrait (Musée National du Château, Versailles):[44] though even here different scholars discern different degrees of Ingres's participation in the different versions, all of which experiment to some degree with the format, or with the pose, or with the background. But money cannot be the prime explanatory factor – if anything, it is likely to be the way in which Ingres made repetition respectable to himself – and that is because in so many ways repetition, repetition and variation, bite deep into Ingres's working habits. They account for the central place occupied in Ingres's practice by two techniques seldom held in high esteem: the reproductive print, and the *papier calque* or tracing-paper.

Ingres had, at any rate from the late 1820s, a strong interest in reproductive prints of his own work: an interest which culminated in Réveil's edition of outline steel engravings of his complete *oeuvre*, published in 1851, which he, Ingres, looked upon as its definitive statement. There was however never replication without variation, and how the two were entwined in Ingres's mind we see from the endless instructions that he gave to his printers, asking for minor alterations, emendations, additions, to existing compositions – even pleading for the printer to accept such improvements after the plate had been cut.[45] And Ingres's attachment to this body of graphic work fully emerges when we realize that it did not simply function for him as a record, an embellished record, of his painted work, as a kind of *Liber Veritatis*, but that it could get itself folded back into the work, as when in the La Salle College *Vergil* of 1865 Ingres painted in oil on top of an impression of the Pradier engraving of 1832 laid down on panel. The Montpellier *Stratonice* of the next year is in oil, graphite, and water-colour applied, not to a print, but to coloured tracing-paper, to a *calque colorié*, which reproduces, and reverses, the Chantilly version.

Tracing is pervasive in Ingres's activity. There was nothing that he was not ready to trace. He traced reproductive prints, he traced his own drawings, he traced students' drawings, he traced vase-paintings, he traced tracings, and, once he possessed the tracing, there was no use to which he was not prepared to put it. He assembled tracings, he cut them up, he mounted them, he coloured them, he transferred them. Every combination and permutation is conserved in the drawing cabinet of Montauban. The one constancy is that tracing always went hand in hand with revision. Tracing and revising become the

262 J.-A.-D. Ingres
Duc d'Orléans 1842–4

263 J.-A.-D. Ingres
Duc d'Orléans 1843–4

crucial techniques for Ingres in innovating detail, in modifying detail, in enriching detail, in conjoining detail.

It was the leading idea behind an exhibition entitled *Ingres: the Pursuit of Perfection* that Ingres's achievement cannot be grasped, either in whole or in detail, so long as we take the distinction within a given artist's work between artistic original and non-artistic copy as though it were an aesthetic universal. In her catalogue essay Marjorie Cohn[46] argued very effectively that with Ingres self-repetition cannot be treated either as an aberration having no real connection with his work or as a symptom of artistic decline. It must be seen as a meaningful activity. The point was brilliantly made, but I would take issue with the particular meaning that Cohn attributed to this activity. The subtitle of the exhibition gives away what this is: Ingres repeated himself (is the view) in pursuit of perfection. I doubt it. In the first place, this ignores the evidently more pressured, more driven, side to repetition in Ingres's work. And, secondly, it does not come to terms with the fact that some of the procedures that Ingres resorted to in pursuit of repetition could be anticipated to place perfection all but inevitably out of reach. Tracing has a tendency to coarsen the line, and the heavy dependence upon prints induced an insensitivity to right-left reversal. This is illustrated in the several versions of the *Paolo and Francesca* composition, in which Paolo, having from 1814 on kissed Francesca on the left cheek, then around 1850 casually turns his attention to the right cheek.

But I have claimed that there is an interpretation that can be placed upon the act of repetition within Ingres's work. Like the interpretations of subject-matter that, I have maintained, we should forego, it is a deep interpretation, and it will turn out to use much of the very same material that, had we gone in for such interpretations, would undoubtedly have found its way into them.[47]

Painting, repetitiously undertaken, is, I suggest, conceived of by the artist — not consciously, of course — as a way of bringing about something in the world: of getting something done, or undone, or altered; of rearranging the environment somewhat. Painting is invested with instrumentality, and this is what repetition evidences. More specifically, what repetition evidences is a cycle: a cycle which passes from hope, based upon conceiving painting as possessed of efficacy, through disillusion, when of necessity painting fails this hope, to renewed hope, renewed delusions of instrumentality. And, since the activity cannot in the nature of things ever achieve what it promises, and, since the agent cannot without self-change convince himself of the vanity of the promise, the cycle is condemned to repeat itself.

On this interpretation painting acquires the status of the wish: the wish being best thought of as a thought, a thought which is about a desired object, and which has been erroneously invested by the thinker with instrumentality. The thought is held to have the instrumentality sufficient to make itself come true.[48] But it must be realized that our recognition of the wishful status that painting enjoys in a painter's practice is perfectly compatible with an inability on our part to say of individual paintings of his just what it is that is being wished for. In the case of Ingres's work, we can say in broad terms that the wish concerns the reconciliation of the family and the abatement of certain rivalries, and we cannot safely go beyond that. To put the matter in the terminology now available to us, the secondary meaning of Ingres's paintings, or what the act of making them meant for Ingres, is in certain respects more accessible than their primary meaning — specifically their primary expressive meaning. But, given what their secondary meaning is, or what making them specifically meant for Ingres, this is just what we should expect. Invariably under the shadow of the wish, massive condensation, massive displacement, massive associative thinking, obscure, indeed destabilize, the object of the desire.

There are, I believe, two features of Ingres's work which strongly support the attribution to it of a wishful character. Again (as with the difficulties of deep

interpretation) I shall consider one feature straightaway, for the other we must wait. We must wait quite a while (section C.4). In each case it is only within a general understanding of primitive or early thinking that we can see how the feature I cite supports the interpretation I place upon the painting.

The first feature is the way a careful spectator will experience a bizarre aspect of this work. Having in the last lecture strongly dissented from what Anthony Blunt said about Poussin's heroic landscapes, I am glad to be able now to make amends to a great scholar and a friend and acknowledge that it was he who first made me fully aware of this aspect and the need it has to be explained.[49] The aspect is the recurrent spatial anomalies, anomalies of a marked kind, which Ingres inserts into his pictures. These anomalies are all the more conspicuous in that they occur within a style that is highly linear and contains many orthogonals, or lines running back into space parallel to the line of vision, and which in linear perspective are represented as converging on the vanishing point. For these lines ordinarily can be looked to to provide the strongest clues to the disposition of objects within the space that the painting represents.

Let us consider some egregious examples. They come from all dates.

In the first *Madame Moitessier* (National Gallery of Art, Washington, D.C.) there is no 264 uniform account that can be given of the dado that runs along the bottom part of the picture: the moulding appears in discrepant ways either side of the sitter. In the second *Madame Moitessier* (National Gallery, London) we are provoked to ask, How much space 265 is there between the sofa and the looking glass? To the right, to our right, of the sitter, there appears to be very little space, though there is, it is true, a piece of ornamental open-work, which is partially reflected (no more) in the glass behind — but to the left there is enough room for a heavy console table. In the *Philibert Rivière* portrait (Louvre, Paris) the 266 curved back of the chair is painted as if it was viewed almost frontally, while the seat of

the chair and the pose of the sitter require that the chair is at an angle to the picture plane.
267 In the *Pope Pius VII in the Sistine Chapel* (National Gallery of Art, Washington, D.C.) the front side of the canopy – the front, that is to say, from the point of view of the congregation – recedes into space at such an angle that, if it were projected, it would run into the wall that is behind and parallel to it long before infinity – in fact, it would run into it very soon – though the shields embroidered on it are painted as if it was viewed
256 frontally. In the Victoria and Albert *Henri IV Playing with his Children* both the drum and the table show more of their side face than their relationship to the viewing point entitles
268 them to. In the Petit Palais *Death of Leonardo* we ask, Is the right-hand chair parallel to the picture plane or not? The arms say, Yes, the legs say, No. In the later of the two versions of
269 *Louis XIV and Molière* (private collection), though the chimney-piece is clearly directly opposite the viewing-point, both volutes on the jambs are represented as if seen from well over to the left.

Painting, omnipotence, and the gaze

(Above left)
268 J.-A.-D. Ingres
Death of Leonardo, detail, 1818

(Above right)
269 J.-A.-D. Ingres
Louis XIV and Molière, detail, 1860

270 J.-A.-D. Ingres
Antiochus and Stratonice 1834–40

271 J.-A.-D. Ingres
Antiochus and Stratonice 1866

But the composition most endowed with such anomalies is *Antiochus and Stratonice* in 270,
all its versions. In both the Chantilly and Montpellier versions there are two large
columns which are unambiguously behind the canopy of the bed. It is strongly
suggested, both by the width of its profile and by how much of the rear wall it occludes,
that the column against which Stratonice is silhouetted – and the same must hold for the
column at the left of the picture and that to the right of the bed – is another member of this
row, and that it is therefore at the same distance from the picture plane. However
according to atmospheric clues this column stands within the depth of the bed-canopy. In
the Chantilly picture the plinth on which the statue of Alexander is placed starts off, at its
base, in the same plane as the column to its left – the patterned floor shows this – but, at
the elevation of the statue itself, the impression is given that the plinth is behind the
column. It is an impression that grows upon us as we retreat from the picture. In the
Montpellier picture, the body of Stratonice appears to be so close to the column against
which she is silhouetted as actually to cast a shadow upon it: she might even be leaning on
it. But the positioning of her feet indicates her to be half the bed's width in front of it.
Indeed if we turn to the other side of the picture we can see there that – as in the Chantilly
picture, which in this respect it reproduces – the corresponding space is enough to
contain the following: a circular table under which the nurse crouches; then a gap; and
then another figure, who leans in distress against a column.

But why do I say that these spatial distortions cohere with the instrumental, the
wishful, character with which, I suggest, Ingres invests painting? What have the two to
do with one another?

274 *Painting, omnipotence, and the gaze*

A preliminary point to make is that these anomalies require a strong explanation. Carelessness, clumsiness, oversight, will not suffice with such a fastidious, painstaking artist dedicated to self-examination and self-correction as well as self-repetition.

The explanation I offer is experiential. It appeals to the way in which a careful observer will respond to these aberrations, and then my claim is that this response is a response to, hence it is a confirmation of, the wishful character of the painting. The spectator will, I suggest, experience these spatial anomalies as though they had been brought about by someone strenuously trying to wrench apart the scene, to dislocate objects, to open up gaps, so as to accomplish changes upon which he has set his heart. He has made for himself increments of space within which he can impose his will. Without these increments the world is too meagre for everything he wants of it.

We have already in these lectures come across an artist whose manipulation of space also calls for a stronger explanation than it generally gets: Manet. Manet's manipulation of space and Ingres's manipulation of space make an interesting contrast. Manet creates for himself a space that is amorphous and mysterious. Ingres leaves behind him a space that has been wrenched out of shape: it is stark and contorted, like a twisted box. Ingres's space is the aftermath of something that he has tried to do. Manet's space is a preparation for something that he wants to occur. Ingres's space is a space over which he has triumphed. Manet's space is a space in which someone else will insinuate himself. Two different uses of space, required for two different ends, generate two different pictorial effects.

For the second feature in Ingres's work that supports the wishful character of the painting we must, as I have said, wait.

And now I must ask, What does such an interpretation presuppose?

6. Painting credited with an instrumentality which it does not, which it could not, have, presupposes, like thought credited with similar instrumentality, as in the case of the wish, an attitude that the person who resorts to it has towards himself. Like the wish, it presupposes an opinion which overestimates, massively overestimates, the person's powers, and without such an opinion the artist would not think of his painting as having the efficacy he attributes to it. In this connection Freud borrowed from a patient the term 'omnipotent'[50] — meaning by this, not, of course, someone who actually was all-powerful, but someone who experienced or conceived of himself and his thoughts as all-powerful.

But the term 'omnipotent' over-simplifies the issue. For what is more plausibly the case is that there are differing degrees of over-estimation, of over-valuation, of idealization, in which the person may hold his mental abilities. All-powerfulness is just a limiting case. The artist must grossly exaggerate his powers before he can think of his activity as efficacious, but it is not the case that he must experience himself as having powers to which no bounds can be set.

In origin omnipotence of thought is an instinctual feature of the primitive or infantile mode of experience, and it arises as the natural, or a natural, response to certain types of anxiety. Specifically, it is a component of the manic defence, and, as we saw in the last lecture, the manic defence is an attempt to master the anxiety that the fear of loss, and, more particularly, the fear of loss through envy, occasions. To dissipate such fears and to dispose of the anxiety they cause, the person comes to think of himself as the source of all goodness: he is, he feels, immune to all attack, he is in no one's debt, and he is beyond need. There is nothing for him to envy, so he envies nothing. It is a feature of the manic defence that it tends to contain within itself an indication of what has incited it: this is because the person, in his self-aggrandizement, not merely borrows characteristics from the figure whom he envies, but he often borrows the very characteristics for which he envies that figure.

Considered in this original form, or as part of the manic defence, a person's belief in his omnipotence is a recurrent condition of early life, and in later life it may be re-invoked briefly, transiently, in response to the vicissitudes of anxiety. However, when omnipotence becomes a recurrent or standing condition of later life — and it is, of course, just this that the conception of painting as instrumental presupposes — then a more complex history than I have suggested is presupposed. Omnipotence of thought must now be thought of as a structural feature of the psychology, and, for it to acquire this status, the person — in our case the artist — must have identified with a figure whose powers he had already, to some considerable degree, overestimated.[51] He must not merely have internalized or introjected this figure, he must have established him at the core of his own psychology: he must have identified with him. This identification we may think of as evinced in the tendency to imagine, or better to phantasize, this figure from the inside.[52] Identification on the artist's part with an overestimated figure is an invariable feature underlying the instrumental conception of painting, but what is variable, what admits of modulation, is the degree of over-esteem in which this internal figure is held: all-powerfulness being one end of the spectrum.

And here implicitly we have the makings of a great inner drama, and it is a drama that in the lifework of Ingres is played out in a remarkably florid form. The seeds of the drama are these: The efficacy of painting as an instrument for readjusting the world is initially enhanced for the artist the more idealized, the more omnipotently conceived, is the figure with whom he identifies. But idealization in itself is a malign phenomenon with the result that identification with an idealized figure can only inhibit the very creativity that it initially promises. Idealization, being a defence against the anxiety that envy generates, is cousin to envy itself. It shares with envy the same insensitivity to the individuality, to the actual nature, of things and persons: so that art, carried out under the aegis of an idealized figure, becomes an art of preconception, by which I mean that the work of art comes to be thought of by the artist as already complete in the mind, before paint is put to canvas, or brush to paint, or hand to brush. Indeed when such thinking is dominant, the term 'work of art' becomes something of a misnomer. Art, on this view of things, does not result from work. It is held to pre-exist the work, and the work itself is thought of as a mere chore, which at best may result in a good approximation to what was there in the artist's head before it began. The contribution of the hand, of the brush, of the paint — in effect of the medium — can, on this scheme of things, never be more than an irrelevance. The baneful effect of such a view is only too easy to guess.

So here is the drama. There will be within art instrumentally conceived a continuous oscillation between identification with figures more, and identification with figures less, extravagantly experienced. The artist will identify sometimes with an idealized figure, and sometimes with a figure approximated to reality. The idealized figure promises to liberate the artist from the pains and uncertainties of toil — as well as from other attendant anxieties. But the redemptive aspect of art is that, in point of fact, it rewards the move towards the more realistic identifications: and it does so precisely by freeing itself from the effortlessness of preconception, and returning to the trial and error, the creativity, of work.[53] Even as the artist paints, the spectator in himself, which in the happier cases is that part of himself which struggles for resolution, is made aware, now of the more benign, now of the more malign, way in which he is working. He sides, invariably, with one way against the other.

In Ingres's case we may observe all this drama in an extreme form. The drive towards idealization is experienced at its most imperious, and the retreat from idealization, the abandonment of preconception, the return to reality, at its tenderest, at its most assuaging. Can we discern what it might have been that in Ingres's case accentuated the swing?

Painting, omnipotence, and the gaze

Predominantly the identification that Ingres sought in the practice of painting must have been with his father. That is the major fact, and qualifications will follow. But, if this is correct, then it is not surprising that, when Ingres painted, or at the very moment at which he sought to outdo the little craftsman from Montauban, the man of whom he himself had said that, had he had his son's advantages, had he, that is, had the advantages that instead he gave his son, he would have been the first artist of his day, Ingres should have wanted to idealize him. He had a motive, a motive in addition to that which the instrumentality of painting draws upon, for doing so. For idealization, over and above subsidizing in a general way the instrumental character of painting, was, in this situation, the coin with which the successful son indemnifies the unsuccessful father, even as he supplants him. It is the way he placates him.

But, if Ingres had more than the usual reasons that an artist committed to instrumentality has for paying in full the price that it asked of him, he also had specific reasons of his own for not wanting to do so. Not merely is idealization in general malign, putting creativity at risk, but idealization, specifically idealization of the father, ran counter to the very aim for which, in Ingres's case, painting in its instrumental mode appears to have been undertaken. I have already said – and it stands repetition – that we cannot say with any specificity what this aim was: we do not have the evidence to infer from the manifest content of Ingres's paintings, not even of the core paintings, the particular desires that form their latent content. But we can guess this much: that they included a re-ordering of the family in which one essential element would be the humanization of the father. The father must melt. What hope could there be of bringing this about, of satisfying these desires, within the orbit of painting, so long as the father who presided over their fulfilment, who was tutelary of wishful painting, was the idealized father, frozen in the posture of unbending self-righteousness? Baudelaire discerned something profounder than he recognized when, talking about the portraits of Ingres, he complained of 'a more or less despotic perfection' that he imposed upon them.[54] What Baudelaire did not recognize was that Ingres also struggled against this perfection: as he did against so much else that was despotic in himself.

Another way of putting the point I have been making would be to say that in Ingres's work there is an inherent tension between the secondary and the primary meaning. If at least some part of the primary meaning of his paintings is the desire that the father should come to life, for at least some part of the time secondary meaning, or its pursuit, exacted from Ingres the belief in a father inhuman in his omnipotence. Only such a father (it intimated) could endow painting with the magical powers that the son asked of it. And we get, I believe, to the real pathos of Ingres's work when we learn to see recorded within its primary meaning, particularly within its representational meaning, the artist's recurrent effort to attenuate, to correct, the falsification that secondary meaning, or the rage for instrumentality, imposed upon the figure of the father. Threaded through much of Ingres's work is the abraded record of his continuous, painful struggle to establish a father with whom he could identify to good effect: a father who was less than divine but who was more than destroyed. And, ultimately, not alone in the world.

273 7. In 1833 Ingres submitted to the Salon a portrait which was not well received. It is now acknowledged to be one of his masterpieces. It is of *Louis-François Bertin* (Louvre, Paris), the owner and founder of the influential *Journal des Débats*, a man of great wealth and assured social position. The portrait represents him as such, as what Théophile Gautier called a '*César bourgeois*',[55] but we can also, on close inspection, see documented in the sitter's imposing features the struggle in which the painting involved Ingres and from which he seems to have emerged, temporarily at least, the victor. The struggle is exposed in an uncanny fashion. For the impression that the portrait makes upon the

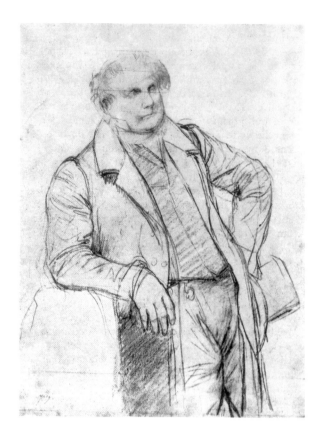

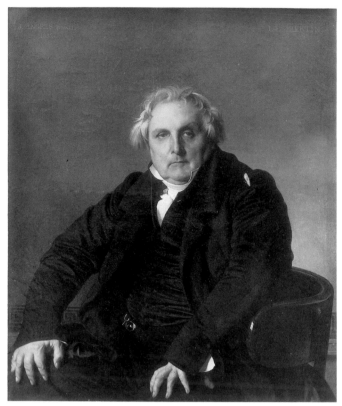

272 J.-A.-D. Ingres
Louis-François Bertin
c. 1832–3, drawing

273 J.-A.-D. Ingres
Louis-François Bertin
1833

spectator initially, or across the gallery in which it hangs, is of a totally statuesque figure. But, as the spectator approaches, the statue comes to life, gradually, though not totally. The effect is not uniform. In the hands not at all, in the hunched shoulders somewhat, barely in the general cast of features, but quite a bit around the upper lip, and then supremely in the eyes and across the cheekbones, this massive Commendatore-like figure begins to soften, there is the faint tremor, the palpitation, of living flesh. Under our very eyes, the idealized father is coaxed back into humanity. 274

Ingres had immense difficulty with this picture. He was close to despair. After weeks of sittings and many varied poses, he had nothing to show for it. Drawings confirm the picture's refusal to progress.[56] 272

There are two stories of how Ingres achieved his breakthrough. From the very beginning he was deeply impressed by Bertin and felt himself to be in the presence of a great personage. Bertin was, Ingres told his pupil Amaury-Duval, 'the best and most intelligent of men'.[57] But this thought manifestly did not help Ingres: we may suspect that it hindered him. One day – and Amaury-Duval who tells the story had it from Bertin himself – Ingres burst into tears. Readers of John Stuart Mill's *Autobiography* will recall a similar incident in which a fit of weeping broke the deep depression into which Mill had fallen.[58] Bertin comforted Ingres, and the sudden gesture of the great man unbending allowed Ingres, very shortly afterwards, as Bertin was talking freely over coffee in the garden after dinner, to go up to him and whisper in his ear, 'Come and pose for me tomorrow: your portrait is done.' And very shortly afterwards – within a month – it was.[59]

A somewhat more detailed account of the breakthrough is given by the vicomte Henri Delaborde, admirer and archivist of Ingres. His source was Frédéric Reiset, *conservateur* of paintings and drawings at the Louvre. One evening at Bertin's house Ingres found himself listening to a conversation between Bertin and his sons on the topic of politics. They

Painting, omnipotence, and the gaze

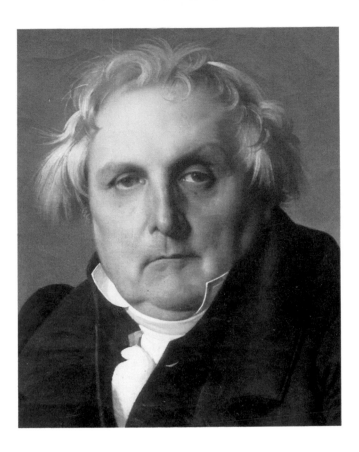

274 J.-A.-D. Ingres
Louis-François Bertin,
detail, 1833

disagreed, and the sons struck to their views. But what impressed Ingres was the effect that disagreement had upon Bertin. It did not irritate him, nor did it make him change his views. What it did was that it increased his self-confidence: he became more certain of himself. What this moment showed was that a father could survive contradiction: he did not have to claim divinity as the only alternative to accepting destruction. This version of the story ends on the same note. '*Votre portrait est fait.*'[60] Amaury-Duval also heard the story directly from Ingres himself. In Ingres's telling of the story there is no word of the tears, and Bertin, even as he reassures Ingres, is credited with a serene aloofness. 'Do not worry about me: above all, don't torment yourself', he is made to say; 'You want to make a fresh start on my portrait? When it suits you. You will never tire me, and, if there is anything you want, I am at your command.'[61] We are likely to feel that whatever the incident meant to Ingres is better preserved in the picture that resulted than in Ingres's telling of it.

There is a coda to the story, which fits in well with my understanding of its purport for Ingres. Someone invited to Ingres's house who did not know him started to praise the portrait of Bertin and said that it was as fine a portrait as any by Raphael. Ingres was enraged. He would not, he said, have the names of the great masters even mentioned in front of a work of his, 'I am nothing by the side of such colossuses.' And, bending down, he almost touched the floor with his hand, 'I am as high as that': though he could not resist adding, wryly, 'As for my contemporaries – well, that is another matter.'[62] With envy and its antidote, idealization, once overcome, Ingres did not want them excited, as he very well knew they could be, in front of the very picture through which he had achieved this triumph.

The portrait of Bertin is, I am suggesting, a belated attempt to repair and reconstruct the father: much of the intensity of which comes from its deferment. And the deferment itself comes fully into focus only when we look back at Ingres's early attempt to paint his

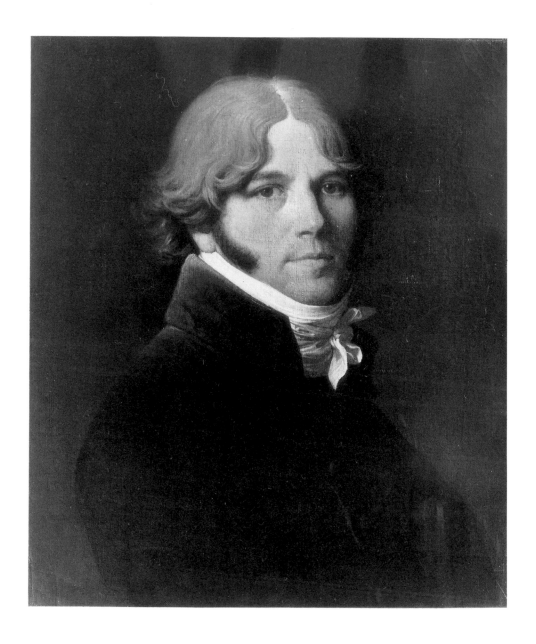

father: to paint him, we might now say, in person. The portrait (Musée Ingres, 275
Montauban) was painted in Paris in 1804. Ingres did not rise to the task, and it is hard not
to feel that there was something that prevented him from doing so. When we look at the
portrait of *Philibert Rivière* (Louvre, Paris), of barely a year later, or indeed at the more or 276
less contemporary *Napoléon Bonaparte, Premier Consul* (Musée des Beaux-Arts, Liège), it is 277
clear that youthful ineptitude cannot be the whole explanation.[63]

The hard, painful work involved in establishing an identification with a father less than
idealized, with a father upon whose lips the kiss of life has been placed, with in effect such
a figure as the Bertin portrait discloses, finds a counterpart, a parallel, in Ingres's
compositional technique. It is mirrored in the hard, painful work that Ingres's method of
constructing his paintings, particularly the method that he employed in his late work,
imposed upon him. It too called for an art of resuscitation.

278 *Jésus parmi les Docteurs* (Musée Ingres, Montauban), commissioned by Louis-Philippe on behalf of his Queen, Marie-Amélie, in 1842, is signed and dated 1862. It gives the artist's age as eighty-two. It is, arguably, Ingres's masterpiece. We must overlook the fact that its taste is not ours. It is a Victorian painting. The picture was not worked on continuously, but it is some sign of its significance for Ingres that he returned to it for solace immediately after his first wife's death.[64] Adjacent to the picture in the Musée
279 Ingres hangs a sketch for it: done, characteristically, four years later. This sketch, in addition to showing that Ingres was not through with the subject, also gives us insight into his method of working.

276 J.-A.-D. Ingres
Philibert Rivière 1805

277 J.-A.-D. Ingres
*Napoléon Bonaparte,
Premier Consul* 1804

The simplest way of describing this method is as collage. The picture is assembled out of fragments: out of fragments of what will be itself. The arduousness with which Ingres constructed the individual fragments is revealed in the various stages in which he worked
280 up the figures of the doctors, for whom there are in all eighty drawings at Montauban. These drawings show us that each figure originated in a life drawing after a nude female model. Then the labour begins. The sex is changed: the body is draped: an imposing bearded head is placed upon the body: and, at each stage, at each transformation, the preferred instrument is, of course, the multifarious *papier calque*.[65]

But, for all the care bestowed upon its compilation, the corpus of fragments is not for Ingres the solution. It is the problem. In this respect the term collage may mislead. For the

Painting, omnipotence, and the gaze 281

278 J.-A.-D. Ingres
Jésus parmi les Docteurs 1842–62

280 J.-A.-D. Ingres
Jésus parmi les Docteurs before 1862, pen drawing

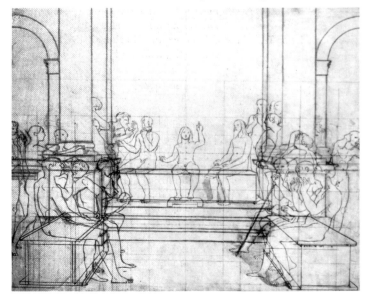

279 J.-A.-D. Ingres, Sketch for *Jésus parmi les Docteurs* 1866

crucial task was how to adjust each fragment, minutely maybe, and in the light of what was simultaneously happening to all the others, so that ultimately it could 'take its place' (the phrase is Ingres's)[66] in the totality that was struggling to emerge. Each fragment must give at the edge, and we do not start to understand Ingres's compositional practice until we grasp how line, which we think of as his crucial tool, plays for him different roles in drawing and in painting. In drawing, line creates volume. In painting, while it still to some extent does this (with tone to help it), what line crucially does is that it defines the fragments of which the picture is made up. It is no accident that Ingres, allegedly the fastest of draughtsmen,[67] was also amongst the slowest of painters. When, but only when, the fragment was defined to Ingres's satisfaction, could it enter the picture. But since no fragment could be satisfactorily defined in isolation, by the time that stage was reached the picture was ready. It was ready for life to flow into it, if the arteries were not by now too strangulated to receive it.[68]

It is this process of animating, of breathing life into, a picture that I take as reproducing, or as providing an outward parallel to, the inner process of restoring the idealized father to life. And the force of the parallel becomes stronger when we appreciate that Ingres made the work of picture-making as arduous for himself as he possibly could. The very glut of detail that he accumulated so that scarcely a square inch of the picture was unaccounted for before it was put together could not but impede the flow of life into its frame.

73, 278 8. If we link the Bertin portrait through its representational content, and the Jesus picture through its transformational history, to the resuscitation, or partial resuscitation, of the father, there are also many many hints, scattered throughout Ingres's work, to suggest that, once the father has been returned to life, it is only so as to participate in a further psychic drama. The drama is now deeper: the clues are more confusing: confusion indeed enters into the drama as an accomplice. With this new turn of events the impelling emotion is no longer envy of the father, it is now jealousy of the mother, and the plot is built around the efforts of the little boy to insinuate himself into the affections of the living, breathing father. The suggestion I now have to make is that, woven into a number of the compositions that we have already considered, especially but not exclusively those I have called 'happy endings', complicating their structure, adding a tinge of perversity, is this thread of seduction, by means of which the child, parading and exploiting his goodness, will captivate the father and prevent the mother.

8, 279 None of this is far from *Jésus parmi les Docteurs*, where the little boy-girl, whose feet cannot reach the ground (a touch admired by the finer critics of the day),[69] uses his innocence to seduce an array of fathers. His indifference to his mother's gesture, his insistence upon being about his father's business, take on new shades of meaning. In 1, 282 *Antiochus and Stratonice* and the *Death of Leonardo* the boy goes further. He smuggles himself into his mother's place, into his father's bed: an object which in both pictures is so drawn that from its contours no regular object can be constructed. It lies outside the world of everyday things. Nestling within its confines, the boy dreams of his father's undivided love, and, as he does so, he is forced to recognize that, to win the father, he must become, or appear to become, the mother. He must assume her body. Thus jealousy of the mother escalates to envy of the mother, and with the oncoming of envy the weapon of seduction becomes imposture. Both in *Antiochus and Stratonice* and in the *Death of Leonardo* the seductive boy uses an accomplice, who is also some part of himself, to drive the king to distraction through the wiles of androgyny. Antiochus is young androgyny, Leonardo old androgyny.

That Antiochus substitutes for the young boy who desires his father's exclusive love is not hard to discern: it lies close to the surface. But that Leonardo also fills this role is more

heavily concealed. The clues are at once more profuse and more diffused. They are scattered across three different figures, and, to perceive the substitution or how the painting records it, we must assemble evidence from all three sources. First, then, there is the figure who comes nearest to being a straightforward representation of the young boy. This is the page. But the page is only one aspect of the boy. He is the boy as he wishes not to be. There are two features to the way in which the page is represented which displays the boy's dissatisfaction with his lot. There is the lack of youthful proportions, the awkward overgrown look which extends even to his possessions — note, in certain versions, the absurd outsize gloves, and the swollen pouch that hangs from his shoulder — all indicating a precocity, at least of desire. The boy is unhappy with the constraints that age places on him: immaturity, and the lack of fame with which to dazzle his father. And then there is the still, entranced look that the page turns upon the dying painter as if to make it clear that it is only there, where his yearning eyes come to rest, rather than where his feet place him, that the boy's desires can expect satisfaction. Such engrossment takes him out of himself, if only momentarily, and some part of the boy, unlocked from the body of the page, drifts into the figure of Leonardo, who is the second source of evidence. If the page is the young boy as he wishes not to be, the old master is the boy with his wildest dreams come true. In consequence he contains the clue to what these dreams are. Leonardo has certainly fulfilled the boy's most overt ambitions on the grandest scale imaginable. He is very old, and he is fame in person. But there is more to it than that. For the price at which Leonardo has achieved fame, at which he has realized all the hopes that a fond mother might once have pinned on him in boyhood, is stamped over his frail, womanly body for all to see. In fulfilling the boy's overt ambitions, the great painter has also, inadvertently, satisfied the boy's most secret desires. The boy's eyes tell him this, and they also fan those desires. For, as the boy's gaze falls on the great bed — and what follows, we must remember, was Ingres's own contribution to the story — the king, who leans forward and holds the painter's limp, passive frame in his arms, stares down at him with a look of idolatry. He no longer patronizes the dying painter, as Vasari suggests: he adores him. The old body, adjusted to meet the boy's desires, finds favour with his royal patron. The sacrifice, the boy sees, does indeed win the love for which it was made, and this perception fans his desires. Thirdly, there is the figure of the patron himself, the king, from whom we might expect news of what is going on under his eyes. The royal features are manifestly borrowed from Titian's famous portrait of *François I* (Louvre, Paris), but a comparison of the two images makes clear that in Ingres's recycling the eager freshness has been drained away from the face, and why. What is spectacular in the *Death of Leonardo* is the avid concentration of gaze with which the king tries to bore his way into the head of the dying genius whom he holds in his arms. There is some secret that is being held back from him. Like Golaud he is not to be deflected from the truth, even if, when he gets it, it will prove beyond his powers to grasp. On the face of it, or as Ingres would have us believe, what the king seeks to learn is the secret of art. However, if my perception of this picture is right, what he stands to find out is something more particular and perhaps more profound. Concealed within the skin and bones of this old man, old woman, and about to be carried into the grave, is the secret, the well-kept secret, of one particular artist, a secret which he reveals only to the extent that he uses painting — for instance, this painting — to try to surmount it.

I said some way back (section B.4) that there is an inherent difficulty in the way of interpreting these family dramas, which is over and above both the general problem of the lack of associations to the pictures and the specific problem of the celebration of concealment, and here we have it. It is the element of imposture. Having witnessed the slow, painful attempt to restore the father, we see next, within the very same picture, the deft, tricky attempt to outwit the Lazarus-like figure who has just been eased back into

Painting, omnipotence, and the gaze

life. If he is tricked, if he is unable to see what is going on under his eyes, the likelihood is that, for some part of the time at least, we shall be too.

253 And now is the moment to take a final look back at the harem or bather pictures, at the representations of women alone. For in the light of this new turn of events, or of the boy's attempt to replace the mother and enjoy the father, they take on a new meaning: more precisely, a new layer of meaning. I have contended that these pictures should be seen primarily as portrayals of women temporarily released from the demands of men, and, as such, they depict them taking innocent pleasure in a new-found idyllic freedom. They are in effect chaste pictures. In the description of the odalisques at play that Ingres had copied out from the letters of Lady Mary Wortley Montagu, we find her writing *'Il n'y avait parmi elles ni gaïté ni posture lascive'*, 'There was not the least wantonness or immodest gesture amongst them', and it is my claim that Ingres by and large adheres closely to these words. By and large: for once the little boy's envy of the mother comes into play, things change. But in a special way.

To the modern sophisticated eye sexuality is everywhere. We should always be wary of such interpretations, but never more so than with paintings where, if sexuality existed, it would be on the surface and therefore at least as visible to the artist as it is alleged to be to us. His ability to conceal such content from himself would be very limited. The series culminating in *Le Bain Turc* belongs to this category, and sexuality enters into their content only when, viewed through the boy's envious eyes, these scenes of women apart take on a new character. For the boy's envy of the mother incites him to extend what had been originally conceived of as a holiday, as a respite, from men into a lifelong exile. The harem becomes a place of banishment, so that henceforth the boy can have the undivided attention of the father. But, even as he institutes this new regime, the boy indemnifies the women in the only currency to which he has access, and with which we are now familiar.

(Above left)
281 J.-A.-D. Ingres
Antiochus and Stratonice
1834–40

282 J.-A.-D. Ingres
Death of Leonardo 1818

Painting, omnipotence, and the gaze

He idealizes them. He idealizes them in a role which until now we were not particularly encouraged to believe was theirs: he idealizes them as sexual creatures. Idealization confers upon female sexuality a self-sufficiency, a transcendence of need, which enables women to exchange amongst themselves delights hitherto outside their reach. These pleasures are headier, more delirious, more enduring, than anything that they could have anticipated from men, whose company they are now summarily denied. It is only the shadow of this new destiny that passes across these scenes of otherwise innocent delight.

C. 1. Secondary meaning, as I use the term, is something that a painting acquires because of what the activity of painting means to the artist who engages in it. I have been considering one example of secondary meaning. I have been considering the meaning that a painting can acquire when the activity of painting is endowed by the artist with instrumentality: when it means to him – unconsciously, of course – a way of altering the world.

But, it may now be felt, the account that I have been offering of this example – and thus, by implication, of secondary meaning in general – is, on my own view of the matter, a one-sided account. On my own view of the matter: for thus far, in laying out how the activity of painting can come to mean something to the artist, I have in effect talked solely of how marking the surface can come to mean something to the artist, as though that were all there is to the activity of painting. I have, in other words, considered only how the artist conceives of the role of the agent. But in earlier lectures I have insisted that, when painting is practised as an art, inextricably entwined with the role of agent is the role of the spectator. The artist has a spectator embedded in him. Does it not therefore follow that any adequate account of secondary meaning should also take stock of how the activity of looking is conceived of by the artist, or what the use of the eyes now means to him?

The answer is, Yes. It should. The reminder is salutary, and it needs only to be supplemented by the obvious recognition that, in so far as the use of the eyes takes on fresh meaning for the artist, this must surely reach, not only to their use in guiding the brush, but to what they do for him in supplying from the outside world what the brush will recapture.

So, returning to the example of secondary meaning when the act of marking the surface is wildly overestimated, or comes to be assigned instrumentality, we should expect to find a corresponding overestimation of looking. We should expect to find an idealized spectator embedded within the idealized agent. I suggest that this is just what we find. Within the orbit of wishful painting, looking too is invested with an instrumentality that it does not, that it could not, have. And in overestimating the spectator within himself, the artist not only exaggerates what he does when he paints with, partly with, his eyes, he also exaggerates what he does when he acquires, through his eyes, the perceptual beliefs that contribute to his painting the way he does.

This too presupposes a certain history. Just as the overestimation of the act of marking the surface must, if it is to become a structural element of the artist's psychology, rest upon his identification with an internal figure whose powers have been exaggerated, so overestimation of the act of looking rests upon the artist's equation of vision with a bodily process which has in turn had its powers exaggerated. If we accept this, it is not so hard to infer what this bodily process might be. Another vicissitude of vision, which is very different from, but is also parallel to, its overestimation, is its sudden disturbance or inhibition, and, when this occurs, there is evidence to suggest that it is accompanied by a repression of the sexual function. It might therefore be thought that the assimilation that underlies both these vicissitudes is that of vision to sexuality.[70] The assimilation of vision to sexuality is further supported by the fact that, in many circumstances of life, the former

Painting, omnipotence, and the gaze

283 Wolf Man
Dream of Wolves
1910–12, drawing

serves the latter. In the sighted, vision functions as the principal transmitter of sexual attraction. Broadly speaking, then, vision overestimated presupposes that it has been equated with an idealized sexual act – though idealized, it must be appreciated, in a very special sense. Idealization of the sexual act greatly exaggerates its power, but it does not put its aim in a particularly rosy or congenial light. On the contrary, when vision has become overestimated, it is experienced as a sexual activity that is at once singularly effective and singularly destructive. A very archaic understanding of these matters rules, and, within this understanding, penis, vagina, eye, devour what they caress.

The destructive power that attaches to the overestimated eye naturally generates its own form of anxiety, and for this reason the name commonly applied to the sexualization of the gaze, 'scoptophilia', or the love of looking, is not fully accurate. In the subsequent flight from anxiety scoptophilia graduates into scoptophobia.

I now wish to turn and consider a picture which is the most remarkable tribute to the eye thus envisaged. It is an altarpiece to ocular sadism.

2. In early 1910 a young man, aged twenty, the son of one of those rich Russian landowning families whose life passed in a progress from one estate to another came to see Freud, seeking treatment. His health had broken down two years before after a gonorrheal infection, and time spent in several German sanatoriums left him with a total inability to work, chronic indecision, several residual phobias, harsh avarice alternating with fatuous extravagance, and a bitter-sweet longing for degradation. The analysis, interrupted by the war, terminated in 1920. Freud published the case-history, but he concentrated upon the patient's infantile neurosis which underlay his later disorders.[71]

A crucial event in the oncoming of this infantile neurosis was a dream which the patient originally dreamed at the age of four, and constantly re-dreamed. When he told Freud the dream, he also made a drawing of it, which is the picture I wish to consider. The manifest content of this dream has given the patient the name by which he is known: the Wolf Man. The Wolf Man died in Vienna at the age of ninety, in 1979.

Painting, omnipotence, and the gaze



Let the Wolf Man recount his own dream:

> I dreamt that it was night and that I was lying in my bed. . . . Suddenly the window opened of its own accord, and I was terrified to see that some white wolves were sitting on the big walnut tree in front of the window. There were six or seven of them. The wolves were quite white, and looked more like foxes or sheep-dogs, for they had big tails like foxes and they had their ears pricked like dogs when they pay attention to something. In great terror, evidently of being eaten up by the wolves, I screamed and woke up.[72]

Associations soon linked the dream to the primal scene: that is, to the little boy's perception, real or phantasized – and Freud was more insistent than might nowadays seem relevant on its reality – of the parents locked in copulation. It goes without saying that the dream is massively rich in its underlying meaning, but for our purposes we can confine ourselves to what is conveyed by two of the most strictly perceptual or visual features of the dream's manifest content: the total stillness and immobility of the wolves, and the searching attention they give the little boy. These are the features of the dream that were salient for the Wolf Man himself. In retrieving the meaning of these features, I somewhat reorganize Freud's interpretation of the dream, which took him several years to put together.

First, there are the wolves themselves, and they are a multiple representation, according to the boy's infantile mode of thought, of the parents interrupted in intercourse, but particularly – and, for certain bits of the meaning of the dream, exclusively – of the father. The basilisk gaze is punitive. It contains a dire threat, which it is also about to put into practice. What it threatens – as associations to various fairy-tales made clear – is castration. The eyes of the wolves zero in on the little boy's penis, which, the dream implies, they are fully competent to remove.

But the intense way in which the wolves look at the child is over-determined. For, in addition to being a way of punishing the child, the gaze also replicates that for which the child is punished. It discloses the offence. This is because the wolves punish the little boy in accordance with the cruel code which holds sway within the domain of infantile sadism: the ancient *lex talionis*. The wolves mete out punishment by the gaze as punishment for the gaze. Their eyes punish the child for the way his eyes once joined in the parental intercourse.

But if we now broaden our perspective on to the dream and adopt the point of view, not of the wolves who are dreamed in the dream, but of the dreamer who dreamed it, more comes to light. For, in applying the ancient law of retribution to this particular case as they do, the wolves assume a tariff the justice of which we must believe the dreamer himself accepts. If the gaze can be punishment as well as offence, if it can be painful to receive just as it was once pleasurable to inflict, we now have some insight into how the dreamer conceived of his offence or the nature of the pleasure it occasioned him. It was not merely an invasion of their privacy. The child must have felt that he was doing to the parents with his eyes what he now fears that they – or their deputies the wolves – will do to him with their eyes. In other words, in joining in the parental intercourse with his eyes, the child savoured the pleasures of aggression. And the gravity of this offence is in no way diminished by the fact that most likely, in keeping with infantile conceptions of sexuality, the child thought that the parents too savoured the pleasures of aggression against each other. They joined in the intercourse aggressively: the scene that the son had interrupted was an interchange of sadistic gratifications.

In so far as the gaze provides the infant with his erotic life, it is an erotic life of a baneful kind. It is this baneful eroticism that this picture uncovers.

Painting, omnipotence, and the gaze

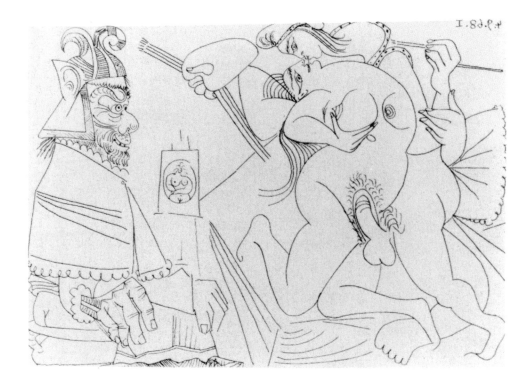

3. The Wolf Man was not an artist: though it is interesting to observe that, of the many ambitions that he entertained in childhood and adolescence, the only one that he managed to preserve and to fulfil in a long lifetime of poverty, tribulation, and mental anguish was that of being a painter. I have seen some of his paintings: they are those of an amiable, sensitive, Sunday painter.[73]

Picasso was an artist, and there is reason to think that he retained, of course in an attenuated form, a conception of painting as instrumental, as having the capacity, somewhat, to shift the world: despite, I am inclined to say, his saying so himself. Picasso, we know, always felt himself involved in a complicity with Ingres, and this conception of painting as instrumental is, I believe, part of their shared secret. It is significant that the series of etchings in which Picasso went furthest in illustrating the instrumental conception of painting should have its starting-point in a work of Ingres. In the twenty-four variations upon *Raphael and La Fornarina* executed in 1968, Picasso establishes an equation between painting the model and possessing her. He does so through an intermediate term: putting paint on her. Painting the model is equated with putting paint on her, which is then equated with possessing her. Something that this series clearly establishes is that in Picasso's case no small part of his overestimation of painting is his overestimation of looking.[74]

It cannot be emphasized too forcefully that we do not find in great artists great disorders of the mind. But what we sometimes find is the way back from such disorders. Certainly one of the great themes of Picasso's work is his attempt to deal with the malignity of the gaze: which he does sometimes by forbidding the gaze, sometimes by finding it benign employment or sublimating it, and sometimes by establishing a countervailing force. Within the comparative seclusion that this topic afforded, Picasso, it would seem, managed to confront some of the darker strains in his psychology: keeping, characteristically, never far away from tragedy, never out of reach of frivolity. As with most topics in his work, Picasso's treatment of the gaze acquired a drama of its own with a narrative which unfolds across the years, and I shall confine myself to a few very general remarks.

284 Pablo Picasso, From Suite 347, after Ingres, *Raphael and La Fornarina* 4 September 1968, etching

284

285

Painting, omnipotence, and the gaze

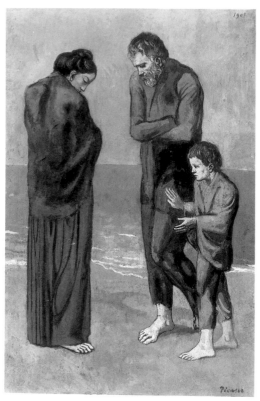

285 Pablo Picasso
The Tragedy 1903

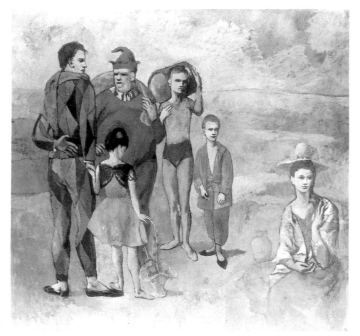

286 Pablo Picasso
Family of Saltimbanques 1905

After what seems to have been a brief youthful admission, Picasso's early work is marked by a sustained denial of the significance that the gaze held for him. He shows himself reluctant to consider the subject, and this unwillingness in turn retards the formation of a style. The gaze is forbidden. This is the story of the blue and the pink periods as I see them, when the painting, for all its charm and its saturation in mood, is 285, ultimately stilted and expressively ineffectual: it exhibits the inflexibility and the exaggeration of the pre-stylistic. The denial of the gaze means that the eyes are represented either as cast downwards or as muted in some kind of inner confusion.[75] The gaze is veiled, and, as if to rationalize the point, there is a preoccupation with blindness, which in turn claims literary justification. And then in the spring of 1907, with the studies

Painting, omnipotence, and the gaze

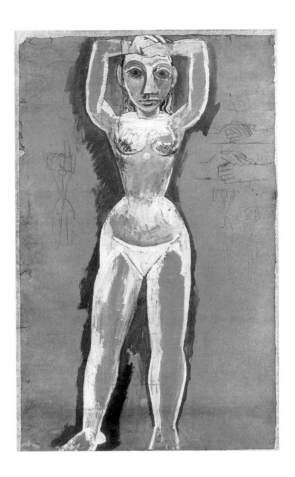

287 Pablo Picasso
Nue de face avec bras levés 1907, brown paper affixed to canvas: oil, pastel, and charcoal

288 preparatory to the *Demoiselles d'Avignon* (Museum of Modern Art, New York City),[76] the gaze is, for the first time in Picasso's maturity, given full and consistent recognition, sentimentality and delight in melancholy are sloughed off, and style appears on the scene in a sudden but well-prepared burst of ferocious splendour. The eyes grow round, and the 287 gaze streams out of the often unmarked socket. A work like the *Nue de face avec bras levés* (Musée Picasso, Paris) might seem to herald a return to the ancient belief that the eye is actually the source of light. It is a beacon in a world of shadow. More significant, it seems to me, than the much-discussed issue of precisely which tribal masks influenced Picasso at this period is the striking fact that it was through masks, through borrowing, adapting, combining, these surrogate heads, that for the first time he was able to do full justice to the human face and the human gaze.

Once the gaze has entered the work, and Picasso's style consolidates itself in a way that totally defies any morphological, indeed any surface, characterization, and is to be described only on a very deep or abstract level, the meaning or content of the painting re-forms around the new admission. From now onwards Picasso's art will have, for much of the time, the engagement of the eye with the world at its very centre. And, by talking of the eye's engagement with the world, I do not simply mean what the eye sees, or even visual experience. I mean the steps that the eye takes to secure visual experience.[77] And the eye in this context is the avid eye: it is the eye that its proud bearer is about to overestimate – with all the baneful consequences that will ensue.

For Picasso here as elsewhere the cure to life lies in art, particularly when art itself is pursued as an extension of life.[78] What mitigates the overestimation of the eye, though not infallibly, is the conscription of the eye into the service of painting. Initially, or as the painter stations himself before his canvas, painting may stimulate overestimation of vision: but, as the process proceeds, or with the gradual marking of the canvas,

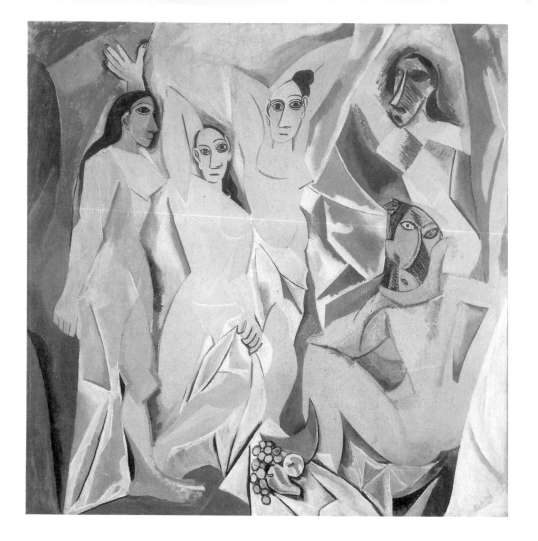

288 Pablo Picasso
Les Demoiselles d'Avignon
1907

overestimation is restrained. The eye, it turns out, is not worth more than what it can do for the brush. It is therefore no surprise that, once Picasso concedes not just the gaze but the significance of the gaze, a recurrent theme in his *oeuvre* should be painting itself, either overtly, through the representation of the act of painting,[79] or covertly, as when in cubist painting the resources of the art and the strategies of the artist are laid out. In the last lecture, in considering the *Déjeuner sur l'Herbe* series, I pointed out how speedily, how instinctively, Picasso acted to transform Manet's celebration of painters relaxing, or trying to relax, in the company of their models, into a study of the painter bearing down relentlessly upon his model, driving her to sleep with the intensity of his gaze, from which she will recover to find herself an element in a work of art. This depicted narrative can be looked at as a parable of Picasso's own art.

230–

The recruitment of the eye into the service of painting is sublimation, and what it amounts to is a re-routing of the gaze from the world into art. But sublimation, I have already suggested, is only one strategy that Picasso employs in order to reduce the dangers implicit in the gaze as well as the anxieties to which these dangers in turn give rise. Another strategy is to establish a countervailing force to vision. To this end Picasso invokes touch, so that what is characteristic of his appeal to touch, and what sets him apart from most other painters, is that for him touch is not ancillary to sight: it is contrastive to it. For at least as long as this strategy endures, touch and sight are conceived of as rivals rather than as allies; touch promising to be the safe, or the comparatively safe, way of making contact with the external world.

Painting, omnipotence, and the gaze

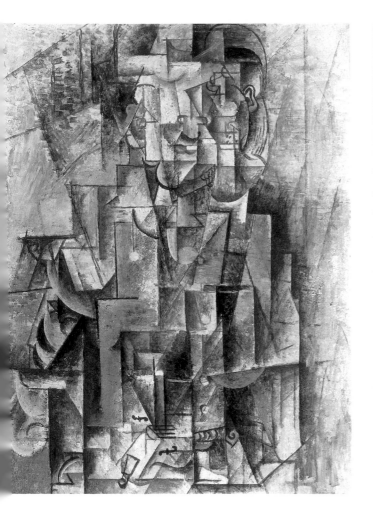

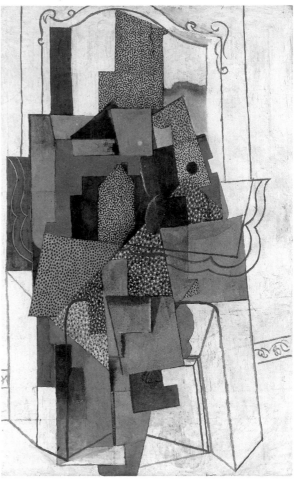

It is within Picasso's cubism – and it is not obvious that the same goes for the cubism of other artists – that touch is most clearly assigned this new role. There are various ways in which Picasso segments touch from vision, and emphasizes the tangible. In the earlier paintings, or works of so-called analytical cubism, such as the *Man with a Violin* (Philadelphia Museum of Art, Philadelphia), painted in the spring of 1912, Picasso asserts the edges of planes. He seizes on mouldings or the small-scale architectural aspects of furniture. He introduces impasto for no obvious visual reason, and he then reintroduces it elsewhere in the picture so that this fact should not escape attention. When he employs *papier collé*,[80] he exposes its jagged edge. He inserts breast-like shapes which ask to be stroked. But it is in the later cubist paintings, or those which come out of so-called synthetic cubism, that this hiving-off of touch from vision, with one then played off against the other, becomes most conspicuous. In a painting like *Homme à la Cheminée* (Musée Picasso, Paris), of 1916, irregular decorative panels, which appear to have been let into the pictorial surface, and which initially seem to address themselves to the eye, on further inspection turn out to be addressed through the eye to the sense of touch. Even as we look at them, they convert themselves from pattern into texture. They arouse, through visual impressions, tactile memories.

Because Picasso appeals to touch to counteract vision, or to neutralize what seemed to him, we may infer, the destructive power of the gaze, this does not mean that to the degree to which touch wins out over vision all is well with his work. It does not mean that the all-out victory of touch would be tantamount to the full release of creativity. That

Painting, omnipotence, and the gaze

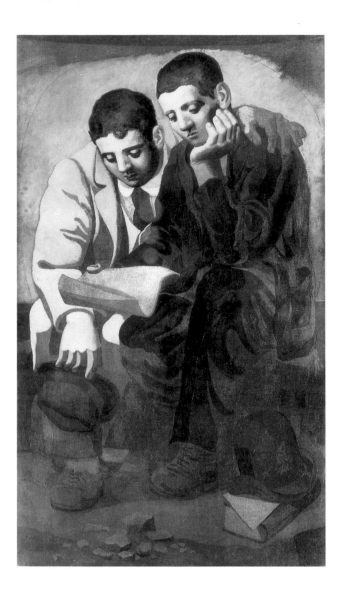

291 Pablo Picasso
La Lecture de la Lettre
1921

would be a simplistic inference, and it runs counter to a substantial body of evidence. This evidence is provided by the work of Picasso's classical period. For this period undoubtedly coincides with the triumph of touch over sight. This, I am suggesting, is how Picasso himself thought of it, and he reveals it in a characteristically direct fashion when, as, for instance, in *La Lecture de la Lettre* (Musée Picasso, Paris), he juxtaposes the 291 organs of the two sense-modalities. The massively enlarged hand dominates the adjacent eye, which is demure and glazed over. But, if we then go on to look at the rest of the picture, indeed if we weigh up carefully the representation of hand and eye, we shall see the cost at which the triumph of touch has been secured. Without a doubt some of the classical paintings contain passages of great beauty, but the characteristic work of this period is, by Picasso's standards, unadventurous. It has a pacified air, it reproduces some of the blandness of the blue and pink periods, and it is inviting to think of this period as extra-stylistic. The hegemony of touch is the rule of King Log.

And then, years later, in the very last paintings, works of amazing self-reconciliation, the drama of the gaze enters its final act, and something not to be foreseen from all that had gone before occurs. The gaze reappears on a massive scale, but for the first time – or, more precisely, for the first time outside paintings that trade heavily on a confusion

Painting, omnipotence, and the gaze

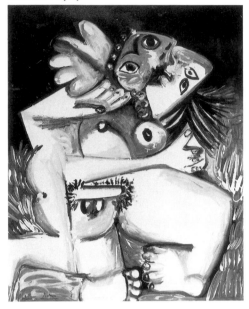

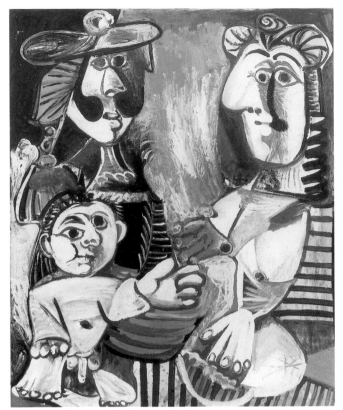

294 Pablo Picasso
La Famille September 1970

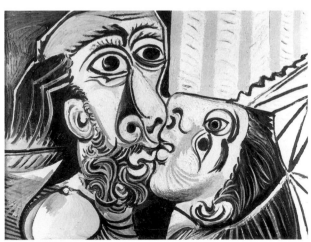

293 Pablo Picasso
Le Baiser 1969

between the sexes — the gaze ceases to be the monopoly of the male. In scenes of intense
, 293 passion, like *L'Étreinte* (private collection) or *Le Baiser* (Musée Picasso, Paris), both of
1969, the woman, locked in embrace, gazes back avidly at the man whose eyes seek to
devour her. Her eyes prove to be a match for his, and sexuality ebbs and flows between
the two partners, as they may now be called. After years in which the gaze had conferred
upon its bearer — like the sword of Henri IV upon the page who carries it through the
palace — an impossibly privileged status, a new reciprocity comes into existence. In the
294 masterwork entitled *La Famille* (Musée Picasso, Paris), of September 1970, the family is re-
created.

Painting, omnipotence, and the gaze 295

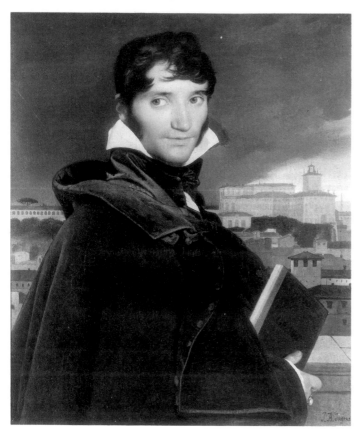

295 J.-A.-D. Ingres
François-Marius Granet 1807

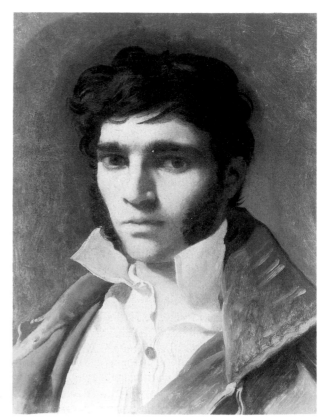

296 J.-A.-D. Ingres
Paul Lemoyne 1819

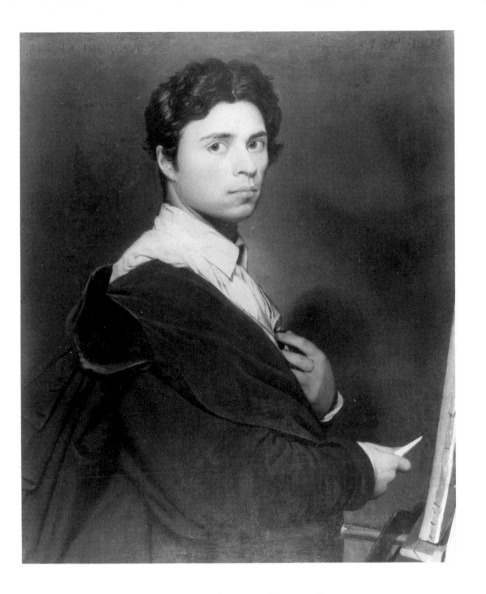

297 J.-A.-D. Ingres
*Portrait of the Artist at
the Age of Twenty-four*
1804, reworked 1851

4. I return to Ingres, expecting to find in him also an artist in whom the overvaluation of looking is a pronounced factor. These expectations are met. Indeed the overvaluation of looking is the second piece of evidence that I said (section B.5) should be placed beside the spatial distortions as speaking for the adoption within Ingres's work of an instrumental or wishful conception of painting.

An obvious place in which to look for such overestimation is amongst the portraits, and, given the particular nature of our inquiry, we might wish to pay particular attention to the male portraits and very particular attention to the portraits of male artists. In three portraits of male friends, all comparatively early, two of sculptors, one of a painter, the eyes burn like lakes of fire. These are the portraits of the painter *François-Marius Granet* (Musée Granet, Aix-en-Provence), painted in 1807, of the sculptor *Jean-Pierre Cortot* (Musée des Beaux-Arts d'Alger, on deposit at the Louvre, Paris), of 1815, and of the sculptor *Paul Lemoyne* (Atkins Museum of Fine Art, Kansas City, Missouri), which dates from 1819. The effect I talk of defies reproduction. In the so-called *Portrait of the Artist at the Age of Twenty-four* (Musée Condé, Chantilly), a self-portrait which was originally executed, as the title implies, in 1804 but was considerably modified at some later date, and in which Ingres initially employed the startling conceit of depicting himself in the act, not of painting a painting, but of obliterating it, the incendiarism of the eyes is flagrant.

Painting, omnipotence, and the gaze

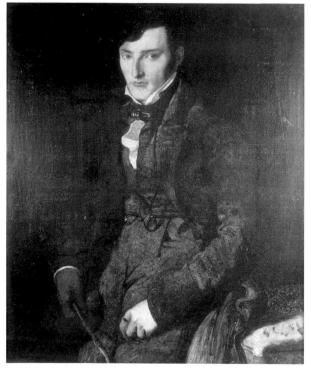

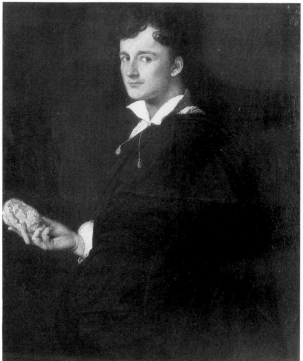

298 J.-A.-D. Ingres
Jean-François Gilibert 1804–5

299 J.-A.-D. Ingres
Lorenzo Bartolini 1806

300 J.L. Potrelle after Ingres
Lorenzo Bartolini 1805, engraving

It is of a piece with what I found to say earlier on about the final turn in the family epic that within Ingres's portraits it is only a short step from this look of blazing omnipotent energy to something that might, in the abstract, seem miles away from it, but in the psychology that I have discerned in Ingres, is closely related: a wily, confusing look in the eyes. This slide from ferocity into slyness or imposture is unmistakable in two very early portraits: those of the lifelong friend and amateur painter, *Jean-François Gilibert*, of 1804–ll298
5, and of the sculptor *Lorenzo Bartolini*, of 1806 (both Musée Ingres, Montauban). ll299
Significantly when the print-maker J.L. Potrelle came to engrave the Bartolini portrait ll300
(Bibliothèque Nationale, Département des Estampes, Paris), he was so mystified by
Ingres's depiction that he gave Bartolini an air of melting folly.[81]

Painting, omnipotence, and the gaze

The eyes burn fierce outside the portraits, and they burn fiercest in a group of
mythological heads: figures who erupt into Ingres's work, sunburnt from some archaic
301 desert. Typical examples are *Profile of a Bearded Man* (Musée Granet, Aix-en-Provence)
302 and the *Head of Jupiter* (Musée Ingres, Montauban), which is a study for the vast *Jupiter and*
248 *Thetis*. Is it out of solicitude for an unrecorded observer that in these pictures the eyes are
invariably cast down, or the gaze turned to the side?

The glorification of the gaze enters into another subject that much occupied Ingres,
which I have not mentioned so far because I did not want to play upon obvious
associations of the theme: I refer to the encounter between Oedipus and the Sphinx. It is
one of the earliest of his dramatic subjects. There are three versions. In the two earlier
303 versions, that of 1808–25 (Louvre, Paris) and that of 1828 onwards (National Gallery,
London), it is hard to resist the impression that the weapon with which this duel to the
death is being fought out is the eyes. The protagonists outstare each other, and from the
beginning the Sphinx appears to have difficulty in returning the look that she receives. If
we find this account of the ordeal credible, then we are rewarded when we come to the
304 final *Oedipus and the Sphinx* (Walters Art Gallery, Baltimore, Maryland), begun in 1835
and completed in 1864. This picture shows not the ordeal in progress but the conclusion.
We see the moment of victory, and, as the Sphinx expires, she does so, not in response to
what Oedipus says – his lips are unmoving – but in response to how he looks at her. His
eyes transfix her, and she, to concede victory, averts not just her eyes, as she might have
done between engagements, but her whole head. She throws down her arms.

No account of any particular artist's overestimation of the gaze could be complete
without some reference to what the artist expected of the overestimated gaze of the
external spectator who will look at his work. It is a larger topic than I can take up in the
case either of Ingres or of Picasso. However for those who are insistent that success was
Ingres's principal aim, the issue is one that cannot be ignored. We cannot even begin to
say what would have counted as success for Ingres unless we are prepared to speculate
about what he dared to hope for from the omnipotent gaze of the spectator as it fell upon
the painted scenes of wish and yearning. It must be insufficient to attribute to Ingres a
wholly material or worldly conception of success.

(Above left)
301 J.-A.-D. Ingres
Profile of a Bearded Man
1808

302 J.-A.-D. Ingres
Head of Jupiter 1810,
canvas on panel

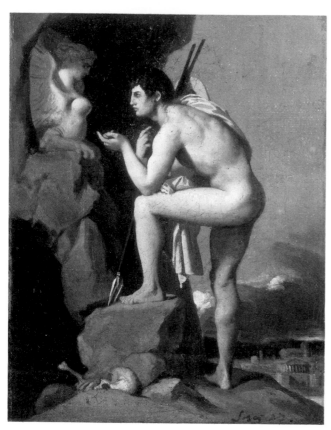

303 J.-A.-D. Ingres
Oedipus and the Sphinx 1828 onwards

304 J.-A.-D. Ingres
Oedipus and the Sphinx 1835–64

Painting, omnipotence, and the gaze

5. There is one last topic into which the theme of the gaze edges me.

At the begining of this lecture, in extracting three themes from Ingres's statement of 1859, I claimed that looming above them is the more comprehensive issue of how an artist, a true artist, should stand to the work of his predecessors. It does not require any deep acquaintance with Ingres to recognize how important this issue was for him. At times it seems to have been paramount, and Ingres often looked upon himself as a mere conduit through which the art of the past could flow smoothly, safely, into the future. But such a compliant view of himself, apart from its other difficulties, suggests that for Ingres what constituted the art of the past, or how tradition formed itself, was itself an unproblematic issue. However this was not the case, and, for some of the time at any rate, Ingres seems to have been pleased that it was not the case. At the purely enumerative level he allowed a narrow conception of the tradition, which made Raphael, Poussin, and the Greeks pre-eminent, to compete in his mind with a more pluralistic conception, which admitted the Trecento, the Flemish painters, Titian, Watteau, and Italian mannerism.

Ingres devoted two compositions to the topic of tradition, broadly understood. The first painting illustrates *traditio* itself, or the act of handing down. This is the *Christ Handing the Keys of Heaven to St Peter* (Musée Ingres, Montauban), painted for a Roman convent in 1820. It is an awkward work, but its awkwardness did not prevent Ingres from putting a lot of effort into trying to reclaim it in order to look at it again. This he eventually succeeded in doing in 1841, when it re-entered his possession. The awkwardness of the picture comes in large part from the somnambulism with which the great act is invested. The most important key in the world is passed on from one sleepwalker to another.

To understand the mood that Ingres re-creates in this picture, we must turn to the second composition, which represents not tradition but the body of persons whom tradition collects across the generations. This is *The Apotheosis of Homer* (Louvre, Paris), which was commissioned in 1826 as a ceiling decoration for one of the nine rooms of the new museum that Charles X instituted in the Louvre, and which Ingres completed, though without the colour, the following year, with only a slight delay.[82] In addition to what it shows us about Ingres's view of the history of art, this picture constitutes, in its oblique way, Ingres's most considered and most lavish testimony to the gaze. Naturally Ingres, having completed the commission, did not leave such a highly charged work alone, and it is in the context of his later revisions that this interpretation gains force.

It was in 1840 that Ingres came back to the composition and, though he began by working on it solely for the benefit of the engraver Calamatta, he soon started to expand and to review the original cast of characters. In the final version, *Homer Deified* (Louvre, Paris), which was finished in 1865, and is executed in graphite and grey wash, measuring roughly two and a half feet by almost three feet, there are more than eighty artists instead of the original forty-six, and Tasso, Shakespeare, and Goethe, have all been removed.[83] So we must ask, What were the grounds on which Ingres admitted some artists into the fold of tradition, and kept others out? Excessive self-expression or self-assertion was in Ingres's eyes unforgivable, but it would certainly be gross distortion to think that Ingres regarded the issue as one between classicism and romanticism.

A key notion in Ingres's slow gestation of *Homer Deified* is that of *exclusivité*.[84] Ingres set himself to be *exclusif*, but, above all, he expected others, or those worthy of entry into the charmed circle, to be, to have been, *exclusif* in their art. No artist should be judged simply by his best work, but he must have been at all times loyal to the ideals of beauty and truth. It was for their backslidings, not for the central drift of their work, it was for what they failed to keep out of it, that Ingres expelled Goethe, whose greatness was not lost on him, and Gounod, whom he had once admired, and the young musician whom he had looked to as the prospective Mozart, Ambroise Thomas.

Painting, omnipotence, and the gaze

305 J.-A.-D. Ingres
*Christ Handing the Keys of Heaven to
St Peter* 1820, reworked

306 J.-A.-D. Ingres
The Apotheosis of Homer 1827, reworked

Painting, omnipotence, and the gaze

In his insistence upon the tribal virtues of fidelity and constancy as the paramount qualities of art, Ingres reveals what should come as no surprise to us: that for him it was not a worn metaphor, it was a living thought, that all true artists form a single family, within which they struggle to abandon rivalry and dissension. *Homer Deified* attests to this view, not only in its completed image, but in its stormy history. For Ingres, in making it, would seem to have passed through all the torments that overcoming the dark, divisive emotions that lie at the heart of the family could cost him. He exposed himself to jealousy and envy at their fiercest. At one moment Mozart, '*le divin Mozart*', of whom Ingres's most considered opinion was that he was '*le dieu de la musique comme Raphael est celui de la peinture*',[85] 'the god of music as Raphael is the god of painting', was about to be excluded.[86] We do not know why. Then Ingres set himself to overcome whatever it was that had prompted him. He succeeded, and Mozart was restored. The finished picture contains, in Ingres's representation of himself, a touching tribute to the chastening effect that the making of it must have had upon his more turbulent feelings: he appears as a boy of twelve or fourteen, a servant, an acolyte who tends the flame of the altar.[87]

Jealousy, envy, and the surmounting of these emotions are a large part of the vision of family life that Ingres implanted upon the theme of pictorial tradition. But they are not the whole of it. Jealousy and envy leave the identities of the family members more or less intact: they do not blur them. What does blur them, and what we have also to reckon into Ingres's conception of the life of the family, is the effort not so much to surmount these emotions as to evacuate them: I refer to projective identification, which we have already seen at work within two of the greatest of Ingres's family dramas, the *Vergil* and the *Stratonice*.

Of course, what the *Vergil* and the *Stratonice* show is the employment of projective identification within the actual or blood family. What I now suggest is that for Ingres the constructed family, or the sequence of artists which forms the tradition of painting, is as much a setting for its employment as the actual family, and it is this that we see at work in the uncertainty, in the confusion, in the agonies of indecision, that surrounded the

307 J.-A.-D. Ingres
Homer Deified 1840–65,
graphite, white gouache,
grey wash on laid paper

compilation of *Homer Deified*, and, if we now return to the *Christ Handing the Keys of* *Heaven to St Peter*, it is this that accounts for the more curious aspects of that picture. What I have called the somnambulism of the central characters, the staggering gait, the vertigo that overcomes them at the greatest moment in the Church's history, attest to the confusion of identity that excessive, indiscriminate defence has introduced into the heart of a family to be. Who is giving?, Who is receiving?, Which is father?, Which is son? Where does Raphael stop, and where does Ingres begin? – The questions float in Ingres's mind unanswered.

'*Les hommes qui cultivent les lettres et les arts sont tous enfants d'Homère.*'[88] 'Those who cultivate letters and the arts are all children of Homer.' The choice of Homer as the common ancestor of all true artists was, as we have seen, not Ingres's own idea: it was introduced to him through a commission. But he evidently warmed to the idea. It struck a deep chord in his psychology. He wanted it to be celebrated in his greatest work as an artist. It is reasonable to think that for Ingres the appeal of the idea was overdetermined. It was history that proposed Homer for the role of father of all artists: he being the person from whom all true artists derive, but who in turn derives from no one. But if we ask what it was that, in Ingres's eyes, confirmed Homer in his title, we must, I believe, look outside history. It is what legend has always insisted upon, or the blindness of Homer, that places the claim of history beyond dispute. It is Homer's enforced abdication of the gaze that alone permits the benign, the relatively benign, gathering of the family under his aegis.

D. 1. And now I want to take up a pledge that I made at the beginning of this lecture, and that is to justify the phrase 'secondary meaning'.

For what I have been doing in this lecture so far is to talk about an aspect of a picture that comes about because of what the act by means of which the artist gives the picture meaning means to him. I call that aspect 'secondary meaning', and the phrase is justified to the extent that the aspect is secondary upon meaning. But that is not enough. For what I have not done is to show that the aspect is itself a kind of meaning. In order for it to be a kind of meaning, should there not also be, in accordance with what I have been postulating for other kinds of meaning, a volition on the part of the artist that the spectator, if there is one, should experience what this act means to the artist? Yet, it might be objected, when the act of painting does have a meaning for the artist, is it not likelier that this is something that the artist will want to keep to himself, and that there will be no volition on his part that it should be revealed to the spectator?

The objection is convincing only if the spectator is thought of in a way that I have been at pains to argue against: that is, as a person, and a person different from the artist. But, once we recognize that being a spectator is a role, and furthermore that this role must be filled by the very person who fills the role of agent, the situation changes. If Manet, in painting *La Musique aux Tuileries*, or Picasso, in painting one of his *Déjeuner sur l'Herbe* variations, did indeed conceive of this act as a way of establishing a benign identification with one of his great predecessors, then he must have wanted the picture to show him what the act of painting it was doing for him. He would want the picture to serve not just as a visible souvenir of, but as visual evidence for, the psychological process accomplished through this act. But for this to happen, what the act of making the painting meant to him would have to be something that is visible in the picture. Of course, the artist is exclusively concerned that the meaning of the act should be visible to his eyes. But, if it is visible to his eyes – really visible, that is – then of necessity it is so for other adequately informed, adequately sensitive, eyes, should they chance to light upon the picture. Visibility, like meaning itself, cannot be private.

If this is correct, we must conclude that the condition required for secondary meaning to be a kind of meaning is indeed satisfied.

Painting, omnipotence, and the gaze

VI

Painting, metaphor, and the body:

TITIAN, BELLINI, DE KOONING, ETC.

A. 1. In this lecture I shall consider a final way in which a painting can gain content or meaning. This is *the way of metaphor*, through which a painting gains *metaphorical meaning*. Metaphorical meaning is a case of primary meaning: that is to say, it accrues to a painting through the making of it, but not through what the making of it means to the artist.

When the way of metaphor works, and the painting acquires metaphorical meaning, there is something for which the painting becomes a metaphor or, as I shall barbarously put it, something which the painting 'metaphorizes'. And 'something' here means 'some *thing*'. It is always an object that the painting metaphorizes. In point of fact I further believe that the fundamental cases of pictorial metaphor are those where a corporeal thing is metaphorized: the painting becomes a metaphor for the body, or (at any rate) for some part of the body, or for something assimilated to the body. In some cases the painting metaphorizes both the body and something other than the body, and in other cases the painting doesn't metaphorize the body at all. But to my mind it is only in so far as the painting metaphorizes the body, with the body taken in the extended sense I have just suggested, that it uses the resources of pictorial metaphor to the full.

For this last claim about pictorial metaphor I have no direct argument, only a set of considerations which may sway the mind. However it is perfectly possible to accept in general outline the account that I shall offer of what pictorial metaphor is without accepting my claim about just what it is that is metaphorized in the fundamental cases, or indeed without accepting the claim that some cases of pictorial metaphor are fundamental and others aren't. I hope that those who can go thus far with me will.

In this lecture I shall consider only cases in which what the painting metaphorizes is the body.

2. At the core of pictorial metaphor there is a relation: a relation holding between a painting and some thing for which it is, in virtue of this relation, a metaphor. I call this relation metaphorizing, and I start with the question, What is metaphorizing?

Earlier on in these lectures I tried to explain the relations that lie at the core of the two basic forms of pictorial meaning: representation, and expression. I tried, in other words, to explain representing and expressing. And I employed the same method in each case. I looked for a certain kind of experience which a spectator can have through looking at a marked surface and which in consequence an artist can, when it is appropriate, induce in the spectator by the way he marks the surface. I did so, because in each case my hope was that the painting's capacity to produce that kind of experience could explain the relation: not single-handedly, but it could explain it in large part. The supplementary factor would always be a standard of correctness. For it is only if the experience that the spectator has is the correct one for him to entertain that it shows that the relation holds, and the standard

of correctness that adjudicates this in turn goes back to what is broadly the intention of the artist. The fulfilled intention of the artist decides which, out of the experiences that a particular painting is able to produce in a spectator, is the correct one for him to have on looking at it.

So, in the case of representation, I offered to explain what representing is by reference to a kind of experience that a representational painting can produce in a spectator: that of seeing-in. My contention was that what a painting represents can be defined in terms of what a spectator can see in it, provided only that what he sees in it concurs with, and is brought about through, the artist's fulfilled intention. The spectator's experience is a determinant of the painting's representational content if he perceives the picture not only representationally but correctly.

This method of explanation recommended itself to me because it conforms to – and, if it could be carried through, would confirm – the kind of psychological account of pictorial meaning to which these lectures are committed: an account that, forswearing any except a peripheral appeal to rules, or conventions, or codes, or symbol systems, grounds pictorial meaning in psychological factors and their interrelations. Accordingly, why not use this method in the present case to try to explain the metaphoric relation, or the relation at the core of pictorial metaphor?

If we do, what explanation proposes itself?

I suggest the following: In the first place, the characteristic experience in which metaphorizing is grounded is not exclusively visual. It is triggered off by perception, and it remains a way of seeing the picture, but it is largely affective. In this respect, the experience is like that in which expressing is grounded, but it goes further in that direction.

Secondly, this affective response will draw upon emotions, sentiments, phantasies, ordinarily directed on to the object metaphorized: in the profounder cases, if I am right about them, the body. However the requirements of metaphor will not be met unless, as well as recruiting to the perception of the picture emotions, sentiments, phantasies already directed on to what it metaphorizes, the picture also encourages the development of fresh feelings. Profound pictorial metaphor modifies, deepens, intensifies, our attitude to the body.

And, thirdly, the complex experience thus aroused in response to the picture is a response to the picture as a whole, or at least to some large zone of it. It is not a piecemeal response.

Now there have been many critics and theorists of painting over the last hundred years who have recognized or stressed the importance of some sort of global or gestalt response in our perception of pictures. Most of them have done so in order to do justice to the new art of their day.[1] But, sometimes sensitive, sometimes insensitive, their criticism has a common feature that certainly makes it irrelevant to the understanding of pictorial metaphor. For all these critics have presented the global response that they advocate as a preferential response. It is a response that is prior to other modes of perception: specifically, to representational seeing. But, whatever the importance of such a response for painting in general, the kind of experience that grounds metaphor cannot be like this. So far from being preferential, it is last in line. It comes after, and therefore can benefit from, other modes of perception. It capitalizes what they deliver and uses it as the cognitive stock which it draws upon. It does this above all with the proceeds of representational seeing.

Having identified a kind of experience or response, I shall now say that the relation of metaphorizing is exemplified when a picture correctly arouses such a response. Furthermore, what it metaphorizes is given by what the emotions, sentiments, phantasies, which the response mobilizes, are normally directed on to.

Painting, metaphor, and the body

3. The question that arises is, Why do I call the kind of meaning that such an experience conveys pictorial metaphor? What is there in common between a painting that causes such an experience and that use of language exemplified when a poet says, 'Juliet is the sun', or when a great thinker says, 'Religion is the opium of the people'?

If we isolate what, on the best understanding of the matter,[2] are the three major features of linguistic metaphor, we shall see that these features are also exhibited by what I have called pictorial metaphor.

In the first place, linguistic metaphor does not require that the words that effect the metaphor lose their normal sense. In my examples neither 'sun' nor 'opium' means something new, and indeed reflection shows that, if these metaphors are to work, if they are to convey the life-giving quality of Juliet or the stultifying effect of religion, then the sense of the crucial words must not change. What some thinkers have pursued as the metaphorical sense of language is an unwanted fabrication. In just the same way, the representational or the expressive meaning of a metaphorical painting undergoes no change, and, again, reflection will show that, if the painting is to convey its metaphorical meaning, this must be the case.

Secondly, linguistic metaphor does not require that there is a special or pre-existent link between what the words carrying the metaphor pick out and the thing metaphorized. There does not have to be a symbolic link between Juliet and the sun, or between religion and opium. If there were, the metaphor could probably survive it, but it is likely that it would be weakened or made banal by being anticipated in this way. Similarly there doesn't have to be, say, an iconographical link between what the picture represents or what it expresses and what it metaphorizes. Pictorial metaphor too could survive such pre-existent links, though such links would tend to trivialize the metaphor. Certainly the metaphor cannot be grounded in them. There is however an exception to this principle, which is when the links are themselves metaphorical: such links can ground pictorial metaphor. I shall return to this very last point.

These first two features of metaphor, which are exhibited both by linguistic and by pictorial metaphor, reflect the essentially improvisatory character of metaphor. Indeed, given the rule-, or convention-, free nature of pictorial meaning, which is something that I have been stressing in these lectures, pictorial metaphor is doubly improvisatory. It is an improvisation upon what is already improvisatory.

Finally, the aim both of linguistic and of pictorial metaphor is to set what is metaphorized in a new light. Juliet, religion, the body — we see whatever it is afresh. Just what it is about the thing metaphorized that we are enabled to see by the light of the metaphor, or how the object looks new, will vary both in specificity and in amenability to description in language. This last point about the way in which metaphor works, to varying degrees revelatory, to varying degrees ineffable, I shall put by saying that paintings that are metaphorical metaphorize their object *under some conception of that object*.

And now for the big difference between linguistic and pictorial metaphor. Linguistic metaphor illuminates what it metaphorizes by pairing it with something else. Juliet is paired with the sun for the better illumination of Juliet: religion is paired with opium for the better illumination of religion. This is the essential metaphoric strategy, which pictorial metaphor follows to the extent of pairing the object metaphorized with something other than that object. But — and this is the crucial point — in the case of painting this something is the picture itself. It is not — as linguistic metaphor might suggest — something that the picture picks out: even though the picture, at any rate normally, has to pick out something, indeed has to represent something, in order to fit itself to be a metaphor. When the way of metaphor works, what is paired with the object metaphorized is the picture as a whole. It is the picture as a whole that is the first term to

308 William Blake
The River of Life c. 1805, watercolour

309 Jean-Baptiste-Siméon Chardin
House of Cards c. 1735

the metaphoric relation, and this fully coheres with what we have seen to be the nature of the experience in which pictorial metaphorizing is grounded: that it is a response to the picture as a whole. When, in what is for me the fundamental case, the picture metaphorizes the body, I shall say that the experience that grounds this relation attributes to the picture the global property of *corporeality*. In this lecture I shall address the question, How does this happen? What is the experience of corporeality?

But, first, a distinction which may clear the air.

4. In this lecture I shall be talking about metaphorical paintings, or about paintings that are metaphors. Let me distinguish between paintings that are metaphors and paintings that have metaphors as their content, specifically as their textual content. Examples of this latter kind would be: a landscape by William Blake, whose textual content is, Life is a 308 river; a domestic scene by Chardin whose textual content is, Life is a pack of cards; or the 309 famous series of paintings by the American artist Thomas Cole, each of which has as its 310, textual content, Life is a journey.

None of these latter paintings metaphorizes anything. The texts they contain do. The texts metaphorize life, embodied life, and what the paintings do is to represent that which the metaphors pair life with. The paintings represent a bubble, a house of cards, a journey. As we saw in Lecture IV, this representational content does not by itself guarantee that the paintings have the corresponding metaphors as their textual meaning. What is further required is that the paintings should show what the metaphors themselves meant to Blake, to Chardin, to Thomas Cole. In citing these paintings as examples of pictures which, though not themselves metaphorical, have metaphors as their textual content, I am simply assuming that this further requirement is met.

(Opposite above)
310 Thomas Cole
The Voyage of Life: Childhood 1842

(Opposite below)
311 Thomas Cole
The Voyage of Life: Youth 1842

Painting, metaphor, and the body

B. 1. I start with two famous paintings, which belong to Titian's first period as an artist
with a formed style. Both represent pastoral scenes of great lyricism and considerable
mystery. The mystery is there to be experienced, certainly not to be resolved: once we
cease to find these paintings mysterious, we no longer understand them. And in both
paintings Titian gives full vent to what is the main expressive theme of his whole work:
human vitality – human vitality as something tied to the body, and tied in consequence at
once to physical sensation and to mortality. The two paintings I have in mind are the
Concert Champêtre (Louvre, Paris), of around 1510, still believed by some (as it was by
Manet) to be by Giorgione, and the exquisite *Three Ages of Man* (collection Duke of
Sutherland: on loan to the National Gallery of Scotland, Edinburgh), of about three or
four years later.[3]

Both these paintings metaphorize the body in addition to representing it, and the
conception under which they metaphorize it corresponds to how Titian at this time
thought and felt about it: as the locus of pleasure, beauty, and death. Both paintings have
corporeality, and in front of them is a good place to ask how Titian secures this effect.
How *Titian* secures it: for the achievement of corporeality is best considered within the
work of a particular artist. This is not because there are no common sources of
corporeality. There are: but different artists are likely to draw upon these sources in such
different ways as to put a common account out of the question.

It is convenient to think of the sources, the broad sources, of corporeality as three in
number, and in consequence the answer to any question such as that which I ask of Titian
is likely to fall into three parts, not sharply demarcated. Partly corporeality is a matter of
how the picture represents what it does, and specifically of how it does this in such a way
as to stir thoughts, emotions, phantasies, about the body. Partly corporeality is a matter
of how such responses are then transferred to the picture itself. And partly it is a matter of
how by other means, or independently of its central representational content, the picture
manages to attract to itself feelings directed on to the body: I call this directly inducing
corporeality. I list the three sources of corporeality in this order for a good reason. The
reason is local, and it is because within the art of Titian the lion's share goes to the first
source: to the way the body is represented. So powerful a sense of the body does his art
generate – something that is constant under the changing conceptions of the body that
his work exhibits – that, once this has been achieved, all that he needs to do is to make
certain that nothing gets in the way of this aura of physicality resettling around the
painting as a whole. Directly inducing corporeality, or developing it out of non-
figurative, let alone non-representational, means, is less of an issue.

How then does Titian represent the body so as to give rise to this powerful sense of
human vitality? His central device exploits what I have been calling twofoldness, or the
way in which, when we see, say, a human body in a picture, there are two aspects, two
distinct but inseparable aspects, of the experience. One aspect involves recognizing
something absent, in this case a body: the other is awareness of the marked surface.
Correspondingly there are two aspects to Titian's device. Recognitionally we sense that
the body that we see is about to move into action: configurationally we become aware of
the coloured expanse in which we see the body as something spreading or pushing
outwards.[4] And – as is the case with twofoldness itself – we attend to these two effects
not sequentially but simultaneously: they are twin aspects of a single, complex
experience.

Titian, I have said, connects the represented body with action. That is one half of his
particular route to corporeality. But, if we are to do full justice to Titian, action must be
understood broadly. It must be taken to include not only behaviour, or something
involving the movement of the limbs, but also, as these early pastoral paintings evince,
the relaxation of the body, the sudden sagging of the limbs, in which the body also

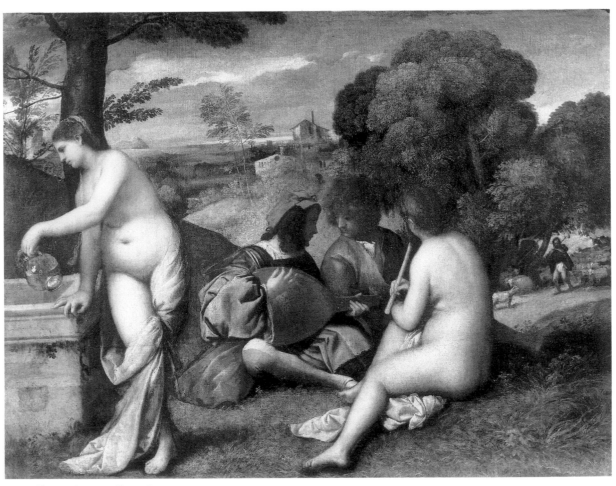

312 Titian *Concert Champêtre* c. 1510

313 Titian *The Three Ages of Man* 1513–14

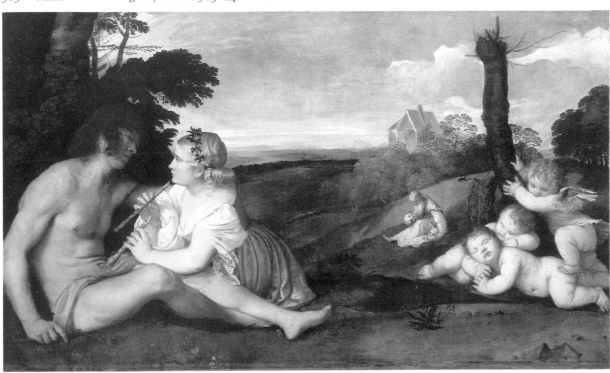

reveals its vitality. Indeed for Titian the distilled essence of action is the gaze: the probing, searching activity of the eye, seeking to gain knowledge, to express adoration, to arouse desire, to catch, to return, to elude, the gaze of the other. After what I found to say in the last lecture about the gaze, I should make clear that with Titian the gaze is not at all a secret weapon. It is, rather, the outpouring of the mind: it is a second, a naïve, voice. From the very earliest painting that we can attribute to Titian's hand, *Jacopo Pesaro presented to St* 314 *Peter by Pope Alexander VI* (Musée Royal des Beaux-Arts, Antwerp), of 1506 or so, the passionate gaze is the mark of Titian's work. For Titian human vitality, along with its companion, the awareness of death, is concentrated in the soft black orb which glows under the single brushstroke with which Titian characteristically describes the curve of the eyebrow.

The pairing of incipient action, concentrated in the gaze, with the other half of Titian's way of securing corporeality, or the effect of spreading configuration, is something that is reiterated across these early paintings. In the *Concert Champêtre* we even become sensitized to the gaze of the seated woman who has her broad back turned to us. In *The Three Ages of Man* Titian elaborates on this effect in a way that it is instructive to follow. First, he bends the bodies of the young girl and her lover away from one another, he makes them open up like the pages of a book: thereby he extends the silhouette that they jointly form to its maximum, so as to generate the spreading effect. Then, having done this, like an afterthought — and, if we look at the X-rays of the picture, we can perceive that 315 this is exactly what it was, an afterthought[5] — he twists the girl's head back towards the young man, so that, the full breadth of the silhouette maintained, her gaze and his gaze are free to ferret each other out. Their eyes copulate.

As to the factors that facilitate the transfer of this particular sense of the body, once achieved, outwards to the painting as a whole, we should first note what a mixed bag they are. In defiance of monistic aesthetic theories, they jumble the configurational, the representational, the expressive: they draw alike upon mark, motif, and image. They include the following: First of all, there are the equivalences that Titian establishes between body and nature: for instance, in the *Concert Champêtre* between flesh and stone, between hair and foliage, or in *The Three Ages of Man* between young skin and sky. Secondly, there is the anonymity of the represented figures, which in turn brings them closer to nature. This anonymity is something which Titian inherited from Giorgione, but it obviously had for Titian a singularly liberating significance. It takes us deep into his psychology. We shall find, revealingly enough, anonymity even in some of his portraits. Thirdly, there is the simplification of colour, and in particular the use of near-complementaries,[6] which has a special binding effect. Fourthly, there is the benign neglect of perspective used as a way of regimenting space — note, for instance, the abandonment of foreshortening in the left leg of the seated woman in the *Concert Champêtre*. This retreat from perspective encourages the global response to the picture as a whole: it was Vasari who noted the aptness of Venetian paintings to be taken in within '*una sola occhiata*', at a glance. Fifthly, there is the production of what asks to be thought of as a paint skin. In the *Concert Champêtre* this is of a uniform graininess, exploiting the coarse weave of the canvas to which Titian inclined: in *The Three Ages of Man*, which is at once a more evolved and a better preserved work, there are many deliberate alternations of texture, so that the visible brushstroke at one moment is there to portray detail, say a leaf in the foreground, and at the next moment suggests mass, such as the swelling foliage of the hedge beyond the near meadow.

Finally, to complete the discussion of corporeality and how it is achieved by Titian, I want to turn to a specific element present in both these paintings and in others of the same period. This element is a residue from the great High Renaissance structures of Leonardo and Raphael, but self-consciously torn out of its context. I refer to the diminutive profiles

Painting, metaphor, and the body

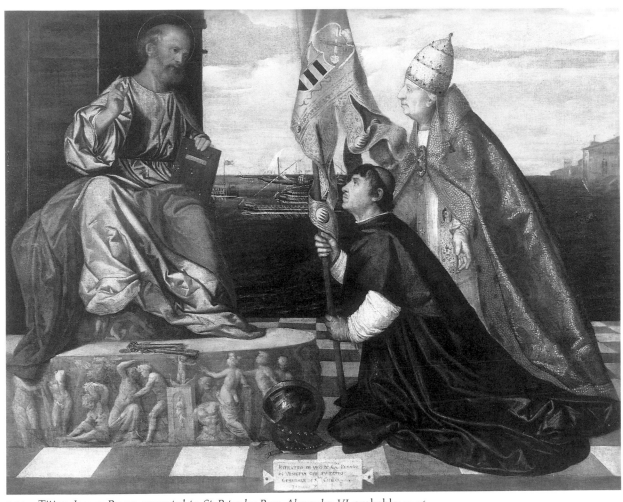

314 Titian *Jacopo Pesaro presented to St Peter by Pope Alexander VI* probably 1506

315 Titian
The Three Ages of Man,
X-ray of left-hand side

316 Titian
The Three Ages of Man,
detail, 1513–14

cut totally in conformity with linear perspective by figures in the middle distance or the background: for example, the silhouette of the shepherd in the Louvre picture, or that of the old man in the Sutherland picture. In a Leonardo or a Raphael these figures, by 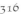 marking out the space they inhabit, would add to the monumental effect: they would enhance the sense of the world as a great basilica. But here, in these very different pictures, with no orthogonals, with no vanishing point, with no indicated point of origin, in the absence, indeed, of all the obvious signs of a projective system in use, these small delicate cut-outs take on a contrary character: they turn into tiny decorative fragments which have been scattered across the picture. But how, it might be asked, does this aid corporeality?

It does so not immediately, but mediately. One constituent of corporeality, which is an optional aspect, for corporeality does not insist on it, is that a picture endowed with corporeality will get itself thought of – thought of metaphorically, of course – as something which a body also is. It will get itself thought of as a container. This thought can be induced in a number of ways. In connection with de Kooning, I shall talk of a way in which the use of the medium encourages the thought. But one way in which the thought can be induced, and a comparatively straightforward way, is for the picture to display elements that themselves invite being thought of – again metaphorically – as things that can be put away in a container. Elements of the picture assimilate themselves to toys, or to jewels, or to mere odds and ends. Inviting this thought, they then compel the prior thought that the picture within whose four sides they lie is a container. It is, then, by activating this train of thought that the delicate, wispy figures, which Titian strews across his pictures, and which momentarily detach themselves from their environment, contribute, all likelihood to the contrary, to the overall effect of corporeality.

Painting, metaphor, and the body

But the most specific, the most active, factor working for the conception of the painting as a container is something else again. It is a factor which the writer who, to my mind, remains the most precise and most percipient critic of early Cinquecento Venetian art identifies as its central topic. Sound, Walter Pater observed, and by sound he included the sound of music, the sound of water, the sound of a novel read aloud, the imagined sound of time passing, is at the core of this kind of painting.[7] Sound penetrates both the *Concert Champêtre* and *The Three Ages of Man*. There are the notes exchanged between the young aristocrat and the peasant, and which the woman who is the third of their party will soon take up: there are the notes which the young girl has played to her naked lover, and which he will take up: there is the sound of water as it falls out of the jug, through the air, back into the cistern.

But how is this so? How does the sound get into these pictures? There is no systematic answer to this question: there is no answer like 'via representation', or 'via expression'. It is rather, as I see it, that the picture gives rise to the thought that the sounds lie around inside it: as we might feel that the notes lie around inside the music box when the tune has stopped, or that the hum lies around inside the fridge. Open up the music box, open up the fridge, open up these paintings, and there we would find the notes. Of course, all these thoughts are metaphorical thoughts, but they are metaphors that record our attempts to capture an impression made upon us. And, once again, these metaphorical thoughts induce the metaphorical thought that they presuppose. The painting is a container: like a body.

2. And now a brief digression on an accusation commonly brought against Titian. Its relevance will emerge. The accusation is that he was worldly. There are here two accusations in one. For, in this connection, 'worldly' sometimes means not other-worldly, so that the accusation is that Titian was not, say, Tintoretto or El Greco, but at other times 'worldly' means 'of the great world' and then Titian is charged with being a respecter of persons in a way and to a degree that flawed his art. Both charges, different though they are, can be seen as misrepresentations, misconceptions, of what I have picked out as the central expressive theme of Titian's work.

The first charge, that of unspirituality, which is raised often enough by secular writers within whose own framework of thought or belief such a charge makes no sense, is the more directly related to what I have found to say. Indeed it more or less recapitulates, but now pejoratively, my claim that Titian held to a view of the human being as essentially connected with the body. If in his earlier work this led him to emphasize hedonism, pleasure is, alas, only one aspect of embodied life. Other aspects are pain, decay, and death, thoughts of which were never all that far away from Titian. They play, as we shall see, an increasing part in the way in which he conceives, hence in the way in which his art metaphorizes, the body. Titian himself would seem to have found no difficulty in combining this attachment to embodiment with religious faith.

The second charge – in effect, that of snobbery – is actually more interesting, just because it involves a misunderstanding of a whole category of Titian's paintings: his portraits. Bernard Berenson, a man of the world himself, in the course of contrasting Titian and Lorenzo Lotto, his favoured artist, formulated the charge thus:

> If artists were at all as conscious of their aims in the sixteenth century as they are supposed to be now, we might imagine Titian asking of every person he was going to paint, Who are you? What is your position in society? – while Lotto would put the question, What sort of a person are you? How do you take life?[8]

So says Berenson, and I believe that he is right to the extent of thinking that some of

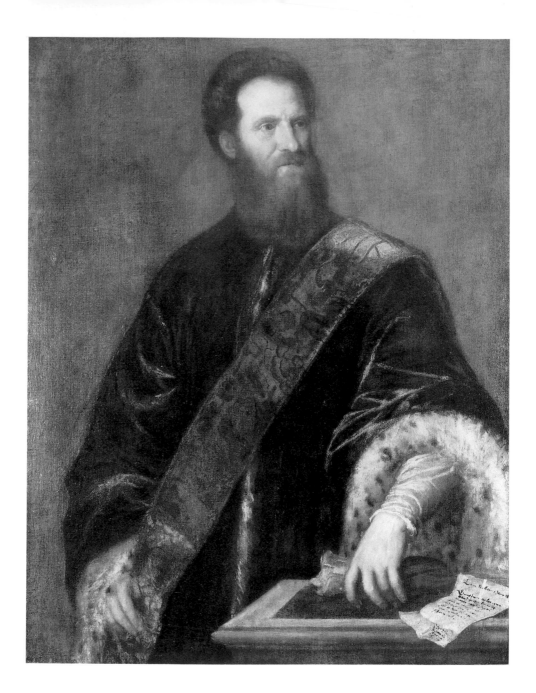

Francesco Savorgnan della
Torre (?) c. 1545

Titian's greater portraits are barely psychological. Let us consider two, which are unsurpassed: *Francesco Savorgnan della Torre (?)* (National Trust, Kingston Lacy, 317 Wimborne Minster, Dorset), of about 1545, and the *Man with a Flute* (Detroit Institute of 318 Arts, Detroit, Michigan), from the 1560s. In both cases anonymity seeps in. But this is not so for the reason that Berenson suggests: that Titian was excessively occupied with the externalities of rank and office. Titian's portraits do not fall short of psychology, but sometimes they overshoot it in that they convey a protean conception of man, a view of humanity as some vast physical mass which assumes temporarily, transiently, now this, now that, particular corporeal guise.

3. In old age Titian painted a number of large canvases, all dealing with topics heavily charged with emotion, in which the body undergoes a violent and unexpected shock, and

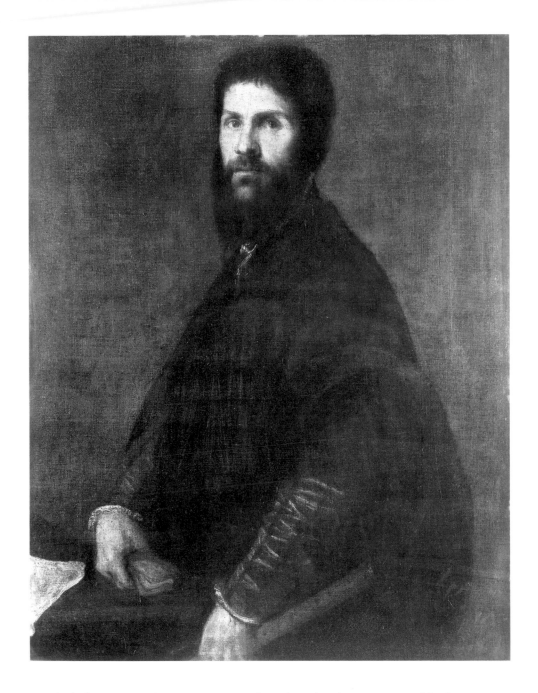

to which the victim's ultimate response is best thought of as acceptance. Not forgiveness, nor reconciliation, nor resignation, but acceptance: acceptance based upon recognition that flesh is weak, that it is continuously exposed to violence, and that it is through its vulnerability that some of its greatest triumphs and ecstasies come about, as well as its worst degradations. These late paintings, like the early pastoral paintings, metaphorize the body, and they do so under a certain conception of the body, but this conception is by now more specific and more daunting. Both the fragility and the exorbitance of the body are stressed.

Two of the greatest of these late paintings – *The Nymph and the Shepherd* (Kunsthistorisches Museum, Vienna), and the *Entombment* (Accademia, Venice), Titian's last painting, unfinished at his death – present certain unresolved problems of condition and interpretation. I shall concentrate on four other paintings: all masterpieces.

318 Titian
Man with a Flute
c. 1560–5

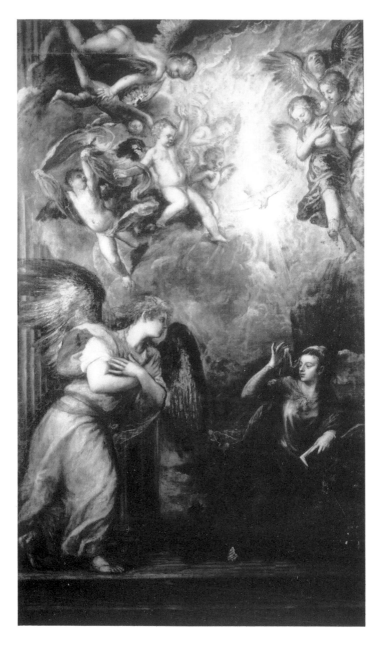

First, the *Annunciation* (San Salvatore, Venice), of the early 1560s, and the *Tarquin and* 319
Lucretia (Fitzwilliam Museum, Cambridge), begun around 1568. In each of these paintings 320
corporeality is established through means already in evidence in the two early paintings.
At its dramatic core we are made aware simultaneously of the giant protagonists tense
with action and recoil, their eyes telling a tale, and of the swelling contours of the painted
areas in which these enormous figures are to be seen. The exploitation of twofoldness
recurs. And then there are the various factors that allow the sense of the body generated
by the represented body to transfer itself to the painting as a whole. However one
difference between these paintings and the early paintings is that now these factors,
instead of operating upon us slowly and singly, all subserve the unity of the paint skin, for
this, it now emerges, is the supreme way of making us respond to the picture as to a vast
body hung or stretched out in front of us.[9] The paint skin becomes just that: it becomes a
skin. This aim is served by the patterning of texture; by the inconspicuousness of

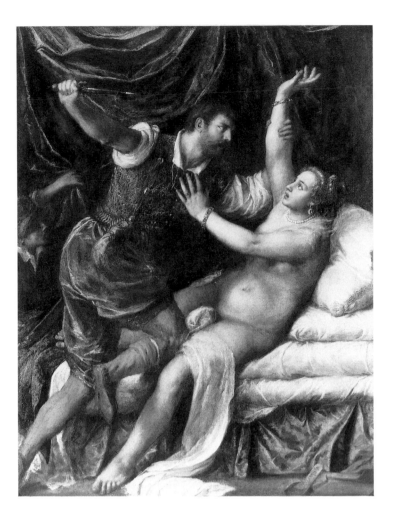

perspective; by the anonymity, the explosive anonymity, of the figures, throbbing with life, but beyond individuality; and, above all, by Titian's new use of colour. 'New' I say, but, of course, the new use of colour is a use evolved from the old. Manifesting itself as a tendency towards the monochrome, so that it is precisely in these terms that some art-historians have characterized it, it is, I suggest, better thought of as an exact parallel to Titian's conception of human nature. It consists, in other words, of an overwhelming sense of the vibrancy, the energy, of colour as such, but – or should it be in consequence? – an apparent indifference to the particularity of colour, to the articulation of colour into colours. Colour too seems envisaged as a protean phenomenon.[10] Only scarlet and black, the hues of blood and death, retain their affective individuality: as we can see in the *Tarquin and Lucretia* and shall see again, even more poignantly, in one of the next pair of Titian's late paintings.

However, as our eyes pass between these first two paintings, trying to identify the common means by which they acquire corporeality, another similarity, another kind of similarity, gradually impinges upon us. It is a similarity between the two represented dramas. And this similarity is of present relevance to us, not for what it shows us about whether these pictures metaphorize the body, but – that now taken for granted – for what it shows us about the conception under which they metaphorize the body.

319 Let us start with the *Annunciation*. In this picture Titian appears to be showing us that we do not fully grasp the message of the announcing angel until we recognize, as Mary manifestly does, that it involves, involves amongst other things, a fierce assault upon a woman's body. That the great tidings have this ominous aspect, or that here too the

Painting, metaphor, and the body 319

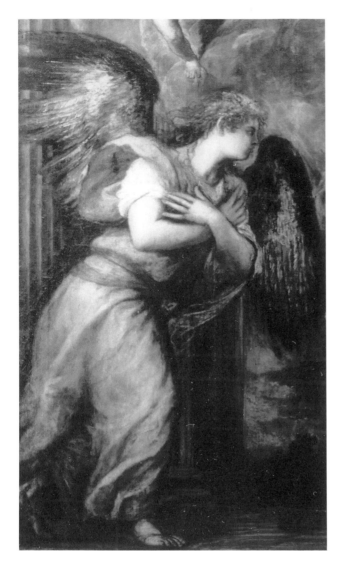

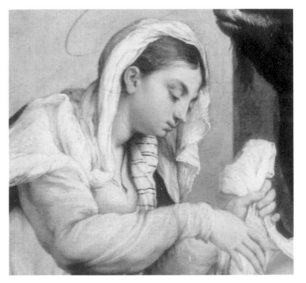

321 Titian
Annunciation, detail,
early 1560s

(Above right)
322 Titian
Annunciation, detail,
early 1560s

323 Jacopo Bassano
*Adoration of the
Shepherds*, detail, late
1540s

vulnerability of the body is at issue and on display, is brought home to us by three disquieting elements in the painting. First, there is the great uninvited presence of the angel whose massiveness is emphasized at every turn – the broad hips twisted parallel to the picture plane, the arms folded in such a way as to maximize the expanse of gilded flesh,[11] the colour flooding out of the body into the rest of the picture – and whose monumental head, with the chopped hair, the bull neck, the glint in the eye, demands instant obedience. The great feathered hulk approaches Mary with the remorselessness of the swan forcing itself upon Leda. Secondly, there is the response of Mary herself who raises her drapery in a gesture of half greeting, half self-defence.[12] For her head Titian has unmistakably gone to Jacopo Bassano, and has borrowed the features of one of his peasant madonnas: consider for a moment the highly characteristic madonna in the great *Adoration of the Shepherds* (collection HM Queen Elizabeth II, Hampton Court), datable to the 1540s. For it is via what I have called the way of borrowing that Titian reinforces his point. Once we recognize the source of the Virgin's physiognomy, our perception of her as a young woman used to a life of hardship and deprivation, prematurely reconciled to suffering, earthy in her disenchantment, will be strengthened, and we shall anticipate that her first reaction to the great dignity thrust upon her will include – it will not be confined to, it would be silly to think that, but it will include – a shrewd sense of the pain to come.

321

322

323

320

Painting, metaphor, and the body

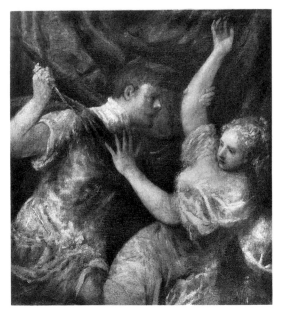

324 Studio of Titian
Tarquin and Lucretia
*c.*1570, unfinished

She receives the news that she is told as news of what will happen to her body.[13] Finally there is the time of day. We do not have here either the sparkling morning light of a Florentine annunciation or the dramatic night effect already pioneered by Central Italian mannerism. Instead there is the heavy melancholy glow of evening, of sunset across the lagoons, suggesting, with Leopardian sombreness, the end of the day's work and the tiredness of the limbs.

320 No one could doubt that what befalls Lucretia is indeed a disaster of the body. But it is a matter of deep interest to observe the means to which Titian has recourse in order to concentrate, to immure, the tragedy within the confrontation of two bodies. Note how, to make this point, he rhymes the two bodies, active and passive, the convex curve of lust, the concave curve of terror: something so simple and direct in its portrayal of violence

324 that it has slipped out of both the studio variants we know. One of them (Gemäldegalerie der Akademie der bildenden Künste, Vienna), instructively, aims at a subtler, and achieves only a lesser, effect. For what the autograph version does is to force upon us as starkly as it can the sense that the frenzy that rages in each of these two bodies burns the fiercer for what goes on inside the other. It is a part of our embodied condition, this picture shows us, that lust inspires terror, and that terror fans lust. Or again note how, and to what powerful effect, Titian adjusts the story that Livy recounts. In Livy's narrative Tarquin raped Lucretia by threatening her with death, which he would then say was retribution for her adultery with a page. In the Cambridge version Tarquin's hand is surely raised in anger, not just in threat, and he reveals himself as the executioner of Lucretia rather than as the instigator of her suicide. By first bringing forward the consequences of the rape and inserting these consequences into the rape itself, by then bringing forward the rape and inserting this act into the baffled lust from which it springs, Titian presents death as something, as some *thing*, that is discharged direct from one body on to, in to, another. The conspicuous dagger with the light wetting the tip and edge of the blade, the concealed penis, and the form that recalls both of them, the surging fold of sheet prizing open the legs of Lucretia, are like three actualizations of the same deadly agency. And this sense of death as an emanation from the body into the body is further encouraged by an effect which is so strong that I cannot believe it to be anything but intentional. The effect is that we are watching something with a ritualistic character, or that Lucretia on her carefully prepared bed with its banked-up mound of pillows is not just a casual victim, she is a sacrifice. She is a sacrifice exacted under some archaic code. She is the body sacrificed to itself.

Painting, metaphor, and the body 321

The liberties, or near-liberties, that Titian has taken with his literary source in this painting lead us straight to one of the second pair of late Titians which I want to consider. This is *The Death of Actaeon* (National Gallery, London): a painting begun probably 325 around 1560, worked on for many years, and still unfinished at Titian's death in 1576. Once again Titian has emended his source – this time it is Ovid's *Metamorphoses* – and he has emended it to similar effect. He has emended it at two distinct points, and in each case so as to link the awesome happenings even more intimately to the body conceived of in this protean way: the body active, the body passive, the body of the victor, the body of the victim.

Ovid tells us that Actaeon, grandson of Cadmus, resting from a particularly bloody day's hunting, stumbles across a sacred grove where Diana and her nymphs are bathing naked. Enraged by the intrusion, Diana, who has no weapon to hand, sprinkles water on Actaeon's forehead and transforms him into a stag. Then his hounds, whom he had trained to be eager for the chase, catch sight of him, and they pursue him over mountains and valleys to his death. As they close in on him, he tries to shout out his name, but no voice emerges, and one by one they fall upon their master and tear him to pieces. The first of Titian's two alterations to the story that Ovid narrates introduces the body of the victor into its tragic ending, the second alteration exposes the body of the victim to fiercer, crueller indignities.

In the first place, then, Titian makes Diana, like Tarquin, the executioner of her prey. Substituting herself for Actaeon's hounds, whose roll-call of names and epithets makes in Ovid's telling of the story such a sinister litany, the goddess in person despatches Actaeon with an arrow from her bow. In fact the arrow was never painted, and we may wonder why, but the posture is beyond all doubt. Titian still finds a role for Actaeon's hounds, but it is a subsidiary role. They hold him still while Diana takes running aim, and it is to be noted that the hounds, starting with the most left-hand one, which slips out through Diana's legs, are treated, rather like Tarquin's dagger, as offshoots of the great seductive body whose will they realize. Diana, in her scanty rose-coloured shift, exudes health and murderousness. Secondly, Titian arrests the metamorphosis of Actaeon so that, at the moment at which he meets his death, he is still mostly human. Only his head is stag. Titian has, in effect, delved deep into what Ovid calls Actaeon's 'deceiving form', he has retrieved the human body inside it, and this body he has set up in the darkening glade as the target for Diana's marksmanship.[14] As in the picture to come, there is no bodily suffering or despoliation that the victim is spared.

Alongside the *Actaeon* I set another picture deriving from the *Metamorphoses*: *The Flaying of Marsyas*[15] (Statnzamek, Kroměříz), painted in the 1570s, possibly unfinished, 326 but certainly brought to the point at which Titian felt he could sign it, a work so horrendous in its general conception as well as in its detail that both Theodor Hetzer and Panofsky, neither of whom had seen the picture, were led, surely wrongly, to doubt its authenticity.[16] This picture, once in the great Arundel collection, was rediscovered only in 1909, and it hangs in a small town in Czechoslovakia where it has been ever since the bishop of Olmütz acquired it at a lottery in 1673.

The picture depicts the terrible outcome to the musical contest between Apollo and Marsyas, Apollo on the lyre, Marsyas on the pipes. Apollo won, by a trick, and, entitled by the rules that the contestants had agreed upon to exact any forfeit that he chose, decreed that Marsyas should be flayed alive. In an ugly copse, on a suffocating stormy night, sentence is carried out. Marsyas hangs upside down, his goat legs spread out and fastened with pink ribbons to the overhanging branches of a tree. His pipes, the sign of his presumption, hang above him like the scroll that set out Christ's claims. On the left-hand side the torturers work through the long hours of darkness like surgeons, to the sound of seraphic music. On the right-hand side we see – again, violations of the literary source –

Painting, metaphor, and the body

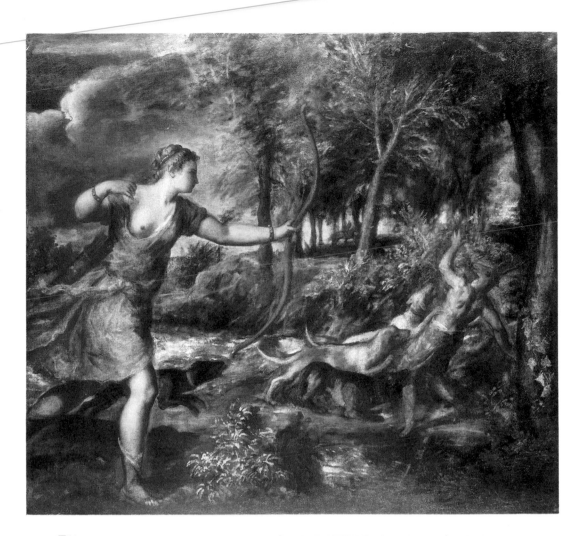

325 Titian
The Death of Actaeon
begun around 1560,
unfinished

326 Titian
The Flaying of Marsyas
1570s

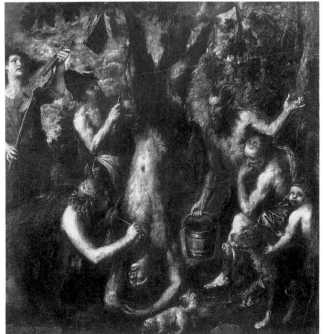

Midas, who had been present at another, a different, contest in which Apollo had also taken part, and Pan, his competitor in that contest, who arrives on the scene with a wooden bucket of water to sluice down the bleeding body. What is clear is that this is no act of charity: it is performed solely so that the knife can be wielded more precisely, or, perhaps, to prevent the victim from losing awareness of what is being inflicted on him. A little pampered dog, the sort that would be, in Titian's Venice, the pet of expensive prostitutes, laps up the blood which streams out of Marsyas's wounds. A larger, greedier, dog is restrained: the child satyr, who holds him back, is in tears at the act that he is compelled to witness.

So massive is the element of condensation in this startling work that we have to tread carefully if we are to retrieve its meaning. To a greater degree than in any of the other three pictures metaphorical content is entwined with representational, expressive, and textual, content, so that the precise conception under which this painting metaphorizes the body has to be sifted out from these other forms of meaning.

On this issue, iconology, left to itself, would have little difficulty in enlightening us. Classical antiquity, Christianity, and the thought of the Renaissance concurred in finding in the imposition of Apollo's will upon the brutish body of Marsyas the victory of what is higher in its nature over what is lower. Over the centuries this understanding of the event came to be articulated on a number of different levels.

Taken as a piece of narrative, the destruction of Marsyas was seen as the punishment inflicted by an angry god upon a mortal creature who had offended him through arrogance, or at least through gross imprudence. To this description of the event other interpretations of a more allegorical sort accrued. One interpretation, which went back to antiquity, saw in the outcome of the musical contest the victory of the superior arts, or of those touched with rationality, exemplified by the music of the stringed lyre, over the inferior or coarser arts, of which the shrill tones of the pipes or flute, which excite the senses without appealing to the intellect, would be typical. This interpretation is to be found in the ancient philosophers.[17] Again, the victory of Apollo over Marsyas was taken to symbolize the ascent of man from the world of confusion into the realm of universal harmony: man enters upon the sunlit domain of reason. Finally, the victory of Apollo stood in for the soul's escape from its earthbound condition. The Christian evaluation of this terrifying story fully bursts upon us when, listening to Dante at the beginning of the *Paradiso* as he places himself under the protection of Apollo, we hear him apostrophize the god, the *'buono Apollo'*, specifically as the tormentor of Marsyas:

> *Entra nel petto mio, e spira tue*
> *sí come quando Marsia traesti*
> *della vagina delle membra sue.*

(*Paradiso*, Canto 1, lines 19–21)

'Enter my breast, and breathe there as you did when you tore Marsyas from out of what sheathed his limbs.'

There are however few if any scholars who would in the context of Titian's painting follow the lead of iconology unconditionally, and would without reserve equate the meaning of the picture with the meaning, the gradually acquired meaning, of the event that it represents. If this reluctance cannot be directly ascribed to the considerations that I advanced in Lecture IV – that is, that we should not, just because a picture represents an event associated with a certain text, infer that the picture means that text, unless the picture also discloses what the text meant to the artist – nevertheless a related consideration is undoubtedly at work. Scholars have been deterred by the fact that, if we accept the interpretation that iconology urges, we shall be required to see the picture in ways that perception cannot negotiate. We shall have to see it as expressive of joy, elation, and triumphant righteousness. That we cannot manage.

Painting, metaphor, and the body

327 Titian
The Flaying of Marsyas,
detail, 1570s

328 Giulio Romano
Study for *Flaying of
Marsyas c.* 1527,
drawing

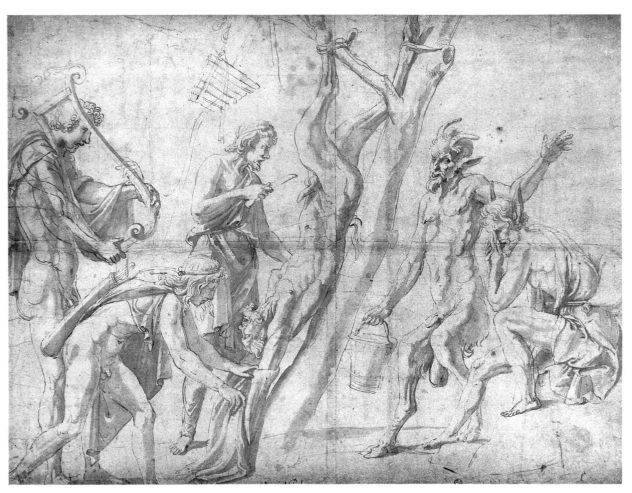

It would, of course, be unjustified to jump to the conclusion that Titian transvalued the ancient myth, or that from his depiction of the event Marsyas emerges as the hero, Apollo as the wrongdoer. Such an interpretation would be historically untenable. However a suggestion which has its appeal, is free of anachronism, and is also fully in keeping with what we otherwise know of Titian, is that in *The Flaying of Marsyas* he brought about, not a reversal of values, but a radical shift in perspective. For if Titian still continued to understand the mythological event in terms of texts that the centuries had associated with it – and just how many of these texts he wished to incorporate into the painting is not something that I need settle in detail – he thought of them in a new way. Their emphasis was displaced. In telling us what lies above or beyond our mortal embodied condition, they were taken by Titian to be showing us, primarily, something about this condition of ours: that it is not merely what precedes, it is a necessary preparation for, indeed it is a way of bringing about, what lies ahead of itself. These texts are not just texts about the soul, they are as much texts about the body: they are, fundamentally, texts about what the body does for the soul. This is what I mean by a shift in perspective,[18] and my claim is that this shift is crucial for grasping the conception of the body under which this great painting metaphorizes it.

The Flaying of Marsyas is given over to the suffering of the body, but in Titian's hands suffering is shown to be fully compatible with the vitality that erupted so buoyantly in the earlier works. The truth is that in this work the vitality of the human frame is projected beyond all recognizable bounds. Marsyas's body, defeated, degraded, in its final throes, has been so placed upon the canvas that, at any rate before the support was unevenly extended,[19] the navel lay at the very centre of the picture, and from this vantage point the body then swells out to assume control of the picture as a whole. It does so by various means. It does so through the blood that, running out of Marsyas's wounds, is carried by Titian's brush, or by his fingertips, with which he also applied the paint, to the farthest parts of the canvas. It does so through the other figures who, in the savage unremitting attention they give to its destruction, acquire a kind of dependency upon it, like leeches upon the ailing frame of an invalid. And it does so through Titian's flickering brushstrokes which, in tumult across much of the pictorial surface, attain an equilibrium as they mark the great cylindrical carcass, flaying it into incandescence. The inverted pose of Marsyas, which has the effect, unless we invert ourselves too, of obscuring from us the expression on his face, makes more mysterious, hence makes more potent, the spell that this enormous polluted body casts over the total painting.

That Titian should, in connecting the body so powerfully with suffering, retain the connection between the body and vitality is what establishes the shift in perspective of which I have spoken. For if the defeat of the flesh is not just what prefaces higher things, but is that through which they are won, then this defeat must somehow be shown as achievement. This Titian does when he presents suffering, massive suffering, as the supreme occasion on which man can, through his determination and the straining of his body, wrest activity out of passivity. If, this activity communicating itself to us, we do invert ourselves and we try to make out the expression on Marsyas's face, a shock is now in store for us. Titian has given Marsyas the features of a young loose-limbed peasant, a farmer or a gardener's boy. The features are distorted by fear and incredulity. But in the great haunted eyes there is also a totally unexpected look of acceptance – acceptance triumphant over suffering. If it is the victory of the soul over the body that we are watching, what makes it possible is the victory of the body over itself.

The domination of the canvas by the awfulness of Marsyas's body is one way in which Titian parades this new conception, or rather this new stage in an old conception, of the body, but there is, I believe, another way. It takes up on what I have said about the *Tarquin and Lucretia* and *The Death of Actaeon*, but it goes further. This is the collusion, the

Painting, metaphor, and the body

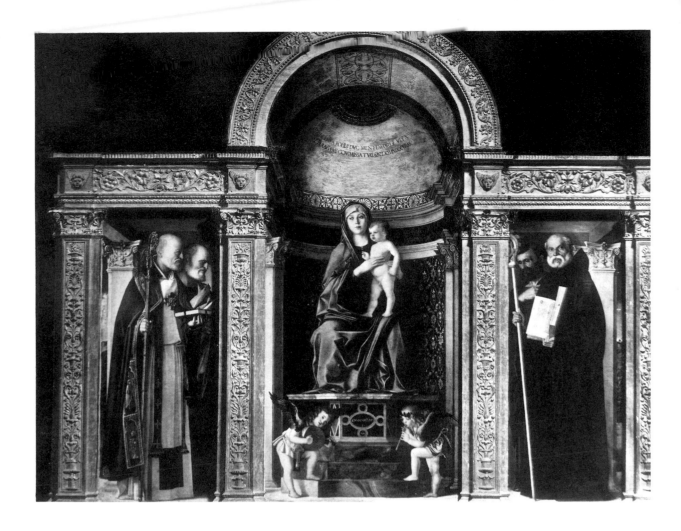

confusion perhaps, between the body of the victim and the body of the victor. Apollo, pressed up against the great hulk of his prey, stares into the exposed flesh with such intensity as to suggest that his desire is to envelop himself in the creature that he dismembers. The significance of his enrapt look is confirmed when we recognize that the look is Titian's direct replacement for the far cruder, far more explicit, gesture of the figure from whom his Apollo derives: that is, the crouching executioner in Giulio Romano, *Flaying of Marsyas* (Palazzo del Té, Mantua), a work that Titian had clearly in mind when he painted his own. Giulio's executioner reveals his designs upon Marsyas's skin: he will put it on, like an overcoat, as soon as he has helped its present wearer out of it. In Titian's painting the penetration of victor into victim is less literally, but no less forcefully, certainly no less corporeally, envisaged. There is to be a merging of bodies.

Nowhere in the whole corpus of Titian's work is the protean conception of humanity more powerfully asserted than in this painting which, through no coincidence, is also his great tribute to art conceived of as a struggle against the direst odds. Of course, Titian did not have at his disposal the critical vocabulary to formulate his aims in this way, even if he had wished to do so. It does not follow — and it would be to my mind a lapse into crass relativism to infer — that therefore he could not have thought in this way.

4. It is appealing to think of these late masterpieces of Titian as a delayed tribute to the late masterpieces of his first teacher, Giovanni Bellini: meaning by this just that, in the mind of one extremely old man, the work of another extremely old man aroused

329 Giovanni Bellini *Triptych with Madonna and Saints* 1488, panel

330 Giovanni Bellini
*Triptych with Madonna
and Saints*, detail, 1488,
panel

thoughts of gratitude and emulation. As a young man Titian pulled away fast from Bellini: the eagerness, the restlessness, the preoccupation with mortal flesh, are not to be found in Bellini, but both painters pushed to the utmost the resources of the medium as they inherited it. Titian in his sense of solidity, in his inherent classicism, was always closer to Bellini than to Giorgione, and in his last works Bellini achieved a corporeality the rival of Titian's.

But just because with Bellini corporeality is for many reasons an attainment, I shall reverse the order of exposition that I have followed (more or less) with Titian, and I shall first consider some of the different devices that Bellini evolved over the years and which, when the conception of the body was ripe, would then, but only then, be deployed to secure corporeality.

For this purpose I propose to consider a work of Bellini's maturity, though not of his last period, predating corporeality: this is the famous *Triptych with Madonna and Saints* 329 (the Frari, Venice), still in the place and frame and light for which it was painted in 1488. I 330 want to look specifically at the wings, for they exhibit to a high degree some of Bellini's most potent devices for achieving corporeality.

328 *Painting, metaphor, and the body*

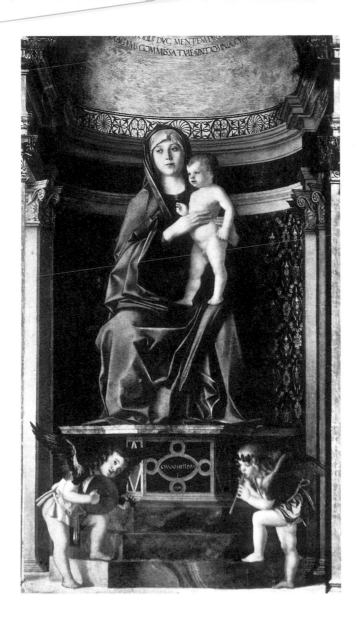

First, there is the elaborate patterning produced by occlusion, or the blocking out of one volume by another that stands in front of it and that, in the cases I have in mind, partially and narrowly underlaps it. I say 'patterning', but what I am talking about is not a flat phenomenon, but something that occurs in represented space, or when one thing is to be seen as in front of another, so that to grasp it again involves twofoldness. Occlusion as patterned by Bellini gives rise to highly distinctive slivers or fragments of the masked objects. It gives rise to vertical slices of architecture behind bodies, to folds of drapery behind drapery, to bits of books that have been left unobscured by hands that grasp them, or to feet behind feet. In each case the vestige is cut to a highly personal formula. The effect that this patterning produces is a form of fretwork, and its upshot is to weld together large zones of the picture, and to do so in such a way that the eyes go on to project over other zones of the picture, not, of course, the pattern itself, but the welding effect that this pattern creates. It is a trick of the eye, just that, and we might call it 331 'composition by association'. An example of this effect is observable in the highly wrought decoration behind the Madonna and Child: for this decoration also binds together those figures behind which it does not lie.

Painting, metaphor, and the body

331 Giovanni Bellini *Triptych with Madonna and Saints*, detail, 1488, panel

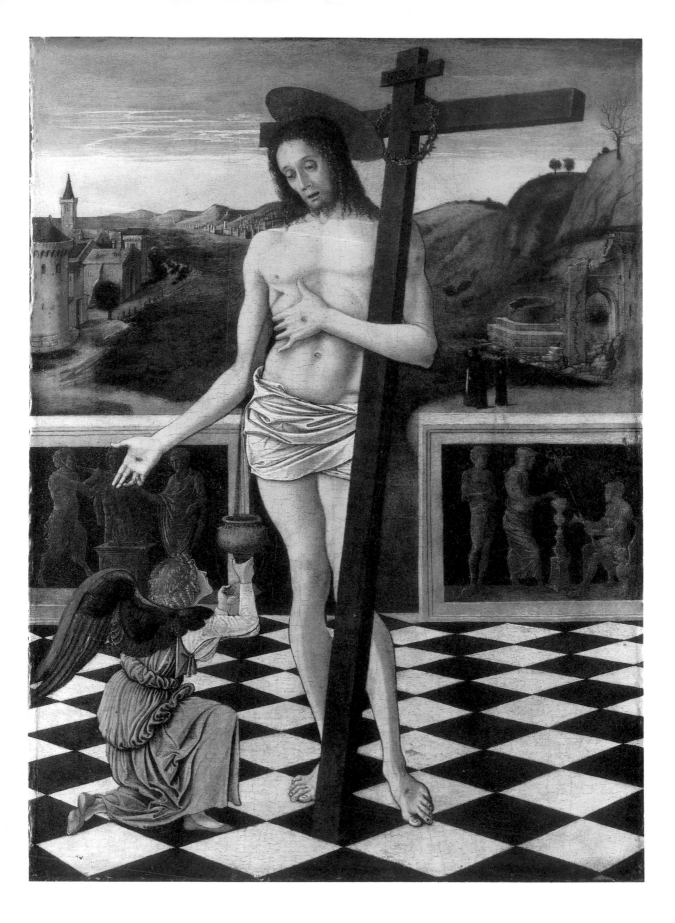

(Opposite)
332 Giovanni Bellini *The Blood of the Redeemer* mid 1460s, panel

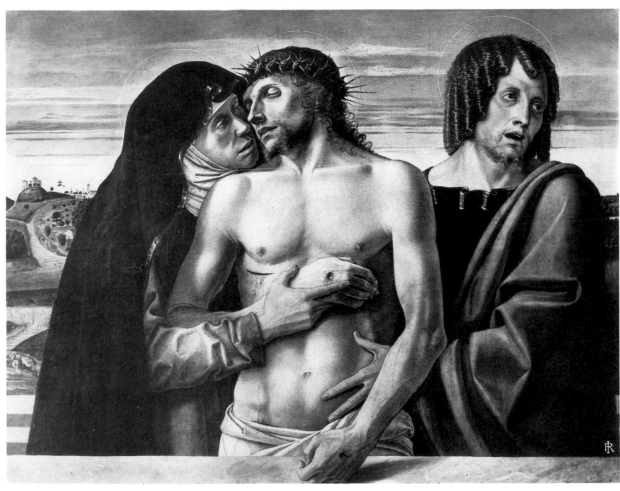

333 Giovanni Bellini *Pietà* 1460s, panel

It has been observed of Bellini's work that, from a fairly early point in his career, he endeavoured to turn his figures so that they stand as parallel as possible to the picture plane.[20] Consider in this context *The Blood of the Redeemer* (National Gallery, London), or the *Pietà* (Brera, Milan), both of the 1460s. However in this endeavour the small modicum of failure is at least as significant as the large measure of success. For when occlusion is patterned over figures lying not strictly parallel to one another but slightly convergent, fretting leads to faceting, and faceting is the second device that will, when the time comes, serve corporeality.

Painting, metaphor, and the body 331

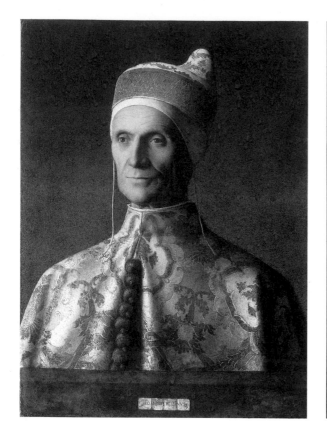

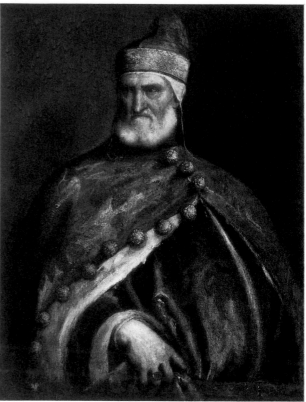

334 Giovanni Bellini
Doge Leonardo Loredan
c. 1502, panel

(Above right)
335 Titian
Doge Andrea Gritti
c. 1535–40

To these two devices, both of which depend upon contour and which have naturally no counterpart within Titian's more painterly style, two more, already apparent in the early work, must be added. One is the turned-in look, the eyes turned inwards upon the mind, but turned inwards not, as I have claimed for Manet, in preoccupation, or to harbour a secret, but to reveal a mind at peace with itself. The wings of the Frari altarpiece 330 exemplify this look. The look is, of course, in stark contrast to the ardent gaze in Titian, and, if the next, the fourth, device, which is the optical effect of the broadening or 334 spreading figure, is (we have seen) shared with Titian, the difference in the scale on which this effect occurs in the work of the two painters is crucial. Titian's figures – at any rate those in his true style – burst open like ripe figs. Bellini's contours, by contrast, slowly, 335 gradually, with gentle insistence, inch outwards.

In 1500 or so Bellini painted for a church in Vicenza a remarkable altarpiece commemorating a visit by one of its citizens to the Holy Land, and which therefore represents the baptism of Christ in the waters of Jordan. *The Baptism of Christ* (Santa 336 Corona, Vicenza) metaphorizes the human body in harmony with nature.[21] To do so it draws upon all the four devices we have considered – fretting, faceting, the turned-in look, the broadening figure – plus two more: they are the use of colour, and the compression of space. These additional devices are best examined – indeed arguably they can only be identified – when corporeality has arrived on the scene. It does so at the turn of the century. It does so in this picture.

Bellini's colour with its rainbow palette seems the direct opposite of Titian's. Nevertheless it is the use of colour – colour as a means of achieving corporeality – that is one of the most powerful links that knit together these two painters. Let us look at another late Bellini, the famous *Madonna and Child with Four Saints* (San Zaccaria, Venice), 337 of 1505, for this demonstrates what I have in mind. In this picture that cohesive effect which Titian is later to achieve, first, by the use of near-complementaries, as in the early

332

Painting, metaphor, and the body

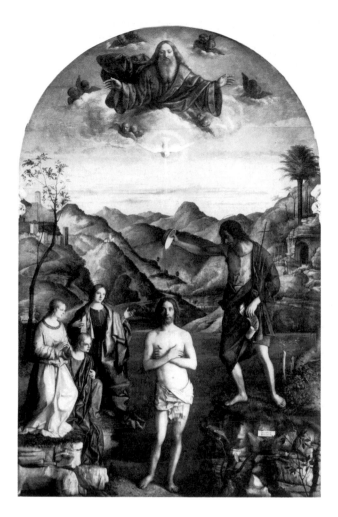

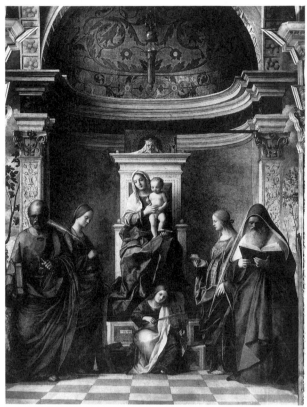

pastoral pictures, and then by the distribution of a very few colours chosen with indifference to local considerations, is here brought about through the use of a wide range of hues but in similar saturation. In the San Zaccaria altarpiece the impact of uniform saturation is all over, and it is emphasized by what we may call 'cross-colouring': that is to say, re-using the same hues in different combinations across the different figures. Moving from left to right across the six clothed figures we get brown and violet-grey; green, rose, and lavender-grey; blue, green, and red; rose and green; blue and brownish-orange; and, finally, red and virginal white. The blues and greys are taken up in the sky, the reds and roses in the architecture.

The final device is compression of space. This, like the broadening of the figure, is a purely optical effect and, like it, exploits twofoldness. The effect collects the various objects in space and squeezes them into what seem like a few shallow slices, which lie parallel to one another and also to the picture plane itself. The miracle is that this effect is achieved without violating clarity of represented space, or, for the most part, without introducing perspective deformation.

This effect, which organizes both these pictures, is more evident in the *Baptism*, just because of the extensive landscape that it purveys: there is a lot to compress, and it is compressed into three slices. The nearest slice contains the five represented figures, the stony shore, and the outcrop of rock on which they stand. Look at the way the tree and the bird in the right foreground are imprinted on the rocks like pressed flowers in a Victorian album. Or consider the three figures on the left. Clearly represented as being at

(Above left)
336 Giovanni Bellini
The Baptism of Christ
c. 1500, panel

337 Giovanni Bellini
Madonna and Child with
Four Saints (Pala di San
Zaccaria) 1505, canvas
transferred from panel

Painting, metaphor, and the body

different distances from the picture plane, they are optically fused through the confluence of their draperies, which mingle together on the rocks. Most striking of all, at least for a modern eye, is the top of the Baptist's bowl. This does involve deformation, if marginally. 338 For what Bellini has done is that he has compelled the top of the bowl to present a profile much closer to the circle than the perspective justifies. In this way Bellini narrows the space that the bowl occupies. This is, of course, a device familiar to modern sensibility from middle and late Cézannes, where objects above the level of the eye are tipped forwards into the plane: as, for instance, in the magnificent *Still Life: Milk Pitcher and Fruit* 339 (National Gallery of Art, Washington, D.C.).

The second slice of the *Baptism* contains the facetcd hills, which hang like a tapestry down into the intervening water, which in turn appears not to exist. And then there is the third slice, which is the curtain of the sky, on to which the Father and the Holy Spirit seem to have been embroidered.

But it needs to be emphasized that these devices – or any others – contribute to corporeality only when the painting as a whole aims to convey some particular conception of the body. And then when it does, the aptness of device to conception is not something that can be explicated. It depends on no general principle. It cannot be grasped outside the experience of the painting, or set of paintings, within which it holds. In the Vicenza *Baptism* the body is represented as an object that is lean, ascetic, dignified, completely at home in nature: the water as it falls off him, back into the water from which it has been drawn, enfolds him in the landscape. But precisely why it is that the compression of apparent space helps to transmit this conception of the body to the picture itself is something we have to go to Vicenza to experience. It is worth it.

338 Giovanni Bellini
The Baptism of Christ, detail, *c.* 1500, panel

339 Paul Cézanne
Still Life: Milk Pitcher and Fruit c. 1900

But, as with Titian, so with Bellini, corporeality once attained, changes can be rung on it to accommodate the subtle inflections that life induces in the conception of the body under which painting then metaphorizes it. I suggest that we now look at one of Bellini's very late paintings, and one of the most haunting and least considered masterpieces of southern Renaissance art: *The Drunkenness of Noah* (Musée des Beaux-Arts et Archéologie, Besançon). This painting is one of the last that Bellini painted, and a date as late as 1516, the year of his death, has been proposed.

What do we see when we look at this picture?

Within a low, horizontal frame just over five feet long, we observe, against a trellis of vine leaves, three youngish men crouched over the body of a very old man who has collapsed. Two of the young men try to cover the naked body: one, it would seem, out of angry intolerance, the other out of kindness. Nothing in the Biblical story prepares us for this distinction of motive. The third brother tries to stop them. His face twists in a prurient smile. His father, with whom he has survived the destruction of creation, has become for him a joke, and he doesn't want his fun spoiled.

The central drama of this picture, which our degraded kind of society makes it difficult for us to recognize, comes out of the culture of poverty. Noah – first cousin, as we can see, to the wise bearded saints of the Frari and the San Zaccaria altarpieces – is like an Indian guru, demented by age and visions, who has fallen down in the middle of a slum. What Bellini is showing us is, in effect, the dignity of a very old body: a dignity nurtured by asceticism, and now enhanced by frailty. He is still a patriarch, though his wits have decayed, and he is drunk.

340 Giovanni Bellini
The Drunkenness of Noah
1516(?)

Painting, metaphor, and the body

For this frail distinguished body to spread and to appropriate the picture as a whole, some but certainly not all the devices we have considered are brought into play. The freer handling, carried to a point unique in Bellini's work, makes some of these devices, like fretting and faceting, no longer available. They depend on linearity. What still operates is the compression of space, far more extreme than in the Santa Corona altarpiece, and very vividly brought to our attention by the drained cup, which is probably the same studio prop as that in the Vicenza picture and treated here in the same way. And there is the use of colour, simplified now to white and the near-complementaries of pink and green, but with a wide tonal range.

However in this picture both these devices subserve, I believe, a further effect, which is that of converting the painting – or, perhaps better, some part of the painting – into the content of a reverie: a reverie that goes on in the head of the right-hand son, the good son, who, without looking either pruriently at, or angrily away from, his father's genitals, draws the wine-coloured, blood-coloured, shroud across them. The young man himself is a familiar type from Giorgionesque painting – the shepherd with a flute, the knight's page, a boy at dusk – but here his features are blurred. Layers of glazes veil his head, as if to suggest (no more than that) that this is where it is all taking place. It is *his* reverie that we observe, and the connection of this fact with corporeality, evident enough in the presence of the picture, is that it ensures that it is under *his* conception, his conception and not that of either of his brothers, under, in other words, a benign conception, of the old patriarch's body that the picture gains corporeality.

Another way of putting what I have been saying would be that the good son is an attenuated version of the spectator in the picture whom I discussed in Lecture III. Attenuated, because he is, of course, represented in the picture. The pure spectator in the picture is not. And, because the good son can be seen in the picture, only some part of the picture can be thought of as corresponding to his vision. It is arguable that we have already observed a similar device: in *The Flaying of Marsyas*. For if we think, as I am inclined to, but the issue is highly controversial, that this picture gives us a double representation of Apollo, Marsyas's victor, once as musician, once as torturer, then it is natural to conclude that the picture, giving us unreality rather than reality, is, partially, a haunted sickly dream that floats through the delirious head of Marsyas in his last moments before he expires.

But, more to the present point, in this attenuated use of a spectator in the picture Bellini seems to have anticipated himself. For in some of the great Madonna and Child paintings of the later years, when Bellini switched from a vertical to a horizontal format, the idyllic landscape suggests itself as the content of a reverie. Actually what Bellini does is more audacious than that. For the landscape is yet more plausibly experienced as the content of a shared reverie. Rock and field occupy two heads: that of the mother and that of the child, or the infant at the breast. There are at least two paintings that lend themselves to this perception: the *Madonna and Child* (Detroit Institute of Arts, Detroit, Michigan), of 1508, 341 made possibly with some studio assistance, but a far finer work than it has generally received credit for being, and the beautiful *Madonna of the Meadow* (National Gallery, 342 London), of the same period, which blends earthiness and refinement to magical effect.

A final word on *The Drunkenness of Noah*.

I have not referred to the typological significance of this work: that is, to the parallel between Noah's drunkenness and Christ's passion. This is not because I wish to deny the picture's possession of such textual meaning. But the parallel with the New Testament scene needs to be introduced into our perception of the picture only after we have seen it as a representation of the Old Testament scene – with all that that involves. The corporeality to which Noah's body gives rise adds pathos to the thought of the dead Christ, who too drained his cup to the dregs.

Painting, metaphor, and the body

341 Giovanni Bellini
Madonna and Child
1508, panel

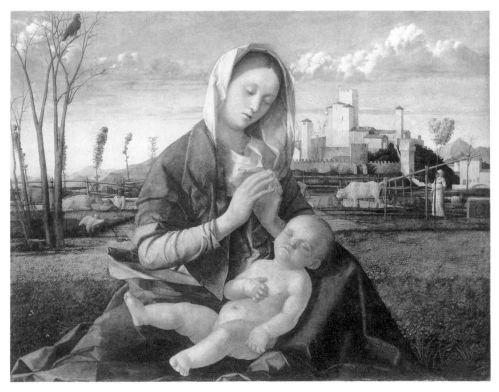

342 Giovanni Bellini
*The Madonna of the
Meadow c.* 1505,
transferred from panel

337

C. 1. A natural question to ask is, Can a painting metaphorize the body without representing it: that is, without making it the central object of representation?

The answer is, Yes, it can. That a painting can metaphorize the body without representing it follows from what I claimed at the beginning of this lecture: that there does not have to be, though there may be, a pre-existent link between what the picture represents and what it metaphorizes. *A fortiori* there does not have to be the link of identity between what the picture represents and what it metaphorizes.

This is not however the whole of the claim that I made. I also claimed that, though in general, if there is a pre-existent link between what the painting represents and what it metaphorizes, this will do no good – in fact the picture is in luck if it does no harm – there is nevertheless, in addition to the trivial case of identity, an important exception to this rule. There is one pre-existent link that can enhance metaphoricity, and that link is the link of metaphor. If what the picture represents is a well-entrenched metaphor for what the picture metaphorizes, then this can – can in the right hands – contribute positively to the formation of the pictorial metaphor. The old metaphor, if embedded in our sensibility, can assist the new metaphor, which the picture brings into being. And this is just what we shall see occurring in the next pictures to which I turn, for they are pictures which metaphorize the human body but do not represent it. They metaphorize the human body, and they represent something which has long been invoked as a metaphor for the body. They are pictures that represent architecture or are buildingscapes.[22] What I shall say of them, and how one kind of meaning that they have enhances the other, goes also for certain landscapes.

But, first, a preliminary point. A problem attaches to pictures that metaphorize the body through representing something that is linked via a metaphor to the body. For we need to know what the difference is between pictures such as these and pictures that contain, or have as their textual content, the metaphor itself. If, say, a picture represents a building, how can we decide whether it metaphorizes the body or whether it contains some metaphor to the effect that bodies are buildings?

Simply on the basis of the information that I have given – namely, that the picture represents a building, and that there is a metaphor linking bodies and buildings – we cannot decide. We cannot decide which of the two categories it belongs to – if either. However each of the two categories of painting has at least one further condition that it requires to be satisfied, and so the crucial question is which of these conditions the artist tried to satisfy and to what extent he succeeded. Did he work upon the image of the building so as to situate the body in a new light? Or did he, in his image of the building, seek to convey what the assimilation of the body to a building meant to him? Depending upon the answer to these questions – and the answer is, of course, given by the eyes, responding to the fulfilled intentions of the artist – we can settle the category to which the picture belongs. It is only if the answer to the first question is, Yes, that the picture is metaphorical of the body. I believe that the answer is, Yes, in the case of the buildingscapes that I shall be considering.

2. I turn then to some striking examples of buildingscape which are also examples of metaphorical painting. They metaphorize the same thing as the great canvases of Bellini and Titian. They possess corporeality to a high degree, and the interesting question is how they do so. They are by two artists, not of genius, but of great distinction and subtlety. Both artists are underrated, and one is very little known.

I propose first to look at two *Views of Schloss Königstein* (City Art Gallery, Manchester) 343, by the north Italian artist Bernardo Bellotto, nephew, pupil, and collaborator, of the less poetic Antonio Canaletto. One view, that which shows the narrow rectangular garden in the foreground, is from the west, the other is from the south. They were

Painting, metaphor, and the body

343 Bernardo Bellotto *View of Schloss Königstein from the South* late 1750s

344 Bernardo Bellotto *View of Schloss Königstein from the West* late 1750s

painted in the late 1750s, for Bellotto's patron, the ruler of Saxony, to whom the castle belonged, and they are works of grave and intricate beauty.[23] They tell us a great deal about how pictures of buildings come to establish their particular version of corporeality.

Undoubtedly in both these paintings the buildings, like the bodies in late Bellini and Titian, appear to swell under our eyes so that, momentarily at least, they promise to take over the total picture, and without this effect it seems likely that the claim of the picture, of the picture as a whole that is, to enter into the metaphoric relation would lapse. But the metaphoricity of these paintings is rooted in something more specific than this: it is rooted in the fine detail of how the buildings are represented, and I shall indicate three features of their representation that generate corporeality. In each case the feature is bound up with an optical effect which is not necessarily conserved in reproduction.

In the first place, the buildings emanate a sense of mass, but they are also without massiveness. By a sense of mass I mean this: The buildings strike us as solid. They are not gimcrack. But they do not just lie on the grass in the way in which we would expect their constituents, or the building materials out of which they are constructed, to do so if they were taken apart: that would be massiveness.[24] They reach upwards: reach, not soar. They seem capable of gentle upward movement – that is the effect their representation makes on us.

Secondly, there is something special about the way the apertures are represented,[25] and this too is best described, though this is not at all how it is experienced, negatively or contrastively. Windows and doors, then, are not treated as mere modifications upon the wall surface: black patches upon a lighter ground. Nor are they represented as places where the wall surface has been cut into, a part of it excised and thrown away, and something else behind it then revealed to exist. The secret to their representation is that they are to be seen as integral or undamaged parts of the wall, which nevertheless allow access to, and exit from, and, above all, knowledge of, what lies beyond the wall. They mark and decorate the junction of outside and inner, as do the eyes, the lips, the anus. In both these views, but particularly so in that from the south, Bellotto attends with anatomical care to the varieties of fenestration.

Thirdly, and closely connected, is the depiction of the wall surface itself, and the achievement here, to be repeated and extended in the next group of paintings, is to present the material of the wall not as some stuff, some chance stuff, out of which these free-standing buildings and their attachments have been modelled or given shape, but as something which has helped to determine their shape and their character. The material has performed for these buildings the same role as the block of marble does for the carved sculpture when the sculpture gives the impression of having been retrieved from the stone by the chisel.

A striking example of this last effect is provided by the low wall which runs across the foreground of the view from the west. It is not hard to reconstruct what the fact of the represented matter is: the plaster has fallen away, and has revealed a core of large stone blocks and rubble. But, at least for a moment, this is not how Bellotto gets us to experience it. Within that moment we feel that nothing is missing and that what we are observing is the material weathering, maturing, forming a patina, exhibiting what a certain kind of theorist of art would call the material's 'truth'. But we might ask, Which material? For another part of the same effect is that, within the moment for which it works, the material is, ambiguously, now plaster, now hard core: it oscillates between the two. At one moment the hard core develops plaster like a bloom, the next moment it is the plaster that has caked into hard core.

What has enabled Bellotto to achieve this effect is the correspondence that he establishes between the paint surface and the wall surface, between the texture of what he

Painting, metaphor, and the body

represents with and the texture of what it is that he represents. In what must be one of the
strangest passages in eighteenth-century painting, Bellotto first depicts in a very precise
manner the two different finishes that the wall presents in its decaying state: one light,
one dark. Then on top of this he lays down an irregular grid of very thinly painted marks,
all strongly evidencing the brush, basically white but with grey, lavender, yellow, and
earth worked in. Most of these strokes criss-cross in an unsystematic fashion, but
sometimes the paint dribbles downwards or it is gathered up in a calligraphic flourish.
Looked at close up, this whole passage suggests – and later on in this lecture we shall be
able to test the justice of this observation – late de Kooning, anticipated in miniature. Just
as, in the majestic pictures we have been considering, the paint skin becomes a skin, so, in
this far more circumscribed picture, the paint surface becomes a surface.

Nor, if I am right about the metaphoricity of Bellotto's art, does it, can it, stop there.
Bellotto's paint surface, having become a surface, becomes a skin: not, of course, in its
localized character, but in its overall effect.

3. A charming touch in *The view of Schloss Königstein from the South*, which turns out to
be a great deal more than this, is the line of washing which the laundrymaids prepare.
Their activity is half ritual, half improvisation. They lay out the laundry with self-effacing
gesture. Then to hang it up they tie a line to the paling that protects a young tree grown
up against one of the castle buildings. Always a sign of ancient culture, today under threat
from modern ideas of decorum, in this particular picture exposed laundry raises its voice
against any false aggrandizement of the castle: it strips it of hyperbole and gentility, it
invokes labour, and it better enables the buildings it decks out to become the bearers of
corporeality.

345 Bernardo Bellotto
*View of Schloss Königstein
from the South*, detail,
late 1750s

Painting, metaphor, and the body

Thomas Jones
Buildings in Naples (with the north-east side of the Castel Nuovo) 1782, oil on paper

The washing, both in itself and in this wider significance, links the Bellotto to the next picture I turn to, the first of six I shall introduce by the maverick Welsh artist, Thomas Jones. It is entitled *Buildings in Naples (with the north-east side of the Castel Nuovo)* (National Museum of Wales, Cardiff). It was painted in June 1782. It measures eight and three-quarter inches by eleven and a quarter inches. Jones, a member of a large family of Welsh landowners, some of whom were rich, but not this one, was a pupil, a copyist, indeed a forger, of the landscape artist Richard Wilson, and much of his work, like that of his master, was given over to Italianate landscapes executed, in Jones's case, with an unappealing dryness. Then, in the course of a few months between 1782 and 1783, his *annus mirabilis*, he produced an altogether remarkable series of pictures, which he had only intermittently anticipated in some earlier outbursts of originality. Jones had, it has been justly said, 'sporadic genius'.[26]

It was in 1776 that, at the age of thirty-four, Jones made his first visit to Italy, which, in one guise or another, he had been painting for a number of years. It was a great moment. As he crossed the Alps, and descended into the north Italian plain, he saw lizards at play for the first time in his life, and he confided the experience to his *Memoirs*.[27] By May 1780 he had reached Naples where he sought the patronage of Sir William Hamilton. There he leased the top floor of a new building opposite the Dogana del Sale, or the salt customs-house, the layout of which we know because he entered it, and a lively account of the life of the neighbourhood, in his journal.[28] In April 1782, just before his lease ran out, he set

346–346

Painting, metaphor, and the body

347 Thomas Jones *Rooftops, Naples* April 1782, oil on paper

348 Thomas Jones *The capella nuova fuori della porta di Chiaja, Naples* 1782, oil on paper

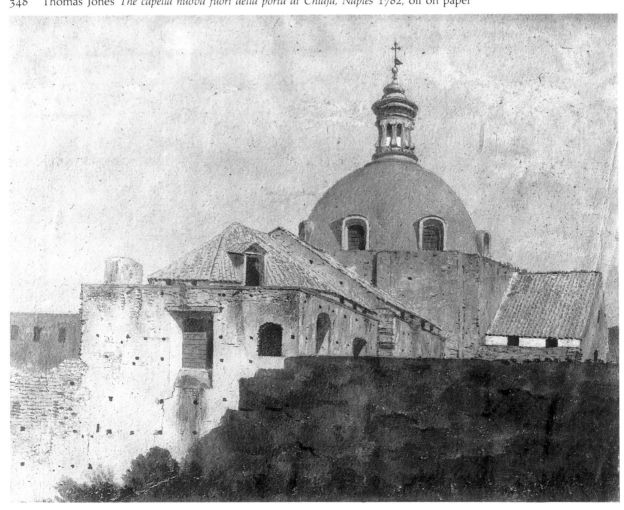

349 Thomas Jones
Window in Naples
1782(?), oil on paper laid
down on board

himself up, first at the open window of the room he used as a studio, and then, more momentously, on the *lastrico*, or *lastrica* as Jones called it, the paved terrace roof, and he painted the buildings opposite. *Rooftops, Naples* (Ashmolean Museum, Oxford) is one of 347 the results. Jones seems not to have appreciated the full novelty of what he was doing, for, though the paintings are carefully dated, he introduces news of it, casually, retrospectively, into his journal. In May he moved to another studio, which also had excellent views, and the habit that he had stumbled into persisted. It was here that he painted *The capella nuova fuori della porta di Chiaja, Naples* (Tate Gallery, London), and 348 probably also the remarkable *Window in Naples* (collection Mrs J. Evan-Thomas). This last 349 work measures four and three-eighths inches by six and a quarter inches. It has been called 'one of the great microcosms of painting'.[29] Over the next few months Jones moved three more times, and he continued to paint from open windows or roof-terraces. However in 1782 his father died, and, needed to look after the family estates, he could not postpone his return to Wales beyond the summer of 1783, and so this amazing burst of creativity was brought to an end.

We must appreciate that all the pictures done over these few months, executed in oil on primed canvas, most of which are lost, were, as Jones's *Memoirs* make clear, intended to be exactly what to modern eyes they seem to be: works of art in their own right. They were 'finished studies',[30] not sketches.

I have brought Jones's buildingscapes into the scope of these lectures, not for their originality or their oddity, though they have these qualities in plenty, but because they metaphorize the body. In doing so they exhibit very strikingly a feature that is present, to some degree or other, in all such paintings. All paintings that metaphorize the body

Painting, metaphor, and the body

receive some part of their authority to do so from the way they engage with primitive phantasies about the body. Indeed it is the submerged presence of this early material – that is, material from the early life-history of the individual – in metaphorical paintings that lends support to my claim that, in the profound cases of pictorial metaphor, what is metaphorized is the body. However in the case of pictures that metaphorize the body, not through representing the body, but through representing something else, something metaphorically linked to the body, the evocation of these phantasies is called for twice over. They are recruited to enhance the corporeality of the picture itself, to which we globally respond, but they do this the better for having already been recruited to ensure corporeality for what the picture represents. If primitive phantasy helps to forge the new metaphoric link, or the link between picture and body, this is largely because of the way it reinforces, it has already reinforced, the old metaphoric link – that is, in the cases we have been considering, the link between building and body. For it is from the old link that the new derives much of its strength, much of its vitality.

The investiture of represented buildings with phantasy about the body, which then comes to settle around the picture as a whole, giving the picture a presence quite out of proportion to its size and its manifest ambition, is something that Jones repeats over and over again in works of the finest period. Primitive feeling irradiates these simple, unaffected pictures with an immediacy that is absent from the statelier, more grown-up, pictures of Bellotto. Phantasy underlies Bellotto's paintings too. Indeed, without this understructure of phantasy the particular properties that I have attributed to his representations of buildings, or at least to the best of them, would not have been possible. But, in Bellotto's case, it is phantasy kept at a distance. With Jones there is no such thing as emotional distance. Everything, everything that he utilizes, is on tap.

Jones's achievement in these diminutive buildingscapes is that he gets timeless, discoloured buildings of great dignity and humble materials to revive the infant's perception of the body: the body, stretched out, close up, palpable, taken in through the eyes of desire or destruction. The remarkable thing is that, at the very moment at which a new mode of painting, *pleinairisme*, came into being, it assimilated its findings to our earliest experience. In Jones's case we become aware of several devices that he used to effect this assimilation.

The central device upon which Jones relies to give his pictures the effect of something near and prone, or to revive the early vision of the body, is the way he standardly dresses the principal building in the painting by the picture plane, and then prolongs the elevation of the building by a startlingly wide angle of vision. In this he is licensed, indeed encouraged, by two features of his work. First, there is the horizontal format that he adopts. Second, there is the way he slips from linear perspective to orthographic projection, in which all orthogonals are drawn as parallel lines. Though the correct geometrical description of such a projective system is to say that it assumes that the spectator is at infinity, the optical effect is that of a series of views on to the object, up and down its length, all of which are close up. The tension that this flatness gives his pictures is evident both in *Buildings in Naples* and in *Rooftops, Naples*. In the Cardiff picture Jones indeed pushes this effect of frontality to an unexpected outcome. For, having first lined up the foremost building by the picture plane, he then takes hold of the flanking wall of the neighbouring building, distinguished by the ornamental parapet that it carries, and he turns it so as to make it appear that it runs not, as it must have done, at right angles to the façade of the principal building, but more or less parallel to it. We can confirm this by, for instance, taking the line immediately under the balustrade and observing how it relates to the other horizontals that are inscribed on the frontal wall: for instance, those below or above the windows, or that under the great lunette. The shock is that it is drawn parallel to them.

350 Thomas Jones
Houses in Naples August
1782, oil on paper

Another device that Jones uses for securing, more immediately, more viscerally, the corporeality of these casual buildings is the proliferation of texture. Either exploiting a difficulty in depictive skill that he had, or encouraging the frontal organization of the picture to create the difficulty for him, or, most probably, a bit of both, Jones invariably allows shadow to convert itself into texture: it smooths the stone, or it roughens the plaster, on which it is cast. In all the paintings I have considered this effect is manifest. The play of light coagulates on the represented wall, and, like the play of time in Bellotto, it enriches the material.

A third device which attaches the buildingscape to the body is one that could readily descend into crudity, and, when Jones employs it, as in *Buildings in Naples*, in *Rooftops, Naples*, or in *Houses in Naples* (British Museum, London), he does so with what must be an unconsciously induced delicacy. I am referring to the filling-in of gaps or intervals in the composition with leaves or with long branches or canes, which are given a character quite outside the eighteenth-century clichés of foliage. In these pictures foliage assumes the quality of fine-spun hair, curling against the body. It is interesting that an equally intimate use of foliage, though more measured in its impact, less frank in its immediate associations, is provided by the elegant *hortus inclusus* in the west view of Schloss Königstein. Direct reference to the body has been left behind, but the garden, with its topiary, and its turreted summer-house, and the ladder left askew, suggests a world heavy with secrets. It is a garden of encounters.

346, 350

Painting, metaphor, and the body

I have spoken of Jones's evocation of the body taken in through the eyes of desire or destruction, and the truth is that these pictures, in their pursuit of corporeality, scarcely ever arouse memories of either of these emotions without the other. Certainly they never put us in mind of infantile attacks upon the body without also displaying the body's ability to survive such attacks. Amongst the phantasies they stir are those which assure us that we have the power to restore, to remake, to rebuild, that which we have damaged, and Jones selects a highly ingenious way of making these phantasies concrete. For one of the many happy topographical accuracies in these informal studies by an eccentric Welsh squire is the way they capture a particular uncertainty that surrounds many southern buildings, which is whether, at the moment we catch sight of them, they are going up or coming down: whether we see them in the course of construction or demolition. This uncertainty is marvellously caught in one of the first and very finest paintings in the series: another *Buildings in Naples* (National Museum of Wales, Cardiff), dated April 1782, which is when Jones first dragged the materials of his craft on to the roof above where he normally worked. However what Jones contrives to do in this picture, and in other works — *Rooftops, Naples* is another example — is to transform visual ambiguity into emotional condensation. These buildings, having come down, or once destroyed, are now restored: they go up again. They rise against a little boy's sky, of clear morning blue or liverish grey, flecked with clouds of cotton wool. These pictures, now the delight of a few discriminating cognoscenti,[31] contain very early material.

351 Thomas Jones *Buildings in Naples* April 1782, oil on paper

351

347

Painting, metaphor, and the body 347

D. 1. Very early material also appears, and on a massive scale, in the work of a great metaphorical painter of our day, and it accounts for the way it looks. It accounts for an undigested sumptuousness. It also makes the way we should think about it problematic. In New York City after the last war there emerged, out of a remarkable body of decorative painting, which was dazzlingly innovatory, two painters of genius – Mark Rothko and Willem de Kooning. In most ways they are antithetical artists, one remorselessly lugubrious, the other volatile and sensuous, and it is of the latter, of de Kooning, that I speak.

In effect de Kooning has taken up a tendency which we have already seen in operation in early Cinquecento Venetian painting, and he has projected it to unenvisaged lengths. This is the impulse to collect and incorporate into a painting, now conceived of – metaphorically, of course – as a box or container, objects of the senses other than sight. Titian and his fellow-Venetians collected sounds. De Kooning has recharged this impulse, and he has extended it to take in objects of the other senses, and also sensations of activity, sensations of moving the limbs or muscles, but all experienced in a heavily regressive mode.

The sensations that de Kooning cultivates are, in more ways than one, the most fundamental in our repertoire. They are those sensations which gave us our first access to the external world, and they also, as they repeat themselves, bind us for ever to the elementary forms of pleasure into which they initiated us. Both in the grounding of human knowledge and in the formation of human desire, they prove basic. De Kooning, then, crams his pictures with infantile experiences of sucking, touching, biting, excreting, retaining, smearing, sniffing, swallowing, gurgling, stroking, wetting. These experiences, it will be noticed, extend across the sense modalities, sometimes fusing them, sometimes subdividing them: in almost all cases they combine sensations of sense with sensations of

352,

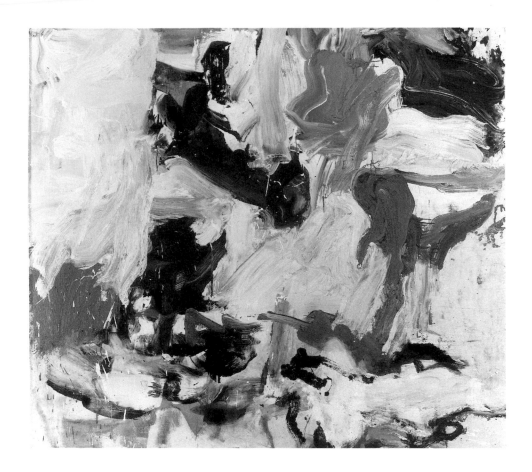

activity. And these pictures of de Kooning's, particularly the later ones, which are to my mind the greatest, contain a further reminder. They remind us that, in their earliest occurrence, these experiences invariably posed a threat. Heavily charged with excitation, they threatened to overwhelm the fragile barriers of the mind that contained them, and to swamp the immature, precarious self.

If I am right in my perception of these pictures, it follows that, for all the primitiveness of the material they carry, there is within them a duality of content. There are two different things to which they try to do justice. There are the experiences, and there is also the experiencer. The self is set over and against the sensations that it contains. Each of these two elements finds its own way into the picture. For the sensations themselves de Kooning relies upon the lusciousness of the paint, and he conveys their archaic character by the fat and gaudy substance into which he works it up. And he selects as the vehicle of the self the box-like look of the support, for which he characteristically chooses a near-square format, and he then establishes a correspondence between the near-square look and the simplicity and the fragility of the rudimentary self. De Kooning's pictures assimilate themselves to enormous shallow saucers in which a great deal of primitive glory is held in delicate suspense: it slops around, but it is kept back by the rim.

If however this is the final effect, it is worth noting, for it underscores the earliness, the primitiveness, of the material to which these pictures are committed, that de Kooning builds it up by manifestly concentrating on one element, and allowing the other element to reconstruct itself. He concentrates on the paint: and he introduces the format, he thematizes its near-squarishness, by the only means left to him – that is, by showing the various ways in which the huge paint-marks engage with the edge of the support. He sets up a drama between the mark and the edge, of which we become spectators and in which the role of the edge can be inferred from how the mark reacts to it. So we become sensitive

353 Willem de Kooning
Untitled II, 1979

Painting, metaphor, and the body

to the swerves in direction that the massive, furrowed brushstrokes make as they try to avoid collision with the edge; or, if there is collision, to the undertow of paint as it is sucked back, like a spent wave, into the interior of the picture; or, in simpler, less dramatic parts of the painting, to the thin, protective deposit of colour that forms, at irregular intervals, around the periphery of the picture, marking previous onslaughts upon its integrity. It is through the insurgency of the paint that we come to recognize the regulatory role of the edge. It is the turbulence of sensation that brings home to us the control that the self endeavours to exercise over it. However, if it is true that the container-like effect of the picture is achieved only indirectly or obliquely, through the protest that its contents make against it, nevertheless once this effect has been achieved, it is through it that corporeality attaches to the picture as a whole, so that the picture can then come to metaphorize the body. It comes to metaphorize the body under the most archaic conception that exists of the body and its workings. It antedates anything we have so far had to consider.

In an interview organized by the art-critic Harold Rosenberg,[32] de Kooning in a free-wheeling mood suddenly conjoined three features of his work. These features fit together in my view of his work but they do not, as far as I can see, have otherwise any obvious connection. If this is so, their conjunction by de Kooning provides some kind of corroboration of my understanding of his work. The three features are: (one) the near-squareness of the format, the favoured proportions being, de Kooning tells us, 7:8; (two) the large size of the support, combined with what he calls an 'involved', or highly detailed, surface; and (three) the loss of apparent size. I have already talked about near-squareness, and its correspondence to the primitive self. As for the next two features, we might ask, When do we associate largeness and complexity with the appearance of smallness? I believe that there is a context in which the connection, or something like it, holds. It is when we start to think about sensation. For though, strictly speaking, we cannot associate sensation with scale, sensation constantly plays tricks upon scale. For instance, we look out on to the Himalayas and we have a twinge of pain, and no literal sense can be given to establishing a ratio between them. The twinge is nothing, and the view is overwhelming. Yet the pain can tower over the Himalayas.

What this last observation brings home is that one way in which de Kooning's work distances itself from that of Jones and, to a greater extent, from that of Bellotto is that the body as his paintings come to metaphorize it is supremely the locus of sensation. It is the locus of sensation and emotion, whereas the body as they metaphorize it is, in accordance with a somewhat more evolved conception, the locus of perception and emotion.

It is interesting to note that de Kooning, in putting together this triad of near-squareness, size, and seeming smallness, uses, for the effect that these factors can, at any rate in his hands, generate, a term that I have used for something that Jones and Bellotto achieve: 'intimate', 'intimacy'. The corporeality of any painter who deals with early conceptions of the body is shot through with intimacy. But in de Kooning's case there is a special, fragile intimacy, which depends upon a technique that he has experimented with from early on: the differential drying of the paint.[33] This process, repeated layer upon layer, produces a kind of localized spotting and cracking of great delicacy, which, at its most intricate, simulates the palpitating, mottled breast of a very small bird. The canvas presses itself up against us. It is a natural defence against the emotional power of these paintings that we should often be led to concentrate solely upon the beauty of such passages. This beauty is something that I have no desire to deny. It exists, and it has a special contribution to make to the kind of corporeality that is to be discerned in de Kooning. But it needs to be seen in that context. It is not autonomous.

2. It is customary for ease of exposition to divide de Kooning's paintings, and so by

Painting, metaphor, and the body

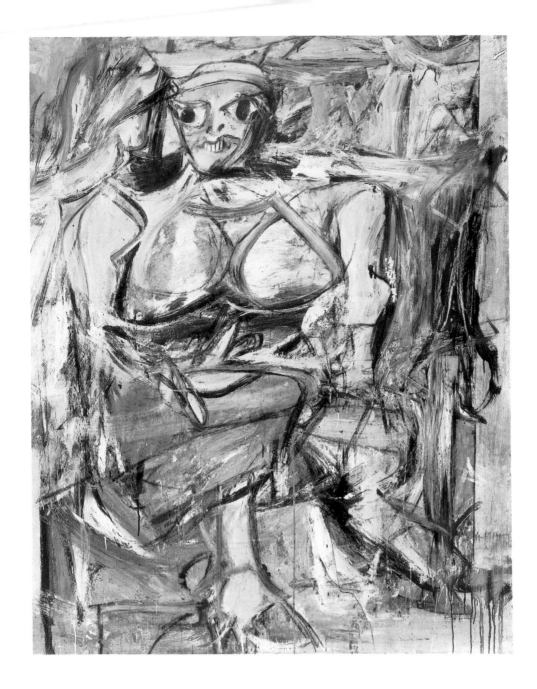

extension the periods into which they fall, into the figurative and the non-figurative.[34]

352 So, for instance, the *Untitled III, 1977* (Anthony d'Offay Gallery, London), and the
353 *Untitled II, 1979* (Xavier Fourcade Inc., New York City), both great pictures to my mind,
354 would count as non-figurative: and the famous *Woman I* (Museum of Modern Art, New York City), of 1950–2, would count as figurative. And there is on the face of it nothing wrong with this classification. But it may be misleading. It may, whilst giving, also distort, the content of these works. Let me explain.

These works are, I take it, fundamentally metaphorical. Furthermore they are metaphorical through their representational content. But – and this is the crucial consideration – I do not believe that they are metaphorical through that part of their representational content which involves figuration. The figurative aspect of *Woman I*,

354 Willem de Kooning
Woman I 1950–2

Painting, metaphor, and the body

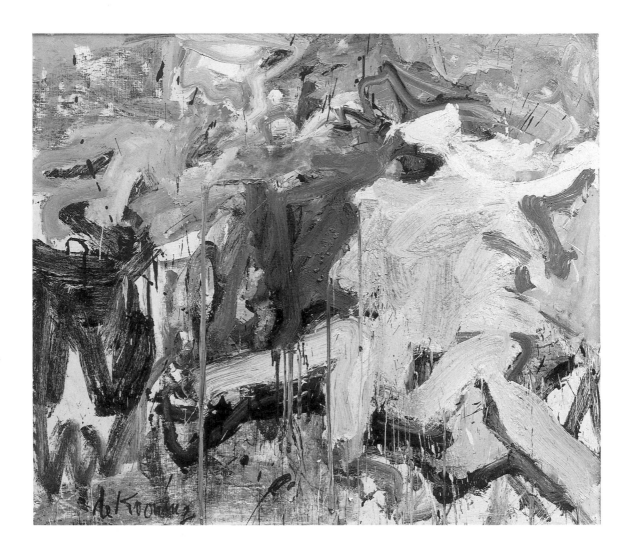

355 Willem de
Kooning
*Two Figures in a
Landscape* 1967

which undoubtedly exists, makes a negligible contribution to the metaphorical meaning of the picture, which is induced almost exclusively by what we might now, following Walter Pater's hint, call the Venetian mode: or the mode to which Titian resorted when he tipped sounds into his pictures. Except that de Kooning, I suggest, tips into the picture a great deal more, and all of it more primitive.

It is then the supremacy of metaphoricity in de Kooning's work, and the nature of the devices on which it rests, that suggests that the application to it of the figurative/non-figurative distinction, while it can be effected, obscures more than it reveals. It is not fundamental: though not for the reason that many zealots of modern art have subscribed to – namely, that figuration is always unimportant. What is always important is to know whether figuration is or is not important in a given artist's work.

It does not follow from what I have said, but it is related to it, and it is of independent interest, that the most uniformly successful paintings of de Kooning's seem to be his semi-figurative paintings: paintings, that is to say, in which representational content hovers between the figurative and the non-figurative. A figure seems about to emerge. We can barely make out a figure in the marked surface. Examples would be the *Two Figures in a* 355
Landscape (Stedelijk Museum, Amsterdam), of 1967, and the *Two Trees on Mary Street . . .* 356
Amen! (Queensland Art Gallery, Brisbane), of 1975.

352

Painting, metaphor, and the body

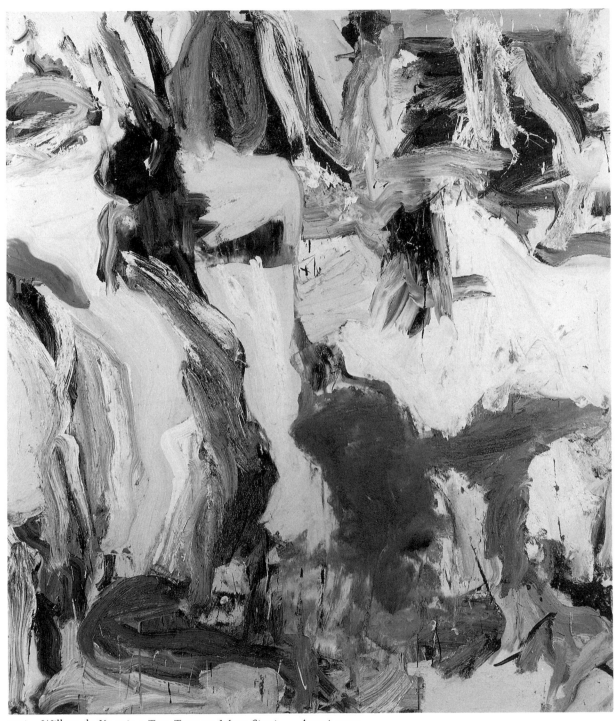

356 Willem de Kooning *Two Trees on Mary Street ... Amen!* 1975

E. 1. I return to pictures that metaphorize the body through their figurative content. I return to the ancient Bellini and to an altarpiece of great expressive simplicity but of a pictorial subtlety for which nothing so far has made us quite ready. It is to my mind one of the great paintings of the world, and I am pleased to end these lectures upon it. This is the *St Jerome with St Christopher and St Louis of Toulouse* (San Giovanni Crisostomo, Venice), 357 painted for the small Venetian church where it is to be found. It is dated 1513, which is when it was completed, and it is unlikely that it was begun much earlier.

Amongst the first sure perceptions that we have of this picture is one which forces upon us the fact that the bottom two-thirds metaphorizes a work of vigorous classical architecture. It throws architecture in a new light: and it does so through what it represents – through what it figuratively represents. Central to this effect is the assimilation of the two flanking saints to architectural members of a structural sort. In this connection we notice the emphatic way in which these figures upstage the two piers represented in sharp recession, against which they are posed. The parallel verticals of pilgrim's staff and bishop's crozier, which attract our attention through the quietly, the delicately, manifest brushstroke, and then the parallel burdens of the Christ-child on the back of St Christopher and the heavy vestments on the slender shoulders of St Louis – all these suggest a load-bearing capacity, more or less effortlessly assumed. But now there is a further turn, and profundity takes over. For in metaphorizing a work of architecture, Bellini captures it, in much the same way as Jones captures the humbler buildings that he represents, at the very moment at which it metaphorizes the human body. So, we must ask, How does a work of architecture do this? Architecture, classical architecture, primes itself to assume the human body as its metaphorical content when its parts or members stand to one another in a manifest relation of reciprocity. By reciprocity I mean more than balance. I do not simply mean the optical effect that we get from a pair of columns when we are sure that, if one was to be removed, the other would fall down. Members reciprocally related enhance one another. They add to one another. This is the visual effect they make. And it is just such a building, or one that makes this kind of corporeal effect, that the figures of the two saints, the parapet between them, and the beautiful rock behind them, metaphorize.

But this architecturalization of a large zone of the painting colludes with a powerful Belliniesque device, here carried to new lengths: the compression of space, familiar to us from the Santa Corona altarpiece. For, as we identify the most forward plane with the piers and the saints, narrow enough, and then look beyond it to see how the rest of the picture organizes itself, we notice that, gradually, or one by one, the other represented objects edge forwards into this frontal slice. In describing the Vicenza *Baptism*, I tried to isolate a certain effect by talking of Bellini's figures *inching outwards*. Here they *inch forwards*. Finally, there is St Jerome himself, who appears to be sitting, not under (for that 358 would be a spatial deformation), but under the aegis of, the rustic *baldacchino* provided by the arch ornamented with mosaic. All that is now left over is the landscape: mountains, and a single building, and the evening sky, which are within as well as without the head of St Jerome.

The expressive value of the picture is unmistakable. It is the total reconciliation of man and nature, typified by two poignant details: by the amusing presence of the fig-tree that provides St Jerome at once with his lectern and with the sparse shade that he requires, and by the incredibly simplified silhouette of the saint himself. In this picture deletion itself is sanctified. Disconcerted by the simplicity, by the unassertiveness, of St Jerome, we start to look around within the painting for another, more conspicuous, equivalence for the body. And we find it: we find it in the picture as a whole. Which eases itself forwards.

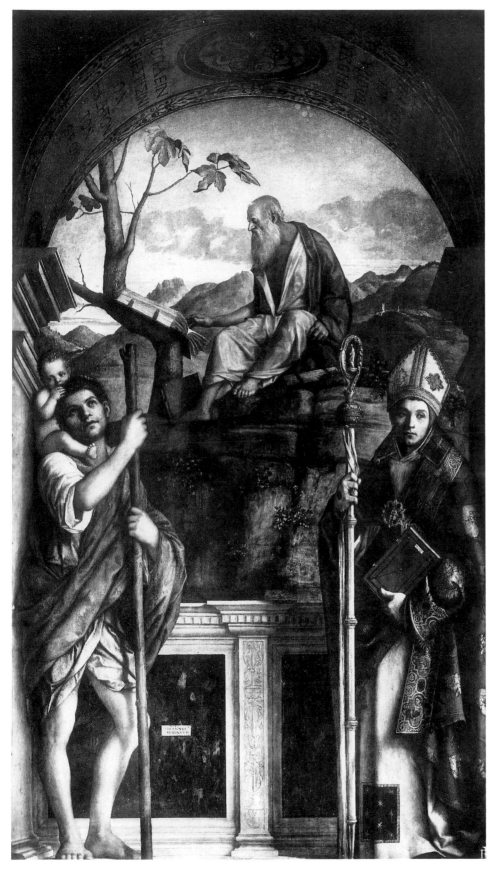

357 Giovanni Bellini
*St Jerome with St
Christopher and St Louis
of Toulouse* c. 1513,
panel

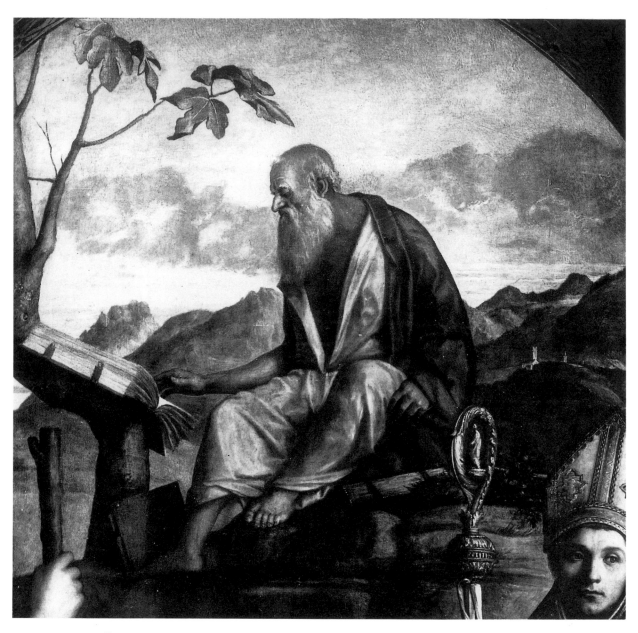

358 Giovanni Bellini
*St Jerome with St
Christopher and St Louis
of Toulouse*, detail,
c. 1513, panel

Conclusion

The psychological account of meaning which I favour, and which I have been pushing in these lectures, roots meaning in some mental condition of the artist which, when it finds outlet in the activity of painting, will induce in the mind of the spectator a related, an appropriately related, mental condition. But — and this is the big question on which everything that I have said hangs — with what right can the artist expect the spectator to think, to feel, even to see, in the way he wants him to? The spectator, I have insisted, must have the required sensitivity and he must have the required information. What he doesn't have to have is what is required of the hearer of a language: that is, knowledge of rules or conventions which he applies to the picture so as to extract its meaning. But how does even the conjunction of sensitivity and information make the transmission of meaning a likely story?

Or we can narrow the question so as to make it bear more sharply on what I have been saying. For I have been interpreting pictures time and time again on the basis of my experience of them: on the basis of what I see, and feel, and think. But, even granted that I have the right sensitivity and information, how can I be sure that my experience is veridical — that is to say, that it gives me appropriate insight into the fulfilled aims and intentions of the artist?

Let me make it absolutely clear that I make no claim, either on my behalf, or on behalf of a better informed, better endowed, critic than myself, to incorrigibility. The claim to incorrigibility is absurd here as everywhere else. But with that claim laid aside, the reply that I should make to this challenge is the simplest, and the most important, thing that I have to say in these lectures.

It takes the form of an evolutionary argument.

It is this: Painting would not go on, it would not have gone on, being practised as an art, if it did not enjoy some of the success of art. If artists over the centuries had not succeeded in putting across what they wished to convey, they would have turned to some other activity to transmit what they intended. Or their public would have asked them to do so. Or, more realistically perhaps, the public would have asked their successors to do so. More realistically, because there is reason to think, in company with the great philosopher David Hume, that the meaning of great works of art — and I hope that what I have been saying in these lectures will also go some way towards re-establishing belief in the hierarchy of art — discloses itself slowly, and with great difficulty, over the years, through the co-operative work of those who happen to be interested in painting. The strongest argument, then, for the intelligibility of painting, over and above our own convictions about the meaning of particular paintings, is the survival of painting: the survival of painting as an art, or as an activity that, with a two-handed gesture, gives meaning to, and claims intelligibility for, its products.

Of course, this evolutionary argument in turn requires us to believe that the societies across which painting has survived as an art are human societies: that is, societies in which a common human nature manifests itself. If painting had continued to be admired, practised, and treasured, over the ages and in different societies, but in each society human nature was an artifact of that society, this would have done nothing to confirm the secular intelligibility of painting. Our belief then in the value of painting as something that has, along with many of its works, stood the test of time stands within a framework that happily locks together two of the commitments by which I steer: the love of painting, and loyalty to socialism.

Notes

Notes to I

1. Broadly used, the term 'Institutional theory' can refer to a range of theories of art, all of which stress the essentially historical character of art or the dependence of art upon tradition. Used more narrowly, as here, the term applies to a theory of which the foremost advocate has been George Dickie, who has advanced it in a number of books and articles which register, at any rate up to its latest formulation, minor refinements of the theory. The most accessible version of the theory is to be found in George Dickie, *Art and the Aesthetic* (Ithaca, N.Y., 1974). The motivation of the theory has been to revive a unitary account of art after the assaults made upon it by philosophers who, influenced in a general way by Wittgenstein, have argued that the concept of art rests not upon a single property but upon a network of family resemblances. For this argument, see Morris Weitz, *Philosophy of the Arts* (Cambridge, Mass., 1950); 'The Role of Theory in Aesthetics', *Journal of Aesthetics and Art Criticism*, Vol.XV, no.1, Fall 1957, reprinted in *Philosophy Looks at the Arts*, ed. J. Margolis (revised edition, Philadelphia, 1978); and 'Wittgenstein's Aesthetics' in *Language and Aesthetics*, ed. Benjamin R. Tilghman (Lawrence, Kansas, 1973). The Institutional theory endeavours to make itself immune to such an argument by showing that the argument is cogent only against a unitary account that also holds that the single property picked out by the concept of art is invariably a 'manifest' or 'exhibited' property: the property of having had a certain status conferred upon it by certain socially identified persons is not an exhibited property of a work of art. That the so-called family-resemblance argument has these limits was pointed out in Maurice Mandelbaum, 'Family Resemblances and Generalizations concerning the Arts', *American Philosophical Quarterly*, Vol.2, no.3, July 1965, pp.219–228. The latest formulation of Dickie's theory is to be found in his *The Art Circle* (New York, 1985), in which Dickie removes from his theory any reference to conferral of status. As the main body of my text makes clear, I regard such a move as a definite improvement, but it decisively takes away the institutional character of the theory. For criticisms of Dickie's view prior to this *volte-face*, see Ted Cohen, 'The Possibility of Art: Remarks on a Proposal by Dickie', *Philosophical Review*, Vol.LXXXII, no.1, January 1973, pp.69–82; Kendall Walton, review of George Dickie, *Art and the Aesthetic*, *Philosophical Review*, Vol. LXXXVI, no.1, January 1977, pp.97–101; and my *Art and its Objects* (2nd edition, New York, 1980, and Cambridge, England, 1983), Supplementary Essay I, 'The Institutional Theory of Art'.

A view related to that of Dickie, but far subtler, and which is concerned more with the interpretation than with the status of the art-work, is to be found in Arthur Danto, 'The Artworld', *Journal of Philosophy*, Vol.61, no.19, 15 October 1964, pp.571–584, and *The Transfiguration of the Commonplace* (Cambridge, Mass., 1981).

An anthology devoted to the Institutional theory is *Culture and Art*, ed. Lars Aagaard-Mogensen (Atlantic Highlands, N.J., 1976).

2. See e.g. Timothy Binkely, 'Piece: Contra Aesthetics', *Journal of Aesthetics and Art Criticism*, Vol.XXXV, no.3, Spring 1977, reprinted in *Philosophy Looks at the Arts*, ed. J. Margolis (2nd edition, Philadelphia, 1978).

3. Examples of such theories, which I have chosen so as to illustrate their varied character, are Clive Bell, *Art* (London, 1914);

David Prall, *Aesthetic Analysis* (New York, 1936); Roger Fry, *Vision and Design* (London, 1920); Kurt Koffka, 'Problems in the Psychology of Art', in *Art: A Bryn Mawr Symposium* (Bryn Mawr, Pa., 1940); Rudolt Arnheim, *Art and Visual Perception* (Berkeley, 1954), and *Towards a Psychology of Art* (Berkeley, 1966); and Étienne Gilson, *Painting and Reality* (New York, 1957).

4. E.H. Gombrich, *Art and Illusion* (New York and London, 1959), *passim*.

5. This point is illustrated in an arresting fashion in Arthur Danto, *The Transfiguration of the Commonplace*, Chapter I. Danto asks us, as a thought-experiment, to consider a number of rectangular canvases, of identical format, all coloured the same red, but each of which corresponds to a totally different motivation and has a totally different history of production. The thought-experiment is designed to draw out of us the different ways in which we would respond to each of these canvases, once we know its history: one, on Danto's own showing, is not even a work of art.

6. The point is argued for, and its implications considered, in G.E.M. Anscombe, *Intention* (Oxford, 1957); and Donald Davidson, 'The Logical Form of Action Sentences', in *The Logic of Decision and Action*, ed. Nicholas Rescher (Pittsburgh, 1967), and 'Agency', in *Agent, Action, and Reason*, ed. Robert Binkley *et al.* (Toronto, 1971), both reprinted, along with other relevant articles, in his *Essays on Actions and Events* (Oxford, 1980).

7. For characteristic examples of the way in which intention has been used and misused in discussions of aesthetics, see e.g. *On Literary Intention*, ed. David Newton-de Molina (Edinburgh, 1974). Michael Baxandall, *Patterns of Intention* (New Haven and London, 1985) is a rare attempt to deal with the nuances of intention as these apply specifically to painting. For Baxandall it is a very significant point that the artist's intention is formed and reformed over time, and indeed even as he paints. I agree with this point, but I do not attach to it the same theoretical weight as he does.

8. The view that an outer picture should be the realization of an inner picture held in the artist's mind is one strand in traditional art-teaching, which goes back to Leonardo. For later developments, see Petra ten Doesschate Chu, 'Lecoq de Boisbaudran and Memory Drawing', in *The European Realist Tradition*, ed. Gabriel P. Weisberg (Bloomington, 1982).

Philosophical authority is lent to, indeed it inflates, the idea of an inner image as the necessary precursor of an outer picture in one of the most influential works of twentieth-century aesthetics, R.G. Collingwood, *Principles of Art* (London, 1938). For central to Collingwood's theory of art is the thesis that the work of art does not merely reflect, it is identical with, something fully formed in the artist's head or mind. For this must mean that, in the case of the visual arts, the work of art is an inner image. A complication, perhaps an inconsistency, in Collingwood's overall position is that he also thinks that a work of art is inseparable from the activity that brings it about, and, in the case of the visual arts, he concedes that this activity is an external activity and involves engagement with a medium. On this last point, and on where it leaves Collingwood's views, see my 'On an Alleged Inconsistency in Collingwood's Aesthetic', in *Critical Essays in the Philosophy of R.G. Collingwood*, ed. M. Krausz (London, 1972), reprinted in a revised and enlarged form in my *On Art and the*

Mind (London, 1973, and Cambridge, Mass., 1974). For a more general criticism of the 'idealist' account of art, see my *Art and its Objects*. For an overview of the current state of research into mental imagery, see *Imagery*, ed. Ned Block (Cambridge, Mass., 1981).

9. In working out this account of Ur-painting, I owe a very great deal to Meyer Schapiro, 'On some Problems in the Semiotics of Visual Art: Field and Vehicle in Image-signs', *Semiotica*, Vol.I, no.3, 1969, reprinted in *Sign, Language, Culture*, eds. A.J. Greimas and Roman Jakobson (The Hague, 1970). Though this article has a different aim from my discussion, it has deeply influenced my thinking. I have also found useful John F.A. Taylor, *Design and Expression in the Visual Arts* (New York, 1964).

10. The notion of 'thematization' derives from the Prague school of linguists. It is however used there somewhat differently.

11. I have set out the notion of seeing-in, in my *Art and its Objects*, 2nd ed., Supplementary Essay V, 'Seeing-in, Seeing-as, and Pictorial Representation'. See Lecture II, note 5.

12. For the distinction between motif and image, see my *On Drawing an Object* (London, 1965), reprinted in my *On Art and the Mind*. See also Maurice de Sausmarez, *Basic Design: the dynamics of visual form* (London, 1964), an excellent pedagogical work, which emphasizes the ubiquitousness of the image, or — as I would put it — of representation.

13. The distinction that I draw between representation and one specific version of representation, or figuration, has been very widely ignored in contemporary critical and art-theoretical writing. However Michael Fried, catalogue of *Three American Painters, Kenneth Noland, Jules Olitski, Frank Stella* (Boston, 1965), pp.14–15, employs a distinction close to that which I make between the representational and the figurative, though he uses the two terms the other way round. More substantively, he is slightly readier than I am to find what I would call non-representationality (and what he calls 'the absence of the figurative'). See also Leo Steinberg, *Other Criteria* (New York, 1972), *passim*.

14. I owe this point to Jim Holt.

15. See particularly Ludwig Wittgenstein, *The Blue and Brown Books* (Oxford, 1958).

16. I have borrowed the notion of deletion from transformational grammar, where it plays a significant role in accounting for certain differences between deep and surface structure.

17. The account that I consider is freely extracted from Clement Greenberg, *Art and Culture* (Boston, 1961). The idea that modern art is characteristically self-referential is everywhere.

18. In this account of style I draw upon and simplify two previous essays of mine on the subject: my 'Style Now', in *Concerning Contemporary Art: the Power Lectures 1968–1973*, ed. Bernard Smith (Oxford, 1975), and my 'Pictorial Style: Two Views', in *The Concept of Style*, ed. Berel Lang (Philadelphia, 1979). For other accounts of style, see Meyer Schapiro, 'Style', in *Anthropology Today*, ed. A.L. Kroeber (Chicago, 1953); E.H. Gombrich, *Meditations on a Hobby Horse* (London, 1963), *Norm and Form* (London, 1966), and 'Style', in *International Encyclopedia of the Social Sciences*, ed. David L. Sills (New York, 1968); James S. Ackerman, 'Western Art History', in *Art and Archaeology*, eds. James S. Ackerman and Rhys Carpenter (Englewood Cliffs, N.J.,

1963); Nelson Goodman, 'The Status of Style', *Critical Inquiry*, Vol.1, no.4, July 1975, reprinted in his *Ways of Worldmaking* (Indianapolis and New York, 1978); and contributions by Kendall Walton, Svetlana Alpers, *et al.* to Berel Lang, *op.cit.*

For a survey of theories of general style, which is comprehensive but leaves something to be desired in the matter of clarity, see Otto J. Brendel, *Prolegomena to the Study of Roman Art* (New Haven and London, 1979). An influential work, which deals with the diachronic aspect of general style, again in an opaque fashion, is George Kubler, *The Shape of Time: Remarks on the History of Things* (New Haven and London, 1972).

Despite the criticisms, theoretical and substantive, that can be urged against his work, Heinrich Wölfflin remains to my mind the boldest, the most engaged, and the most suggestive, writer on the subject; see his *Die klassische Kunst* (Munich, 1899), trans. Peter and Linda Murray, as *Classic Art* (London, 1952), and *Kunstgeschichtliche Grundbegriffe* (Munich, 1915), trans. M.D. Hottinger, as *Principles of Art History* (London, 1932).

19. See Denis Mahon, *Studies in Seicento Art and Theory* (London, 1947).

20. The distinction between style and signature is also drawn, though in a somewhat different fashion, in Nelson Goodman, 'The Status of Style'.

21. The term derives from Ludwig Klages, *Ausdrucksbewegung und Gestaltungskraft* (Leipzig, 1923).

22. Some of these arguments are rehearsed in my *Art and its Objects*, 2nd ed., Supplementary Essay IV, 'Criticism as Retrieval'.

23. The case against the social explanation of art, at any rate in the existing state of knowledge, is brought home very forcefully when we turn our attention from works of art to artifacts that do indeed have a social function, and we observe how powerful a method social explanation becomes in such cases. In this context, see a highly interesting work: Adrian Forty, *Objects of Desire: Design and Society 1750–1980* (London, 1986).

Notes to II

1. I have discussed this issue in my *On Drawing an Object*, Inaugural Lecture, University College London (London, 1965), reprinted in my *On Art and the Mind* (London, 1973, and Cambridge, Mass., 1974). For bringing out the importance of the question whether the eyes are or are not essential to a given activity, I am indebted to G.E.M. Anscombe, *Intention* (Oxford, 1957).

2. See Leo Tolstoy, trans. Aylmer Maude, *What is Art?* (London, 1930). This essay originally appeared in 1898.

3. For feedback, see G.A. Miller, E. Galanter, and K.H. Pribram, *Plans and the Structure of Behavior* (New York, 1960).

4. Everything that I have found to say about the artist's posture and about the general function that it fulfils and the consequences that can be drawn from this for the nature of painting is perfectly compatible with the thesis that, in different societies, at different periods, under different ideals of painting, this function might be more finely differentiated, which in turn would impose more determinate constraints upon the posture itself. For the necessity of making this point, I am indebted to Kurt Forster.

5. For seeing-in, see my *Art and its Objects* (2nd edition, New York, 1980, and Cambridge, England, 1983), Supplementary

Essay V, 'Seeing-as, Seeing-in, and Pictorial Representation', and my 'Imagination and Pictorial Understanding', *Proceedings of the Artistotelian Society*, Supplementary Vol.LX, 1986, pp.45–60. In the first of these two essays I give my reasons for preferring the concept of seeing-in to that of seeing-as, which derives from Ludwig Wittgenstein, trans. G.E.M. Anscombe, *Philosophical Investigations* (Oxford, 1953), Part II, section XI, and which I had used in the first edition of *Art and its Objects* (New York, 1968, and London, 1970). For the concept of seeing-in, I am indebted to Richard Damann. See also Christopher Peacocke, 'Depiction', *Philosophical Review*, Vol. XCVI, no.3, July 1987, pp.383–410, for an attempt at a more extended analysis of seeing than I am inclined to think possible.

6. For twofoldness, see my 'Reflections on *Art and Illusion*', *Arts Yearbook*, no.4, 1961, and my *On Drawing an Object*, both reprinted, the former in a much extended form, in my *On Art and the Mind*. However in both these writings I had conceived of twofoldness as a matter of two distinct experiences occurring simultaneously. I owe the abandonment of this view to Malcolm Budd and Michael Podro. For the relevant considerations, see Michael Podro, review of my *Art and its Objects*, *Burlington Magazine*, Vol.CXXIV, no.947, February 1982, pp.100–102, 'Fiction and Reality in Painting', *Poetik und Hermeneutik*, Band X, 1983, pp.225–237, and 'Depiction and the Golden Calf', in *Philosophy and the Visual Arts: Seeing and Abstracting*, ed. Andrew Harrison (The Hague, 1987).

E.H. Gombrich, *Art and Illusion* (New York and London, 1959) denies the possibility of twofoldness, either in the sense of two simultaneous experiences or (though he does not explicitly consider this possibility) in the sense of two aspects of one experience, and he does so partly by appeal to intuitive considerations, partly by assimilating what I call the recognitional/configurational distinction, or what he calls the nature/canvas dichotomy, to the distinction between the duck and the rabbit aspects of the duck-rabbit figure. For he then claims that, just as we cannot simultaneously see the duck and the rabbit aspects of the duck-rabbit figure, so we cannot simultaneously see nature and canvas. It is true that we cannot simultaneously see the duck and the rabbit aspects of the duck-rabbit figure. To do so would require, in my terminology, an experience with two recognitional aspects, which nothing – and certainly nothing in my account of twofoldness – leads me to anticipate. But the assimilation of the two sets of experiences, on which Gombrich rests his case, seems without justification unless it is assumed from the outset that twofoldness is impossible. For what do the two pairs of experiences have in common – if we do not make the assumption that in both cases the experiences are incompatible? Indeed there is one obvious discrepancy between the two pairs. In the duck-rabbit case the two experiences are homogeneous: in both cases I see something in the world. But in the nature/canvas case the two experiences are at least *prima facie* heterogeneous: In one case I see something in the world, in the other case I see something in the picture. Until this heterogeneity is explained away, the assimilation on which Gombrich partially relies lacks plausibility. Gombrich returns to the impossibility of twofoldness in 'Mirror and Map: Theories of Pictorial Representation', *Philosophical Transactions of the Royal Society of London*, Vol.270, 1975, pp.119–149, reprinted in his *The Image and the Eye* (Oxford, 1982).

In M.H. Pirenne, *Optics, Paintings, and Photography* (London, 1970), there is an empirical argument which in effect supports my view of the matter, for it claims that twofoldness is required in order to explain the fact that represented objects maintain a constant appearance even though the spectator changes his position in front of the painting. This argument is made use of in Michael Polanyi, 'What is a Painting?', *British Journal of Aesthetics*, Vol.10, no.3, July 1970, pp.225–236.

7. See *The Notebooks of Leonardo da Vinci*, ed. and trans. Edward McCurdy (London, 1938), p.231.

8. I think that it is right to regard the ability to account for this widespread phenomenon as a requirement upon any satisfactory account of representation. Both the semiotic and the make-believe theories of representation have grave difficulties in meeting the requirement. See Christopher Peacocke, *op.cit.*

9. The story is told in Lucien Daudet, *Autour de Soixante Lettres de Marcel Proust* (Paris, 1928), pp.18–19.

10. Marcel Proust, *À la Recherche du Temps Perdu*, Tome I, *Du Côté de Chez Swann* (Paris, 1914), pp.273–277, trans. C.K. Scott Moncrieff and Terence Kilmartin, as *Remembrance of Things Past*, Vol.I, *Swann's Way* (London, 1981), pp.242–246.

11. These cross-cultural studies are reported in W. Hudson, 'Pictorial Depth Perception in Sub-Cultural Groups in Africa', *Journal of Social Psychology*, Vol.52, November 1960, pp.183–208, and 'Cultural Problems in Pictorial Perception', *South African Journal of Science*, Vol.58, no.7, July 1962, pp.189–195. Hudson's methodology has been considerably criticized in, e.g., G. Jahoda and H. McGurk, 'Pictorial Depth Perception in Scottish and Ghanaian Children: A Critique of Some Findings with the Hudson Test', *International Journal of Psychology*, Vol.9, no.4, 1974, pp.255–267; and Margaret A. Hagen and M.M. Johnson, 'Hudson Pictorial Depth Perception: Cultural Content and question with a Western Sample', *Journal of Social Psychology*, Vol.101, February 1977, pp.3–11. A good survey article of the field is Rebecca K. Jones and Margaret A. Hagen, 'A Perspective on Cross-Cultural Picture Perception', in *The Perception of Pictures*, Vol.II, ed. Margaret A. Hagen (New York, 1980). Jones and Hagen distinguish between the perception of pictures of isolated objects and the perception of pictures of spatial relations. For me this can be at best a distinction of convenience, since both kinds of picture fall within the scope of the same perceptual capacity.

J. Hochberg and V. Brooks, 'Pictorial Recognition as an unlearned Ability: a Study of one Child's Performance', *American Journal of Psychology*, Vol.75, 1962, pp.624–628, showed that a child of nineteen months, reared with severely restricted access to pictures, could recognize familiar objects in photographs and line drawings, and it concluded that there must be 'an irreducible minimum of native ability for picture recognition'.

12. I owe this information to Jerome Bruner.

13. In this section I am much indebted to H.W. Janson, 'The "Image made by Chance" in Renaissance Thought', in *De artibus opuscula XL: Essays in Honor of Erwin Panofsky*, ed. Millard Meiss (New York, 1961), reprinted in his *16 Studies* (New York, 1973).

14. See Svetlana Alpers, *The Art of Describing* (Chicago, 1983), pp.80–82.

15. Gotthold Ephraim Lessing, *Laokoon: oder über die Grenzen der Mahlerey und Poesie* (Berlin, 1766), trans. Sir R. Phillimore, as *Laocoon* (London, 1905).

16. The most extended and most rigorous discussion of this distinction is to be found in Nelson Goodman, *The Languages of Art* (Indianapolis and New York, 1986). Goodman's distinction is made in terms of existential generalization. In other words, for him a picture denotes a particular man (his phrase) just in case it is valid to infer from 'This picture represents a man', 'There exists something that this picture represents'. Otherwise the picture is (his phrase again) a man-representing picture. I prefer to make the distinction in terms of modes of reference as these are employed

Notes

by pictures. There are two advantages to my method. One is that it allows me to ground the distinction in the nature of pictures rather than in what we say about them. The other is that it enables me to group pictures of Venus and Mr Pickwick together with pictures of Napoleon and Madame Moitessier, which is where I believe they belong, rather than with goddess-, or man-, representing pictures, which is where Goodman locates them. The reason behind this last point is that a picture of Venus employs the same pictorial mode of reference as a picture of Napoleon, though, of course, 'This is a picture of Venus' does not permit of existential generalization. It is arguable that Goodman, if he wanted, could allow for the same grouping of pictures as I favour by relativizing the existential operator ('There exists . . .') to a universe of discourse. Other metaphysical commitments on Goodman's part would not incline him to this tactic, but that is irrelevant to the point that I am making. For the theoretical underpinning of my method, see Gareth Evans, *Varieties of Reference* (Oxford, 1982).

The best discussion of modes of pictorial reference is to be found in Antonia Phillips, *Picture and Object* (forthcoming 1988).

17. For representing-as, see Nelson Goodman, *op.cit.*, Chapter I.

18. Two accounts of naturalism are offered in E.H. Gombrich, *op.cit.*, of which one is in terms of illusion, the other in terms of quantity of information. Nelson Goodman, *op.cit.*, offers an account in terms of the familiarity, or degree of entrenchment, of the symbol system employed: this account deems it a virtue that it relativizes naturalism, or makes it 'a matter of habit'. All three accounts manifestly appeal to only one aspect of the seeing-in experience – that is, the recognitional aspect – and in this respect they are typical. A fourth account is to be found in Patrick Maynard, 'Depiction, Vision and Convention', *American Philosophical Quarterly*, Vol.9, no.3, July 1972, pp.243–250, where naturalism is explained in terms of vividness. Maynard's account is the only one I know that anticipates the point that I emphasize: that both aspects of the seeing-in experience are properly recruited by naturalism.

19. For the Illusion view, see e.g. S.K. Langer, *Feeling and Form* (London, 1953); E.H. Gombrich, *Art and Illusion*; and Clement Greenberg, *Art and Culture* (Boston, 1961). *Art and Illusion* also contains other views of the nature of representation.

20. For the Resemblance view, see e.g. Plato, *The Republic*, Book X; Monroe Beardsley, *Aesthetics* (New York, 1958); Ruby Meager, 'Seeing Paintings', *Proceedings of the Aristotelian Society*, Supplementary Vol.40, 1966, pp.63–84; and Jerry Fodor, *The Language of Thought* (New York, 1975), Chapter 4. For a variant of this view, which replaces resemblance between the representation and the thing represented with resemblance between the experience that the representation causes and the experience that the thing represented causes, see Roger Scruton, *Art and Imagination* (London, 1974).

The Resemblance view can acquire an undeserved plausibility because of the way we often seem to settle what a picture represents by standing in front of it and saying 'It looks like . . .'. What the picture represents is then thought to be given by whatever description, inserted into the gap, makes the sentence true. But the support that this consideration appears to lend to the Resemblance view is spurious because the 'it' in the quoted sentence is so used as to pick out not the picture itself, either in whole or in part, as the Resemblance view would have to claim, but the object or the event in the picture. So, for instance, we conclude that a picture represents Sydney Freedberg because the man in the picture – not some fragment of the marked surface – looks like Sydney Freedberg. However not only is this not the

resemblance in terms of which the Resemblance view claims to explain representation, but 'the man in the picture' means 'the man that the picture represents'. And this has the consequence that the quoted sentence, so far from being able to explain representation, presupposes it.

21. For the Make-believe view, see Kendall Walton, 'Pictures and Make-Believe', *Philosophical Review*, Vol.LXXXII, no.3, July 1973, pp.283–319, 'Are Representations Symbols?', *The Monist*, Vol.58, no.2, April 1974, pp. 285–293, 'Points of View in Narrative and Depictive Representation', *Noûs*, Vol.X, no.1, March 1976, pp.49–61, and 'Transparent Pictures: On the Nature of Photographic Realism', *Critical Inquiry*, Vol.11, no.2, December 1984, pp.246–277.

The distinctive feature of Walton's view is that a picture represents an object or event when we are led, on the basis of its appearance, to make believe that we see that object or event. The requirement that the picture must have this effect on the basis of its appearance differentiates Walton's from a semiotic view, but, since Walton's view holds that there is a conventional link between the appearance of the picture and what we are led to make-believedly see, and therefore does not require that we bring a special kind of perceptual capacity to bear on the appearance of the picture, there is a considerable divergence between the Make-believe view and my view. One way in which this divergence manifests itself is that Walton thinks, and I do not, that the two sentences, 'I see peasants' and 'There are peasants there', uttered in front of a picture of haymakers, require a similar kind of analysis, which amounts to thinking of both of them as exercises in make-believe. While I am ready to think that something like this analysis is required for the second or existential sentence, I regard the first sentence as expressing a genuine perceptual judgment: it reports, elliptically, the fact that I see peasants in the picture in front of me.

22. For the Information view, see J.J. Gibson, 'The Information Available in Pictures', *Leonardo*, Vol.4, no.1, Winter 1971, pp.27–35; and John M. Kennedy, *A Psychology of Picture Perception* (San Francisco, 1974). The theory is criticized in Nelson Goodman, 'Professor Gibson's New Perspective', *Leonardo*, Vol.4, no.4, Autumn 1971, pp. 359–360; and in T.G. Roupas, 'Information and Pictorial Representation', in *The Arts and Cognition*, eds. David Perkins and Barbara Leondar (Baltimore, 1977). Some support is given to the Information view in E.H. Gombrich, *op.cit.*

23. The Semiotic view is a rather special case. For within mainstream semiotics, which descends from C.S. Peirce, a distinction is made between, on the one hand, signs that are conventional in their application and hence arbitrary in the way they match sign and signified and, on the other hand, those where there is a natural link between sign and signified: the latter are called 'iconic', and pictures are generally taken to be the supreme example of iconic signs. With semioticians who take this line I have no particular dispute, and it would be hard to have one since they are not associated with any specific positive account of pictorial meaning. It is with radical semioticians who hold that all signs, including pictures, are conventional that I have my disagreement. The boldest and also the most sophisticated version of such a view is to be found in Nelson Goodman, *The Languages of Art*. For more informal versions of the radical semiotic view, see Gyorgy Kepes, *Language of Vision* (Chicago, 1944); Louis Marin, *Études sémiologiques: Écriture, peinture* (Paris, 1971); Umberto Eco, *A Theory of Semiotics* (Bloomington, 1976); and Rosalind E. Krauss, *The Originality of the Avant-Garde and other Modernist Myths* (Cambridge, Mass., 1985).

24. For the rejection of the traditional requirement, see Nelson Goodman, *op.cit.*, Chapter II.

25. The difference between the two forms of projection is seldom recognized explicitly in the psychological literature. I have emphasized the distinction in my *The Thread of Life* (Cambridge, Mass., 1984, and Cambridge, England, 1985).

26. For the idealization of 'doubled-up' predicates, see Nelson Goodman, *op.cit.*, Chapter II. This is criticized in Anthony Savile, 'Nelson Goodman's "Languages of Art"', *British Journal of Aesthetics*, Vol.11, no.1, Winter 1971, pp.3–27.

27. For the denial that expression is a causal notion, see S.K. Langer, *Philosophy in a New Key* (Cambridge, Mass., 1942); Monroe Beardsley, *op.cit.*; Alan Tormey, *The Concept of Expression* (Princeton, 1971); and Nelson Goodman, *op.cit.*, Chapter II.

28. For the analogy between the perception of artistic expression generally and the perception of bodily expression, see Heinrich Wölfflin, *Renaissance und Barock* (Basel, 1888), trans. Kathrin Simon, as *Renaissance and Baroque* (London, 1964), Part II. For contemporary versions of the view, see Guy Sircello, *Mind and Art: An Essay on the Varieties of Expression* (Princeton, 1972); and Vergil C. Aldrich, 'Pictures and Persons – an Analogy', *Review of Metaphysics*, Vol.28, no.4, June 1975, pp.599–610. For an excellent discussion of this topic, which, along with much else that the author says, is transferable to pictorial expression, see Malcolm Budd, *Music and the Emotions* (London, 1985).

29. This account of pictorial expression, or one strand of it, became transformed into an aesthetic maxim in the programme of so-called 'action painting', in Harold Rosenberg, *The Tradition of the New* (New York, 1959).

30. There is a brilliant discussion of this point in Maurice Merleau-Ponty, *Signes* (Paris, 1960), trans. Richard C. McCleary, as *Signs* (Evanston, Ill., 1964), and *L'Oeil et L'Esprit* (Paris, 1964), trans. Carleton Dallery, as *Eye and Mind*, and reprinted in his *The Primacy of Perception* (Evanston, Ill., 1964).

31. For connoisseurship, see Jonathan Richardson, *Two Discourses* (London, 1719), reprinted ed. Richard Woodfield (Menston, 1972); and Giovanni Morelli, trans. Mrs Richter, *Italian Masters in German Galleries* (London, 1883), and trans. Constance ffoulkes, *Italian Painters: the Borghese and Doria-Pamfili Galleries in Rome* (London, 1892).

On Richardson, see Carol Gibson-Wood, 'Jonathan Richardson and the Rationalization of Connoisseurship', *Art History*, Vol.7, no.1, March 1984, pp.38–56. On Morelli, see my 'Giovanni Morelli and Scientific Connoisseurship', in my *On Art and the Mind*; and Carlo Ginzburg, 'Spie: Radici di un paradigma indiziario', in his *Miti, Emblemi, Spie* (Turin, 1986). Ginzburg's essay on Morelli is to be found in English, trans. Marta Sofra Innocenti, as 'Clues: roots of a scientific paradigm', *Theory and Society*, Vol.7, 1979, pp.273–288, and reprinted in *Sign of Three*, eds. Umberto Eco and T. Seboek (Bloomington, 1983). On Morelli as a cultural phenomenon, see also Edgar Wind, *Art and Anarchy* (London, 1963), Lecture III.

32. Restrictions upon the spectator's cognitive stock have been most usually discussed in connection with intentionalist criticism and then largely in the domain of literary criticism. The seminal work here has proved to be Monroe Beardsley and W.K. Wimsatt, Jr., 'The Intentional Fallacy', *Sewanee Review*, Vol.LIV, Summer 1946, reprinted in W.K. Wimsatt, Jr., *The Verbal Icon* (Lexington, Ky., 1954) and in many anthologies. The most useful of these anthologies, on account of the related articles that it contains, is *On Literary Intention*, ed. David Newton-de Molina (Edinburgh, 1974).

For a more general discussion of cognitive stock, see N.R. Hanson, *Patterns of Discovery* (Cambridge, England, 1961), and Fred I. Dretske, *Seeing and Knowing* (London, 1969). Hanson's thesis that all perception is 'theory-loaded' is a specific variant of the broader thesis that what is visible is relative to background information.

33. See Michael Baxandall, *Painting and Experience in Fifteenth-Century Italy* (Oxford, 1972), p.11. Baxandall originally referred to *St Francis renouncing his Heritage* (National Gallery, London), but, in consultation with him, I have changed the example to another picture from the same series on the grounds that, in the present condition of the two works, it better illustrates his point.

34. See Erwin Panofsky, *Studies in Iconology* (Oxford, 1939), Introductory, pp.9–12, or *Meaning in the Visual Arts* (New York, 1955), Chapter I, pp.33–34.

35. Johann Wolfgang Goethe, *Die Wahlverwandtschaften* (Tübingen, 1807), trans. Elizabeth Mayer and Louise Bogan, as *Elective Affinities* (Chicago, 1963), Part II, Chapter V.

36. e.g. Arthur Koestler, 'An Essay on Snobbery', *Encounter*, Vol.V, no.3, September 1955, pp.28–39. On the aesthetic significance of attributions, see Nelson Goodman, *op.cit.*, Chapter III.

37. See Georges Grappe, *Claude Monet* (Paris, n.d [1909]); William Seitz, catalogue of *Claude Monet, a Loan Exhibition* (St. Louis, 1957), and *Claude Monet* (New York, 1960); Joel Isaacson, 'La' Débâcle by Claude Monet', *Bulletin, Museums of Art and Archaeology, The University of Michigan*, Vol. I, 1978, pp.1–15; Grace Seiberling, *Monet's Series* (New York and London, 1981); and Robert Gordon and Andrew Forge, *Monet* (New York, 1983). A crucial consideration for this interpretation of Monet's work 1879–80 is how to distinguish expressively these paintings from the later set of *Débâcles*, where Monet set out to re-create what he had already done.

38. On communication, see Noam Chomsky, *Language and Mind* (New York, 1968), and *Problems of Knowledge and Freedom* (New York, 1971); and Donald Davidson, 'Communication and Convention', in his *Inquiries into Truth and Interpretation* (Oxford, 1984).

39. That a speaker means something by his words only if he intends that these words should bring about a certain effect in his hearer by way of the hearer recognizing his intentions is central to the account of 'non-natural' meaning given by H.P. Grice. See his 'Utterer's Meaning and Intentions', *Philosophical Review*, Vol.LXXVIII, no.2, April 1969, pp.147–177. See also John Searle, *Speech Acts* (Cambridge, England, 1969), and Stephen Schiffer, *Meaning* (Oxford, 1972).

40. Marcel Proust, 'Chardin', in his *Contre Sainte Beuve, suivi de Nouveaux Mélanges* (Paris, 1954).

41. Giorgio Vasari, 'Descrizione Dell'Opere di Tiziano da Cadore, pittore', in his *Le Vite de' più Eccellenti Pittori Scultori e Architettori* (2nd edition, Florence, 1568); Sir Joshua Reynolds, *Discourses on Art* (London, 1797), Discourse XIV; and Émile Zola, 'Mon Salon', *L'Évènement*, 27 April 1866, and 'Une Nouvelle Manière en Peinture: Édouard Manet', *Revue du XIXe Siècle*, 1 January 1867, both reprinted in his *Mes Haines* (Paris, 1879).

42. I owe this point to Michael Fried.

1. Pictures containing a spectator have received of recent years renewed attention in the wake of the brilliant but elusive discussion of Velázquez's *Las Meninas* that is to be found at the beginning of Michel Foucault, *Les Mots et les Choses* (Paris, 1966), trans. anon., as *The Order of Things* (London and New York, 1970). See e.g., John R. Searle, 'Las Meninas and the Paradoxes of Pictorial Representation', *Critical Inquiry*, Vol.6, No.3, Spring 1980, pp.477–488; Joel Snyder and Ted Cohen, 'Reflections on *Las Meninas*: Paradox Lost', *Critical Inquiry*, Vol.7, No.2, Winter 1980, pp.429–447; Leo Steinberg, '*Las Meninas*', October, No.19, Winter 1981, pp.45–54, which was written before, though published after, Foucault's discussion, and sets out the issues with greater perspicuity; and Svetlana Alpers, 'Interpretation Without Representation, or the Viewing of *Las Meninas*', *Representations*, No.1, February 1983, pp.31–42. This literature is discussed incisively and in a way that bears directly upon the thesis of this lecture in Charles Karelis, 'The *Las Meninas* Literature – and its Lesson', in *Creation and Interpretation*, eds. Raphael Stern, Philip Rodman, and Joseph Cobitz (New York, 1985), pp.101–114. The Foucault thesis that the royal pair constitute spectators in the picture in Velázquez's picture is effectively argued against on intentionalist grounds in Jonathan Brown, *Images and Ideas in Seventeenth-Century Spanish Painting* (Princeton, 1978), which points out that any such intention involving the king and queen would have been unthinkable in the context of prevailing standards of decorum.

2. For this distinction, see Bernard Williams, 'Imagination and the Self', *Proceedings of the British Academy*, Vol.52, 1966, reprinted in his *Problems of the Self* (Cambridge, England, 1973); and my 'Imagination and Identification', in my *On Art and the Mind* (London, 1973, and Cambridge, Mass., 1974).

3. See Bernard Williams, *op.cit.*, pp.28–34 for a very penetrating discussion of this topic.

4. I have developed these and related ideas at length in my *The Thread of Life* (Cambridge, Mass., 1984, and Cambridge, England, 1985).

5. Wolfgang Stechow, *Dutch Landscape Painting of the Seventeenth Century* (London, 1966), pp.17-18, 34–35.

6. The point is powerfully made in Charles Rosen and Henri Zerner, 'What did the Romantics Mean?', *New York Review of Books*, Vol.XX, no.17, 1 November 1973, reprinted as 'Caspar David Friedrich and the Language of Landscape', in their *Realism and Romanticism* (Cambridge, Mass. and London, 1984).

7. F.W.B. von Ramdohr, 'Über ein zum Altarblatte bestimmtes Landschaftsgemälde von Herrn Friedrich in Dresden, und über Landschaftsmalerei, Allegorie und Mystizismus überhaupt', *Zeitung für die Elegante Welt*, 17–21 January 1809.

8. Veith's engraving was published in the *Bilderchronik des Sächsischen Kunstvereins*: see E. Sigismund, *Caspar David Friedrich. Eine Umrisszeichnung* (Dresden, 1943).

9. S. Hinz, *Caspar David Friedrich in Briefen und Bekenntnissen* (Berlin, 1968), p.128. This aphorism is reprinted in English in William Vaughan *et al.*, catalogue of *Caspar David Friedrich 1774–1840: Romantic Landscape Painting in Dresden* (London, 1972), p.103.

10. Willian Vaughan *et al., op.cit.*, entry no.100, p.89; cf.

11. William Vaughan *et al., op.cit.*, entry no.62, p.75; cf. Helmut Börsch-Supan and Karl Wilhelm Jähnig, *op.cit.*, entry no.297, pp.377–378.

Helmut Börsch-Supan and Karl Wilhelm Jähnig, *Caspar David Friedrich* (Munich, 1973), entry no.399, p.431.

12. Charles Rosen and Henri Zerner, *op.cit.*

13. I am not, of course, suggesting that in any of these pictures we can, or are expected to, reconstruct the secret. Precisely this is attempted in Mona Hadler, 'Manet's "Woman with a Parrot" of 1866', *Metropolitan Museum Journal*, Vol.7, 1973, pp.115–122.

14. Anne Coffin Hanson, *Manet and the Modern Tradition* (New Haven and London, 1977) argues for such a view of Manet's fundamental aims as an artist, specifically against more 'formalist' interpretations: see particularly pp.18–43 and 58–68.

15. See Anne Coffin Hanson, 'Manet's Subject Matter and a Source of Popular Imagery', *Museum Studies: Art Institute of Chicago*, Vol.III, 1969, pp.63–80, and *op.cit.*, pp.64–65.

16. There is one picture which provides a striking, and perhaps the only, exception to the characterization I offer of Manet's group compositions. This is the scintillating *Chez le père Lathuille* (Musée des Beaux-Arts, Tournai), of 1879. The lovers stare into each other's eyes. Manet had enormous difficulty with this composition, and, at the third sitting, he made some last-minute changes, some of which were forced upon him: he was obliged to introduce a new female model, and at the same time he took the young man out of his cavalry uniform, which had been the original inspiration of the painting, and put him into the smock he was wearing himself. It was only in the course of these unexpected reversals of plan that the present effect materialized. For the making of this picture, see A. Tabarant, *Manet et ses Oeuvres* (Paris, 1947), pp.352–353.

17. It is significant that in the two replicas that Manet produced of *Le Déjeuner sur l'Herbe*, one in watercolour (Ashmolean Museum, Oxford), one in oil (Courtauld Institute Galleries, London), though he somewhat altered the position of the head of the far man, he still managed, by making the corresponding alteration in the direction of the gaze, to preserve the preoccupied or absent look.

18. There are many points in common between my perception of these pictures and that to be found in Bradley Collins, 'Manet's "In the Conservatory" and "Chez le Père Lathuille"', *Art Journal*, Vol.XLIV, no.1, Spring 1985, pp.59–66. However Collins traces the element of detachment in Manet's work to a fundamentally aesthetic motive: detachment, he contends, serves an aesthetic of instantaneity and it allows the paintings to avoid the formulas of genre. Furthermore – and this is obviously where my disagreement with Collins is fundamental – he seems to think that some such account as this, invoking an aesthetic motivation, is necessary, and perhaps sufficient, if detachment is to be thought of as part of the meaning or content of the works it colours. See also John House, 'Manet's *Naïveté*', in Juliet Wilson Bareau, catalogue of *The Hidden Face of Manet* (London, 1986).

19. A similar proposal to mine, though with different implications, and with different reasoning to support it, was put forward in the case of one of Manet's earlier and more problematic paintings in Rosalind E. Krauss, 'Manet's Nymph Surprised', *Burlington Magazine*, Vol.CIX, No.776, November 1967, pp.622–627. Krauss argues that Manet, who originally intended to show a nymph surprised by a satyr, removed the satyr so as to give his

role to the spectator (in the picture?). Beatrice Farwell, 'Manet's "Nymphe Surprise"', *Burlington Magazine*, Vol.CXVII, No.865, September 1975, pp.224–227, effectively disputes the factual basis of Krauss's interpretation by showing that it was not Manet who painted out the original satyr: on the contrary, the alteration was a later intervention, after the painting had left Manet's studio, and probably after his death. The point is taken up in Beatrice Farwell, *Manet and the Nude: a Study in Iconography in the Second Empire* (New York and London, 1981). Françoise Cachin, in Françoise Cachin *et al.*, catalogue of *Manet 1832–1883* (Paris and New York, 1983), entry no.19, p.84, makes the unexpected observation that Krauss's hypothesis that the spectator plays an active role in the picture anachronistically places Manet's painting in the framework of conceptual art. Juliet Wilson Bareau, *op. cit.*, pp. 35–36, makes it clear that the innovation made by Manet in the course of painting *La Nymphe Surprise* was to introduce the satyr.

20. Of recent years it has been John Richardson, *Edouard Manet* (London, 1958), a work which is highly sensitive to Manet's achievement, which has brought the issue of his ineptitudes to the fore. Richardson writes of Manet's 'compositional difficulties', and he describes both his sense of design and his responsiveness to scale as 'faulty'. The charge that Manet could not compose goes back at least to Joseph Péladan, 'Le Procédé de Manet', *L'Artiste*, February 1884, reprinted in *Manet raconté par lui-même et par ses Amis: Ses contemporains, sa Postérité, Documents*, ed. Pierre Courthion (Geneva, 1953), pp.155–183.

So long as a formalist interpretation of Manet, which derived from a partial misunderstanding of what Zola had written about Manet as well as from current pictorial preoccupations, prevailed, which it did from the 1920s into the 1950s, these ineptitudes could not be intelligently discussed, or even properly identified. Of recent years two articles which have recognized the problematic features in Manet's work for what they are, and have inclined also to the view that these features are intentional, are Seymour Howard, 'Early Manet and Artful Error: Foundations of anti-Illusionism in Modern Painting', *Art Journal*, Vol.XXXVII, No.1, Fall 1977, pp.14–21, and Jean Clay, 'Onguents, Fards, Pollens', in the catalogue of *Bonjour Monsieur Manet* (Paris, 1983), pp.6–24, trans. John Shapley and reprinted as 'Ointments, Makeup, Pollen', *October*, No.27, Winter 1983, pp.3–44. Unfortunately both critics give a crudely historicist explanation of the features they identify in that they are content to ascribe them to a broad, unspecific desire on Manet's part to break with tradition. This seems insufficient. Anne Coffin Hanson, *op.cit.*, devotes a chapter to reinterpreting Manet's 'compositional difficulties', and concludes that they are due to Manet's desire to reconcile multiple viewpoints.

Nils Gösta Sandblad, *Manet: Three Studies in Artistic Conception* (Lund, 1954), a highly intelligent work, gives in the Introduction a useful overview of the various stages of Manet criticism up to the date of publication. This survey is carried forward in Theodore Reff, *Manet: Olympia* (London, 1976).

21. *Lola de Valence* had originally a background of this type. See A. Tabarant, *op.cit.*, p.53, and Françoise Cachin *et al.*, *op.cit.*, entry no.50, p.146.

22. Étienne Moreau-Nélaton, *Manet raconté par lui-même* (Paris, 1926), Vol.I, p.72.

23. For the dream-screen, see Bertram Lewin, 'Sleep, the Mouth and the Dream Screen', *PsychoAnalytic Quarterly*, Vol.15, No.4, 1946, pp.419–443, 'Inferences from the Dream Screen', *International Journal of PsychoAnalysis*, Vol.29, Part 4, 1948, pp.224–231, and 'Reconsideration of the Dream Screen', *Psycho-*

Analytic Quarterly, Vol.22, no.2, 1953, pp.174–199. See also Otto Isakower, 'A Contribution to the Pathopsychology of Phenomena Associated with Falling Asleep', *International Journal of PsychoAnalysis*, Vol.19, Part 3, 1938, pp.331–345.

24. See Theodore Reff, *Degas: The Artist's Mind* (New York, 1976), Chapter VII.

25. The account is to be found in Théodore Duret, *Histoire d'Edouard Manet et de son Oeuvre* (Paris, 1902), p.71–73. It reappears in Théodore Duret, trans. J.E. Crawford Flitch, *Manet and the French Impressionists* (London and Philadelphia, 1910), pp.54–55: in this volume the translator has included other writings of Duret.

26. Unaccountably the tie is described as black in A. Tabarant, *op.cit.*, p.150.

27. e.g. Paul Mantz, 'Les Oeuvres de Manet', *Le Temps*, 16 January 1884, reprinted in Pierre Courthion, *op.cit.*, pp.121–141; Jules Castagnary, 'Le Salon de 1868', *Le Siècle*, 26 June 1868, reprinted in Étienne Moreau-Nélaton, *op.cit.*, Vol.I, p.99; and Théophile Thoré (W. Bürger), *Salons de W. Bürger 1861 à 1868*, (Paris, 1870), Vol.II, pp.531–533. The same view is repeated in Fritz Novotny, *Painting and Sculpture in Europe 1780–1880* (London, 1960).

28. For Manet's lighting, see Beatrice Farwell, *Manet and the Nude*, pp.127–130.

29. The caricature was by Randon and appeared in *Le Journal amusant*, 29 June 1867. It is reproduced in Françoise Cachin *et al.*, *op.cit.*, entry no.50, p.148, as Fig.d.

30. Aloïs Riegl, *Das holländische Gruppenporträt* (Vienna, 1902).

31. For the view that painting has a grammar, see C.W. Morris, 'Foundations of the Theory of Signs', in *International Encyclopedia of Unified Science* (Chicago, 1938); *Picture Language Machines*, ed. S. Kaneff (New York, 1970); and Curtis Carter, 'Painting and Language: A Pictorial Syntax of Shapes', *Leonardo*, Vol.9, no.2, Spring 1976, pp.111–118.

32. These issues are further discussed in Anthony Savile and my 'Imagination and Pictorial Understanding', *Proceedings of the Aristotelian Society*, Supplementary Volume LX, 1986, pp.19–60.

33. It is only when it has been conceded that the internal spectator need not be a total spectator that the claims of the *Bar aux Folies-Bergère* to contain an internal spectator can be considered. For, if it does contain an internal spectator, he is presumably the man who is accosting the barmaid and whose reflection in the mirror shows that he is not standing at the point of origin. The other way in which he would differ from the typical internal spectator that Manet employs is that he is not just any old person. He is something more specific, for to judge, again, from his reflection he is a man, middle-aged, of no great panache, and sexually avid.

34. Remarkably enough, of these claims those to the effect that the spectator of the picture *could have been* part of the content of the picture – that is, would have been if the artist had not taken steps to exclude him – have come to play a highly interesting role in some recent art-historical speculation. The thesis that the exclusion of the external spectator was an increasing preoccupation on the part of progressive Western painters over the last two centuries is a central theme in the writings of Michael Fried. Fried has postulated a range of strategies that painters, within the

constraints of their age, have evolved to this end. For the strategies of eighteenth-century painters, see Michael Fried, *Absorption and Theatricality: Painting and Beholder in the Age of Diderot* (Berkeley, 1980). For Courbet's strategy, see his 'The Beholder in Courbet: His Early Self-Portraits and Their Place in his Art', *Glyph*, 4, 1978, pp.85–129, 'Representing Representation: On the Central Group in Courbet's Studio', in *Allegory and Representation: Selected Papers from the English Institute 1979–1980*, ed. Stephen J. Greenblatt (Baltimore, 1981), and 'The Structure of Beholding in Courbet's *Burial at Ornans*', *Critical Inquiry*, Vol.X, no.3, March 1984, pp.510–542. For the strategies of modernism, see his 'Art and Objecthood', *Artforum*, Vol.V, no.10, June 1967, reprinted in e.g. *Minimal Art*, ed. Geoffrey Battcock (New York, 1969).

For all the disagreements that I have with the way in which the issues are framed, I have found Fried's writings enormously stimulating. They show a rare commitment to, and understanding of, the thesis that painting is an essentially visual art.

The conflation of the external and the internal spectator, which I regard as marring Fried's analysis, also underpins a form of neo-puritanism, generally feminist in inspiration, which argues that traditional pictures of naked women are intended to entice the spectator or to minister to his sense of sexual proprietorship: see John Berger *et al.*, *Ways of Seeing* (London, 1972). The views of Berger *et al.* are well caught in the following passage: 'In the average European oil painting of the nude the principal protagonist is never painted. He is the spectator in front of the picture and he is presumed to be a man. Everything is addressed to him. Everything must appear to be the result of his being there. It is for him that the figures have assumed their nudity. But he, by definition, is a stranger – with his clothes still on'.

35. I should now make it clear, if it is not so already, that my argument for thinking that, if the external spectator of a picture were to fill the role of internal spectator, this would involve an unacceptable change of the picture's content from one external spectator to another does not take off from the two following premisses: that each spectator would be required to think some such demonstrative thought as 'She (the represented figure) is looking at me', *and* that this thought is a different thought in the mind of each spectator. For the purpose of my argument it is a matter of indifference whether we think that it would be in each case the same or a different demonstrative thought. What my argument takes off from is what would have to be the case if the thinking of this demonstrative thought were to be relevant to fixing the content of the picture. What would need to be the case is that the thinker of the thought was, at any rate for the time that he stood in front of the picture and looked at it, located in the represented space. For, if this were not the case, the thought expressed by saying 'She (the represented figure) is looking at me' would turn out to be the more familiar thought better expressed as 'I can see in the marked surface a woman looking outward': in consequence the device of the spectator in the picture would turn out not to have been invoked at all.

On demonstrative thoughts, see David Kaplan, *Demonstratives* (mimeographed, UCLA, Los Angeles, 1977); John Perry, 'Frege on Demonstratives', *Philosophical Review*, Vol.LXXXVI, no.4, October 1977, pp.474–497; and 'The Problem of the Essential Indexical', *Noûs*, Vol.13, no.1, March 1979, pp.3–21; John Searle, *Intentionality* (Cambridge, England, 1983); and Christopher Peacocke, *Thoughts: an Essay on Content* (Oxford, 1986).

36. An art which trades on the effect that represented figures obtrude into our space has much to do with what Michael Fried has called 'theatre': see especially his 'Art and Objecthood'.

Notes to IV

1. It would be difficult to give effective examples of current practice, just for the reason that the views that I cite are implicit. I believe that they are also pervasive.

2. The scholar who appears to come closest to my views, at any rate in his explicit statements, is Edgar Wind. For Wind's views on textual meaning, see the methodological comments in his *Pagan Mysteries of the Renaissance* (London, 1958). His ' "Borrowed Attitudes" in Reynolds and Hogarth', *Journal of the Warburg and Courtauld Institutes*, Vol.2, 1938, reprinted in his *Hume and the Heroic Portrait* (London, 1986), gives an account of how historical meaning arises – admittedly in a very circumscribed context, or where wit is involved – with which I find myself in complete agreement.

3. A reductionist view of historical meaning is to be found in Fritz Saxl, 'Continuity and Variation in the Meaning of Images', in his *Lectures*, ed. G. Bing (London, 1957), and reprinted in his *A Heritage of Images*, eds. Hugh Honour and John Fleming (London, 1970). For Saxl the history of an image recounts how one and the same image, which is morphologically individuated, changes its meaning over the years of its use. There is no suggestion that earlier meaning can enter into later meaning.

A more extreme view is to be found in Leo Steinberg, 'Introduction', in Jean Lipman and Richard Marshall, catalogue of *Art about Art* (New York, 1978). Steinberg argues that, though artists may borrow motifs and images from earlier art for a number of reasons, the motive that I emphasize could never be theirs. This is assured by the fact that the spectator is never expected to recognize the borrowing. Indeed Steinberg maintains that, in so far as borrowing is connected with the generation of meaning, the borrowing is undertaken by the artist so as to give meaning not to his art but to the art from which he borrows. Steinberg does not say whether this backward production of meaning is a real possibility, or only a hope or wish, and *a fortiori* he does not say how, if it is a real possibility, it is actually achieved.

Göran Hermerén, *Influence in Art and Literature* (Princeton, 1975), produces an elaborate cross-classification of artistic influence, but he does not discuss ways in which it can give rise to meaning.

4. For the most part I have followed the reconstructed chronology of Poussin's *oeuvre* worked out by Denis Mahon in a series of brilliant articles, i.e., 'Poussin's Early Development: An Alternative Hypothesis', *Burlington Magazine*, Vol.CII, No.688, July 1960, pp.288–304, 'Poussin au carrefour des années Trente', *Actes du Colloque Poussin*, ed. André Chastel, Vol.1 (Paris, 1960), pp.237–263, 'Réflexions sur les Paysages de Poussin', *Art de France*, no.1, 1961, pp.119–132, 'Poussiniana: Afterthoughts Arising from the Exhibition', *Gazette des Beaux-Arts*, 6e période, Tome LX, July–August 1962, pp.1–138, reprinted as *Poussiniana* (Paris, London, and New York, 1962), and 'A Plea for Poussin as a Painter', in *Walter Friedlaender zum 90 Geburtstag*, eds. Georg Kauffman and Willibald Sauerländer (Berlin, 1964), pp.113–142. I have however used the titles for the paintings to be found in Anthony Blunt, *Nicolas Poussin*, Vol.III (Critical Catalogue) (London, 1966) with just one exception: the *Bacchanale with Lute-Player*.

5. Anthony Blunt, *Nicolas Poussin*, Vol.1 (Text) (New York and London, 1967), pp.103–124, 148–150. The claim has met with widespread acceptance, though it is treated with some scepticism in Rensselaer Lee, review of Walter Friedlaender, *Nicolas Poussin*, *Art Bulletin*, Vol.LI, no.3, September 1969, pp.298–303.

6. Anthony Blunt, *op.cit.*, Vol.I, p.103.

7. The grouping of these paintings and the label attached to them as a group are due to Denis Mahon: see his 'Poussin's Early Development: An Alternative Hypothesis'.

8. The significance of the winged horse, generally erroneously referred to as Pegasus, was established by Charles Dempsey in his *Poussin and the Natural Order* (Ph.D. dissertation, Princeton University, 1963: unpublished). In equating the winged horse with the morning star Poussin would have been drawing on the researches of his friend, Girolamo Aleandro. For this information, and for his general encouragement, I am very grateful to Charles Dempsey.

9. I owe this observation to Elizabeth Cropper.

10. The parallel between the Poussin and the Rubens is noted in Martin Davies, *National Gallery Catalogue of the French School* (London, 2nd ed., 1957), entry no.65, pp.174–176, though no borrowing is claimed.

11. The evidence is surveyed in Jacques Thuillier and Jacques Foucart, *Rubens's Life of Marie de Medici* (Paris, 1969, and New York, 1970) and in Deborah Marrow, *The Art of Patronage of Maria de Medici* (Ann Arbor, 1980). I am indebted to personal communications from Jacques Foucart and Deborah Marrow. Jacques Foucart believes that in the delicate political situation at the time it is not likely that such a comparatively obscure figure as Poussin would have been allowed into the gallery where both scholars agree that the *Presentation* would then have hung.

12. Anthony Blunt, *op.cit.*, Vol.I, pp.39, 50.

13. The date of Poussin's departure from Paris, as well as the route that he followed, which took him through Venice, is established in Denis Mahon, 'Nicolas Poussin and Venetian Painting: A New Connexion I & II', *Burlington Magazine*, Vol.LXXXVIII, No.514, January 1946, pp.15–20, and No.515, February 1946, pp.37–43, respectively.

14. The borrowing of the pose of Cephalus from Titian's *Bacchus and Ariadne* was first proposed in Denis Mahon, 'Nicolas Poussin and Venetian Painting II'. Poussin also drew upon *Bacchus and Ariadne* in his *Adoration of the Golden Calf* (National Gallery, London). I owe this last piece of information to Michael Podro.

15. This interpretation of the pose in Poussin's painting depends upon thinking that Titian's painting depicts – or, more precisely, that Poussin thought that Titian's painting depicts – the original encounter between Bacchus and Ariadne. Whether, despite the powerful evidence of the picture itself, this is a correct view of its subject-matter is a question that is in turn inseparable from that of the literary source or sources upon which Titian drew. The standard version of the story, as found in Ovid, *Fasti* III, lines 459–616, records two meetings between Bacchus and Ariadne. Of these the first occurs just after Theseus has sailed away, abandoning Ariadne: Bacchus makes love to her and he then deserts her. The second meeting takes place upon Bacchus's triumphal return from India. So long as we regard the *Fasti* as Titian's source, then, since his painting evidently represents Bacchus returning from the East, we have to believe, surely against the evidence of the eyes, that the encounter that we see involves no fresh conquest. It has however been cogently argued in Graves H. Thompson, 'The Literary Sources of Titian's *Bacchus and Ariadne*', *The Classical Journal*, Vol.LI, no.6, March 1956, pp.259–264, that Titian based himself not on the *Fasti* but on

Ovid, *Ars Amatoria*, I, lines 525–564, which records only one meeting between Bacchus and Ariadne. On this account Bacchus first sets eyes on Ariadne when he arrives flushed with triumph from India: he immediately falls in love with her, and he promises her marriage and immortality amongst the stars. It is this source that makes best sense of the gesture that dominates the painting, and which Poussin was to borrow. The issue of Titian's literary sources is further discussed in Erwin Panofsky, *Problems in Titian, Mostly Iconographical* (New York, 1969), pp.141–144. Panofsky contends that Titian combined his sources, but he agrees with the *Ars Amatoria* hypothesis to the extent of believing that in Titian's painting it is Bacchus's first sight of Ariadne that is recorded. I must repeat that for the present argument the crucial consideration is not the actual subject-matter of Titian's painting but what Poussin understood it to be: however Poussin was a very sensitive spectator and he had studied Titian's *Bacchanals* with great care.

16. The significance that the representation of nature had for Poussin is recognized and is perceptively treated in Paul Alfassa, 'Poussin et le Paysage', *Gazette des Beaux-Arts*, 5ᵉ période, Tome XI, May 1925, pp.265–276. Alfassa sets himself in opposition to the excessively rationalistic interpretation of Poussin that was current then as now, and he puts his claim by saying that nature exerted the same revivifying influence over Poussin that the human body did over Ingres. For nature in Poussin's early work, see Charles Dempsey, 'The Classical Perception of Nature in Poussin's Earlier Work', *Journal of the Warburg and Courtauld Institutes*, Vol.29, 1966, pp.219–249. However the most profound understanding of Poussin's involvement with nature, and its darker side, remains that to be found in William Hazlitt, 'On a Landscape of Nicholas Poussin', in his *Table Talk: or Original Essays on Men and Manners* (London, 1821–2).

17. See Erwin Panofsky, *op.cit.*, pp.21 and 96. Blunt goes so far as to refer to Poussin's painting as *The Andrians*. In this case I do not follow him. See note 4 above.

18. See Michael Kitson, 'The Relationship between Claude and Poussin in Landscape', *Zeitschrift für Kunstgeschichte*, Vol.XXIV, Heft 2, 1961, pp.142–162.

19. e.g. Georg Kauffmann, 'Beobachtungen in der Pariser Poussin-Ausstellung', *Kunstchronik*, 14th Year, no.3, April 1961, pp.93–101, and Antony Blunt, *op.cit.*, Vol.I, p.117.

20. Anthony Blunt, *op.cit.*, Vol.I, pp.114–118.

21. It is, for instance, proposed in Erwin Panofsky, 'Imago Pietatis' in *Festschrift für Max J. Friedlaender* (Leipzig, 1927) that the pose is derived from a pietà by Paris Bordone (formerly Palazzo Ducale, Venice): a claim that is made more plausible if Poussin did indeed pass through Venice on his way to Rome. It is, of course, the aesthetic significance of this claim, not its historical accuracy, that I dispute. It must in fairness to Panofsky's method be conceded that, since any specific claim that a particular pietà is the source of Poussin's painting supports the general claim that Poussin's painting derives from a pietà, his proposal is to that degree – but, I would claim, no more – relevant to the meaning of the painting. Art-history often fails to see that greater specificity does not necessarily ensure greater relevance.

22. 'News from the Delphic Oracle' from W.B. Yeats, *Last Poems 1936–1939* (London, 1939). I am grateful to Patrick Gardiner for pointing out these lines to me. When Yeats wrote about this picture, its subject was believed to be Peleus and Thetis.

23. Indubitably the Bacchanals painted for Cardinal Richelieu to adorn his château at Richelieu – *The Triumph of Pan* (National Gallery, London), *The Triumph of Bacchus* (Nelson Gallery, Atkins Museum, Kansas City, Missouri), and the now-lost *Triumph of Silenus*, of which we have only a copy (National Gallery, London) – abound in luxuriant growth and heavy fecundity, but because of the strong element of commission I forego them as evidence.

24. For the pessimism in Poussin's later work, as well as for the way in which expressive meaning is made increasingly to depend on the overall effect, rather than on the anecdotal detail, of a painting, see Walter Friedlaender, 'Poussin's Old Age', *Gazette des Beaux-Arts*, 6ᵉ période, Tome LX, July–August 1962, pp.249–263, and *Nicolas Poussin: A New Approach* (New York, 1966).

25. J.-L. Vaudoyer, 'Le voluptueux Poussin', *L'Art Vivant*, 1ᵉʳ Année, no.4, 15 February 1925, pp. 10–12, has a promising title, but, in order to defend the thesis behind the title, the author is prepared to sacrifice all of Poussin's work after the early 1630s. In effect he accepts the conventional account of Poussin's work, and disagrees only in his estimate of the relative value and interest of its different phases.

26. A date of 1640, immediately prior to Poussin's departure for Paris, is proposed for this work on archival grounds in Liliana Barroero, 'Nuove Acquisizioni per la Cronologia di Poussin', *Bolletino d'Arte*, Anno LXIV, no.4, October–December 1979, pp.69–74.

27. For the connection between Poussin and Stoicism, see Walter Friedlaender, 'Nicolas Poussin' in *Allgemeines Lexikon der Bildenden Kunst*, eds. Ulrich Thieme and Felix Becker (Leipzig, 1907–50), Vol.XXVII (1933); and Anthony Blunt, 'The Heroic and the Ideal Landscape in the Work of Nicolas Poussin', *Journal of the Warburg and Courtauld Institutes*, Vol.7, 1944, pp.154–168, and *Nicolas Poussin*, Vol.I, particularly Chapters IV and IX.

28. I am grateful to Edward Morris for additional information about this painting: see his contribution to *Supplementary Foreign Catalogue of the Walker Art Gallery Liverpool* (Liverpool, 1984), entry no.10350, pp.15–18. I am pleased to have had the chance of looking at this picture in his company.

29. Henry Bardon, 'Poussin et la Littérature Latine', in *Actes du Colloque Poussin*, ed. André Chastel, Vol.I (Paris, 1960), pp.123–132, argues that Poussin had little Latin, though he was capable of consulting an original text. It must be inferred that he had less Greek.

30. The error occurs in the translation by Jacques Amyot.

31. Anthony Blunt, *op.cit.*, Vol.I, p.294.

32. e.g. Walter Friedlaender, *Nicolas Poussin: A New Approach*; Howard Hibbard, *Poussin: The Holy Family on the Steps* (London, 1974), pp.34–38; R. Verdi, 'Poussin and the Tricks of Fortune', *Burlington Magazine*, Vol.CXXIV, No.956, November 1982, pp.681–685; and Christopher Wright, *Poussin Paintings: A Catalogue Raisonné* (London, 1985). This perception of the picture has also entered a number of works of general art-history, e.g. Kenneth Clark, *Landscape into Art* (London, 1949); H.W. Janson, *History of Art* (New York, 1962); and Julius Held and Donald Posner, *17th and 18th Century Art* (Englewood Cliffs, N.J., and New York, 1979). I am surprised to find this perception endorsed in Denis Mahon, 'Réflexions sur les Paysages de Poussin'.

33. Anthony Blunt, *op.cit.*, Vol.I, p.295.

34. André Félibien, *Entretiens sur les vies et sur les ouvrages des plus excellens peintres anciens et modernes* (Paris, 1668–88). The life of Poussin was in the fifth volume, which appeared in 1688. It has been reissued as *Félibien's Life of Poussin*, ed. with commentary Claire Pace (London, 1981).

35. Denis Mahon, 'Réflexions sur les Paysages de Poussin'.

36. Charles G. Dempsey, 'Poussin and Egypt', *Art Bulletin*, Vol.XLV, no.2, June 1963, pp.109–119.

37. Richard Verdi, 'Poussin and the "Tricks of Fortune" ', *Burlington Magazine*, Vol. CXXIV, No.956, November 1982, pp.681–685, offers a different interpretation of the great landscape paintings of Poussin's middle and later years. He sees them as illustrating a text which Poussin had expounded in a letter to his patron Chantelou in 1648: that is, that men, if they are not endowed with exceptional wisdom or exceptional stupidity, are constantly exposed to the tricks of fortune. In his letter to Chantelou Poussin expressed the desire to devote seven paintings to this text. I do not wish to deny that 'a trick of fortune' may be seen as precipitating each of the great dramas that Poussin depicts, but the fundamental concern of Poussin with these dramas is to show how man reacts to the circumstances in which fortune places him and what are the resources upon which he can draw in doing so. In other words, Verdi correctly identifies the circumstances in which Poussin's subject-matter makes its appearance, but not the subject-matter itself.

38. See Anthony Blunt, *op.cit.*, Vol.I, pp.314–315 n.3, for the representation of the snake in Poussin's later work. Blunt describes the representation of the snake as 'something of an obsession' on Poussin's part, which I cannot believe to be a just description.

39. Interestingly enough – though the fact has not been utilized by the 'stoicizing' interpreters of Poussin – the ambivalence of the snake was emphasized by the Stoics, in particular the Roman Stoics. See Martha Nussbaum, *The Therapy of Desire* (forthcoming, 1988).

40. See *Drawings of Nicolas Poussin: Catalogue Raisonné*, eds. Walter Friedlaender and Anthony Blunt, Vol.III (London, 1953), entry nos.167–169, pp.14–15; and Anthony Blunt, *op.cit.*, Vol.I, pp.319–320.

41. Anthony Blunt, *op.cit.*, Vol.I, pp.286–291.

42. Martha Nussbaum, *op.cit.*, points out how in Seneca, *Medea*, a major work of Roman Stoicism, the same word 'orbes' is used for cosmic order and for the snake's writhing coils. The snake creates out of the materials of passion a counter-world to the domain of virtue and reason.

43. A spontaneous tribute to the ambivalence generated by the monochromaticism of this painting is to be found in the otherwise totally conventional catalogue entry in F.-A. Gruyer, catalogue of *La Peinture au Château de Chantilly: École Française* (Paris, 1898), entry no.LIII, pp.121–122. Gruyer allows himself to write, 'La tonalité générale est faite de douceur et d'austérité.'

44. Willibald Sauerländer, 'Die Jahreszeiten: Ein Betrag zur allegorischen Landschaft beim späten Poussin', *Münchner Jahrbuch der Bildenden Kunst*, Dritte Folge, Band VII, 1956, pp.169–184, suggests that Poussin in *Spring* represents the Garden of Eden as it will be remembered after the Fall: that is, as a place of total simplicity. Sauerländer regards the absence of the snake, which I refer to in the next paragraph, as serving this effect. Sauerländer offers a typological interpretation of the Seasons

cycle, and he claims that the meaning of the individual pictures is not disclosed if we take them one by one. Sauerländer connects *Spring* with the old paradise, or the state *ante legem: Summer* with the expectation of grace: *Autumn* with the new paradise, or the life redeemed: and *Winter* with the Last Judgment. Though he may in fact be right about the textual content of the paintings, the method he employs does not, to my way of thinking, establish the point. For nowhere does he show that Poussin, in addition to representing events connected with this corpus of texts, also reveals what these texts meant to him. Significantly Sauerländer thinks that his task is to '*entziffern*', to decipher, the pictures. In a footnote to the penultimate page of his article, Sauerländer concedes the difficulty of connecting Poussin and the texts that on the typological interpretation his pictures are supposed to incorporate.

45. For infantile sadism, see Sigmund Freud, *Three Essays on the Theory of Sexuality*, and *From the History of an Infantile Neurosis*, in *Complete Psychological Works of Sigmund Freud*, ed. James Strachey (London, 1953–74), Vols.VII and XVII, respectively; Karl Abraham, *A Short Study of the Development of the Libido*, in his *Selected Papers on Psycho-Analysis* (London, 1927); and Melanie Klein, *The Psycho-Analysis of Children*, in *The Writings of Melanie Klein*, ed. Roger Money-Kyrle (London, 1975), Vol.II.

46. Examples of Poussin's benign treatment of water would be *Landscape with a Man Killed by a Snake* (National Gallery, London), *Landscape with a Roman Road* (Dulwich Picture Gallery, Dulwich, London), *Landscape with Orpheus and Eurydice* (Louvre, Paris), *Landscape with St Francis* (Palace of the President of Yugoslavia, Belgrade), *Christ Healing the Blind Men* (Louvre, Paris), *The Calm* (private collection, England), *Holy Family with the Bath Tub* (Fogg Art Museum, Harvard University, Cambridge, Mass.), *Holy Family with Six Putti* (J. Paul Getty Museum, Malibu, California), *The Exposition of Moses* (Ashmolean Museum, Oxford), and *Landscape with Diogenes* (Louvre, Paris). What is remarkable is the way in which water preserves its placid, faithful character in paintings where so much else of nature has become treacherous and unpredictable, e.g. *Landscape with Two Nymphs and a Snake* (Musée Condé, Chantilly), and *Landscape with Polyphemus* (Hermitage, Leningrad).

47. See note 44 for the typological interpretation of this picture. The Flood anticipates Christ's washing away of the sins of the world, which the Last Judgment presupposes.

48. See Fréart de Chantelou, *Journal du Voyage de Cavalier Bernin en France*, ed. Ludovic Lalanne (Paris, 1885), trans. Margery Corbett, as Paul Fréart de Chantelou, *Diary of the Cavaliere Bernini's Visit to France*, ed. Anthony Blunt (Princeton, 1985).

49. Harold Bloom, *The Anxiety of Influence* (New York and London, 1973), *A Map of Misreading* (New York and London, 1975), and *Poetry and Repression* (New Haven, 1976). In saying that I disagree with the way in which Bloom conceptualizes the problem I have in mind his identification of a poem – of every poem by a strong poet – with a poetic misinterpretation of a precursor poem or set of poems. Bloom slides from a theory of interpretation, or how to read an individual poem, whose identity is not so far itself in dispute, to an ontological theory, which in effect denies identity to individual poems. The elision occurs because Bloom contends that, if one poem essentially re-interprets another poem, then it is no more than an extension of that poem. To this process no limit is set. The radical conclusion to which all this appears to point – namely that the only proper subject of study is poetry as a totality – is, on Bloom's conceptualization, itself in deep trouble. For of what, we may ask, is poetry a totality? The obvious answer, or that poetry is the

totality of individual poems, is one that Bloom has already denied himself.

50. Recognition that the problem of influence exists for the visual arts is to be found in Norman Bryson, *Tradition and Desire: From David to Delacroix* (Cambridge, England, 1984).

51. I owe this remark to Frank Auerbach.

52. For envy, see Melanie Klein, *Envy and Gratitude* (London, 1957), reprinted in *The Writings of Melanie Klein*, Vol.III.

53. See Melanie Klein, *op.cit.* Also Hanna Segal, 'A Psycho-Analytical Approach to Aesthetics', in *New Directions in Psycho-Analysis*, eds. Melanie Klein *et al.* (London, 1955), reprinted in her *The Work of Hanna Segal* (New York), 1981).

54. Antonin Proust, *Edouard Manet: Souvenirs* (Paris, 1913), p.94.

55. The fifth work, which to my eye is very un-Manet in the way it combines technical sophistication and lack of freshness or immediacy, is *At the Races* (National Gallery of Art, Washington, D.C.).

56. On these pictures, see Jean C. Harris, 'Manet's Race-Track Paintings', *Art Bulletin*, Vol.XLVIII, no.1, March 1966, pp.78–82; Theodore Reff, catalogue of *Manet and Modern Paris* (Washington, D.C., 1982); and Françoise Cachin *et al.*, catalogue of *Manet 1832–1883* (Paris and New York, 1983), entries no.99, 100, and 101, pp.263–268.

57. John Richardson, *Edouard Manet* (London, 1958), entry no.40, p.124.

58. This view is to be found in Germain Bazin, 'Manet et la Tradition', *L'Amour de l'Art*, 13e Année, no.5, May 1932, pp.153–163; Paul Colin, *Manet* (Paris, 1932); John Rewald, *History of Impressionism* (New York, 1946); Michel Florisoone, *Manet* (Monaco, 1947); and Christian Zervos, 'Manet est-il un grand Créateur?' and 'A propos de Manet', *Cahiers d'Art*, Vol.7, nos.6–7, 1932, pp.295–296, and nos.8–10, 1932, pp.309–333, respectively.

59. An awareness that Manet's relations to his sources have an obliquity which is meaningful is to be found in Alain de Leiris, 'Manet, Guéroult, and Chrysippus', *Art Bulletin*, Vol.XLVI, no.3, September 1964, pp.401–404; Beatrice Farwell, 'Manet's "Espada" and Marcantonio', *Metropolitan Museum Journal*, Vol.2, 1969, pp.197–207, and *Manet and the Nude: A Study in Iconography in the Second Empire* (New York and London, 1981); and Joel Isaacson, catalogue of *Manet and Spain: Prints and Drawings* (Ann Arbor, 1969), pp.9–16.

60. This view is to be found in Germain Bazin, *op.cit.*, and Christian Zervos, 'Manet est-il un grand Créateur?'

61. Theodore Reff, 'Manet and Blanc's *Histoire des Peintres*', *Burlington Magazine*, Vol.CXII, No.808, July 1970, pp.456–458.

62. See Anne Coffin Hanson, *Manet and the Modern Tradition* (New Haven and London, 1977), pp.57, 80.

63. For the sources of this painting, see Charles Sterling, 'Manet et Rubens: précisions', *L'Amour de l'Art*, 13e Année, no.9, September–October 1932, pp.290–300; Rosalind E. Krauss, 'Manet's Nymph Surprised', *Burlington Magazine*, Vol.CIX, No.776, November 1967, pp.622–627; Beatrice Farwell, 'Manet's "Nymphe Surprise" ', *Burlington Magazine*, Vol. CXVII,

No.865, April 1975, pp.224–227; Françoise Cachin *et al.*, *op.cit.*, entry no.19, pp.83–84; and Juliet Wilson Bareau, catalogue of *The Hidden Face of Manet* (London, 1986), pp.26–36 and entry nos.1–16, pp.90–91.

64. See Julius Meier-Graefe, *Edouard Manet* (Munich, 1912), p.38, for this information, which was supplied to him by Léon Leenhoff, Suzanne's son. For the drawing preparatory to *La Nymphe Surprise*, see Françoise Cachin *et al.*, *op.cit.*, entry nos. 19–24, pp.83–92.

65. On this picture see Charles Sterling, *op.cit.*; Michel Florisoone, *op.cit.*; Anne Coffin Hanson, 'Manet's Subject Matter and a Source of Popular Imagery', *Museum Studies: Art Institute of Chicago*, Vol.III, 1969, pp.63–80, and *Manet and the Modern Tradition*; Michael Fried, 'Manet Sources', *Artforum* Vol.VII, no.7, March 1969, pp.28–82; and Theodore Reff, ' "Manet's Sources": a Critical Evaluation', *Artforum*, Vol.VIII, no.1, September 1969, pp.40–48.

66. See Alain de Leiris, *op.cit.* For the corrected identity of the sitter, who was a famous gypsy known as le Père Lagrène, see Marilyn R. Brown, 'Manet's *Old Musician*: Portrait of a Gypsy and Naturalist Allegory', *Studies in the History of Art: National Gallery of Art, Washington*, Vol.8, 1978, pp.78–87.

67. The Rubens source was first published, with an acknowledgment to Charles Sterling, in Germain Bazin, *op.cit.* The two other paintings from which *La Pêche* derives are Annibale Carracci, *The Hunt*, and *Fishing* (both Louvre, Paris). These findings were first published in Paul Jamot, 'Etudes sur Manet', *Gazette des Beaux-Arts*, 5ᵉ période, Tome XV, January 1927, pp.27–50. In neither article was the intermediary role of Charles Blanc recognized.

68. See Nils Gösta Sandblad, *Manet: Three Studies in Artistic Conception* (Lund, 1954), p.44; and Theodore Reff, 'The Symbolism of Manet's Frontispiece Etchings', *Burlington Magazine*, Vol.CIV, No.710, May 1962, pp.182–186.

69. *La Musique aux Tuileries* was traditionally dated 1860, and the revised date is due to John Rewald, *History of Impressionism* (New York, 1946), p.48. The importance of the new dating is discussed in Nils Gösta Sandblad, *op.cit.*, pp.27–33.

70. See Theodore Reff, 'Copyists in the Louvre 1850–1870', *Art Bulletin*, Vol.XLVI, no.4, December 1964, pp.552–559, where it is maintained that Manet must have copied the 'Velázquez' during his 1859 registration as a copyist at the Louvre. A. Tabarant, *Manet et ses Oeuvres* (Paris, 1947) had proposed a date as early as 1855 for the original watercolour, and Anne Coffin Hanson, catalogue of *Edouard Manet 1832–1883* (Philadelphia, 1966), p.39, follows him. See Joel Isaacson, *op.cit.*, entry no.1, pp.24–25.

71. It was Nils Gösta Sandblad, *op.cit.*, pp.36–45 and 148–151, who first attached significance, though not exactly the same as I do, to Manet's inscription of his own features into these two works. Michael Fried, *op.cit.*, pp.28–82, depsychologizes the issue to the extent of seeing these substitutions (as well as Manet's borrowings in general) as part of a larger strategy to create an art that was self-consciously reflective on the past. However nothing that I say is incompatible with this approach, provided that the approach is seen as offering only a partial interpretation. For the strategy that Fried attributes to Manet itself requires explanation, and this explanation will have to go back to the psychology of Manet if it is to be informative. More specifically, Fried thinks that Manet, in aligning himself with the

past, set himself first to consolidate and then to continue what was for him the indigenous French pictorial tradition. For difficulties specifically connected with this last aspect of Fried's thesis, see Theodore Reff, ' "Manet's Sources": a Critical Evaluation', and Petra ten Doesschate Chu, *French Realism and the Dutch Masters* (Utrecht, 1974).

72. Douglas Cooper, *Pablo Picasso Les Déjeuners* (Paris, 1962), trans. the author, as *Picasso: Les Déjeuners* (New York and London, 1963), p.11. I am deeply indebted to this brilliant essay for my understanding of the *Déjeuner sur l'Herbe* series.

73. For assessments of Picasso's late work that can, at any rate with hindsight, only be regarded as crass, see e.g. John Berger, *Success and Failure of Picasso* (London, 1965); Clement Greenberg, 'Picasso since 1945', *Artforum*, Vol.V, no.2, October 1966, pp.28–31; and Timothy Hilton, *Picasso* (London, 1975).

74. For Manet's conception of *Le Déjeuner sur l'Herbe* as a tribute to Giorgione, see Antonin Proust, *op.cit.*, p.43. An unduly narrow view of the matter, characteristic of the mechanical way in which modern criticism tends to conceive of borrowing, is the remark, to be found in John Rewald, *op.cit.*, p.85, that Manet's painting is only 'superficially related' to Giorgione. Morphologically or compositionally this is true, but that is only one aspect of borrowing as I see it. I should prefer to say that Manet's picture is profoundly, but not superficially, related to the *Concert Champêtre*. See also Juliet Wilson Bareau, *op. cit.*, pp.37–41.

75. The source was pointed out in Gustav Pauli, 'Raffael und Manet', *Monatsheften für Kunstwissenschaft*, Vol.1, January–February 1908, p.53. From this source the fact entered the art-historical consciousness. It had however been recognized at the time in Ernest Chesneau, *L'Art et les Artistes modernes en France et en Angleterre* (Paris, 1864), p.190.

76. Douglas Cooper, *Picasso: Les Déjeuners*, p.11.

77. Douglas Cooper, *op.cit.*, p.35.

78. Antonin Proust, *op.cit.*, p.43. When Manet submitted the picture to the Salon, it still bore the title of '*Le Bain*', though by now this was barely appropriate. See Paul Jamot and Georges Wildenstein, *Manet: Catalogue Critique* (Paris, 1921), Vol.I, entry no.79, pp.124–125.

79. See Marie-Laure Bernadac, 'De Manet à Picasso: l'Éternel Retour', in the catalogue of *Bonjour Monsieur Manet* (Paris, 1983), pp.33–46. The cardboard cut-outs for this project are now in the Musée Picasso, Paris, and the sculpture itself is in the Moderna Museet, Stockholm.

80. Douglas Cooper, *op.cit.*, p.22.

81. John Richardson, 'Picasso's Sketchbooks: Genius at Work', *Vanity Fair*, Vol.49, no.5, May 1986, pp.74–95.

Notes to V

1. The enemy was the Baron Vivant Denon, the Director-General of Museums and a protégé of Napoleon. Denon died in 1825, and the incident is recounted in a letter written by Madame Paul Lacroix, a cousin of Ingres's: the letter dates from 1854, and was printed in *L'Indépendence Belge*, 30 May 1898. Ingres succeeded to Denon's place in the Académie des Beaux-Arts, and sitting in the dead man's *fauteuil* gave him an indescribable pleasure. Madame Lacroix, who had the story from Ingres

himself, wrote that he told it to her 'avec l'air doux qui est le sien'. The text of the letter is given in Boyer d'Agen, *Ingres d'après une Correspondance inédite* (Paris, 1909), p.44n.

2. Henri Delaborde, *Ingres, Sa Vie, ses Travaux, sa Doctrine* (Paris, 1870), p.108.

3. I find myself in general agreement with the thesis advanced in Adrian D. Rifkin, 'Ingres and the Academic Dictionary: An Essay on Ideology and Stupefaction in the Social Formation of the "Artist"', *Art History*, Vol.6, no.2, June 1983, pp.153-170, that it would be erroneous to take Ingres's writings and aphorisms on art at face-value as evidence for reconstructing his artistic intentions. The point is anticipated by Charles Blanc, *Ingres, sa Vie et ses Ouvrages* (Paris, 1870), p.214: 'Au surplus, rien de ce que disait Ingres, rien de ce qu'il écrivait ne doit être pris au pied de la lettre, l'exagération étant le trait distinctif de son caractère et de son esprit.' Avigdor Arikha, Introduction, catalogue of *J.A.D. Ingres: Fifty Life Drawings from the Musée Ingres at Montauban* (Houston, Texas, 1986) is a determined attempt to see Ingres's work in the light of his writings, but in fact the interest of this essay and of the ensuing catalogue entries lies in the illuminating comments on Ingres's practice. However, in holding this view, I do not think of Ingres as being in this regard an exceptional case. A painter's writings have always to be interpreted in the light of his paintings: a point which scholars, who are professional devotees of the word, tend to overlook. If there is anything distinctive about Ingres's writings, it is a certain kind of tell-tale incoherence and a readiness to contradict himself which came over him under stress. This is particularly noticeable in his letters. For instance, in a letter to the comte de Pastoret, dated 15 February 1827, he says that he has always been unable to '*recopier*' himself, and then, only three sentences later, he talks of how he has done *Raphael and la Fornarina* twice, and is now about to do it for the third time. See Pierre Angrand and Hans Naef, 'Ingres et la famille de Pastoret, Correspondance inédite: second et dernier article', *Bulletin du Musée Ingres*, no.28, December 1970, pp.7-22. Apart from what he has to say about the reliability of Ingres's writings as an index of his thought, I find little to agree with in Rifkin's article.

4. For accounts of Ingres's aversion to portraiture, see e.g. Henri Delaborde, *op.cit.*, pp.40-42; Charles Blanc, *op.cit.*, pp.41-46; Boyer d'Agen, *op.cit.*, pp.26-27; and Amaury-Duval, *L'Atelier d'Ingres: Souvenirs* (Paris, 1878), p.54. The whole issue, and the genuineness of Ingres's expressed attitude to portraiture, is discussed in Hans Naef, *Die Bildniszeichnungen von Ingres* (Berne, 1977-80), Vol.I, Introduction, pp.8-26, and in Avigdor Arikha, *op.cit.* Robert Rosenblum, *Ingres* (New York, 1967) was the first critical work to restore Ingres's history paintings, indeed his paintings generally, to their proper place within his *oeuvre*.

5. Boyer d'Agen, *op.cit.*, p.27n.

6. Henri Delaborde, *op.cit.*, pp.372, 374.

7. There are only two commissions that Ingres appears to have found uncongenial. These are *The Vow of Louis XIII* and *The Duke of Alba at Saint-Gudule*. The first, which was a commission from the Ministry of the Interior, dissatisfied Ingres because of what he took to be its 'double sujet', or the way it required him to combine a religious subject, the Assumption of the Virgin, and a purely historical subject, Louis XIII's dedication of France to the Virgin. It is probable that Ingres misunderstood the terms of the commission and that he was really asked to represent the king's vow on the day of the Assumption. The letter in which Ingres complained to the prefet of Tarn-et-Garonne is cited in Charles Blanc, *op.cit.*, pp.70-71, and Boyer d'Agen, *op.cit.*, pp.78-79, and the issue of

the possible misunderstanding is discussed in Daniel Ternois *et al.*, catalogue of *Ingres* (Paris, 1967), entry no.131, pp.190-192. However any change in the commission required royal intervention and, though such permission was eventually obtained, by this time Ingres was totally reconciled to the commission as he originally understood it. The second commission, which celebrated the sixteenth-century Duke of Alba, and which Ingres received from the Alba and Berwick family through their *homme d'affaires* in Rome in 1813, repulsed Ingres because of the way it appeared to condone the bloodthirsty repression of the Protestants by the Spaniards and to glorify the man responsible for this outrage, '*cet horrible homme*' as Ingres called him in Notebook IX. For this, see Delaborde, *op.cit.*, pp.229-230. In fact Ingres never completed the work, though we do not know precisely why. A sketch of great delicacy survives (Musée Ingres, Montauban), in which the duke is seated at the very rear of the church, and the picture is in blood red relieved only by grey. See Hans Naef, 'Ein non finito-Gemälde von Ingres', *Du*, 19 Jahrgang, March 1959, pp.38-39, translated and reprinted as 'Un Tableau d'Ingres inachevé: Le Duc d'Albe à Sainte Gudule', *Bulletin du Musée Ingres*, no.7, July 1960, pp.3-5. There was a third commission, that for *The Apotheosis of Homer*, that Ingres also objected to, but not because of its subject-matter: he objected to the time in which he was required to complete it, and the matter is discussed in note 82.

8. Boyer d'Agen, *op.cit.*, p.286.

9. Henri Delaborde, *op.cit.*, p.216: see also pp.99-100, and 215-220.

10. As in Georges Wildenstein, *Ingres* (London, 1954), catalogue no.322, p.232, and in Emilio Radius and Ettore Camesasca, *L'Opera Completa di Ingres* (Milan, 1968), catalogue no.130e, p.108.

11. This is confirmed by Raymond Balze, 'Notes inédits d'un Élève de Ingres', *La Renaissance de l'Art Français*, May 1921, pp.216-218. Balze and his brother Paul were responsible for much of the decorative detail under the direct supervision of Ingres. On the sources for the frescoes, see W. Deonna, 'Ingres et l'imitation de l'antique', *Pages d'Art*, December 1921, pp.367-375.

12. Amaury-Duval, *op.cit.*, pp.83-84.

13. Henry Lapauze, *Le Roman d'Amour de M. Ingres* (Paris, 1910), p.101.

14. See Hélène Toussaint, 'Remise en cause de deux célèbres dessins du Louvre: *Portrait de Femme* et *Antiochus et Seleucus*', *Actes du Colloque International: Ingres et Son Influence, Bulletin Spécial du Musée Ingres*, nos.47-48, September 1980, pp.157-171. Toussaint argues that the well-known Louvre drawing of Antiochus and Stratonice is not by Ingres's hand.

15. For Ingres's admiration of Méhul, see Henri Delaborde, *op.cit.*, pp.171, 375, and Boyer d'Agen, *op.cit.*, p.436. In an unpublished draft, which was found amongst the papers of Charles Blanc, Ingres gives the details of a large-scale composition that he planned and in which he intended to assemble all the musicians whom he most admired. The two laureates, Gluck and Mozart, flank Apollo, and Méhul stands by Gluck's side: see Norman Schlenoff, *Ingres: ses Sources Littéraires* (Paris, 1956), pp.308-309. The composition is listed in Henri Delaborde, *op.cit.*, p.323, as a projected work.

16. It has, for instance, been observed in Norman Schlenoff, *op.cit.*, pp.242-243, that in the opera, as in Ingres's painting,

Stratonice distances herself from the action, which is then played out between the men: the *prima donna* is required to maintain an almost unbroken silence. Other similarities are noted by Wolfgang Stechow,' "The Love of Antiochus with Faire Stratonica" in *Art', Art Bulletin*, Vol.XXVII, no.4, December 1945, pp.221–237; and by Agnes Mongan, 'Ingres and the Antique', *Journal of the Warburg and Courtauld Institutes*, Vol.X, no.1, 1947, pp.1–13. Méhul, or his librettist François-Benoît Hoffmann, presumably out of a sense of propriety, depicts Stratonice, not as the wife of Seleucus, but as engaged to marry him. Ingres restored the original story. On this, see H. Lemmonier, 'A Propos de la "Stratonice" d'Ingres', *La Revue de l'Art Ancien et Moderne*, Tome XXXV, no.203, 10 February 1914, pp.81–90.

17. Letter to Magimel, dated 30 August 1858, reprinted in Henry Lapauze, *Ingres, sa vie et son oeuvre (1780–1867)* (Paris, 1911), p.520.

18. For this information I am deeply grateful to Professor Jean Mongrédien and David Charlton. *Stratonice* was also performed in Paris on at least three occasions between 1797 and 1806, when Ingres was there, initially as a student of David, and thus he would have had an opportunity to refresh his knowledge of the work: see Norman Schlenoff, *op.cit.*, pp.242–244. Most writers on Ingres, e.g. Agnes Mongan, *op.cit.*, and Daniel Ternois, *Ingres* (Paris, 1980), assume that one or other of these performances would have been the occasion on which Ingres first heard the opera. If this were so, then, by the time he heard it, he certainly would have already known the pictorial tradition and, presumably, been influenced by it. Ingres owned a score of *Stratonice*, which he specifically donated in his will to the Musée Ingres: see Charles Blanc, *op.cit.*, p.220. The will is quoted in full in Boyer d'Agen, *op.cit.*, pp.456–460.

19. See J. Momméja, *Ingres* (Paris, n.d. [1903]), p.55.

20. There is a discussion of this question in Agnes Mongan and Hans Naef, catalogue of *Ingres: Centennial Exhibition 1867–1967* (New York, 1967), entry no.20 (no pagination), and in Daniel Ternois *et al.*, catalogue of *Ingres* (Paris, 1967), entry no.131, pp.190–192.

21. Albert Boime, 'Declassicizing the Academic: A Realist View of Ingres', *Art History*, Vol.8, no.1, March 1985, pp.50–65, describes the subject-matter of this picture as the contrast of male power and 'female subservience'. This seems to me quite inaccurate. Thetis uses her weakness to gain power. Is that subservience?

22. Louis Durand, 'Les dessins dits "secrets" légués par Ingres au Musée de Montauban', *Bulletin du Musée Ingres*, no.23, July 1968, pp.27–38. Durand suggests originals for some fourteen of these drawings that had been recently published.

23. Notebook IX, pp.34 recto, 37 verso.

24. There is, of course, no incompatibility between my interpretation and the suggestion frequently made that in these pictures anatomy has been sacrificed to the demands of design. What my interpretation points to is the conditions under which Ingres found such sacrifice admissible.

25. For Ingres's difficulties with the composition, see note 7.

26. For Ingres's doubts and conflicts on this subject, see Charles Blanc, *op.cit.*, pp.79–80. However Blanc does not give sufficient consideration to Ingres's use of chiaroscuro in the Brussels version of the *Vergil reading the Aeneid*.

27. For the incident, see Charles Blanc, *op.cit.*, pp.80–81, and Henry Lapauze, *op.cit.*, p.220.

28. For a lucid analysis of the relationship of *The Vow of Louis XIII* to its High Renaissance prototypes, see John Pope-Hennessy, *Raphael* (London, 1970), pp.252–255.

29. Robert Rosenblum, *op.cit.*, p.126, finds the Virgin's look steeped in 'boudoir sensuality', and he describes her as 'courtesan-like'. I do not find this accurate.

30. See Boyer d'Agen, *op.cit.*, p.103.

31. For an interesting account of the political background to this composition, and its manifest content, see Carol Duncan, 'Ingres' *Vow of Louis XIII* and the Politics of the Restoration', in *Art and Architecture in the Service of Politics*, eds. Henry A. Millon and Linda Nochlin (Cambridge, Mass., 1978). I say 'background', because Duncan's observations do not engage with our perception of the picture. Having made good to her satisfaction the claim that 'extra-aesthetic' (as she calls them), and specifically political, motives are necessary to any account of why Ingres undertook the original commission, she then, without further argument, assumes that this same motivation is sufficient to explain the changes that Ingres made in the composition as he worked on it. She concedes that Ingres 'would not have undertaken a task that seriously violated his artistic credo', but she then goes on to claim, 'Having divined the kind of opportunity that the Montauban commission presented, it is little wonder that Ingres's artistic imagination came up with a pictorial solution that fulfilled its original purpose'. The opportunity she has in mind is the pursuit of social success. However, in order to remove the wonder from Ingres's change of mind and subsequent achievement, Duncan would need to show how this kind of opportunity would have engaged with his psychology. She does not attempt the task. Duncan makes the excellent observation that Ingres's original objection that the commission made for a picture without unity is understated unless we take into account the import of the work for him: unity is always relative to import. Unfortunately she does not go on to investigate what import the work did have for him, and this is largely explained by the narrow view she takes of import, equating it exclusively with 'ideological import'. Furthermore, as I go on to propose in the later part of this lecture, the very notion of success was highly problematic for Ingres.

32. See Henri Delaborde, *op.cit.*, p.150, and Raymond Balze, *Ingres, son école, son enseignement du dessin, par un de ses élèves* (Paris, 1880). In the later work, Ingres is quoted as saying, 'Que signifie ce procédé d'exécuter par la touche? Où donc voyez-vous la touche dans la nature? C'est la qualité des faux talents pour montrer leur adresse des pinceaux. Si habile qu'elle soit, la touche ne doit pas d'être apparente, elle empêche l'illusion, immobilise tout. Au lieu de l'objet elle fait voir le procédé: au lieu de la pensée, elle dénonce la main.'

33. Boyer d'Agen, *op.cit.*, p.92.

34. Henri Delaborde, *op.cit.*, p.233, and Boyer d'Agen, *op.cit.*, pp.86–88 and 109–110.

35. Madame Campan, *Mémoires sur la vie privée de Marie-Antoinette, suivis de Souvenirs et Anecdotes historiques sur les Règnes de Louis XIV, de Louis XV, et de Louis XVI* (second edition, Paris, 1823), Vol.III, pp.8–9. 'Valet de chambre' in this context does not mean 'footman', as it is sometimes translated: it means a minor court official. Molière had recently been made a *valet de chambre*.

Notes

36. Albert Boime, *op.cit.*, argues that, if we wish to gain a complete understanding of the manifest content of these pictures, we need to take account of the fact that they were commissioned by the comte de Blacas, Louis XVIII's ambassador to Rome. I am sure that Boime is right. These pictures depend on what Boime calls 'Restoration ideology'. Restoration ideology is discussed with great finesse in Ruth Kaufmann, *Political Themes and Motifs in French Painting of the Restoration Period* (Ph.D. thesis, University of London, 1978: unpublished). The next question to ask is, What did this ideology mean to Ingres?, and I believe we deserve a better answer than, A way of achieving success. Marcia Pointon, ' "Vous êtes roi dans votre domaine": Bonington as a Painter of Troubadour Subjects', *Burlington Magazine*, Vol. CXXVIII, No.994, January 1986, pp.10–17, suggests that Ingres's *Death of Leonardo*, a picture also painted for the comte de Blacas, was intended by the painter as an implicit criticism of the lack of royal patronage of the arts at the time.

37. Ingres's tribute to his father, written in 1855, appeared in the *Biographie de Tarn-et-Garonne* (Montauban, 1860). The text of Ingres's biography is reprinted in Charles Blanc, *op.cit.*, pp.2–5. The original letter, from which the biography was extracted, is to be found in Henry Lapauze, *op.cit.*, pp.9–11, and in Hans Naef, *Die Bildniszeichnungen von J.A.D. Ingres*, Vol.I, pp.54–55.

38. The text appears in Henry Lapauze, *op.cit.*, p.5, and is reprinted in Hans Naef, *op.cit.*, Vol.I, p.59.

39. The letter is printed in Boyer d'Agen, *op.cit.*, pp.23–26, and in Hans Naef, *op.cit.*, Vol.I, pp.60–61. The original is in the History of Art Archives, Getty Center for the History of Art and the Humanities, Los Angeles, where I have been able to examine it. Naef suggests that this letter is the work of a professional scribe, but the handwriting rules this out: I am grateful to Marie Gallup of the Getty Center for confirming this for me. In this letter Ingres's mother goes on to place in his charge his two unmarried sisters. Ingres showed himself totally unable to deal with these responsibilities. Shame, self-righteousness, indignation, avarice, all played their part in accounting for his woefully inadequate behaviour: for the details see Hans Naef, *op.cit.*, Vol.I, pp.62–68. None of this is incompatible with, indeed it lends credence to, the hypothesis that in phantasy Ingres tried to set right the family relations which he could not bear to experience at first hand.

40. For projective identification, see Melanie Klein, 'Notes on some Schizoid Mechanisms' and 'Some Theoretical Conclusions regarding the Emotional Life of the Infant', both in *Developments in Psycho-Analysis*, ed. Joan Rivière (London, 1952), and 'On Identification' in *New Directions in Psycho-Analysis*, ed. Melanie Klein *et al.* (London, 1955), all reprinted in *The Writings of Melanie Klein*, ed. Roger Money-Kyrle (London, 1975), Vol.III; Herbert Rosenfeld, *Psychotic States: A Psycho-Analytic Approach* (London, 1965); Wilfred Bion, *Second Thoughts* (London, 1967); James S. Grotstein, *Splitting and Projective Identification* (New York, 1981); and Leslie Sohn, 'Narcissistic Organization, Projective Identification, and the Formation of the Identificate', *International Journal of PsychoAnalysis*, Vol.66, Part 2, 1985, pp.201–213. For the connection between projective identification and claustrophobia, see Melanie Klein, 'Notes on some Schizoid Mechanisms'.

41. Charles Blanc, *op.cit.*, p.118. A slightly different version of the story is also told in Henry Lapauze, *op.cit.*, p.358.

42. For the identity of the models for this painting, see Georges Wildenstein, *Ingres* (London, 1954), entry no.232, p.211. Wildenstein does not disclose his source, but it seems likely that he relied upon Louis Flandrin, 'Deux Disciples d'Ingres: Paul et Raymond Balze. 1er article', *Gazette des Beaux-Arts*, 4e période, Tome VI, August 1911, pp.139–155: see particularly p.144n. Flandrin's article draws upon the unpublished papers of Raymond Balze.

43. For this list of Ingres's major compositions and their versions, I have drawn upon Patricia Condon *et al.*, catalogue of *Ingres: In Pursuit of Perfection* (Bloomington, 1983).

44. See Georges Wildenstein, 'Les Portraits du duc d'Orléans par Ingres', *Gazette des Beaux-Arts*, 6e période, Tome XLVIII, November 1956, pp.75–80; Pierre Angrand, *Monsieur Ingres et son Epoque* (Paris, 1967), pp.187–198; J J Whiteley, *Ingres* (London, 1977); and Hélène Toussaint, catalogue of *Les Portraits d'Ingres: peintures des musées nationaux* (Paris, 1985), entry nos.XV–XVI-8, pp.99–109.

45. For Ingres's dealings with Calamatta, see Daniel Ternois, 'Lettres d'Ingres à Calamatta', and 'Lettres d'Ingres au graveur Luigi Calamatta', annotated by Daniel Ternois, *Actes du Colloque International: Ingres et son Influence, Bulletin Spécial du Musée Ingres*, nos.47–48, September 1980, pp.61–77, and pp.77–110 respectively. For Ingres's dealings with Réveil, see Henry Lapauze, *op.cit.*, pp.434–435.

46. Marjorie Cohn, 'Introduction: In Pursuit of Perfection', in Patricia Condon *et al.*, *op.cit.*

47. Albert Boime, *op.cit.*, also challenges Marjorie Cohn's account of the role of repetition in Ingres, but he comes up with a very different explanation from mine. Boime offers a summary of his views as follows: 'In his dreams [Ingres] inhabited the Giottesque realm, a realm of ideal harmony unsullied by contingent substances. But I hope to have shown that while he imagined himself to be pursuing perfection on the way to this celestial domain, he in fact was satisfying the aspirations and fantasies of the privileged few who wanted to enjoy heaven on earth.' This, even as a summary, is not accurate. In fact Boime fails to relate the theme of repetition in Ingres's work to the socio-political aims that he attributes to Ingres the man. Of the former he offers only a superficial interpretation. He writes, 'His "pursuit of perfection" is inseparable from his race to fortune.' And, again, 'Like the film and television industries, the models of the safe and secure production, there is a fear of going out on a limb and risking calamitous financial failure.'

48. For the wish, see particularly Sigmund Freud, *The Interpretation of Dreams*, and *Totem and Taboo*, in *Complete Psychological Works of Sigmund Freud*, ed. James Strachey (London, 1953–74), Vols.IV–V and XIII respectively.

49. Anthony Blunt, review of Georges Wildenstein, *op.cit.*, *The Listener*, 11 March 1954, pp.433–434. See also Robert Pincus-Witten, 'Ingres Centennial at the Fogg', *Artforum*, Vol.V, no.9, May 1967, pp.46–48, for a discussion of some perspectival distortions in the drawings.

50. See Sigmund Freud, *Notes upon a Case of Obsessional Neurosis*, and *Totem and Taboo*, in his *Complete Psychological Works*, Vols.X and XIII respectively.

51. See Melanie Klein, 'Notes on some Schizoid Mechanisms', and 'Some Theoretical Conclusions Regarding the Emotional Life of the Infant', in *The Writings of Melanie Klein*, Vol.III; and Herbert Rosenfeld, 'The Superego and the Ego-Ideal', *International Journal of PsychoAnalysis*, Vol.43, Parts 4–5, 1962, reprinted in his *Psychotic States: a PsychoAnalytic Approach*.

52. See my 'Identification and Imagination', in *Freud: A Collection of Critical Essays*, ed. Richard Wollheim (New York, 1974).

53. On idealization and creativity, see Melanie Klein, 'Some Theoretical Conclusions Regarding the Emotional Life of the Infant'; Adrian Stokes, *Three Essays on the Painting of our Time* (London, 1961), and *Painting and the Inner World* (London, 1963), both reprinted in *The Critical Writings of Adrian Stokes*, ed. Lawrence Gowing (London, 1978), Vol.III; and Hanna Segal, 'Delusion and Artistic Creativity', *International Review of Psycho-Analysis*, Vol.I, Part 1, 1974, reprinted in her *The Work of Hanna Segal* (New York, 1981).

54. Charles Baudelaire, 'Guys, le peintre de la vie moderne', *Figaro*, 26 and 28 November and 3 December 1863, reprinted in his *L'Art Romantique*, ed. F.-F. Gautier (Paris, 1931), trans. Jonathan Mayne, as *The Painter of Modern Life, and Other Essays* (London, 1964).

55. Théophile Gautier, *Moniteur Universel*, 14 July 1855, reprinted in Mathieu Méras, 'Théophile Gautier, Critique officiel d'Ingres au *Moniteur*', *Actes du Colloque International: Ingres et son Influence, Bulletin Spécial du Musée Ingres*, nos.47–48, September 1980, pp.205–219.

56. See Hélène Toussaint, *op.cit.*, entry nos.XIII–XIII-6, pp.71–77.

57. Amaury-Duval, *op.cit.*, p.144.

58. John Stuart Mill, *Autobiography* (London, 1873), Chapter V.

59. Amaury-Duval, *op.cit.*, p.145.

60. Henri Delaborde, *op.cit.*, pp.245–246.

61. Amaury-Duval, *op.cit.*, p.144.

62. Amaury-Duval, *op.cit.*, pp.146–147.

63. Hans Naef, who disagrees with my opinion of Ingres's painting of his father, makes an observation analogous to mine about a group of portrait-drawings by Ingres of his family, which are amongst his earliest works and which he kept by him all his life in the simple frame in which they are still to be seen (Musée Ingres, Montauban). Naef comments that the stiffness of Ingres's drawing of his father is in marked contrast to the freedom and ease with which he drew his sisters, though the drawings are probably not more than two years apart: the clothes suggest that the portrait of the father is *c*.1792, those of the sisters *c*.1794. See Hans Naef, *op.cit.*, Vol.I, pp.53–54.

64. Boyer d'Agen, *op.cit.*, p.401.

65. This is confirmed in Henry Lapauze, *op.cit.*, pp.538–539.

66. Charles Blanc, *op.cit.*, p.200.

67. On Ingres's speed as a draughtsman, see Amaury-Duval, *op.cit.*, p.46. This has however been contested in Marjorie B. Cohn, 'The Original Format of Ingres's Portrait Drawings', *Actes du Colloque Ingres, Bulletin spécial du Musée Ingres*, Special no., October 1969, pp.15–25.

68. I have been helped to an understanding of Ingres's practice by certain observations in two articles: Denis Milhau, 'Valeurs et contradictions du concept de néo-classicisme dans le rapport de Picasso à Ingres', *Actes du Colloque International: Ingres et le Néo-Classicisme, Bulletin du Musée Ingres*, Special no., October 1975, pp.103–131, and 'Ingres, la ligne et la Couleur', *Actes du Colloque International: Ingres et son Influence, Bulletin Spécial du Musée Ingres*, nos.47–48, September 1980, pp.111–130.

69. See Théophile Gautier, *Moniteur Universel*, 10 April 1862, reprinted in Mathieu Méras, 'Une Critique de Théophile Gautier sur "Jésus parmi les Docteurs" ', *Bulletin du Musée Ingres*, no.40, December 1976, pp.21-27; and Prosper Mérimée, *Correspondance Générale*, ed. Maurice Parturier (Paris, 1941–64), Vol.XI, p.80.

70. For overestimation of the eyes, see Sigmund Freud, 'The Psycho-analytic View of Psychogenic Disturbance of Vision', in his *Complete Psychological Works*, Vol.XI; Karl Abraham, 'Restrictions and Transformations of Scoptophilia in Psycho-Neurotics', in his *Selected Papers on Psycho-Analysis* (London, 1927); and Otto Fenichel, 'The Scoptophilic Instinct and Identification', in his *Collected Papers*, eds. Hanna Fenichel and David Rappaport (London, 1954).

71. Sigmund Freud, 'From the History of an Infantile Neurosis', in his *Complete Psychological Works*, Vol.XVII; see also *The Wolf-Man and Sigmund Freud*, ed. Muriel Gardiner (London, 1972).

72. Sigmund Freud, *op.cit.*, p.29.

73. Muriel Gardiner very kindly allowed me to see some of the Wolf Man's pictures in her collection.

74. On Picasso's variations on the *Raphael and La Fornarina* theme, see Gert Schiff, 'Picasso's Suite 347, or Painting as an Act of Love', in *Woman as Sex Object*, eds. Thomas B. Hess and Linda Nochlin, *Art News Annual*, Vol.XXXVIII, 1972, pp.239–253, and catalogue of *Picasso: The Last Years 1963–1973* (New York, 1983), pp.49–50; and Leo Steinberg, 'A Working Equation or – Picasso in the Homestretch', *Print Collector's Newsletter*, Vol.III, no.5, November–December 1972, pp.102–105.

75. It is significant that the one borrowing of Picasso from Ingres that has been established for this period is from the highly statuesque Brussels version of *Vergil*, where the eyes are frozen into a sculptural immobility. See Meyer Schapiro, 'Picasso's *Woman with a Fan*: On Transformation and Self-Transformation', in *Essays in Archaeology and the Humanities: In Memoriam Otto J. Brendel*, eds. Larissa Bonfante and Helga von Heintze (Mainz, 1976), reprinted in his *Modern Art: 19th and 20th Centuries* (New York and London, 1978).

76. See William Rubin, 'From Narrative to "Iconic" in Picasso: The Buried Allegory in *Bread and Fruitdish on a Table* and the Role of the *Demoiselles d'Avignon*', *Art Bulletin*, Vol.LXV, no.4, December 1983, pp.615–649.

77. This highly illuminating distinction is made, in connection with the art of Chardin, in Michael Baxandall, *Patterns of Intention* (New Haven and London, 1985), p.102.

78. The critic who has done most to spell out the interconnection between Picasso's art and his life is John Richardson: see particularly his 'Your Show of Shows', and 'Picasso and l'Amour Fou', *New York Review of Books*, Vol.27, no.12, 17 July 1980, pp.16–24, and Vol.32, no.20, 19 December 1985, pp.59–69, respectively. This approach is rejected in Rosalind E. Krauss, 'In the Name of Picasso', *October*, no.16, Spring 1981, reprinted in her *The Originality of the Avant-Garde and other Modernist Myths* (Cambridge, Mass., 1985), where it is called, more in cuteness than in accuracy, an 'art history of the proper name'. The phrase puns on Wölfflin's 'art history without names'.

79. A brilliant essay on this topic is Michel Leiris, 'The Artist and his Model' in *Picasso, 1881–1973*, eds. Roland Penrose and John Golding (London, 1973). Another remarkable essay on the same topic is Leo Steinberg, 'The Algerian Women and Picasso at Large', reprinted in his *Other Criteria* (New York, 1972).

80. A very promising analysis of the role of *collage* and *papier collé* in the work of Picasso and Braque is to be found in John Golding, *Cubism: a History and Analysis, 1907–1914* (London, 1959), pp.103–122.

81. Hélène Toussaint, *op.cit.*, entry no.XI-2, p.66.

82. The commission for *The Apotheosis of Homer* was worked out jointly by the director of the Louvre, the comte de Forbin, who, like Ingres, had been David's student, and by the vicomte Sosthène de la Rochefoucauld, representing the Département des Beaux-Arts, and it was one of eight commissions for the galleries that were to make up the new Musée Charles X for antiquities. The decoration of each gallery was intended to reflect the art that it displayed, and Ingres was entrusted with the gallery where Greek ceramics were exhibited. The commissions were sent out to the artists on 29 July 1826, and the artists had to engage themselves to deliver their work by 1 November 1827 in time for the Salon exhibition to be held in the new museum. At the last moment Ingres had his date for delivery postponed to 1 December and in consequence the gallery could not be opened by the king until 15 December. Ingres's illness was given as the official explanation. See Christiane Aulanier, *Histoire du Palais et du Musée du Louvre*, Vol.VIII, *Le Musée Charles X* (Paris, 1961), pp.35–49. The official commission specified only the topic, and Ingres was proud that he had worked out the composition within a week. For a more detailed account of Ingres's treatment of the topic, see Norman Schlenoff, *op.cit.*, pp.148–200.

83. For the process of exclusion of artists, see Boyer d'Agen, *op.cit.*, pp.336 and 455–456; Charles Blanc, *op.cit.*, pp.189–190; and Henri Delaborde, *op.cit.*, pp.271–273 and 355–364.

84. On Ingres's use of the term *'exclusif'* as a term of approbation, see Norman Schlenoff, *op.cit.*, pp.303–306.

85. Boyer d'Agen, *op.cit.*, p.305.

86. Boyer d'Agen, *op.cit.*, p.456; and Henri Delaborde, *op.cit.*, p.356.

87. This is cited from Ingres's own account of the picture in Henri Delaborde, *op.cit.*, p.363.

88. Henri Delaborde, *op.cit.*, p.271.

Notes to VI

1. Examples would be Wilhelm Worringer, *Abstraktion und Einfühlung* (Munich, 1908), trans. Michael Bullock, as *Abstraction and Empathy* (London, 1953); Clive Bell, *Art* (London, 1914), and *Enjoying Pictures* (London, 1934); Georges Bataille, *Manet, Etude biographique et critique* (Geneva, 1955), trans. Austryn Wainhouse and James Emmons, as *Manet* (New York, 1955); and Anton Ehrenzweig, *The Hidden Order of Art* (London, 1967).

2. The account of metaphor upon which I draw derives from Donald Davidson, 'What Metaphors Mean', *Critical Inquiry*, Vol.5, no.1, Autumn 1978, reprinted in *On Metaphor*, ed. Sheldon Sacks (Chicago, 1979), pp.29–45, and in his *Inquiries into Truth and Interpretation* (Oxford, 1984). A brief way of characterizing

Davidson's account is to say that it removes metaphor from the domain of semantics to that of pragmatics. I do not believe that this point can be applied to painting with any greater exactness than I attempt in the main body of the text, if only for the reason that the distinction between semantics and pragmatics does not hold for pictorial meaning. Other contributions to the Sacks anthology are relevant to the present discussion.

3. For the subject-matter of *The Three Ages of Man*, see Erwin Panofsky, *Problems of Titian, Mostly Iconographic* (New York and London, 1969), pp.94–96. For a discussion of the subject-matter of the *Concert Champêtre* that, in its complete neglect of artist's intention, is to my way of thinking a model of how pictorial meaning should not be established, see Patricia Egan, '*Poesia* and the *Fête Champêtre*', *Art Bulletin*, Vol.XLI, no.4, December 1959, pp.303–313. The author concedes the point on the penultimate page of her article. A highly imaginative reinterpretation of the *Concert Champêtre* is put forward in Philipp Fehl, 'The Hidden Genre: A Study of the *Concert Champêtre* in the Louvre', *Journal of Aesthetics and Art Criticism*, Vol.XVI, no.2, December 1957, pp.153-160. Though the argument is very persuasively presented, the interpretation that it proposes, which is that the two women are nymphs who therefore inhabit a different domain from the young men, requires such a radical shift in our perception of the picture that I feel we need stronger visual evidence than we are provided with before we should accept it. Fehl himself tends to underestimate the perceptual revision that his interpretation calls for. He summarizes his interpretation by saying that the women are 'as *invisible* to the young men as they are visible to us' (his italics). This is correct. But on my view of representation, this requires that, in seeing the women, we should see them *as* invisible to the men. Precisely what this would involve is obscure. In his article Fehl also applies this interpretation to *The Andrians* (Prado, Madrid) and to the *Pardo Venus* (Louvre, Paris). In his 'The Worship of Bacchus and Venus in Bellini's and Titian's Bacchanals for Alfonso d'Este', *Studies in the History of Art: National Gallery of Art, Washington*, Vol.6, 1974, pp.37–95, Fehl extends the interpretation to two further paintings by Titian. These are *The Amores* (Prado, Madrid) and *Bacchus and Ariadne* (National Gallery, London).

4. For pointing out this configurational effect I am deeply indebted to Johannes Wilde, *Venetian Art from Bellini to Titian* (Oxford, 1974): a work whose modesty of presentation conceals a wealth of the most profound pictorial observation.

5. See Giles Robertson, 'The X-ray examination of Titian's *Three Ages of Man*', *Burlington Magazine*, Vol.CXIII, No.825, December 1971, pp.721–726.

6. On the use of near-complementaries, see Adrian Stokes, *Colour and Form* (London, 1937), reprinted in *The Critical Writings of Adrian Stokes*, ed. Lawrence Gowing (London, 1978), Vol.II. Stokes contends that near-complementaries are more effective than complementaries in securing simultaneous contrast. This is the optical effect whereby one coloured area encourages a neighbouring greyed area to move towards its complementary: for instance, an orange area will induce a neutral area adjacent to it to move towards blue.

7. Walter Pater, *The Renaissance* (2nd edition, London, 1877), pp.130–154.

8. Bernard Berenson, *Lorenzo Lotto: An Essay in Constructive Art Criticism* (New York and London, 1895), p.315.

9. Titian's employment of paint simultaneously to indicate the colour of a represented object and to generate a physical

analogue to the represented scene is a central theme in Theodor Hetzer, *Tizian: Geschichte seiner Farbe* (Frankfurt am Main, 1938). See Johannes Wilde, review of Theodor Hetzer, *Tizian, Zeitschrift für Kunstgeschichte*, Band VI, no.1, 1937, pp.52–55. I find myself in sympathy with Hetzer's thesis, but not with the extravagant terms in which he expresses it.

10. Panofsky points out how, in the late *St Margaret* (Prado, Madrid), of 1565, Titian makes the saint's dress green, and at the same time the ample landscape is painted in all imaginable shades of brown and red but with no trace of green: see Erwin Panofsky, *op.cit.*, p.50.

11. Charles Hope, *Titian* (London, 1980), p.141, finds the angel's gesture 'inept' in that the crossed arms traditionally belong to the annunciate Virgin rather than to the announcing Angel. If this fact, taken in isolation, were evidence for anything, it would show, not so much that the painting was not painted by Titian, as that it was never painted at all. Hope finds the Virgin's pose, which I come to next, 'mannered'. I am unable to share many of the author's perceptions either of this picture or of *The Death of Actaeon*.

12. The Virgin's pose is discussed in David Rosand, 'Titian's Light as Form and Symbol', *Art Bulletin*, Vol.LVII, no.1, March 1975, pp.58–64, where her recoil is connected with the doctrine of the conception *per aurem*.

13. The Bassanoesque face is significantly missing from a version of the San Salvatore *Annunciation* (San Domenico Maggiore, Naples) which manifests the hand of either Palma Giovane or some other studio assistant. The resultant picture loses the historical meaning of the original. The same is true of the Cornelis Cort engraving of the San Salvatore painting.

14. On Titian's emendations to the story, see Erwin Panofsky, *op.cit.*, p.163. For an observation on the presence of Diana in this picture that is related to mine, see Augusto Gentili, *Da Tiziano a Tiziano* (Milan, 1980), p.159. See also Jane C. North, *Veiled Images* (Cranbury, New Jersey, 1985).

15. Of recent years, *The Flaying of Marsyas* has been fortunate in its commentators. See Jaromir Neumann, *The Flaying of Marsyas* (London, 1965); Philipp Fehl, 'Realism and Classicism in the Representation of a Painful Scene: Titian's Flaying of Marsyas in the Archiepiscopal Palace at Kroměříz', *Czechoslovakia Past and Present*, ed. Miloslav Rechcigl, Jr. (The Hague, 1969), Vol.II, *Essays on the Arts and Sciences*, pp.1387–1415; Lawrence Gowing, 'Human Stuff', *London Review of Books*, Vol.6, no.2, 2–15 February 1984, pp.13–14; and Sydney Freedberg, 'Titian and Marsyas', *FMR*, America, First Year, no.4, September 1984, pp.51–68.

16. For the rejection of the painting as a work by Titian, see Theodor Hetzer, 'Tiziano Vecellio', in *Allgemeines Lexikon der Bildenden Kunst*, eds. Ulrich Thieme and Felix Becker (Leipzig, 1907–50), Vol.XXXIV (1940); and Erwin Panofsky, *op.cit.*, p.171n. See also Frederick Hartt, *Giulio Romano* (New Haven, 1958), Vol.I, p.111, n.8.

17. On this theme, see Emmanuel Winternitz, 'The Curse of Pallas Athene', in *Studies in the History of Art Dedicated to William Suida on his 80th Birthday* (London, 1959), pp.186–195.

18. This shift in perspective is well illustrated in Sydney Freedberg, *op.cit.*, pp.54–56, through a comparison of Titian's painting and Giulio Romano, *The Flaying of Marsyas* (Palazzo del Té, Mantua), from which Titian's work derives many of its compositional features. Freedberg writes of the 'awesome difference' between the two works. The comparison is also pursued in Philipp Fehl, 'Realism and Classicism in the Representation of a Painful Scene'. Giulio Romano's composition is, on account of its present condition, best approached through a drawing for it which survives (Cabinet des Dessins, Louvre, Paris).

19. See Jaromir Neumann, *op.cit.*, p.12.

20. See Johannes Wilde, *op.cit.*, pp.9–13.

21. For discussion of this great but comparatively neglected picture, see Luitpold Dussler, *Giovanni Bellini* (Frankfurt, 1935); Johannes Wilde, *op.cit.*, pp.43–44; and John Steer, *A Concise History of Venetian Painting* (London and New York, 1970), pp.73–76, and *Giovanni Bellini, Paul Cézanne and the Sense of Place in Painting*, Inaugural Lecture, Birkbeck College London, 1983 (unpublished).

22. For the capacity of architecture to metaphorize the human body, I am deeply indebted to the writings of Adrian Stokes, particularly *The Quattro Cento* (London, 1932), *Venice* (London, 1945), *Inside Out* (London, 1947), *Art and Science* (London, 1949), *Smooth and Rough* (London, 1951), 'The Impact of Architecture', *British Journal of Aesthetics*, Vol.1, no.4, September 1961, and *The Invitation in Art* (London, 1965), all reprinted in *The Critical Writing of Adrian Stokes*, Vols.I–III.

23. These pictures are discussed in Stefan Kozakiewicz, *Bernardo Bellotto* (Recklinghausen, 1972), Vol.I, pp.100–101, Vol.II, entry nos.238, 241, p.184.

24. For the distinction between mass or mass-effect and massiveness, see Adrian Stokes, *The Quattro Cento*, particularly Part II, section 5.

25. For architectural apertures, see Adrian Stokes, *Smooth and Rough*, particularly Part III, section 6.

26. Lawrence Gowing, *The Originality of Thomas Jones* (London, 1986), p.7

27. 'Memoirs of Thomas Jones', ed. A.P. Oppé, *The Walpole Society*, Vol.XXXII (London, 1946–8).

28. A.P. Oppé, *op.cit.*, pp.96–99.

29. Lawrence Gowing, *op.cit.*, p.47.

30. A.P. Oppé, *op.cit.*, p.111.

31. For Thomas Jones, see also John Gere, 'An Oil-Sketch by Thomas Jones', *British Museum Quarterly* XXI, no.4, 1959, pp.93–94, and 'Thomas Jones: An Eighteenth-Century Conundrum', *Apollo*, Vol.XCI, no.100 (N.S.), June 1970, pp.469–470; Ralph Edwards, 'Thomas Jones 1742–1803, a reappraisal of his Art', *Connoisseur*, Vol.168, no.675, May 1968, pp.8–14; and John Jacob with Ralph Edwards, catalogue of *Thomas Jones, 1742–1803* (London, 1970).

32. Harold Rosenberg, *Willem de Kooning* (New York, 1973), p.43.

33. Jörn Merkert, 'Stylelessness as Principle: The Paintings of Willem de Kooning', in Paul Cummings *et al.*, catalogue of *Willem de Kooning* (New York, 1983), p.126.

34. e.g. Jörn Merkert, *op.cit.*

List of illustrations

List of illustrations

List of illustrations

379

List of illustrations

Index

Figures in italics refer to illustration numbers.
Roman numerals refer to colour plates.

abstract art 62, *101*, 348, 350–352
Adams, Ansel, *Ellery Lake, Sierra Nevada 20*
aesthetics of painting, central issue of 13;
 externalism and internalism in 13, 15–16;
 general and substantive 7; internalism in 16
Alken, Samuel Henry 235; *The Finish of the
 1853 Derby 235, 214*
Alpers, Svetlana, *The Art of Describing* 58
Amaury-Duval 253, 278–279
Amsterdam school, according to Riegl 178–
 179, *180*
Anonymous, *Miraculous Images Found in an
 Apple Tree* 58, *37*
Antonello da Messina, *Portrait of a Young
 Man 57*
architectural painting, and pictorial metaphor
 354
art, and function 37–38
art, and human nature 8, 9, 357
art, and socialism 8, 357
art-history, and history of patronage 252,
 370n.7, 371n.31, 372n.36, 374n.82;
 positivism in 9; and social explanation 9,
 37–38, 359n.23, 371n.31, 372n.47; and
 structuralism and post-structuralism 9
art-world 14, 15, 358n.1
artist as agent 17–25, 36–40, 43, 286
artist as spectator 39–40, 43–45, 286
Atget, Eugène, *La Nappe 83*
attributions 93

Ballantyne, John, *Sir Edwin Landseer* 70, *56*
de Balleroy, Albert 243
Barnard, E.E., *Cumulus Cloud, Mushrooming
 Head 19*
Bassano, Jacopo, *Adoration of the Shepherds*
 320, *323*
Baudelaire, Charles 82; on Ingres 277
Baxandall, Michael 90–91, 362n.33
Bellini, Giovanni 327–336, 354; and colour
 332–333, 336; and compression of space
 333–334, 336, 354; contrasted with Manet
 332; contrasted with Titian 332; and
 corporeality 328–336; and fretting and
 faceting 329–331, 336; and reverie 336;
 and the 'spreading effect' 332; and the
 turned-in look 332; *The Baptism of Christ*
 220, 332–334, 354, *336, 338,* XXII; *The
 Blood of the Redeemer* 331, *332; Doge
 Leonardo Loredan 334; The Drunkenness of
 Noah* 8, 335–336, 340, XXIII; *Madonna and
 Child 336, 341; Madonna and Child with
 Four Saints* 332, *337; The Madonna of the
 Meadow* 336, *340,* XXIV; *Pietà* 331, *333; St
 Jerome with St Christopher and St Louis of
 Toulouse* 354, *357, 358,* XXX; *Triptych with
 Madonna and Saints* 328, *329, 330, 331*
Bellotto, Bernardo 338–341, 344, 345, 346,
 350; and apertures 340; and corporeality
 340–341, 346; and 'mass-effect' 340; and
 'paint-surface' 340–341; (two) *Views of
 Schloss Königstein:* 338–341, 346, *343, 344,
 345,* XXVII, XXVIII

Berenson, Bernard 89, 315
Bernini, Gian Lorenzo 231
Bertin, Louis-François 277–280
bison *21, 22*
Bitaubé, Paul-Jérémie 257
Blake, William, *The River of Life* 308, *308*
Blanc, Charles 235–237, 266–268; biographer
 of Ingres 266–268; *Histoire des Peintres* 235–
 237; after Rubens, *Park of the Château of
 Steen 240, 224*
blindness, in Ingres 304; in Picasso 290
Bloom, Harold, *The Anxiety of Influence* 231,
 368n.49
Blunt, Anthony 213–218, 272
borrowing 187–190, 198, 204, 320, 369n.74
Börsch-Supan, Helmut 138–139
Botticelli, Sandro 51
breast, the 164, 195, 293
Bronzino, Agnolo 75; *A Young Woman with
 her Little Boy 65*
buildingscapes, and pictorial metaphor 338–
 340

Calamatta, Luigi 301
Canaletto, Antonio 338
caricature 70
Carracci, Annibale 240
Cézanne, Paul 24, 29, 334; *Still Life: Milk
 Pitcher and Fruit* 334, *339; View of Auvers*
 29, *1; View of Médan* 29, *2*
Chantelou, Fréart de 213, 223
Chardin, Jean-Baptiste-Siméon 98–100; *The
 House of Cards* 308, *309; The White
 Tablecloth 82*
Charles X 301
Clairin, Georges, *Sarah Bernhardt* 164–166,
 133, V
Claude Lorrain 210, 220; *Ascanius Shooting the
 Stag of Sylvia 220, 198; St Philip baptizing
 the Eunuch 187*
codes 22
cognitive stock 16, 44, 89–96, 204, 362n.32;
 must affect perception 91–95, 204, 366n.21
Cohn, Marjorie 271
Cole, Thomas, *The Voyage of Life: Childhood*
 308, *310; The Voyage of Life: Youth* 308, *311*
communication 96, 362n.39
connoisseurship 9, 25, 31, 36, 89
Constable, John, *Hadleigh Castle* 86, *70*
Constantin, Abraham 261
convention 15, 22, 23, 44, 61, 95
Corot, Jean-Baptiste 40; *The Artist's Studio 14*
corporeality 308, 314; in Bellini 328–336, 354;
 in Bellotto 340–341, 346; in Jones 345–
 347; in de Kooning 349–350; in Titian
 310–315, 316–319, 320, 321, 322, 326
correspondence 81–84, 88, 208–213
Courbet, Gustave 100, 243; *Le Sommeil* 195,
 162, 164
Cranach, Lucas 243

Dalby, John, *Racing at Hoylake, 1851* 235, *213*

Dante, Alighieri 259, 324
Danto, Arthur 358nn.1&5
Daudet, Lucien 51
David, Jacques-Louis, *Antiochus and Stratonice*
 253
Davidson, Donald 374n.2
Degas, Edgar 149–150, 157–160, 170, 234–
 235; *Au Café* 150, *112; Girl in Red* 157, *123;
 Diego Martelli* 157, *124; Duc et Duchesse de
 Morbilli* 149–150, *111; Thérèse de Gas,* 157,
 125
Delaborde, Vicomte Henri 278–279
Delacroix, Eugène 243
Delaroche, Paul, *The Assassination of the Duc
 de Guise* 253, 268, *241*
delight, visual 45, 98–100
Dempsey, Charles 222–224
devotional imagery 185
Domenichino 30, *191*
doubling-up of predicates 84–85
dreams 163–164, 175, 283, 287–288
dream-screen 164
Duran, Carolus, *Mademoiselle de Lancey* 164–
 166, *132*
Duret, Théodore 170–172

envy 231–232, 235, 275, 279
envy, fear of 235, 243; in Manet 235–243; in
 Ingres 277
envy and jealousy 283; in Ingres 277, 283–
 286, 303–304
expression 45, 80, 84–89, 138–139
expressive perception 45, 80–89, 138; prior to
 pictorial expression 45, 85–87; and
 standard of correctness 85–89
Eyck, Jan van, *The Adoration of the Mystic
 Lamb* 65, *47*
eyes, the 25, 43–45, 89, 100, 286–287, 288,
 289–295, 297–299, 304, 312

Fantin-Latour, Henri 75, 163; *Still Life 64*
Fayum, *Portrait of a Woman* 71, *58*
feedback 45, 88–89
Félibien, André 220
figuration 21, 62, 351, 359n.13
Flandrin, Hippolyte 266
Forestier, Jean 253
Fourment, Hélène 240
Fried, Michael 359n.13, 364–365n.34, 369n.71
Friedlaender, Walter 213
Friedrich, Casper David 131–140, 166–168,
 181; *Afternoon* 138, *95; Cliffs of Rügen* 166–
 168, *134; The Cross in the Mountains (The
 Tetschen Altarpiece)* 136, *93; Greifswald in
 Moonlight 88; Landscape with an Obelisk 84;
 Landscape with a Rainbow 86; The Large
 Enclosure, near Dresden* 86, *131, 136, 138,
 69, 92; Meadows near Greifswald 89; Two
 Men by the Sea at Moonrise* 166–168, *135*

gaze, the, in Ingres 297–299, 304; in Picasso
 289–295; in Titian 312; in the Wolf Man
 288

Index 381